DAVID HOCKNEY

A RETROSPECTIVE

March 1988

Happy Birthday ∧Mummy !!
κουλτουριάρα

Much love
Mexxxxx.

NEWSWEEK JUST DID a cover story called "The Two Britains" (North and South). It began, of course, with Disraeli's famous lines about "The Two Nations" from his novel *Sybil*, written in 1845. From the moment Hockney and I arrived (the same day) at the Royal College of Art in 1959, the question of class in England has intrigued me. It has always fascinated David. I believe it has driven him as poignantly and decisively as his sexual life has. If his origins (which include his extraordinary parents) drive him, they drive his art. There is a genius in origins—ripe for picking in art and life for those who feel it's there for them. For me as a Diasporist Jew, my own origins explained themselves to me slowly and bodied forth in my life and pictures unsurely and uneasily. Hockney the Yorkshireman was never in doubt. Northern England is his native strength and he knows it. A few years ago we were driving down Nichols Canyon (both Diasporists by then in some palpable way). I was feeling sorry for myself and saying I felt alien in England after a quarter of a century. I'll not forget what he replied: "I've got Bradford; they'll never take that from me."

From our earliest days together one of his constant reformist themes has been the habit in our poor, put-upon England of treating too many people like children or lesser others—from those who uphold the licensing laws in pubs to the sexual censorship to those among our betters who know what's relevant in art and what's not. These things drive him gently and briefly nuts. David's never been deceived by Marxists who know what's good for people either. In another context Senator Pat Moynihan said recently: "For reasons that have been well catalogued, Leninism has a particular attraction for youth of the upper classes." Hockney will tell you that more often than not these are the same old experts, exercising the gentle functions of the same old order. I watched his amazing natural genius unfold in his art. If a class order had helped to blight his beloved Yorkshire—and who can doubt it who has walked the streets of the north of England (or read Orwell)?—then he, Hockney, would rise up in his art and become, to paraphrase one of his favorite (real classy) early books,

a not-so ragged-trousered philanthropist. And, by the way, he would fulfill *my* favorite definition of art. It is Nietzsche's: "Art is the desire to be different, the desire to be elsewhere." Exclusivist and awkward, this short pronouncement is the name of the game, and it fits every artist I've ever met in some way, from the most selfish careerist to the monkish cultist to the populist. Hockney began his search for Wider Perspectives a long time ago. Nijinsky said genius was staying up in the air just a little longer than anyone else. Living well may be the best revenge, as the saying goes, but so is drawing just a little better than anyone else. During our first days at the Royal College I spotted this boy with short black hair and huge glasses, wearing a boilersuit, making the most beautiful drawing I'd ever seen in an art school. It was of a skeleton. I told him I'd give him five quid for it. He thought I was a rich American. I was—I had $150 a month GI Bill money to support my wife and son. I kept buying drawings from him. I've still got them all. I've even got a very rare Hockney abstraction from his two-week abstract period.

His romance with L.A. was about two things. Los Angeles was "elsewhere," about as unlike England as a place could be, and, as his friend Isherwood said about Berlin, Los Angeles meant boys. Together those things spelled romance, swimming pools, and thus his memorable paintings, which may be (arguably) the best anyone ever painted out there so far. It is a rare event in our modern art when a sense of place is achieved at the level of very fine painting. Sickert's Camden Town comes to mind, and above all, Hopper's America, in which I grew up. Hockney's California is one of the only recent exemplars.

I would claim him (and *have*) for our School of London and its great depictive powers, but he is as restless as I am and won't stay put. Nor will his art. The sheer distribution of its wealth is enough to make a social redistributor blanch with envy. His pictures *please* a great many people in all walks of life. Their society is truly classless, and I believe there is a genius in that too.

R. B. Kitaj

DAVID HOCKNEY

A RETROSPECTIVE

Organized by
Maurice Tuchman and Stephanie Barron

Los Angeles County Museum of Art

Thames and Hudson

Exhibition Itinerary
Los Angeles County Museum of Art
February 4–April 24, 1988

The Metropolitan Museum of Art
June 18–August 14, 1988

Tate Gallery
October 26, 1988–January 3, 1989

The following publishers have generously given permission to use quotations from copyrighted works: From *The Principles of Chinese Painting*, by George Rowley. Copyright © 1947, © 1959 by Princeton University Press. Reprinted by permission of Princeton University Press. From *The Renaissance Rediscovery of Linear Perspective*, by Samuel Y. Edgerton, Jr. Copyright © 1975 by Samuel Y. Edgerton, Jr. Reprinted by permission of Basic Books, Inc., Publishers. From *Wholeness and the Implicate Order*, by David Bohm. Copyright © 1980 by Routledge & Kegan Paul. Reprinted by permission of Associated Book Publishers (U.K.) Ltd.

Copublished by the Los Angeles County Museum of Art, 5905 Wilshire Boulevard, Los Angeles, California 90036, and Thames and Hudson Ltd., 30-34 Bloomsbury Street, London, England WC1B 3QP.

ISBN 0-500-23514-7

COVER: *A Walk around the Hotel Courtyard Acatlán* (detail), 1985

ENDSHEETS: *A Visit with Christopher and Don, Santa Monica Canyon* (details), 1984

CONTENTS

FOREWORD

As one of the most innovative and productive artists at work today, David Hockney has been the subject of more than two hundred solo exhibitions and participated in another two hundred group exhibitions, and his work has been discussed in books and periodicals extensively. Now, on the occasion of his fiftieth year, we survey a quarter-century of his art in this retrospective exhibition and book. Los Angeles, New York, and London are the most important cities for Hockney and his development, and consequently it is appropriate that the exhibition be presented in all three. The opportunity for visitors to the Los Angeles County Museum of Art, the Metropolitan Museum of Art, and the Tate Gallery to see Hockney's work in all media at one time is a special one.

Since the 1960s British-born artist David Hockney has maintained an ongoing relationship with Los Angeles, frequently visiting, constantly depicting regional characteristics, and finally in 1979 establishing a residence and studio. It is through Hockney's work that many people derive their impressions of life in Southern California, a landscape redolent with sunshine, swimming pools, and palm trees. Yet since moving to Los Angeles, Hockney has worked with an intensity that is hard to equal: exploring ways of working in the theater, with the camera, and with commercial printing and office copying machines, while continuing to produce ambitious canvases and extensive print works.

Maurice Tuchman, senior curator of twentieth-century art, and Stephanie Barron, curator of twentieth-century art, organized and coordinated this exhibition and publication. The book also benefited from the efforts of managing editor Mitch Tuchman, who worked closely with our copublishers Harry N. Abrams, Inc., and Thames and Hudson Ltd.

We express our deepest gratitude to David Hockney, who was extremely helpful in securing loans for the show and who was enthusiastically supportive of all our efforts. The many lenders to the exhibition, who are listed separately in this volume and who agreed to part with works from their collections for one year, have our deepest thanks as well.

David Hockney: A Retrospective received major funding from AT&T, and we gratefully acknowledge the early and strong commitment of James E. Olson, J. Kent Planck, and R. Z. Manna to this extensive undertaking. Additionally many of the foreign loans were indemnified by the Federal Council on the Arts and Humanities.

Earl A. Powell III
DIRECTOR
Los Angeles County Museum of Art

SPONSOR'S STATEMENT

WE AT AT&T have long held that communication is the beginning of understanding. That is not limited to telecommunications. In sharing the works of David Hockney through this catalogue and the exhibition it represents, we are hoping to expand international understanding through the language of a brush stroke, a photograph, a stage design.

Hockney is a consummate painter, an inventive draftsman, a photographer who has explored Cubism for the camera, and an artist who has produced distinguished work even from the ordinary copying machine. In addition his provocative designs for the theater have given audiences a fresh idea of what stage perspective is all about. Working in a wide range of media, Hockney challenges our visual sense and redefines our conceptions of space.

We are pleased to present the works of David Hockney in Los Angeles, New York City, and ultimately in London, the capital city of the artist's homeland.

We are also pleased to have been able to help underwrite the Los Angeles Music Center Opera's production of Wagner's *Tristan und Isolde*, for which Hockney designed the sets, some of which appear in the exhibition and are reproduced in this volume.

For more than a century AT&T has been in the business of exploring science and technology to transform and improve the way people communicate. For nearly half that time we also have been associated with the world of ideas that shapes people's sense of the possibilities of life and gives rise to the arts. As we near our half-century milestone in sponsoring the arts, David Hockney, who has applied advances in science and technology to enhance communication through the visual arts, is marking his fiftieth birthday. We believe it is altogether appropriate that to celebrate the occasion, AT&T and Hockney join together in this spectacular retrospective.

J. E. Olson
CHAIRMAN AND CHIEF EXECUTIVE OFFICER
AT&T

ACKNOWLEDGMENTS

DAVID HOCKNEY has been since his twenties one of the most widely discussed and documented artists of his generation. The subject of numerous exhibitions and publications, he is also one of the most articulate artists of our time. His lectures with their clear and provocative insights have become legendary, and his own account of his career, *David Hockney by David Hockney,* never out of print, remains one of the most popular art books of recent times. Thus the responsibility of publishing an authoritative account of Hockney's multifaceted career, spanning twenty-five years and work in all media, was as challenging as it was intriguing.

We approached a number of art historians who had already written with insight on the artist and invited them to the museum for a conference with Hockney about the exhibition and the approach that each might take in its catalogue. The participating writers—Henry Geldzahler, Christopher Knight, Gert Schiff, and Lawrence Weschler—were joined by our colleague and collaborator William S. Lieberman, chairman of the Department of Twentieth-Century Art at the Metropolitan Museum of Art. We are grateful to them all for their contributions to the conference and for the essays that form the core of this book. Subsequently they were joined by three excellent additional essayists—Anne Hoy, R. B. Kitaj, and Kenneth E. Silver—as well as by Tate Gallery librarians Beth Houghton and Meg Duff, who through the kind offices of our colleague at the Tate, Michael Compton, former keeper of museum services, compiled our authoritative bibliography.

During the four years of discussions and planning that preceded *David Hockney: A Retrospective* and this publication, it was a special pleasure for us to work with David Hockney on every aspect of this undertaking. His enthusiastic collaboration has been an exciting stimulus for all involved. His keen eye and sensitivity to the challenge of mounting a retrospective for an artist who is at the peak of his creative explorations were always greatly appreciated. His ideas about the conception and design of the publication have challenged the authors, designer, and publishers to think innovatively about this book and books in general.

From the beginning it was intended that Hockney would design a special section of this volume, bringing to it a fresh approach, something beyond the traditional reproduction of finished artwork. The twenty-four pages at the end of this book contain prints created expressly for the volume, taking into account the characteristics of commercial printing and allowing each reader to experience a portfolio of original work. Similarly within the installation of the exhibition in Los Angeles we reserved an area for very recent work by Hockney, which includes dramatically lit models of the three sets for *Tristan und Isolde,* which he designed for the Los Angeles Music Center Opera's 1987 production. It was exciting and challenging to work with the artist on this special aspect of the retrospective.

Tracing the locations of many of the works desired for the exhibition was an arduous process involving many people. Hockney's work, even early on, received widespread attention and was desired by museums and private collectors, resulting in frequent changes of ownership for some. For their assistance in locating works we are grateful to Karen S. Kuhlman and Charlie Scheips, members of Hockney's staff, who were always available to answer questions and work on the myriad details of this project. With their unfailing professionalism they were a pleasure to work with. Kuhlman also contributed diligently to the extensive bibliography that appears in this volume. David Graves in London was very helpful in the initial organization of works to be included in the exhibition, and Cavan Butler was particularly helpful in providing photographs. Other members of Hockney's family and

staff in Los Angeles and London provided assistance, including Paul Hockney, Dan Chapman, Richard Schmidt, Jerry Sohn, and Jimmy Swiene. Jeff Kleeman worked with us on the *Tristan und Isolde* models. We received assistance from galleries that have been associated with Hockney's work: in Los Angeles Peter Goulds and Kimberly Davis of L.A. Louver Gallery; in New York City André Emmerich, Nathan Kolodner, and Lindsay Dimeo of André Emmerich Gallery; and in London Leslie Waddington and Sarah Schott of Waddington Galleries—all were diligent and very helpful. We also acknowledge the assistance of the following: the British Council; Acquavella Gallery, New York; Petersburg Press and Sotheby Parke-Bernet, New York and London; Christies, New York; Kasmin, London; Kenji Nishimura, Tokyo; Louis Kaplan Associates Ltd. and the Royal Academy of London; Caroline da Costa at the Tate Gallery; and Dave Gardner, Los Angeles. Without the cooperation of the lenders, who are listed elsewhere, this show would not have been possible. They have agreed to part with their works for one year so that this show may complete its international tour.

The keen interest in this project, the first retrospective in the museum's Robert O. Anderson Building, was gratifying. Museum director Earl A. Powell III and the Board of Trustees shared our enthusiasm from our first discussions. In the Twentieth-Century Art Department Carol S. Eliel, assistant curator, contributed the chronology and aided with the organization. Lynn Yazouri, secretary, was unfailingly resourceful and showed great initiative in pursuing the many details involved in the execution of such a project. She managed extensive correspondence and international communications with aplomb and good cheer. Roz Leader, volunteer, helped coordinate special photography arrangements in America and Europe. Judi Freeman, associate curator, was helpful at initial phases as was secretary Richard Morris. Steven Oliver of the museum's Photographic Services Department was the supervising photographer for the catalogue and along with Steven Sloman in New York, John Webb in London, and Steven Young in Seattle is responsible for many of the outstanding photographs that appear throughout.

In the Publications Department, Mitch Tuchman, managing editor, has skillfully seen this book through its various stages. Museum graphic designer Sandy Bell's elegant design derives in part from her working relationship with Hockney. Her dedication, imagination, and enthusiasm for this book have been the very model of collaboration among artist, designer, and curator. At Harry N. Abrams, Inc., our copublisher in the United States and Canada, we were fortunate to work with Phyllis Freeman, senior editor. Frank Kurtz edited the bibliography.

We thank the museum's Information Office under the direction of Pamela Jenkinson; the museum's Registrar's Office and in particular assistant registrar Lisa Kalem; and the museum's Conservation Department and again in particular the contribution of painting conservator Joe Fronek.

Director of Development Julie Johnston and Terry Monteleone, former associate director of development, worked closely with us to secure funding for the exhibition. Elizabeth Algermissen, John Passi, and Doria Leong of the Exhibitions Division helped coordinate details of the tour.

Our colleague at the Metropolitan Museum of Art, William S. Lieberman, and Kay Bearman, administrator, made significant contributions throughout the development of the project. Our counterparts at the Tate Gallery, Alan Bowness, director, Michael Compton, and Ruth Rattenbury, exhibitions coordinator, were a pleasure to work with.

Maurice Tuchman and Stephanie Barron

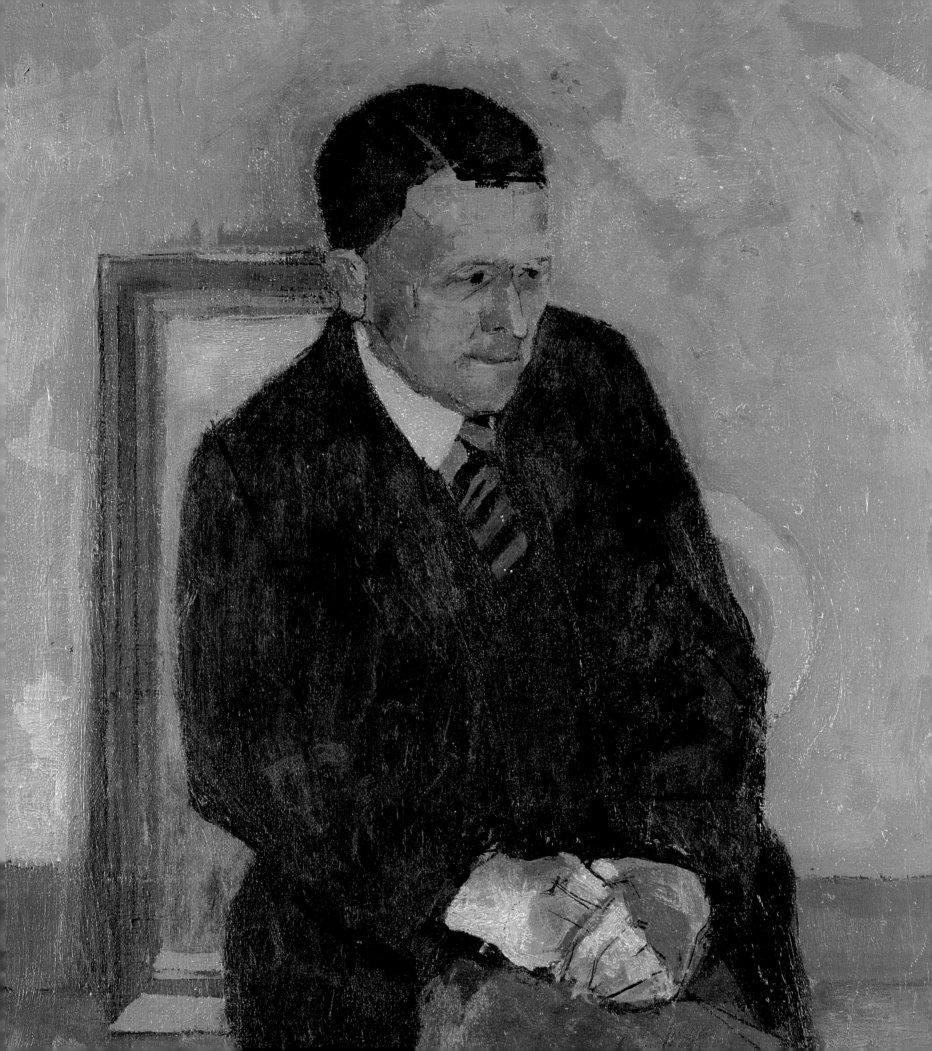

HOCKNEY: YOUNG AND OLDER

HENRY GELDZAHLER

BASIC TO David Hockney's art from the first has been the need to communicate directly with the viewer. Hockney is not at all involved in the creation of beauty as an end in itself. It is exactly this didactic urgency, this need to be heard plainly and to be understood clearly, which is the basis of his phenomenal popularity. No other artist today has been the subject of so many books, most of them generated by the prodigious flow of his own art, work that he produces in abundance and with great care. As often as I have visited David over the years, I have never seen an empty studio; his cornucopia is always full to brimming.

Studying his earliest work, we may ask, How might he have painted if left to his own devices and those of his masters at Bradford School of Art? Judging from the very few paintings that survive from the mid-fifties—the painting of his father (fig. 1) done in 1955, when Hockney was eighteen years old, being our chief evidence—we would be justified in thinking of Hockney as an Intimist, somewhat in the manner of Walter Sickert, whose work was sanctified in the English art schools of the day.

Intimist might be defined in this context as an affectionate record of homely truths; and Intimism, as an art that typically portrays a sweater as stretched through use and close to unravel-

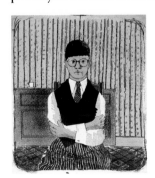

ing. It is this David Hockney who tells us twenty years later that the aged dress best because, with all vanity and fashion consciousness out the window, they wear only the clothes that fit comfortably, trousers and dresses that read almost as a subclass of portraiture in their unexceptionable ordinariness.

Hockney's work is often so delightful that we are brought up short by

the realization that a message always lurks in it, that a message must be implicitly present for him to undertake it.

The Hockney household was poor in material things with five children tumbling about in severely restricted spaces; but in rich compensation there was an abundance of fond familial attachment and—perhaps equally important to the child David—a riot of definitely held opinion. The causes that inspired various members of the family included his mother's religion and devotion to vegetarianism and his father's imaginatively waged campaign against war and smoking. That David ate meat and smoked when I first met him in 1963 (at Andy Warhol's Factory) could be construed as a tribute to his inherited cussedness, his lifelong penchant for swimming upstream.

It is almost as if a need for a cause more than a specific message attracts him. An early touching and telling work is the 1961 etching *Myself and My Heroes* (fig. 2). The heroes are Mahatma Gandhi, to whom is given the phrase "vegetarian as well / down with the Taj Mahal"; and Walt Whitman, "for the dear love of comrades"; while David's words are: "I am 23 years old and I wear glasses."

Gandhi is there by reason of his pacifism too. In 1957–59, after David finished Bradford Art School, he did his stint in lieu of military service at a hospital in the south of England, where he spent what free time he had reading literature, with poetry a great and enduring interest.

Walt Whitman in *Myself and My Heroes* does triple duty: first, as a great poet; next, as a caring man whose nursing of soldiers in hospitals during the Civil War is the emotional basis of so much of his work; and finally, as a prophet of free sexual expression, a fresh voice from a new continent, which was to retain its appeal for David.

Fig. 1. *Portrait of My Father* (detail), 1955 (pl. 2)

INSET: *Self-Portrait*, 1954 (pl. 1)

Fig. 2. *Myself and My Heroes*, 1961

As for the third character in this key print, David was not to place himself in his work much again until the 1980s, when he discovered that if he built a panoramic photograph with his own feet pictured at the base, the viewer would identify with him and thus comprehend the scope of the subject more readily.

One reason there are so few self-portraits in Hockney's oeuvre of this period, 1962–75, was his great hunger for psychological insight into his sitters' lives and where there are more than one, into their relationships. It is no accident that so many of the important paintings of the late sixties depict couples. In getting it down on paper or canvas, Hockney was affording himself an opportunity to observe the complexities within relationships, lessons of more than routine interest to the artist, whose obsession with his work was keeping his romantic life at bay.

It was impossible for Hockney to do commissioned portraits because of his consuming devotion to the "truth" of his experience. At the same time, as his work became better known, the very glamour of this rarity, the Hockney portrait, appealed more and more, especially for wealthy collectors on the fringe of contemporary art. In the first drawings of a new sitter David found that he had to work hard to "find" his subject, that double truth of likeness captured and character evoked, the idiosyncrasies that made the drawing "like." Every successful drawing was a victory; many were discarded. When a subject was particularly resistant to his Rapidograph or colored crayon (his preferred drawing materials in the sixties), he used a phrase, wicked but apt: "I couldn't find him" or "I couldn't find her."

It is only now, with the evidence of three decades, that certain things become clear, such as the fact that David's work periodically undergoes great changes because he is interested in a technique only as long as it provides resistance. It is the struggle to learn, to overcome "ham-fistedness" (a Yorkshire word that

David loves), which provides impetus—not, in fact, that he has ever been clumsy.

We can now see that David turned away from the Rapidograph portraits of the sixties for no discernible reason except that he knew too well how to do them. There is a fear of and distaste in David for the facile in art, especially his own, which closes off avenues he has traveled successfully. He reacts against any hint of sentimentality as he does against doing versions of his pictures that have become twentieth-century classics, such as the Swimming Pool Paintings.

We see this too in his increasing fascination with a kind of Realism in his paintings of 1967–74 and in his later retreat from it. This ambition in his work was probably the last vestige of old-fashioned thinking that he had to shuck off to become the increasingly complex artist he has become. His success in painting the world in the most conventional, Victorian way was making him more and more famous and more and more uneasy in his own skin. This move toward a popular Victorian style, which harks back to Ford Madox Brown and John Everett Millais, climaxes in the double portrait *Mr. and Mrs. Clark and Percy* (1970–71, fig. 3), which the Tate Gallery tells us is the most popular work in their collection.

David was experiencing unscalable difficulties in attempting to continue innovatively in the direction of conventional ideals of verisimilitude: the unfinished double portrait of his great friends George Lawson and Wayne Sleep, book dealer and actor-dancer, for instance, or another of Gregory Masurovsky and Shirley Goldfarb, American artists in Paris. David was driving himself to the point of abandoning projects in his frustration. His work was demanding ever greater technical skill at the same time that his worldview was altering under the pressure of another reality: his loss of innocence, the realization of death's inevitability.

DETAIL: *Mr. and Mrs. Clark and Percy*

Picasso's death in 1973 hit him hard. For Hockney, Picasso was a heroic figure, whose later paintings, those made after the Second World War, were vastly underrated by the art world. In some way Picasso's demise became entangled with the decline and eventual death in 1978 of David's father. They shared a gritty defiance of death, a willful refusal to slow down in the face of the inevitable. The reassessment of Picasso's eight decades had begun in earnest three years before his death. It was the 1970 exhibition of Picasso's recent work in Avignon, organized by Yvonne Zervos, which forced attention to revaluation of paintings that had been dismissed previously as too quickly made and without coherence as a body of work.

It was Hockney's contention, along with a small number of art historians—Gert Schiff and Robert Rosenblum prominent among them—that the later Picasso was unfairly dismissed with a pious word, while his Blue, Rose, Cubist, and Surrealist periods were counted as the sum of his achievement.

The shock of energy Hockney felt in contemplating the later Picasso was translated into a wonderfully rich "Picassoid" period. It is as symptomatic of the end of his innocence that I remark upon it. It was as if a torch had been handed to David to run with, a relay race as old as art. All we need do is examine the memorable etching David made in homage to Picasso, *The Artist and*

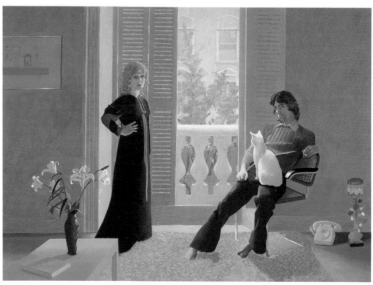

Fig. 3. *Mr. and Mrs. Clark and Percy,* 1970–71

15

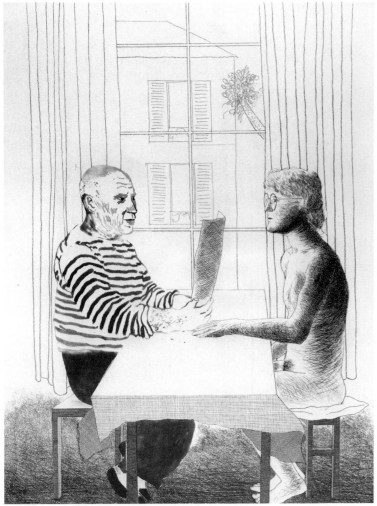

Fig. 4. *The Artist and Model*, 1973–74

Model (1973–74, fig. 4), to gauge the truth of these remarks. A youthful David sits naked at a table with the aged Picasso, wearing the maillot of a French sailor. We are witness to a meeting of apprentice and master, the innocent and uncorrupted showing his work to the great artist of the century. (For me the special joy of this etching has always been the intrusive palm tree that pridefully bursts forth on a line directly above the young man's genitalia, masked as they are by the table.)

Hockney returned to his parents as a subject in the early seventies, the time that he lived and worked in Paris, the period I call his "loss of innocence." Eventually he destroyed that painting and returned to London, where he built an elaborate studio in Powis Terrace, and there undertook and completed the second and final version of the painting. It was not the likenesses of his parents that proved difficult so much as his idea of their attitudes toward each other and even more crucially the way he saw himself with regard to each of them. He had to invent a composition that could bear the freight of all this unacknowledged feeling. It is of interest to note that he is the only child in the family portrait, *My Parents and Myself* (1975, fig. 5); none of the older or younger siblings, three boys and a girl, is portrayed. It is difficult, in fact, to remember more than a few drawings of his brothers and sister. Given my American predilection for Freudian psychology, it seemed important to me at the time that David come to terms with his deeply conflicted feelings toward his family.

What turned out to be the most arduous task was placing himself in the portrait. If he was in focus (in a mirror placed on the artist's taboret in front of which his quite disparate parents sat), he lost the tension and clarity of his mother's and father's images. It was only when he dropped himself out of the equation that he was finally able to complete the painting in quite another

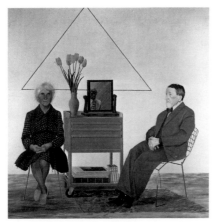

Fig. 5. *My Parents and Myself,* 1975, oil on canvas, 72 x 72 in. (183 x 183 cm), David Hockney

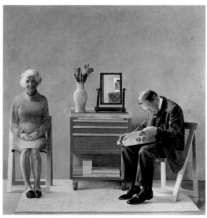

Fig. 6. *My Parents,* 1977 (pl. 58)

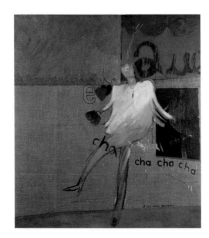

version, *My Parents* (1977, fig. 6), executed on his final return to London from Paris.

The fame and riches that have been attendant on David Hockney's every endeavor may seem to have been his goal. Nothing could be less true. What has propelled him from the first—and still does to a remarkable degree—is not illusory fame and riches; if anything, they bother and distract. What does move David is the double entrancement of learning and teaching. The learning in recent years has ranged rather widely: to the theories of time and vision in Chinese art and to the new physics and mathematics, two fields that have dominated his thought and his conversation for much of the present decade. If we add the later Picasso and the aims and limitations of photography, we have catalogued all his interests in this decade. His eagerness to share his thoughts with close friends and new-found dinner companions is legendary. What he is doing is continuing his education in private and public, as has been his procedure from the beginning. Learning and teaching, not fame and riches, are the spurs, the excitement worth its weight in rubies.

We sense much in Hockney's polemic—and he does love a nice "jar" about painting and theory—which would place him firmly as a stubborn "pre-Modern" in a Modern world. He and the American painter R. B. Kitaj were at the Royal College of Art in overlapping years, 1959 and 1960. Through ideological sympathy they got themselves locked into an elaborate defense of figurative over abstract art. In their argument "humanism" in painting seems always to have been reduced to the presence of humans portrayed—figurative art. It got to the point in the late sixties, when their battle with the adherents of Clement Greenberg's strictures against facile humanism crested, that the names of certain English and American painters would be enough to cause their eyes to roll.

In this context it is fascinating to view David's early progress during the first decade of his career. From his point of departure,

Fig. 8. *The Most Beautiful Boy in the World*, 1961

Fig. 7. *The Cha-Cha That Was Danced in the Early Hours of 24th March*, 1961

Fig. 9. *Man Taking Shower in Beverly Hills* (detail), 1964 (pl. 20)

The Most Beautiful Boy in the World (1961, fig. 8) and *The Cha-Cha That Was Danced in the Early Hours of 24th March* (1961, fig. 7), he moved to the carefully drawn and composed Victorian pictures of the early 1970s, complete with one-point perspective. The boisterous titles of the earlier paintings hint at the energy that was both contained and released by the young student. I am always astonished at how much vitality he managed to suggest in the barely articulated figures of those paintings.

A major influence in David's early days in London were the homosexual and nudist magazines available there, illustrated first with tawdry black-and-white photographs; and a few years later, amazingly hyped cinematic color. Through them he became aware of California, whence most of these publications emanated. It came to mean for the young, impecunious artist a freedom

from the cant and dubious moral standards that were paid lip service in the England of the day. From this source too can be traced the paintings of males in showers (fig. 9), which predate by a year his move to Los Angeles, as can the flooding of many interiors in these pictures of the mid-sixties with "natural" light. David has commented that the scenes in these illustrations are often "obviously (like old movies) shot in made-up sets out of doors. Bathrooms had palm tree shadows across the carpets, or the walls suddenly ended and a swimming pool was visible."[1]

Other influences on his work at that time—Francis Bacon, Larry Rivers, and the English sculptor William Turnbull—have been described often. We can't help but feel that there was not that great a degree of choice available to David, who in his mid-twenties was frankly learning his craft. It wasn't as if he was shrugging off an uncanny ability at verisimilitude to which he later succumbed. It is exactly the ongoing fascination with learning (and then abandoning) techniques that describes his path through the sixties.

British art circles in 1960 were still reeling from the impact of *The New American Painting*, the major exhibition of large American paintings that was circulated throughout Europe under the aegis of the Museum of Modern Art in 1958. It was an exhibition that suddenly put all art theories and practices into question, on the table, so to speak. The size of the paintings by Pollock and Rothko and Still was something new in studio art, as was the boldness with which each abstractionist claimed his bit of the psychic landscape, his personal topography.

Undeniably art in Europe and America since the war had been made and seen against a background of the Holocaust and the atom bomb. The European reaction—and I speak here in generalizations—was to show the agony of the individual. The flayed, emaciated, and tortured figures of sculptors on the Continent and in England—Lynn Chadwick, Reg Butler, and Elisabeth Frink among them—can be seen in the crucial competition for a Monument to the Unknown Political Prisoner, which gave programmatic definition to the entire generation of figurative sculptors. In David's generation those who didn't become abstract artists were the friends and contemporaries who invented and sustained British Pop, led by their wise and witty teacher Richard Hamilton, an artist whose intellect Hockney respects greatly. Except for a few very early paintings incorporating brand names,

such as *Alka-Seltzer* (1961) and Typhoo Tea (*Tea Painting in an Illusionistic Style,* 1961, fig. 10), and a certain openness to the spirit of his day, Hockney himself really can't be comfortably called Pop, a designation that is much too narrowly concerned with the contemporary to contain his questioning nature. Hockney's sources and exemplars are more likely to be the poets George Herbert and Andrew Marvell or Degas and Toulouse-Lautrec than this morning's headlines. Curious as he is intellectually, he has little room in his working aesthetic for the cascade of data that crackles about us like static.

In 1976 I began an essay on the artist: "David Hockney's art has been lively from the first because he has conducted his education in public with a charming and endearing innocence."[2] A decade later this "innocence" has been dealt a series of rude shocks through deaths in his circle: first, that of his father, and then, the relentless clanging tocsin of AIDS, which seems every month to toll for still another great friend or colleague. One cannot help but wonder whether all loss of innocence, even that in the Garden of Eden, comes with the realization that death is inevitable and that no one lives happily ever after, not even Snow White and the Prince. Indeed in folk and fairy tales, a favorite source for David's work, the soothing convention of reanimation is maintained in defiance of tragedy: Sleeping Beauty (Death) is awakened by another Prince, cousin to Snow White's animator, death defying, death denying. Go to sleep, little boy, you're safe, you'll awaken on the morrow.

The extent of David Hockney's attraction to and puzzlement over the "happily ever after" bromide is evident in his most recent major project, the sets and costumes for a production in December 1987 of Wagner's *Tristan und Isolde,* directed by Jonathan Miller and conducted and performed by Zubin Mehta and the Los Angeles Music Center Opera. *Tristan* ends with the death on stage of the cheerless lovers, a death that in Hockney's description is followed by several chords of heavenly beauty, signaling a transfiguration that transports the lovers to an eternity in which their love endures. More elaborately than "happily ever after" this solution to the irrevocability of death carries the denial to a higher level of metaphysical contemplation. We might say that organized religion, with its circular arguments and self-sufficient systems, aspires to the same end, an end that somehow is not *the*

Fig. 10. *Tea Painting in an Illusionistic Style,* 1961

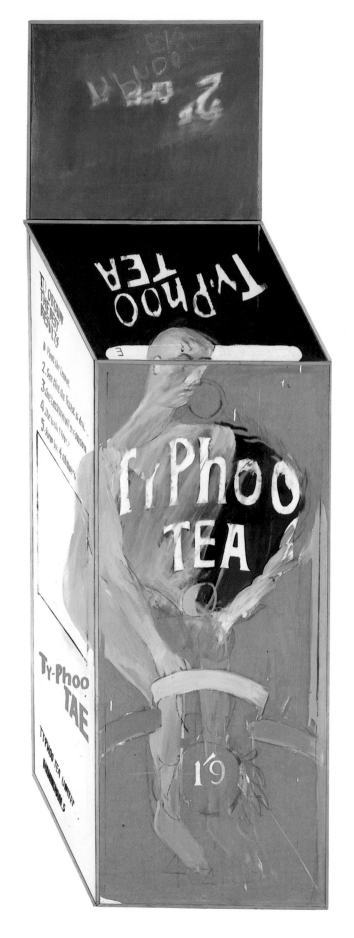

Fig. 11. *Kerby (after Hogarth) Useful Knowledge,* 1975

end. We sense Mother Hockney's religion in the offing.

But as a proselytizer it has been through his brilliant stage sets, his thorough sense of how a production must look, that Hockney has found a new and enthusiastic audience. What is interesting about his opera work is the way in which it fertilizes everything else he does. I was frankly concerned that all this preoccupation with theater was distracting him from his real job, his painting. This turned out to be nothing but the endemic narrowness of the traditional art historian. I was quite mistaken.

The unforgettably witty sets and costumes for his first Glyndebourne endeavor, Stravinsky's *The Rake's Progress* (1975, fig. 12), based in large measure on Hogarth's prints, fed directly out of Hockney's work as a printmaker, with all its hatchings and crosshatchings, and then back into his painting *Kerby (after Hogarth) Useful Knowledge* (1975, fig. 11).

The French triple bill for New York's Metropolitan Opera, with music by Satie, Ravel, and Poulenc, was a perfect blend of music, text, and sets. In this case the excitement at the saturation with throbbing color, especially in the Ravel, *L'Enfant et les sortilèges,* inspired Hockney to rethink and repaint his house and studio in the Hollywood Hills with the very same reds and greens and blues that he had used in the sets. These new surroundings were then in large measure the colors and vibrant harmonies of his new paintings. Everything gets used and recycled: the work is a dialogue David Hockney holds with himself.

During the rehearsals for the French triple bill one ten-year-old chorister whispered aloud to another, "Did you see that tree and that sky? The tree is blue."

"That's nothing," said the second boy. "You should see the designer."

The child had observed wisely that David does nothing half-heartedly; he dresses the stage as he dresses himself. He changes his home, the frame in which he lives, to make it consonant with his current obsession. And in all this sits the teacher, eager to learn so he can impart.

N O T E S

1. Quoted in Christopher Finch, *David Hockney in America,* exh. cat. (New York: William Beadleston, 1983), unpaginated.

2. Henry Geldzahler, "Introduction," in *David Hockney by David Hockney,* Nikos Stangos, ed. (New York: Abrams, 1977), 9.

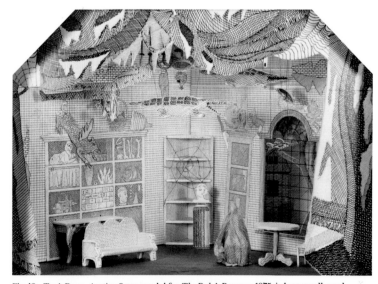

Fig. 12. *Tom's Room, Auction Scene,* model for *The Rake's Progress,* 1975, ink on cardboard, 16 x 21 x 12 (40.6 x 53.3 x 30.5 cm), David Hockney

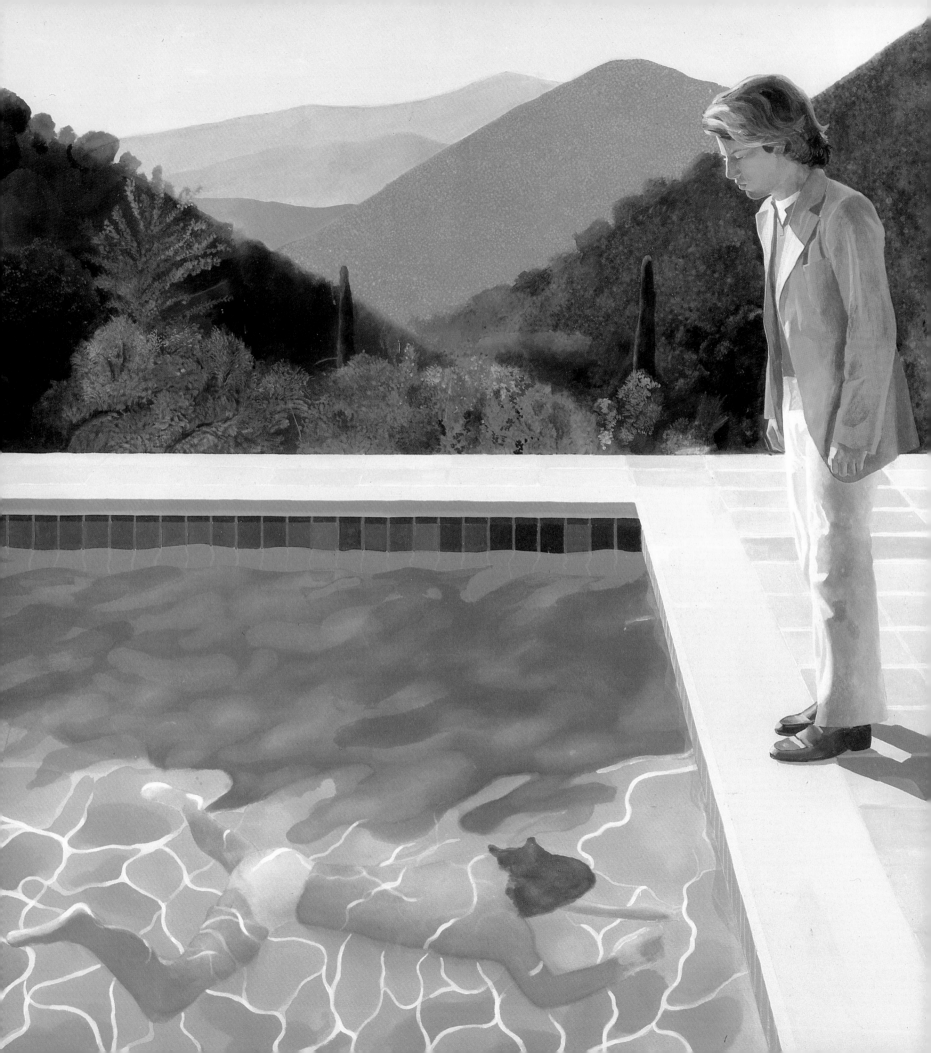

COMPOSITE VIEWS: THEMES AND MOTIFS IN HOCKNEY'S ART

CHRISTOPHER KNIGHT

IF THERE IS ONE IMAGE that more than any other is conventionally associated with David Hockney's art, surely it is the image of the swimming pool. There are many reasons for this. He has painted, drawn, photographed, or made prints containing images of swimming pools from the mid-1960s to the present day. His rise to public prominence more than twenty years ago was coincident with the first appearance of this image in his work. As an expatriate Britisher living principally in Los Angeles, he is easily associated with the commonplace cliches of that sunny clime, the swimming pool among them. A rather silly film, although one that achieved a degree of cultish popularity in the 1970s, chronicled his execution of a picture called *Portrait of an Artist (Pool with Two Figures)* (1971, fig. 1) and was titled with the name of another swimming-pool painting, *A Bigger Splash* (1967). That work is among his most familiar images—a large, square canvas depicting the splash made by a now submerged and unseen diver, which has been claimed as an affectionate image of the blank good life under the California sun that only a foreigner could have painted.

Certainly there are several images other than the celebrated swimming pool that have appeared with frequency in Hockney's art—some, no doubt, even more often. He's been an unstoppable portraitist; Celia, Henry, Nick, Ann, Gregory, Peter, Mo, Ossie, his father, his mother, Christopher, Don, and several more have each appeared countless times, his body of work thus constituting a kind of pictorial family album, in whose pages we've seen assorted faces again and again. Still lifes, from a simple shirt casually strewn across a wicker chair to deliberate pastiches of Cubist motifs; a litany of landscapes (within which the many swimming pools might be called a subset) which chronicle travels in Europe, the Americas, and the Orient; and assorted genre scenes, usually domestic in nature—all are recurrent in his art.

For an artist who has never really been interested in pursuing complete abstraction, these subjects are not in the least surprising. They form a simple catalogue of the visual world, seen everyday by everyone. Portrait, still life, genre, and landscape are merely the conventional terms that attend the productive business of any artist who chooses to work representationally. Some artists will gravitate toward a specialization in one or the other. Hockney does not. All such Realist conventions have been grist for his mill, and they continue to be so today.

Only with certain difficulty can we use the term *Realism* to describe what Hockney does, though, for the term is notoriously difficult to pin down in the face of Realist strategies that can range from the illusionistic technical wizardry of trompe l'oeil to the spare suggestiveness of simple contour drawing. Yet, in relation to his commitment to the artifacts of the visible world, a Realist he is. Realism is the most conservative of modern styles, the one least given to revolutionizing what it has inherited from the past. Realism tends to avoid the universalizing utopianism—a wiping clean and building anew—so common to the revolutionary avant-garde in the twentieth century. Instead, it favors a persistent, even delirious embrace of the world as constituted, while always attuning itself to the endless necessity for modification of conventional doctrine and practice.

This, then, is precisely the aspect of Hockney's work that bears consideration and scrutiny. What does his habitual attraction toward all manner of conventions imply? And how does he position his art in relation to those omnipresent conventions?

Fig. 1. *Portrait of an Artist (Pool with Two Figures)* (detail), 1971 (pl. 45)

INSET: *Sun on the Pool Los Angeles April 13th 1982* (detail), 1982 (pl. 83)

These two questions grow in relevance when one thinks of other aspects of Hockney's art for the place that is occupied by convention is central in his work and touches on every feature of his artistic endeavor. Formal conventions, stylistic conventions, material conventions, technical conventions, and not least of all social conventions are simultaneously adopted and contradicted. His is a passion for the world as it is, but it is a passion matched by a relentless desire to make the enigma of simple experience more habitable and congenial, to render it less mystifying but no less delightfully mysterious.

I think of David Hockney's progress as an artist in three big chunks: there are the well-known paintings of the 1960s, the acclaimed stage designs of the 1970s, and the photography-based works of the 1980s. To be sure, this division into mediums neatly slotted into decades is inaccurate. Hockney has taken photographs almost all his life, and camera images were important as sources for many of the paintings of the 1960s. Those paintings often assume a straightforwardly theatrical bearing, complete with proscenium and curtain, while his earliest theatrical set design—for a 1966 production of Alfred Jarry's play, *Ubu Roi*—was conceived as a sequence of "stage pictures." His subsequent stage designs have mined territory familiar from paintings by Hogarth, Dufy, Picasso, and others. Throughout his prolific career he has devoted considerable energy to drawings and especially to prints. He didn't cease painting at the end of the 1960s, and he didn't stop working on stage designs in 1980. Actually the "three big chunks" describe areas of consuming interest at different moments, areas that grew out of and fed back into other work circuitously. Hockney is the kind of artist who, upon encountering a question in his work, no matter how small or seemingly insignificant, will follow the path that opens up until he feels comfortable with the new terrain.

The beginning of David Hockney's serious work as an artist dates from around 1960, when particular problems related to painting, to theatricality, and to photographic imagery began to come together in his art. His training at the Bradford School of Art, from 1953 to 1957, had been decidedly traditional, while his subsequent entrance into London's Royal College of Art was, in general, coincident with two larger developments in the world of art: the established success abroad of the export of American Abstract Expressionism[1] and the mounting sense of exhaustion, and even crisis, in abstract painting in New York. Adventurous students are commonly attracted to the latest critically acclaimed offerings of the avant-garde, and there seems to have been no shortage of derivative Abstract Expressionism at the Royal College of Art.[2] Hockney, though, never gravitated toward complete abstraction. To him it seemed that abstract painting, which had come to represent the legitimate standard for a truly avant-garde sensibility, had been transformed into an academic code complete with a growing set of systemic principles. As he was later to say: "The very term academic is not about style; it's really about attitudes, a drying-up, and sterility."[3] For him the attitude toward abstraction had become academic. Significantly, however, his work from the first several years of the 1960s did not forego the exigencies of Expressionist style; as a student at Bradford he had been keenly interested in the paintings of Oskar Kokoschka and Chaim Soutine, while his work revealed obvious affinities to the contemporaneous paintings and sculptures of Jean Dubuffet, Francis Bacon, Lynn Chadwick, and other prominent Expressionists who did not fully embrace abstraction.[4]

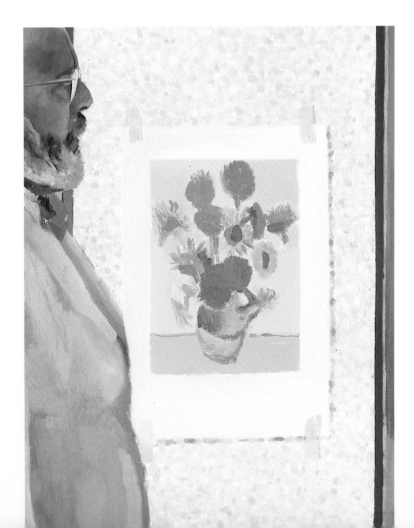

DETAIL: *Looking at Pictures on a Screen*

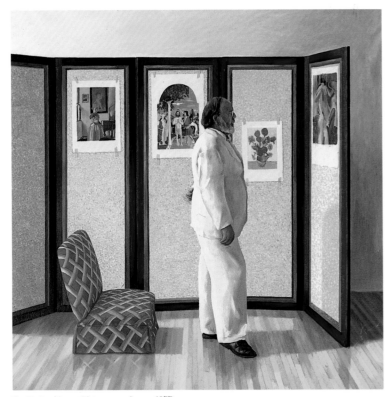

Fig. 2. *Looking at Pictures on a Screen*, 1977

Style, as a range of formal possibilities for aesthetic effect, became for Hockney the object of considerable attention during these years, and it has remained so throughout his career. His highly traditional training at Bradford School of Art served him in good stead in this regard, providing a firm grounding in the technical skills with which to engage in assorted stylistic experiments. (Hockney is an exceptional draftsman; his colored-pencil drawings are among the most beautiful Realist renderings by an artist of his generation.) A simple list of titles of several paintings from the period suggests the kinds of stylistic formal problems with which the young artist engaged himself: *Figure in a Flat Style* (1961), *Picture Emphasizing Stillness* (1962), *Accident Caused by a Flaw in the Canvas* (1963). As these titles make plain, Hockney was working through the materially based tenets of "truth to the medium," which reside at the core of a formalist approach to painting.

This commitment to "mediumistic truth" has played a principal role in all the artist's subsequent work, and it has habitually informed the ways in which he thinks about the possibilities of a medium that is new to him. When he began to consider seriously the possibilities of the camera as a tool in the late 1970s, for

instance, it was in these mediumistic terms. Perhaps the only time photography can be completely true to its medium, he decided, is in making reproductions of paintings. Why? "[On] the flat surface of the photograph is simply reproduced another flat surface—a painting."[5] His explorations with photocopying machines in the 1980s proceeded likewise from the realization that this standard piece of office equipment is, on its most basic level, a camera that has been designed expressly for the purpose of photographing flat surfaces. His paintings too address the flatness of the picture plane, even when the image is rendered illusionistically. To single out just one from among dozens of possibilities, *Looking at Pictures on a Screen* (1977, fig. 2) declaratively represents a man looking at pictures on a screen (specifically the artist's friend Henry Geldzahler looking at photographic reproductions of paintings tacked onto a folding screen), while simultaneously describing the activity in which the viewer of the painting is himself engaged: looking at a picture on the flat surface, or "screen," of Hockney's canvas.

Clearly these three examples of "truth to the medium" are not what strict formalist theoreticians would regard as such, but then Hockney's engagement with formal problems was marked by a slyly ironic wit from the very start. The evocation of a landscape in the small 1963 painting *Accident Caused by a Flaw in the Canvas* is composed of a flurry of stained, smudged, and gestural strokes of paint. The three Olympian, torch-bearing figures shown dashing across this nominal, abstract "landscape" were not drawn freehand but were reproduced with a stencil; they are literally flat, utterly coincident with the surface of the canvas. The otherwise seamless physical weave of that canvas is marred by a vertical flaw at the left—a literal ridge disrupting the flatness of the canvas, rather like a bump on a road —and it is this "material truth"

DETAIL: *Looking at Pictures on a Screen*

25

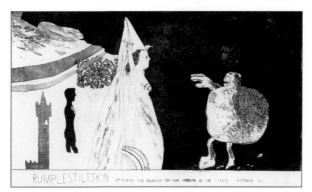

Fig. 3. *Rumplestiltskin*, 1962, etching and aquatint, 11⅞ x 19⅝ in. (30.3 x 50 cm), David Hockney

on which one of the runners is shown to be stumbling. Truth to the material accident has been the cause of a pictorial accident.

With maneuvers such as these Hockney turned conventional formalist principles inside out. The normal or expected result is made incongruous as an affirmation is made through denial. Irony, the humorous insertion of the dialectical opposite of a literal meaning, nudges a self-conscious ripple of amusement from the viewer. In this way a small but crucial transformation begins to take place. For a viewer made self-conscious is no longer a passive consumer of quotidian data but an actively engaged spectator. Made aware of his status as perceiver, a spectator watches while watching himself watch. Hockney's "flawed" canvas performs, and a performance is always constructed with an audience in mind.

Irony is essentially a literary style, while the audience-directed frame within which irony is made is a theatrical one. In a seemingly perverse way Hockney began to turn formalist principles to theatrical ends. The quintessentially theatrical image of a curtain first appeared in *A Grand Procession of Dignitaries in the Semi-Egyptian Style* (1961, fig. 7) and began to assume prominence around 1963 in such pictures as *Still Life with Figure and Curtain* (fig. 5) and *The Hypnotist* (fig. 4). The latter is especially significant, for in this large oil the curtain has become a

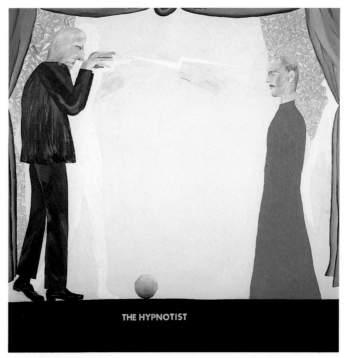

Fig. 4. *The Hypnotist*, 1963

directly articulated reference to the traditional space of the theater, defining the edges of the canvas as a proscenium arch and identifying the field of pictorial action as a stage. (Significantly too the inspiration for this painting was a comedic scene between Vincent Price and Peter Lorre in a popular Hollywood movie, *The Raven*.)

Straightforward literary subjects, from poetry to fairy tales, appeared in Hockney's art as early as 1960–61 in paintings inspired by Arthur Rimbaud, Constantine Cavafy, and Walt Whitman, and in such etchings as the Rake's Progress suite and *Rumplestiltskin* (1962, fig. 3). *Portrait of Kasmin* (a 1964 lithograph of his friend and dealer disporting à la Al Jolson), *Play within a Play* (1963), *Closing Scene* (1963, fig. 6), and many others accelerated the literary and theatrical ambitions of Hockney's work—ambitions that one can trace back to his childhood preoccupation with drawing cartoons (several of which were published in the Bradford Grammar School magazine in 1953.)

As his skills developed in the 1960s and 1970s, and as his growing fame provided assorted opportunities to undertake projects unavailable to younger or less-established artists, Hockney began to work directly in the theatrical arena itself, designing sets and costumes for operatic spectacles. Given the principles on which his painting had

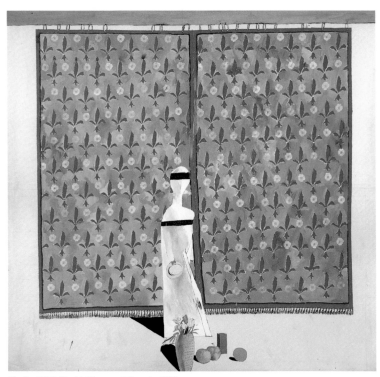

Fig. 6. *Closing Scene*, 1963

Fig. 5. *Still Life with Figure and Curtain*, 1963

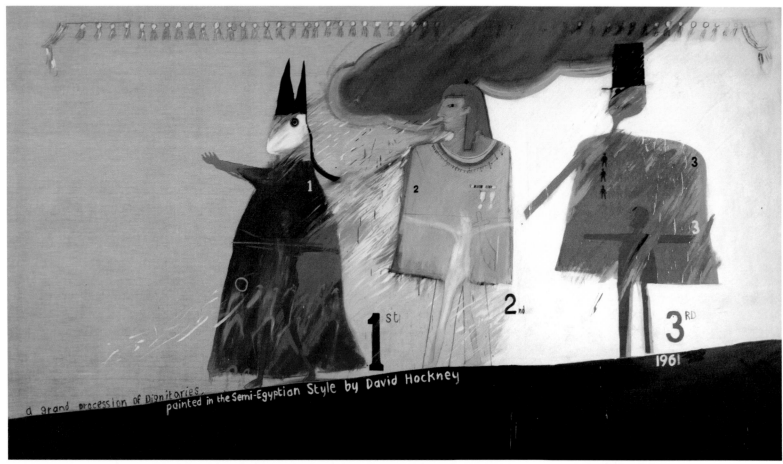

Fig. 7. *A Grand Procession of Dignitaries in the Semi-Egyptian Style*, 1961

developed from the start, it should be no surprise that his designs for the stage have turned out to be among his most admired and accomplished works.

This highly theatrical element of Hockney's art was certainly at odds with conventional formalist rhetoric. As practiced by Clement Greenberg and his most articulate disciple, Michael Fried, formalism focuses on two integral elements: the artist as individual creator and especially the work of art as autonomous object. In this scenario the audience is incidental; it is expected that the audience on viewing the work of art will assume a position of consciousness roughly coincident with that occupied by the artist when making it. By contrast theatricality is a mode of address specifically made to a third party, or triangulated speech that is framed with the audience in mind. In the early 1960s, and to the growing dismay of formalist critics as the decade progressed, this theatrical quality of incorporating "the beholder"—to borrow a term from Fried's negative description of theater's primary device in his celebrated 1967 essay "Art and Objecthood"[6]—was emerging in the work of more and more artists. Pop art and Minimalism, which now in many ways seem to be the representational and abstract sides of a common coin, aggressively acknowledged the presence and perambulations of the beholder, or audience, while happenings and other early forms of performance art went after participatory engagement. First by implication, then by direct address, the social space of art became a crucial part of its subject.

To generate and clarify the viewer's condition of emphatically self-conscious spectatorship is to insist on the importance of recognizing where one stands within the complex relations of social discourse. In 1960 and 1961 Hockney painted a number of pictures whose subject matter was love, and more often than not, specifically homosexual love. Paintings such as *Doll Boy, The Most Beautiful Boy in the World, Sam Who Walked Alone by Night, We Two Boys Together Clinging,* and several works

Fig. 8. *Adhesiveness,* 1960, oil on board, 50 x 40 in. (127 x 102 cm), private collection

generically called Love Paintings were executed in the Expressionist, graffitilike manner then prominent in Hockney's work, which derived principally from Dubuffet. Male desire has been a conventional theme throughout the history of Western painting, of course, but casting another man as the object of that desire has been rather less conspicuous. At first Hockney evinced a decided tentativeness in his forays into that thematic territory. Although the sexual coupling between the two men in *Adhesiveness* (1960, fig. 8) is fairly explicit, the picture contains a "hidden code." The numbers printed on each figure derive from Walt Whitman's device of pairing letters of the alphabet sequentially with numbers (the title of the picture, too, derives from a Whitman poem; Hockney had read all the poet's work that year, and he regarded him as a hero). The numbers *4. 8.* and *23. 23.* thus translate into "D. H." and "W. W."—David Hockney and Walt Whitman. This veiled tentativeness soon gave way to a more direct and complex examination of socially specific subjects. In 1961 Hockney painted a small tondo in a square frame based on Ford Madox Brown's ironic ode to a vanishing way of life, *The Last of England.* In it he converted the male-female couple into two boys and pointedly added a question mark to Brown's title, which he printed on the frame above the words "Transcribed by David Hockney 1961." The same year saw *A Grand Procession of Dignitaries in the Semi-Egyptian Style,* loosely based on Constantine Cavafy's poem "Waiting for the Barbarians" and as its title suggests, composed as a flat, rhythmic processional in which a clergyman, a soldier, and a manufacturer march across the canvas in a manner related to motifs in ancient Egyptian wall paintings. The two central figures in *We Two Boys Together Clinging* (fig. 11), also from 1961, are composed from blocky shapes with sticklike legs and a single, crudely drawn arm; strongly reminiscent of Dubuffet (fig. 10), the figures have the feel of a child's rendering, while the various scribblings and writings on the canvas owe much to street graffiti.

These three paintings, like others from the period, show a clear sense of social responsiveness in the specific choices of subject matter.[7] The tone, however, is never assaultive, not a righteous howl of protest against the triumvirate of church-state-capital nor a saber-rattling attack against socially repressive conditions of the topical moment. (*The Last of England?* and *We Two Boys Together Clinging* are, after all, about love and connectedness, while *A Grand Procession* marches through the entire history of

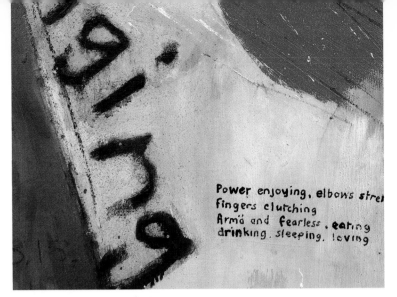

Power enjoying, elbows str[e]
fingers clutching
Arm'd and fearless, eating
drinking, sleeping, loving

DETAIL: *We Two Boys Together Clinging*

Western civilization as if to reiterate, "The more things change, the more they remain the same.") Instead these pictures radiate a poignant tension between highly personal and emotional content and the sheer anonymity of the styles in which they are painted. Graffiti is a publicly Expressionist manner in which the identity of its maker is unknown. Children's drawings partake of an utterly unself-conscious point of view, closely revealing the most private thoughts, while they tend to display a certain sameness, regardless of who made them. Finally the styles of ancient Egyptian wall painting, whose shifts over centuries were subtle and often minute, are almost always rigid, formulaic, dismissive of individual personality.

The highly individual and the utterly anonymous coexist on equal footing in Hockney's paintings. In a most peculiar way, however, these polarities tend to be reversed. The highly personal and emotional content, suggested by the theme of love and charged by its specific "illicitness" within a repressive culture, is socialized through the conscious public discourse of art and its history. Conversely the shroud of anonymity shared by the stylistic sources of these pictures is made highly specific and declaratively personal—"Transcribed by David Hockney 1961"—at a time when any use of Expressionist manner was conventionally identified with the articulation of self.

From the start Hockney's art was not composed from radical elements, only radical juxtapositions. This assertive reversal and reinvention of polarities is fundamental to his art. On the simplest level this reversal is intrinsic to certain subject matter in his early work. *Doll Boy* (1960–61, fig. 9), for instance, derives from a contemporaneous song by the popular British rock idol Cliff Richard (the Whitmanesque numerical code for his initials, 3. 18., is inscribed below the figure on the canvas), which contained the lyric, "She's a real live, walking, talking, living doll." Hockney's

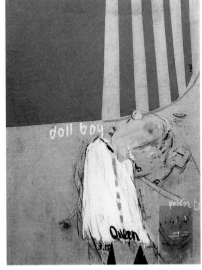

Fig. 9. *Doll Boy*, 1960–61, oil on canvas, 60 x 48 in. (152.4 x 121.9 cm), private collection

Fig. 10. JEAN DUBUFFET (France, 1901–85), *The Effacement of Memories*, 1957, oil, 35 x 46 in. (88.9 x 116.8 cm), Los Angeles County Museum of Art, bequest of David E. Bright

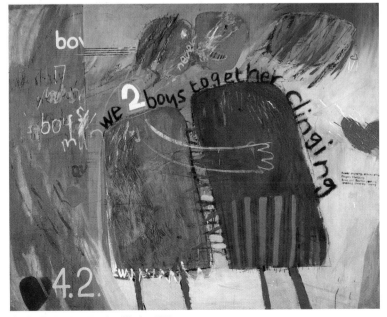

Fig. 11. *We Two Boys Together Clinging*, 1961

29

pictorial reversal of gender makes the painting a kind of "pinup boy." Similarly, *Sam Who Walked Alone by Night* (1961), inspired by a short story that Hockney had found in a gay literary magazine on his first trip to New York earlier that year, depicts a male transvestite.

As images of male desire the Love Paintings and other works incorporating gay subjects differ significantly from conventional representations of heterosexual desire in Western art. For if in our culture sexual desire requires the charged presence of a polarity—in heterosexual desire that most basic polarity being manifest as the dichotomy between male and female—then homosexual desire, which cannot spring from that dichotomy, requires the continual improvisation of new polarities.[8] Despite these inventions—or perhaps more accurately, because of them—Hockney's images of homosexual desire are revealed as no more or less eroticized than any other images of desire in the conventional canon of Western art history. What differs is the style through which desire finds form.

One should not be surprised to find, therefore, that at precisely the same time that Hockney's move into frankly homosexual subject matter was occurring, he was also conspicuously involved in acquiring fluency in a range of formal means. Questions of pictorial style, in part presented to him by his interest in the

work of the American expatriate R. B. Kitaj (as well as by his friendship with the artist), became important. For a 1962 juried exhibition in London called *Young Contemporaries* Hockney chose to submit four paintings whose emphasis was on stylistic multiplicity. Collectively (and pointedly) called a Demonstration of Versatility, the four paintings submitted and accepted for exhibition were *A Grand Procession of Dignitaries in the Semi-Egyptian Style, Tea Painting in an Illusionistic Style* (1961), *Swiss Landscape in a Scenic Style* (1961, retitled 1962 *Flight into Italy—Swiss Landscape),* and *Figure in a Flat Style* (1961).

Style, illusionism, flatness: these four paintings constitute a concerted effort at representing the processes available to the medium of painting, processes then under much discussion in the art world. Raw canvas is the open "sky" in *Flight into Italy— Swiss Landscape* (fig. 14), while a ribbon of rainbow stripes playfully describes a mountain range. The box of Typhoo brand tea in *Tea Painting in an Illusionistic Style* (fig. 13) is a shaped canvas; at the external boundaries of the painting it imitates a traditionally interior perspective. The *Figure in a Flat Style* (fig. 12) is constructed from two canvases—a small "head" atop a larger "torso"—while two wooden sticks protruding from the bottom do double duty as "legs" for both the figure and a painter's easel. Painting's materiality is everywhere emphasized in these works, and so is painterly illusionism.

This dual condition is recurrent in Hockney's art. *Two Stains on a Room on a Canvas* (1967) is perhaps the most straightforward, even didactic, example: the painting sets the color-field technique of stained acrylic paint against the flat depiction of the corner of a room in which a prismlike sculpture stands. Thus, the three-dimensional illusion of materiality, the emphatically two-dimensional surface, the materiality of surface, and the material illusion of three-dimensional space (generated by the stain technique) all happily coexist. Frequently a shift in medium accompanies an assertive reemergence of this dual condition in Hockney's work. In 1964, for instance, the artist changed from oil-based paints to acrylic paints, in which the plastic pigment is diluted in water. In the previous year he had made a few paintings and drawings of figures in bathroom showers, and the switch to acrylic was quickly followed by the appearance of water as a major subject: showers, swimming pools, lawn sprinklers, and the like turned up everywhere in his art. As manifest in the material world and in the

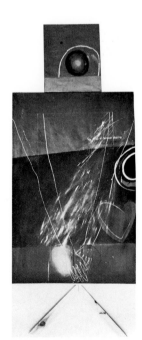

Fig. 12. *Figure in a Flat Style*, 1961, oil on canvas, 36 x 24 in. (91 x 61 cm), Dr. Michael Stoffel

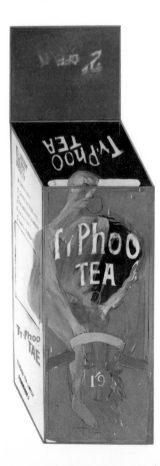

Fig. 13. *Tea Painting in an Illusionistic Style*, 1961 (in color, p. 19)

Fig. 14. *Flight into Italy—Swiss Landscape*, 1961

medium of acrylic paint the focus of pictorial effects in numerous paintings of the late 1960s and 1970s became the aqueous properties of surface, reflection, translucence, refraction, motion, and stillness. In fully self-defining fashion Hockney declares the illusoriness of the illusions he creates.

In the preface to the first edition of *Leaves of Grass* (1855) Whitman had insisted that the great poet "swears to his art, I will not be meddlesome, I will not have in my writing any elegance, or effect, or originality, to hang in the way between me and the rest like curtains. I will have nothing hang in the way, not the richest curtains. What I tell I tell for precisely what it is." Hockney knows

that the effacement of style, which Whitman is proposing, is an impossibility; still he wants to affirm the "what it is" of mediumistic truth. So he paints the curtains, pulls them back, and shows you a painted stage.

What is peculiar, then, about Hockney's twin preoccupations of the very early 1960s is the "theatricalized" wedding of older conventions of representational painting with newer conventions of formalist style, for the latter had been fundamentally linked to the legitimacy of abstraction as an organizing principle for art, a legitimacy that had thrown the very possibility of representa-

tional painting into doubt. Significantly the spectacular expansion of the machinery of mass culture in the 1930s had been the very event against which the authoritative pronouncements of formalist abstraction initially had been erected. Hockney, who was born in 1937, grew to maturity during a period of extraordinary alterations in social life. It was in the 1930s that the machinery of what we now call popular, or mass, culture swung into high gear with the rapid expansion of radio networks and broadcasting, the sudden proliferation of picture magazines in Europe and America, the wide assimilation of such technical advances in moviemaking as sound and color, experimentation with the new electronic method of picture transmission called television, the transformation of advertising into a full-scale industry, and much more. (It's worth noting too that this spectacular expansion in mediums of mass communication was coincident with the first large-scale, institutionalized attempt at promoting mass understanding and acceptance of modern artistic achievement, with the founding of the Museum of Modern Art in New York and its inauguration of national and international touring programs that were popularly well received.) An economy based on production was bumptiously metamorphosing into an economy based on consumption, and the transformation was being carried out through an elaborate discourse of images.[9]

At the end of the decade a vast and still growing body of fantastic images conveyed by these relentlessly expanding mediums of mass communication was carried into the horrific reality of World War II, during which it functioned as a kind of collective imagination and memory. In the face of daily threats of violent annihilation, such a bonding agent was crucial to sustaining emotional life. Simultaneously the technical mediums of mass communication themselves were being marshaled as tools for the war effort.

Among much else, then, the war conspired to embed a new and greater commonality of experience—both the lived experience of the war and the imaginative experience generated through the channels of mass culture—within a decidedly heterogeneous constituency. The tensions and conflicts between heterogeneity and this new kind of commonality formed the undercurrent of social and political life in the 1950s, after the period of reconsolidation in the years immediately following the war. With the ingredients already thus put into place, the groundwork was soon being laid for a civil rights movement that would encompass blacks, women, gay people, students, and others who stood outside the conventional boundaries of social mobility.

The tendency toward theatricality in art that began to coalesce around 1960 had a decidedly social and political dimension. In part, the acknowledgment of and emphasis on conditions of passive spectatorship perceptively recognized the immobilizing pervasiveness of this new mass-culture environment. (In the channels of mass communication the exchange of information is always one way.) Even more important the strategies that emerged for transforming a passively unconscious condition of spectatorship into an actively self-conscious one were aimed at revealing the complexities of cultural positioning. This budding comprehension of one's place in the cultural scheme of things, which is always at the center of political movement, was intrinsic to the social restiveness that marked the following decade.

At the end of the 1930s Clement Greenberg published his first two critical (and highly influential) essays on the nature of modernist art in general and of abstract painting in particular. "Avant-Garde and Kitsch" appeared in the fall of 1939; "Towards a Newer Laocoön," in the summer of the following year. In these two essays (as well as in subsequent writings) Greenberg eloquently argued for mediumistic purity, in which art would reflect its own existence, as the hallmark of aesthetic quality; furthermore he divined the ever-expanding operations of mass culture, which produced kitsch, as the source of the confusion into which he believed the various disciplines of art had fallen. A true avant-garde imitates the processes of art, he wrote, while kitsch merely imitates art's effects.[10] As the chaos of global war and catastrophe loomed in 1939, Greenberg asserted that the highest function of art was to keep culture moving in the midst of traumatic ideological confusion; for the artist, he maintained, accomplishing that task meant withdrawing from any attempt at socially engaged art and retreating into a fortress of aesthetic autonomy. An ideologically confused and aesthetically debased mass culture was the predator; and the arts, the prey. Painting, literature, music, and the rest had "been hunted back to their mediums" for sheer survival.[11]

Hockney's oft-stated commitment to mediumistic truth, by contrast, butts up against his equally committed belief in the pleasurable availability of art to anyone. In his work the latter

tenet takes many of its cues from features common to the new mass-culture environment—which is essentially narrative ("literary"), engaged with the middle class, and oriented toward entertainment—while the former owes much to the newly consolidating canons of Modernist art.

Although Hockney has never been a purely abstract painter, neither has he ever been uninterested in abstract art and its premises.[12] From his student days to the very early 1970s he was attentive to developments in Abstract Expressionism and color-field painting, the two arenas in which Greenberg had emerged as an articulate champion. Greenberg's formulation had been built in part on the teachings of Hans Hofmann, who had established a polarity between the processes of an artist's consciousness and the processes of his medium. (For instance, the "outside subject matter" of Dali's Surrealism, which sought to articulate the processes of consciousness, thus was seen to constitute a reactionary move.)[13] The goal of painting's concern with the processes of its medium was aesthetic unity, a condition in which art would increasingly approach the unity found in nature. When Hockney set about making a "demonstration of versatility" to the members of an exhibition jury, mixing together a disparate array of formal devices within a single canvas, it was always with the aim of achieving such Modernist aesthetic unity.

In "Towards a Newer Laocoön" Greenberg asserted that the claims of abstract art could not be disposed of by simpleminded evasion or by negation: "We can only dispose of abstract art by assimilating it," he contended, "by fighting our way through it."[14] In a roundabout way this is what David Hockney began to do: he brought questions of formalist style into representational painting. Not regarding the formal problems of style to be transparent, naturally determined, or somehow neutral, Hockney emphatically employed style as a device with which to articulate the processes of consciousness. It was as if style itself was a character as potentially vivid and lively as any of the figures that populated his canvases, a character that could be made to perform in his newly theatrical arena.

The paintings, drawings, photographs, and other works of art in the present exhibition have been assembled not into a chronological sequence but into groups that for the most part can be described as sets of formal problems. Each group contains work produced at various stages in Hockney's career, an indication of the ongoing life of these assorted "formal characters" in the artist's universe: there are problems of the visual and conceptual relationship between inside and outside, of the nature of surfaces, of the tensions between flatness and depth, of naturalism and artifice in depiction, of the delimiting frame, of motion and stillness. Certainly, consigning one or another picture to a specific category involves a decided element of arbitrariness. *Contre-jour in the French Style—Against the day dans le style francais* (1974, fig. 15), to cite a single obvious example, essays flatness and depth, inside and outside, the elusiveness of surfaces, naturalism and artifice, as well as other formal problems. Yet the division into sets has its usefulness in underlining the larger operation of Hockney's art. For even the pair of subject categories included in the exhibition—self-portraits and portraits of family and friends (or the relationships and distinctions between self and other)—suggests the play of dualities that characterizes his art.

Fig. 15. *Contre-jour in the French Style—Against the day dans le style français,* 1974

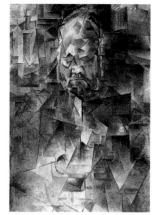

Fig. 16. PABLO PICASSO (Spain, 1881–1973), *Portrait of Ambroise Vollard*, 1909–10, oil on canvas, 36⅝ x 26 in. (93 x 66 cm), Pushkin Museum, Moscow.

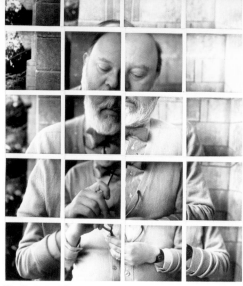

Fig. 17. *Henry Cleaning His Glasses* (detail), 1982, composite Polaroid, 14½ x 13½ in. (36.8 x 34.3 cm), David Hockney

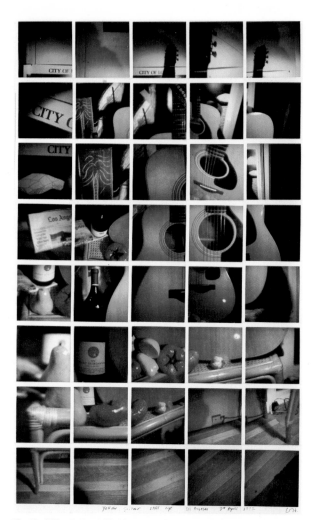

Fig. 18. *Yellow Guitar Still Life, Los Angeles, April 3, 1982*, 1982, composite Polaroid, 28½ x 17½ in. (72.4 x 44.5 cm), David Hockney

Significantly Hockney's is not a dialectical transformation of polarities into a new synthesis. Rather he articulates the multiple distinctions between each pole, and through his complex set of reversals attempts to generate a freedom of movement or sense of mobility between them, a denial of stasis or exclusivity. Consider, for example, the composite Polaroids and photocollages he began to make in 1982.

David Graves Pembroke Studios London Tuesday 27th April 1982 (1982, fig. 20) consists of 120 Polaroid photographs assembled in a grid to form a larger image of a figure seated in an interior. Each single Polaroid records its image frontally and in focus. When assembled in a grid to form the composite image, everything in the picture—whether foreground, middleground, or background—is seen closeup on a shallow plane defined by the camera's focal length. Like the hard, bright Polaroid colors, the composite image itself is dense, highly saturated, and artificially manufactured.

The "shattered" images built from numerous interlocking planes of visual information bear superficial resemblance to the fragmentation of Cubist paintings. Hockney openly acknowledges this resemblance in several works: the tabletop assemblage of plastic fruit, a newspaper and a guitar in *Yellow Guitar Still Life, Los Angeles, April 3, 1982* (1982, fig. 18) recalls numerous Picasso still lifes; *Henry Cleaning His Glasses* (1982, fig. 17) looks remarkably like the Spaniard's *Portrait of Ambroise Vollard* (1909–10, fig. 16), somehow transposed into the synthetic colors of Polaroid film; and the debt is most clearly stated, with a simultaneous nod to the ubiquity of mechanical reproduction, in *Bing Looking at Picasso* (1982, fig. 19), in which the artist's studio assistant is seen scrutinizing a reproduction of a Picasso painting. The assembled scraps of photographic paper in these composites even recall the Cubist invention of collage.

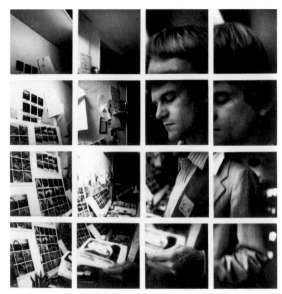

Fig. 19. *Bing Looking at Picasso, 3rd March 1982*, 1982, composite Polaroid, 14 x 14 in. (35.6 x 35.6 cm), David Hockney

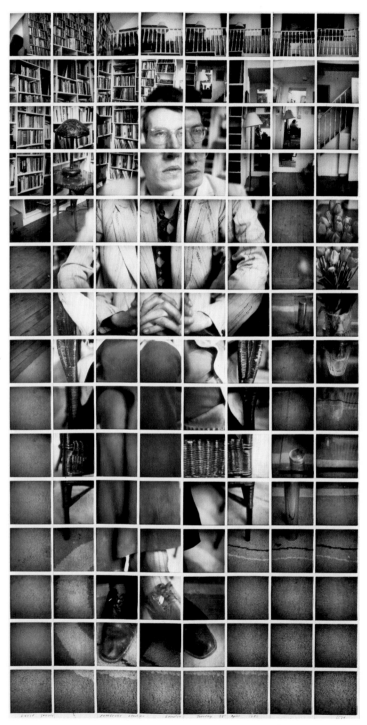

Fig. 20. *David Graves Pembroke Studios London Tuesday 27th April 1982*, 1982, composite Polaroid, 51³⁄4 x 26¹⁄4 in. (131.4 x 66.7 cm), David Hockney

Still these are not simply camera-trick gimmicks made in homage to the master, nor is Hockney's method new; other artists have used techniques of combining multiple photographs to form a composite image. Rather the technique and the Cubist allusions spring less from a desire to find new ways to make an image than they do to find ways to see an image, to allow the reality-based objects that photography captures to reveal themselves.

Assembled in a grid, these individual snapshots become a kind of "visual list" of things in the room: fingers, balcony, books, lips, rumpled sleeve, shoelace, flowers, bookcase, lampshade, mirror, doorknob, and on and on. Each photograph is an artifact, and each artifact is given equal weight in the nonhierarchical composition of the grid. The isolating eye of the camera segments the views, but the reassembled grid juxtaposes things of sharply different natures: the hard geometry of the floor yields a sensual pleasure different in kind but equal in intensity to the fragile petals of the tulips adjacent. In this equalizing process everything becomes an aesthetic object to be enjoyed for the visual pleasure it yields, and each of these separate voices in the polyphonic chorus is equivalent to the whole of *David Graves Pembroke Studios London.*

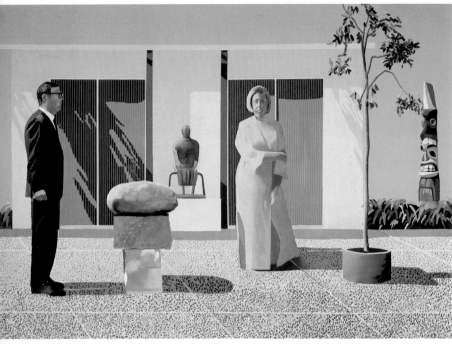

Fig. 21. *American Collectors (Fred and Marcia Weisman)*, 1968

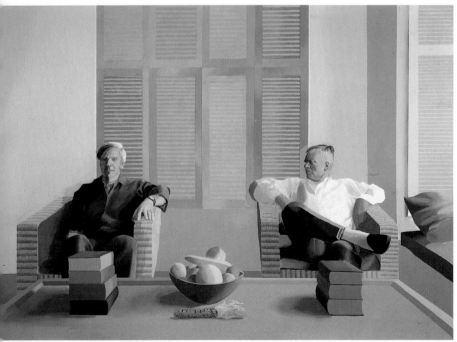

Fig. 22. *Christopher Isherwood and Don Bachardy*, 1968

There is a remarkable luxuriousness to these photographic works, a sensuousness that is at the heart of this (and, for that matter, every) Hockney enterprise. It is a sensuousness born of surfaces. The camera's focal length, which keeps everything in the composite picture in focus in a manner much richer than the eye would see, is the distance between the camera and the surface of the thing photographed. Scanning the composite, one imagines the artist moving around the room, approaching the object of desire, embracing it at a distance as the shutter clicks and the electronic motor purrs, then retreating and moving on to the next. The distanced embrace, which the intervention of the camera requires, keeps the artist in a position of detached passion. The composite image is reconstructed from the composite of sensory experiences, of surfaces seen and collected through time. Everywhere the drab and insignificant becomes the singular and radiant, while the image assumes the properties of spectacle.

Hockney's Polaroid composites and photocollages display a kind of voraciousness that is at once exhilarating and quietly seductive, as the seemingly impersonal eye of the mechanical camera becomes the vehicle for personal involvement in the accumulation of sensual experience. (Such luxurious detachment is perhaps the ultimate in contemporary dandyism.) There is a decided element of pathos too within this exhilarating seductiveness, for the freedom of mobility and radiant sensuousness butts up against the impenetrability of the image. David Graves, like almost every figure in almost every work of art Hockney has made since the early 1960s, seems contemplative, lost in thought, introspective, and remote. His self resides beyond the surface that we see, a surface that connects him to, yet isolates him from, our penetrating gaze.

Whatever the medium, Hockney fills his work with sensual surfaces and seductive visual information, often plucked whole from a variety of sources. His is a collage technique in which forthright pictorial references to the work of disparate artists (Piero della Francesca, Fra Angelico, Domenichino, Vincent van Gogh, Seurat, Matisse, Dufy, and many others in addition to the ubiquitous Picasso) and a wide assortment of already given styles, subjects, and photographic sources are torn apart and pieced together—a democratic esprit of multiplicity that coheres in aesthetic unity.[15] As much as the obvious example of the photocollages, his paintings, prints, drawings, and set designs are

DETAILS: *Christopher Isherwood and Don Bachardy*

composite views that deny the monomorphic realm of appearances.

With all that, however, his art is equally filled with a yawning sense of absence. Indeed presence and absence everywhere intertwine. It is this polarity between the profound desire for connection and the awful fact of aloneness that is the central theme of David Hockney's art. Double portraits have been a recurrent feature of his work—*American Collectors* (1968, fig. 21), *Henry Geldzahler and Christopher Scott* (1969), *Mr. and Mrs. Clark and Percy* (1970–71), *George Lawson and Wayne Sleep* (unfinished, 1972–75), *The Artist and Model* (1973–74), *My Parents* (1977), and many others—and all of these portraits attempt to record a condition of connection/isolation in regard to the couples depicted.

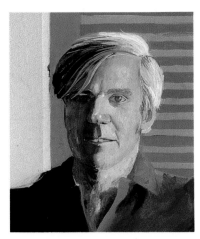

Through his assorted and often subtle modes of theatrical address Hockney also nudges the spectator into precisely this conflicting condition of delightful connectedness to, and self-conscious separation from, the work of art. In the 1969 etching *Peter* (fig. 23) the figure of the naked boy at first seems distorted and out of proportion, his head too large and his legs sharply truncated, yet it is very much the way in which we would see the actual boy if we were standing face to face, and then allowed our gaze to travel down his body. Here we see an ephemeral image the way we would see flesh and blood.

The double portraits attempt the same effect between spectator and painting. In the 1968 painting *Christopher Isherwood and*

Don Bachardy (fig. 22) we look at Isherwood's image, which looks at Bachardy's image, which looks directly at us, completing a triangulated circuit of connection. Likewise each element in the painting of the living room—which has been rearranged and drastically pared down from the actual assortment of objects one would have found there when the double portrait was painted (Hockney photographed the room extensively before commencing work)—is inextricably linked with the others by the picture's all-over compositional grid.[16] Simultaneously each is utterly self-contained, autonomous, and isolated.

It is in the paintings begun in the late 1960s—especially the famous images of swimming pools—that this central theme coalesced in Hockney's art. Pictures of empty chairs (conceptually indebted to van Gogh); of an article of clothing casually strewn aside by a figure since withdrawn; of still-life objects—pencils, paper, dictionary, TV, food—carefully laid out on a tabletop as if

Fig. 23. *Peter*, 1969, etching, 28 x 22 in. (69 x 54 cm), David Hockney

in preparation for solitary use but as yet untouched; of a vacant suburban yard, its automatic sprinklers having usurped the activity of both nature and gardener—these and many others from the period refer directly to figures departed. Among the most compelling is *A Bigger Splash* (fig. 24), a pool painting in which the baroque flourish that disrupts the center of the otherwise flatly painted canvas signals the disappearance of a diver beneath the placid blue surface of a backyard oasis. The angle of the diving board, which juts out and away from the lower-right corner of the canvas, invites us into the clean, radiant clarity of the crisply beguiling picture. Thus located in relation to the scene, we are next in line for the disappearing act.

Hockney's pictures of swimming pools, like the luxurious paintings of boys in bathroom showers begun slightly earlier, in 1963, are perhaps most revealing in this regard, for they are contemporary adaptations of the conventional literary and artistic theme of the Golden Age. The voluptuous and sybaritic bather is a primary symbol of that classical myth of origin, a myth that speaks of a lost, pastoral Arcadia of peace and harmony, which stands in sharp contrast to the convulsively animated world of history.[17] The image functions as a refusal of the impure world of the everyday, and its use finds its implicit meaning in the gap between those Edenic origins and the crushing realities of contemporary life. In the profound and assertive social upheavals of the 1960s—social reorientations in which the artist himself was deeply engaged—Hockney's committed embrace of the world as constituted was met by the countervailing force of a viscerally inflected sense of loss.

Portrait of an Artist (Pool with Two Figures) represents the apogee of this newly evolved theme. The standing boy, conspicuously clothed, leans over the edge of the pool to gaze at an amoebic figure swimming under water, adrift in a beautiful yet alien realm. In contrast to the evident naturalism of the surrounding landscape the rendering of the pool and swimmer is carefully patterned, highly artificial, contextually abstracted. It is as if the standing boy is staring deep into a perfect picture, thoroughly seduced yet fully aware of its utter inaccessibility. The picture is a portrait of an artist—but it is a portrait of a spectator too.

NOTES

1. The years around 1960 saw a flurry of museum and commercial gallery exhibitions of American art in England, especially the Abstract Expressionist painting of the New York School. In 1959 the Tate Gallery showed *The New American Painting*, an exhibition organized by New York's Museum of Modern Art of seventeen American avant-garde painters, including Willem de Kooning, Sam Francis, Barnett Newman, Jackson Pollock, and Mark Rothko. The Marlborough Gallery mounted a show of Pollock's paintings from the Krasner collection in 1961, and the following year the United States Information Agency sent *Vanguard American Painting* to the American embassy in London. The Institute of Contemporary Arts, under the directorship of Lawrence Alloway, was hospitable to the art of the New York School, while the Whitechapel Gallery presented shows of Philip Guston, Pollock, Robert Rauschenberg, Rothko, and Mark Tobey. In addition, several commercial galleries, including Robert Fraser, Kasmin, and Waddington, regularly featured American art.

2. Henry Geldzahler, "Introduction," in *David Hockney by David Hockney*, Nikos Stangos, ed. (New York: Abrams, 1977), 11.

3. *Hockney by Hockney*, 123.

4. Modern art in Britain has traditionally avoided the critical extension of avant-garde modes originating elsewhere; witness the lack of important responses to Impressionism, Cubism, and Surrealism in the decades before the rise of Abstract Expressionism. British artists instead have tended to assimilate stylistic properties of the avant-garde into their own idiosyncratic, and generally figurative, artistic tradition. For an early, insightful discussion of this phenomenon in relation to Hockney's work, see Gene Baro, "The British Scene: Hockney and Kitaj," *Arts* 38 (May–June 1964): 94–101.

5. David Hockney, *David Hockney: Looking at Pictures in a Book* (London: National Gallery, 1981), 8.

6. Michael Fried, "Art and Objecthood," in *Minimalism: A Critical Anthology*, Gregory Battcock, ed. (New York: Dutton, 1968), 116–47.

7. For two years before beginning postgraduate study at the Royal College of Art in 1959—and immediately before the appearance of socially inflected subject matter in his art—Hockney, as a conscientious objector from the military, had worked in a hospital to fulfill his National Service obligation.

8. Edmund White, "Sexual Culture," *Vanity Fair*, December 1983: 64–68.

9. For an excellent history of the new mass-culture phenomenon of the 1930s, see Alice Goldfarb Marquis, *Hopes and Ashes: The Birth of Modern Times, 1929–1939* (New York: Free Press, 1986).

10. Clement Greenberg, "Avant-Garde and Kitsch," in *Clement Greenberg: The Collected Essays and Criticism*, John O'Brian, ed. (Chicago: University of Chicago Press, 1986) 1: 17.

11. Clement Greenberg, "Towards a Newer Laocoön," in *Greenberg* 1: 32.

12. *Hockney by Hockney*, 20.

13. Greenberg, "Avant-Garde and Kitsch," 9.

14. Greenberg, "Towards a Newer Laocoön," 37.

15. The most thorough examination of Hockney's sources and methods will be found in Marco Livingstone, *David Hockney* (London: Thames and Hudson, 1985).

16. This compositional structure, which is a recurrent feature of Hockney's art, undoubtedly owes something to his admiration for the paintings of Piero della Francesca.

17. The "sexual paradise" that constitutes the workings of erotic fantasy was the initial source for Hockney's imagery of bathers. His first shower picture, *Domestic Scene, Los Angeles* (1963), was painted in London a year before he ever visited the West Coast. The image of one man washing the back of another under the cascading spray of a shower derived from a photograph in *Physique Pictorial*, a homoerotic magazine published in Los Angeles.

Fig. 24. *A Bigger Splash* (detail), 1967 (pl. 37)

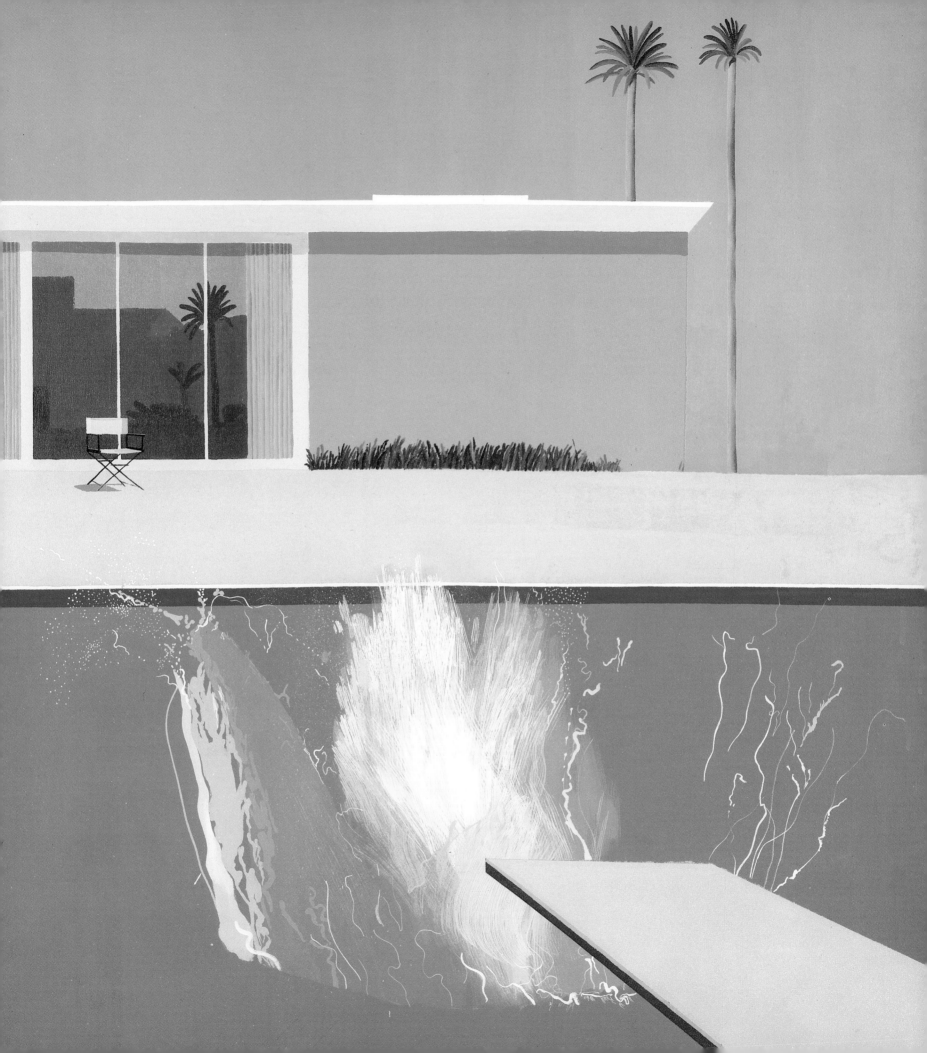

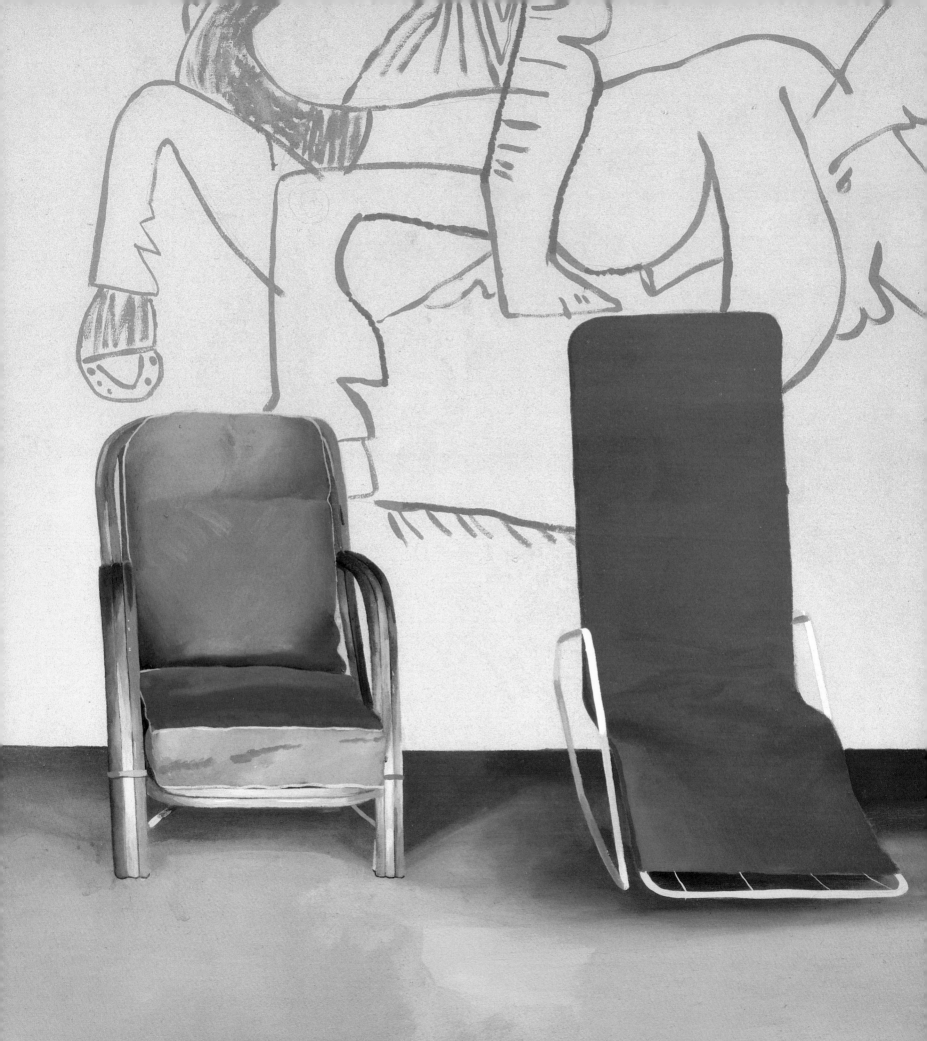

A Moving Focus: Hockney's Dialogue with Picasso

GERT SCHIFF

THE HISTORY OF ART is a history of appropriations. Artists incorporate in their works forms and formal procedures of earlier masters and thus engage in a dialogue with these revered models. The Mannerists maintained a dialogue with Michelangelo; Ingres with Raphael; Delacroix with Rubens; Manet with Velázquez; Cézanne with Poussin; and Picasso with all of these and scores of others. In our time David Hockney is engaged in a dialogue with Picasso, and I don't think it is premature to say that this is a fact of considerable significance, for Picasso is the only artist of his stature who never taught, who never originated a school, and whose formal innovations (with the sole exception of some Cubist devices) proved too idiosyncratic to be appropriated by others. Yet now Hockney, whose art has sometimes been dismissed as lightweight, pursues a deep investigation of some of Picasso's modes of creation. He has thereby also made a vital contribution to our critical understanding of Picasso. One might almost say that Hockney has endeavored single-handedly to make up for the lack of a Picasso school. He has been able to adapt his reading of Picasso's art to his own very different representational problems and has thereby created works that are fresh, innovative, and personal. Could there be better proof of the incisiveness of his reading?

His fascination began in 1960. A large exhibition of Picasso's works was held at the Tate Gallery. Hockney, then a student at the Royal College of Art, visited it eight times. Not that he tried instantly to paint like Picasso, as one might expect from an impressionable twenty-three-year-old. He continued, with paintings such as *Adhesiveness* (1960, illustrated p. 28), to work in his early idiom of informal abstraction, enlivened by cryptic numbers and spirited homosexual reference. It was rather a lesson in principle that Hockney derived from his experience of Picasso. "Style," he realized, "is something you can use, and you can be like a magpie, just taking what you want. The idea of the rigid style seemed to me then something you needn't concern yourself with, it would trap you."[1] As a consequence "I deliberately set out to prove that I could do four entirely different sorts of pictures."[2]

Hockney's first pictorial references to Picasso occur almost ten years later in two paintings: *Three Chairs with a Section of a Picasso Mural* (1970, fig. 1) and *Chair in Front of a Horse Drawing by Picasso* (1971). These works commemorate Hockney's visit in 1970 to the late Douglas Cooper. The mural (or rather, graffito) consists of scenes of love and war in the quasi-Neoclassical style of Picasso's variations on the *Rape of the Sabines*. It fit splendidly into the outdoor patio of Cooper's late seventeenth-century Château de Castille. Fragmented and partly covered by chairs, Hockney's re-creation shows the work as part of a domestic setting—art incorporated into life.

Picasso died on April 8, 1973. Hockney was deeply moved. He welcomed the offer of a Berlin publisher to contribute a print to a portfolio, *Homage to Picasso*, for this commission gave him an opportunity to declare publicly his admiration and love for the deceased master. According to Marco Livingstone, Hockney "recalls . . . that it was only with Picasso's death that one could begin to see the consistency of his life's work, making sense of the apparent stylistic breaks as the result of a unified attitude towards style and content."[3] By now the importance of Picasso as a model of creative freedom was firmly anchored in Hockney's self-awareness as an artist. In consequence he found it easy to express his feelings for the great Spaniard with unaffected modesty, wit, and candor.

Fig. 1 and inset: *Three Chairs with a Section of a Picasso Mural* (details), 1970 (pl. 42)

He executed the print in Paris in the studio of Aldo Crommelynck, Picasso's master printer. Again Livingstone: "The contact was decisive: Crommelynck not only showed Hockney sugar lift and colour etching techniques which he had perfected for Picasso, but also spoke with great affection of the Spanish master, telling Hockney how well the two of them would have got on with each other."[4]

This print, *The Student: Homage to Picasso* (1973, fig. 2), has been somewhat underplayed in the literature. It is a fine work, pervaded with subtle self-irony. Hockney approaches Picasso, who is represented as a giant sculptured head resting on a column. The younger artist is carrying a portfolio of his drawings, evidently in order to submit them to the master's inspection. The wit of this invention, however, consists in the fact that Picasso is depicted as we recall his likeness from a photograph taken late in 1916 in his studio in the rue Schoelcher, that is, as the thirty-five-year-old creator of Cubism, with an almost aggressive, youthful manliness. Hockney depicts himself, by contrast, as a somewhat etherealized old young man, wearing a broad-brimmed hat, trademark of the late-Romantic salon artist. Hence he is showing himself to be not only biologically but also historically "older." Does Hockney mean to imply that, ensnared in the self-limiting modes of Realistic depiction as he had been for many years, he had not even begun to absorb the revolutionary lesson of Picasso's Cubism? Picasso casts at him that piercing, probing glance that, as has often been reported, unsettled all but his most intrepid interviewers.

If this print has a weakness, it can only be its excess of humility. Yet Hockney etched another homage to Picasso, the print *The Artist and Model* (1973–74, fig. 3), which was begun in 1973, temporarily dropped, but resumed and finished the next year. Here the old master and his young admirer are united in a situation of comparative familiarity. Beside a window with a view of a villa on the Riviera, they sit face to face at a table. Picasso is wearing that striped jersey known from several photographs of his late years. He holds in his hands what may well be a drawing or print by Hockney. Again he glances inquisitively past the sheet at his interlocutor.[5] The latter is naked. (Note a charming little detail revealing the born narrator: they both sit on rather uncomfortable, low stools; the nude man sits on a cushion, the dressed one not.) How are we to read this allegory? According to

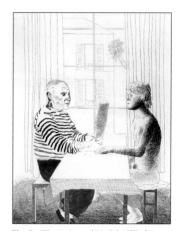

Fig. 2. *The Student: Homage to Picasso,* 1973 Fig. 3. *The Artist and Model,* 1973–74

Livingstone, "Hockney humbly places himself in the role of the model rather than artist."[6] Yet I think there is another possible interpretation, more in keeping with the hint of a Socratic Eros implied in Hockney's depiction of his discipleship. Nudity is the original state of primitive humanity. It is reassumed whenever a high spiritual purpose requires a return to primeval innocence. The resurrected appear naked at the Last Judgment; therefore the Adamites worshiped God naked in order to bring about the End of Time. The Doukhobors practice communal and public nudity in order to recover prelapsarian innocence. As we learn from a grim little story by Maupassant, it was customary among Breton fishermen to present the newborn naked at baptism, no matter how cold it was, for *"Il faut attendre le Bon Dieu tout nu."* If Hockney puts himself into this pristine state, he probably does so in order to be quite innocent and unencumbered by the trammels of (pictorial) convention, a pure receptacle for the spirit of Picasso, his "model."

Hockney was to go on experimenting with Cubist devices for some time. In 1976 a poem, itself inspired by Picasso, elicited his first tentative appropriation of the great Spaniard's art.

Hockney read Wallace Stevens's poem "The Man with the Blue Guitar" at the suggestion of Henry Geldzahler during his vacation on Fire Island in 1976. Struck by the poem's reference to Picasso and by its exposition of the conflict between the artistic imagination and the world, Hockney did a series of ten drawings in colored crayons that freely interpret the mood of the poetry. That fall he converted the drawings into a series of twenty colored etchings. These were published in 1977, first as a portfolio and then as a book, which has since become a vade mecum of Hockney fans.[7]

The poem takes as its point of departure Picasso's painting of

1903 *The Old Guitarist.* The figure becomes an embodiment of the poet who strums on his "blue guitar"—the imagination—tunes provoked by his opposition to "things as they are," as Helen Vendler rightly notes.[8] In ways that must have been largely unknown to Stevens himself, however, his ruminations correspond profoundly with Picasso's work and thought as we know them now.

Stevens conceived of the world as his adversary. Picasso too reacted to the world with hostility and fear, even if he was not as unsociable, as estranged from the physical, as Stevens. There were things that, thanks to their sensual appeal, allowed Picasso time and again to break through the barrier. Witness a remark he made to André Malraux, incidentally in the same year, 1937, that Stevens wrote his poem: "I too am against everything. I too believe that everything is unknown, that everything is an enemy. Everything! Not the details—women, children, babies, tobacco, playing—but the whole of it!"[9]

The mood of Stevens's poem shifts many times between the extremes of resignation vis-à-vis the deadly torpor of "things as they are" and hopes for the aesthetic redemption of the world in the work of art. At his most savage the poet dreams himself, with Picassian hubris, "playing man number one" and driving the dagger into the heart of his adversary, the world, which now appears as a "serio-comic cadaver."[10] In lines that resound with the fury of Picasso's assaults on the human form, he proposes:

> To lay his brain upon the board
> And pick the acrid colors out,
>
> To nail his thoughts across the door,
> Its wings spread wide to rain and snow,
>
> To strike his living hi and ho,
> To tick it, tock it, turn it true,
>
> To bang it from a savage blue
> Jangling the metal of the strings.
>
> (Canto III)

In a more lighthearted mood he "holds the world upon his nose" (xxv), making it his toy, and his language adapts itself to nursery rhymes much as Picasso often derived inspiration from children's drawings.

Both Picasso and Stevens believed that artistic inspiration is rooted in reality. Stevens: "Here is a fundamental principle of the imagination. It does not create except as it transforms. There is nothing that exists exclusively by reason of the imagination, or that does not exist in some form in reality."[11] Picasso: "There is no abstract art. You must always start with something. Afterward you can remove all traces of reality. There's no danger then, anyway, because the idea of the object will have left an indelible mark."[12] The poet and the painter agree, however, that reality is ultimately elusive. Picasso demonstrates this by reference to Frenhofer, the hero of Balzac's "*Chef-d'oeuvre inconnu*," who sets out to paint the perfect woman and ends up with an impenetrable web of meaningless lines and blurs of color: "At the end, nobody can see anything except himself. Thanks to the never-ending search for reality, he ends in black obscurity. There are so many realities that in trying to encompass them all one ends in darkness."[13] Stevens, in one of the most marvelous cantos of "The Man with the Blue Guitar," xxvii, expresses a similar notion through his jibe at geographers and philosophers who, in Vendler's words, "cannot let the landscape alone, but tour the world trying to rearrange it in an orderly way, not realizing that the world, ironically enough, is always in the process of re-arranging itself."[14]

How, then, did David Hockney translate this meeting of two kindred spirits in Stevens's poem into the language of his "illustrations"?

In the portfolio he explains: "The etchings themselves were not conceived as literal illustrations of the poem, they are about transformations within art as well as the relation between reality and the imagination, so these are pictures within pictures and different styles of representation juxtaposed and reflected and dissolved within the same frame."

That is to say, Hockney keeps closer to the artifice of the poem than to its darker moods; he dwells more upon its dream-colored images ("sun's green, cloud's red," xxii) than upon the thoughts from which they emerge. He takes to heart the poet's assertion: "Nothing must stand / Between you and the shapes you take / When the crust of shape has been destroyed" (xxxii), for he understands this as a confirmation of the artist's preroga-

Fig. 4. *The Old Guitarist,* from the Blue Guitar series, 1976–77

Fig. 5. *Tick It, Tock It, Turn It True,* from the Blue Guitar series, 1976–77

tive to change the appearance of things as the imagination dictates. Hockney demonstrates this license in two ways: first, through the many borrowings from Picasso, each in a different style, which are scattered over these etchings; second, through a commingling of still-life objects with invented ones, or—and this is a step beyond Picasso—with "artistic devices," that is, free configurations of line and color, which hark back to certain of his paintings of 1965, for example *Portrait Surrounded by Artistic Devices* (pl. 28). Another leitmotiv of these etchings is the blue guitar itself. It appears eleven times all told, sometimes in stasis, then again as a mirage floating in air; in Cubistic fractioning or surrounded by vibrating "sound waves"; as a "mold" for the poetry or resting on a shelf atop a portrait of Wallace Stevens. In some images objects are kept suspended by loops formed by the isolated strings of the guitar. These include a draftsman's pen, a tuft of green hair, and a waving blue- and red-colored line, which naively depicts life as "It picks its ways on the blue guitar" (IV). Hockney was greatly helped in these "demonstrations of versatility" by a technique he had learned from Crommelynck which allowed him to etch in different colors on the same plate.[15] Livingstone observes that "there was also a poignancy about using a technique which had been invented for Picasso but which the master had not had a chance to use before his death."[16]

Never does Hockney come closer to a rendition of the despair that pervades the greater part of Stevens's poem than in the central image of the frontispiece (fig. 4). His copy engulfs *The Old Guitarist* in a blue that is markedly different from the moonlight color of the original: it is undifferentiated darkness, which all but dissolves the lean, ethereal body of the player. He thus appears really as "a shadow hunched / Above the arrowy, still strings, / The maker of a thing still to be made" (IX). The "thing still to be made," however, is joyfully displayed in red and green remarques, shorthand copies of later works by Picasso, lightheartedly scattered over the lateral margins. One recognizes a mock-Cubist bust of a woman (after a painting of 1935), a diagram of Picasso's son Paulo as a pierrot, a candle, a pre-Cubist fruitbowl—all interspersed with artistic devices of Hockney's own making. Even the Virgin Mary from Picasso's *Crucifixion* (1930) appears in this context less like a devouring praying mantis than in the original.[17]

Hockney transposes most of the poetic material into a lighter

key. When he takes up Stevens's savage assault on the world (in the lines quoted from canto III), he does not depict the adversary as a "serio-comic cadaver" nailed across the door but as a broken jumping jack, his parts dancing across a comfortable interior (fig. 5). The metaphysical battle is transposed onto the pictorial plane as a clash between the realistic depiction of the setting and the figure made up of "artistic devices."

A similar transposition occurs in *A Picture of Ourselves* (1976–77, fig. 6). This etching was inspired by canto XIX, another variation on the poet's struggle with the world, which is this time apostrophized as a monster. The two confront each other in a mirror relationship: here the Man with the Blue Guitar, there the world as "the monstrous player of / One of its monstrous lutes." They finish in a draw, the poet being "the lion in the lute / Before the lion locked in stone." Hockney associates the "monster" in the poem with Picasso's female monsters, and the combat transforms itself into a confrontation of the human form with what art makes of it. This is a cardinal theme of Picasso's. An instance is etching number 74 of the Vollard Suite, *Model and Surrealist Sculpture* (1933, fig. 7), where the nude model stands musing in front of an assemblage of broken furniture, as if unable to believe that this could be an image of herself. Instead of copying it, Hockney places a nude from another Vollard etching (1933, fig. 8), in front of a wooden assemblage of his own invention. Yet as if to remind us that there are in life (and in Picasso) many other, much more monstrous realities, he confronts the nude with a mirror that

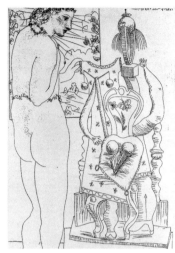

Fig. 7. PABLO PICASSO (Spain, 1881–1973), *Model and Surrealist Sculpture*, 1933, etching, 10⁹⁄₁₆ x 7⁵⁄₈ in. (26.8 x 19.3 cm), Museum of Modern Art, New York

Fig. 8. PABLO PICASSO (Spain, 1881–1973), *Sculptor at Rest and Model with Mask*, 1933, etching, 10¹⁄₂ x 7⁵⁄₈ in. (26.7 x 19.3 cm.), Museum of Modern Art, New York

reflects her in the shape of one of Picasso's dinosaurian monsters, this one taken from the gouache *Two Nudes on the Beach* (1937, fig. 9).[18] Again it is Hockney's primary intention to show "different styles of representation juxtaposed"; yet in calling the print "a picture of *ourselves*," he adds an irony all his own.

"What Is This Picasso?" Hockney asks in the concluding etching (1976–77, fig. 10). He is apparently a magician hiding behind a

Fig. 6. *A Picture of Ourselves,* from the Blue Guitar series, 1976–77

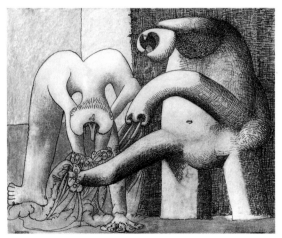

Fig. 9. PABLO PICASSO (Spain, 1881–1973), *Two Nudes on the Beach*, 1937, india ink and gouache on wood, 8⁵⁄₈ x 10⁵⁄₈ in. (22 x 27 cm), Musée Picasso, Paris

Fig. 10. *What Is This Picasso?*, from the Blue Guitar series, 1976–77

Fig. 11. PABLO PICASSO (Spain, 1881–1973), *Girls with a Toy Boat*, 1937, oil, pastel, and crayon on canvas, 50½ x 76¾ in. (128 x 195 cm), Peggy Guggenheim Collection, Venice

curtain who by a wave of his wand floods the scene with figments of his imagination; these materialize for a moment as they slide past us as if on a conveyor belt. There appears the elliptical face that rises above the horizon in Picasso's painting *Girls with a Toy Boat* (1937, fig. 11); an ill-defined shape, which may or may not be derived from the muzzles in some of Picasso's "theriomorphic" pictures of women; the well-known *Portrait of Dora Maar* of 1937;[19] and a bunch of flowers.

But in several other etchings, such as one entitled *I Say They Are* (1976–77, fig. 12), invented objects (a coat hemmed with bricks, surmounted by a Julio Gonzalez-like "head") and pure artistic devices (materialized drippings of red, blue, yellow, green, and black) dominate the scene. This composition refers to one of the more affirmative cantos (XXVIII), which ends with the lines:

> Here I inhale profounder strength
> And as I am, I speak and move
>
> And things are as I think they are
> And say they are on the blue guitar.

This implies a temporary resolution of the conflict between the imagination and the world. The imagination wins out. Hockney resolved the conflict in painterly fashion: for him, his artistic devices are "things as they are," the ultimate reality.

· · ·

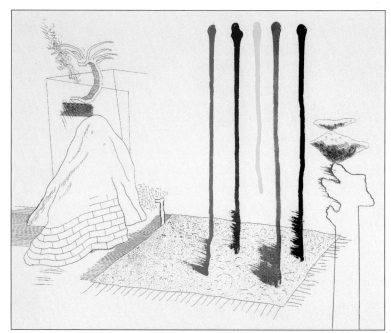

Fig. 12. *I Say They Are*, from the Blue Guitar series, 1976–77

Fig. 13. PABLO PICASSO (Spain, 1881–1973), *Reclining Nude and Man in Profile*, 1965, oil on canvas, 19¹¹/₁₆ x 24 in. (50 x 61 cm), David Hockney

On January 11, 1983, at the Los Angeles County Museum of Art Hockney gave a lecture on Picasso entitled "Great Paintings of the Sixties." The title referred to a series of thirty-five paintings on the theme of Painter and Model that Picasso had executed between March 23 and 31, 1965. In the succeeding months Hockney reexamined these works and presented a revised lecture entitled "Important Paintings of the Sixties" on April 3, 1984, at the Guggenheim Museum in New York. Now the lecture, in a broader sense, referred to the master's entire production of his last years, 1963–73, then the subject of an exhibition organized by the present writer.[20] This exhibition marked a watershed for during the entire eleven years since Picasso's death his last period had been passed over in silence. Public and private collectors largely ignored those works. To dealers they seemed a bad investment. Even the majority of Picasso's critics, people who had written admiringly about his earlier achievements, responded to the late works with embarrassed incomprehension. "Picasso seemed to have spent his dotage at a costume party in a whorehouse."[21] Foremost among these detractors was the art historian Douglas Cooper, who should have known better for he had been friendly with Picasso for many years, amassing a splendid collection of his paintings, and during that time had written authoritatively about Picasso's Cubism and designs for the theater. Yet in 1973, when the incredibly rich production of the two preceding years was displayed in the Palace of the Popes in Avignon, Cooper joined in the chorus of those who refused to see in these works anything but frantic, senile gibberish.

Not so David Hockney, who saw the show in the company of Cooper. It may just be that Cooper's tirades forced him into opposition, but he did not really need this incentive. Picasso's late paintings stirred him viscerally. He never quite stopped thinking

of them. In 1980 he saw the major retrospective at the Museum of Modern Art "and like everybody else was incredibly excited by it."[22] A year later, Hockney relates,

> Claude Bernard in Paris had organized a show of perhaps fifty small Picassos from all periods. One in particular from 1965 caught my eye and mind, and delighted me [*Reclining Nude and Man in Profile* (fig. 13)]. I could not exactly say why. It was a picture with not very many brush strokes in it. I have since attempted to count them and I think there are about thirty-five. Later in the year I was offered the picture in exchange for two big paintings of mine (this one is very small), and although I am not a collector by nature—postcards will do for me actually—I became the owner, and the painting has never stopped thrilling me.

Hockney then began to study his own Picasso in the context of those thirty-five paintings to which it belongs. He had to do so largely on the grounds of reproductions in the catalogue by Christian Zervos[23] for the originals were dispersed and inaccessible. Yet his thorough investigation of the series triggered insights that became not only a clue to the entire production of Picasso's last years but also helped Hockney himself a great deal in the development of new representational procedures in his own painting.

Hockney's lucid and impassioned deductions in his Guggenheim lecture played a major part in that battle for the acceptance of Picasso's last works, which the exhibition succeeded in winning. The endorsement of a much younger artist of international standing may have won over some who were still undecided. Those of us who had loved the late work ever since its first broad presentations in Avignon in 1970 and 1973 found in Hockney's words a brilliant confirmation—and food for more thought.

In talking about the Painter and Model series of 1965 (which had otherwise been completely neglected), Hockney spoke entirely from the point of view of a painter. He noticed things that only a painter could see in this way and made his audience see them. This was no minor achievement, considering that he had to rely almost exclusively upon slides taken from the black-and-white reproductions in Zervos.

In a kind of prelude he commented upon two paintings by Picasso, both relatively offbeat yet dear to him: the much-criticized *Massacre in Korea* (1951)[24] and *Portrait of Emilie-Marguerite Walter, "Mémé"* (1939, fig. 14), the mother of Picasso's mistress Marie-Thérèse. Hockney used both paintings as evidence for an "attack on photography," whose claims of truthfulness and documentary objectivity he aimed to demolish. *Massacre in Korea* depicts an incident impossible to photograph because the photographer ought to have been on the side of the executioners, "otherwise he would have been shot with the women and children . . . and this seems to clearly state a major photographic problem. You have to be there. It cannot be from memory or imagination." Memory, however, is an intrinsic part of visual perception. We perceive sequentially. Our perception of an object always includes the memory of how we viewed it split seconds earlier and from different angles. This, of course, is the insight underlying the multifaceted depiction of objects in Cubism. Since Picasso adhered all his life to this principle, he remained a Cubist even in works that, like those of his last ten years, retain hardly a trace of Cubism's quasi-geometric stylization. These last works, according to Hockney, represent precisely the most refined form of Picasso's Cubism.

If not all of this is precisely "news," Hockney illustrated it nonetheless with an analogy that would hardly have occurred to a historian of Western art: he read those beautiful paragraphs from George Rowley's *Principles of Chinese Painting* that describe the Chinese landscape as "an art of time as well as space."[25] "It's the best condemnation of the photograph I've come across and read."

The landscape scroll is an art of moving focus. It has to be experienced in time, like literature and music, as the eye proceeds sidelong, from right to left, instead of following converging van-

ishing lines into depth, as in Western space, which is dominated by centralized perspective. The individual motifs (rocks, for instance) form their own respective focal points and must be viewed in sequence. As he said in his lecture:

> When the Chinese were faced with the same problem of spatial depth in the T'ang period, they reworked the early principles of time and suggested a space through which one might wander and a space which implied more space beyond the picture frame. We restricted space to a single vista as though seen through an open door; they suggested the unlimited space of nature as though they had stepped through that open door and had known the sudden breathtaking experience of space extending in every direction and infinitely into the sky.

What Hockney implies is evidently that the eye has to wander through a Cubist painting in much the way that it has to wander through the Chinese landscape scroll, thereby reexperiencing the sequence of perceptions that combined in the multifaceted image. Since in Cubism objects are not disposed in receding space but tend rather to project from the picture plane, Cubism is an art of closeness, the same closeness with which the interaction of painter and model is viewed in those thirty-five paintings that Hockney now discussed one by one as they appeared on the screen in the Guggenheim auditorium.

He treated the series as a continuous narrative, unfolding on several levels. A painter is painting a woman. He paints his hesitation, the struggle of depiction, and the way he continually invents her anew ("it's very hard to escape what we believe a person actually looks like"). In some paintings the model appears beside the empty canvas; in others she is confronted with her

Emilie-Marguerite Walter

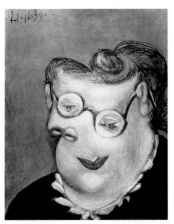

Fig. 14. PABLO PICASSO (Spain, 1881–1973), *Portrait of Emilie-Marguerite Walter, "Mémé,"* 1939, oil on canvas, 16¹/₈ x 13 in. (41 x 33 cm), Maya Witmayer-Picasso, Paris

painted image, which makes the depiction of her "real" figure almost seem naturalistic. Hence these pictures are about style or rather about the sovereign freedom of the experienced old master to use whichever means of depiction are precisely suited to his purpose. In some cases Picasso used a pictorial shorthand that might seem crude. Yet Hockney demonstrated how these broadly brushed lineaments place the body in space as they fix its shifting attitudes in time "with the arms becoming more playful. . . . You begin to see the front, the back, the side, and many things." In one instance the image on the canvas is simply a piece of white paint squeezed from the tube, yet Hockney shows us that Picasso "had also echoed the woman on the right in the way he squeezed it because he bends the paint over at the bottom like her legs sitting." Several of Hockney's observations converge in that little gem that he so happily calls his own. The artist, seen close up, looks with one eye at his canvas, with the other (whose lids extend like a searchlight) at the model. The canvas is seen edgewise. "There he is and he is going to paint the girl on a flat surface. It is a wonderfully witty way of representing the flat surface by turning it around and showing you a thin line. . . . I think the model's arm becomes the sofa as well." These pictures are "extremely refined because they are telling you again about his body making the picture, which at least gives you your body back a bit in a way that one-point perspective . . . takes it away. . . . Again, the photograph is holding us back because we still believe that's the way we see. This is much closer to it, truer to it, and it is artistic representation rather than scientific representation. I think for an artist, for myself anyway, it opens up vast things."

Vast things indeed. Hockney's critique of photography led to his own collaged photographs with multiple viewpoints (discussed in another essay in this volume).[26] His observations on the time element in Picasso and Chinese painting also triggered, among other things, some highly idiosyncratic portraits and one stupendous, large-scale landscape.

It is memory that is our recorder of the time element, and Hockney observed that the presence of memory also explains the "distortions" in the 1939 portrait of Emilie-Marguerite Walter.

A photograph of the mother of Marie-Thérèse Walter shows a middle-aged lady with her eyes screwed up. She's having to peer out of them. She had taken off her glasses for the

Fig. 15. *Christopher with His Glasses On,* 1984

Fig. 16. *Christopher without His Glasses On,* 1984

photographer, but for Picasso it didn't matter, he'd seen her wear them, so they were always there in his memory. His painting of her seems infinitely more truthful, even though we've never met her or seen her. It seems to have far more authenticity.

Evidently this observation gave Hockney the idea of portraying his friend the writer Christopher Isherwood both with and without glasses (1984, figs. 15 and 16). A comparison proves that Hockney's appropriation is a truly creative one, however, in which he adopted Picasso's method without merely mimicking externals.

Several perceptions are combined in Picasso's portrait of the mother of his mistress. He seems to have envisioned her first in profile, facing left. Then the entire nose may have caught his interest, and he zooms in from below upon the nostrils. The complete olfactory organ somewhat resembles the muzzle of Kazbek, Picasso's Afghan hound. (He had introduced this reminder of man's animal nature in some heads of men licking ice-cream cones, done in 1938. It became a hallmark of his wartime portraits.) With the addition of the second nostril Picasso has settled for a depiction of the whole face, seen frontally. A broad movement of his eyes (and his whole body) pulls the compound

Christopher Isherwood

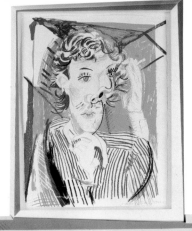

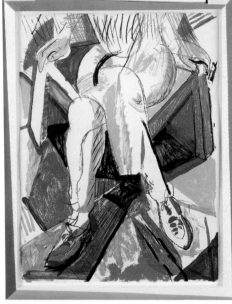

Fig. 17. *An Image of Gregory*, 1985, lithography, collage, top: 32 x 25½ in. (81.3 x 64.8 cm), bottom: 46 x 35 in. (116.8 x 88.9 cm), David Hockney

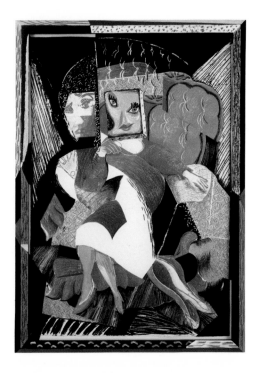

of Madame Walter's eyes and eyeglasses across the bridge of the nose into frontality. The painter now aims at his subject from a greater distance and farther to the right. The trajectory of his change of position is echoed in the downward slope of the glasses; this in its turn is countered by the upward-pointing corners of the mouth. Virtuoso brushwork models the face in such a way that the dislocation of mouth versus nose, and the missing philtrum, are not perceived as unorganic. On the perceptional level every dislocation represents an adjustment to a different focus. On the representational plane the face conveys the lady's good humor, her quiet composure, the nodding of her head.

Hockney projects a similar shift from profile to front view in his two portraits of Isherwood. With Picasso, however, the separate perceptions follow each other staccato—his focus "jumps"—whereas Hockney moves much more smoothly from one vantage point to the next. He achieves the same truthfulness as Picasso, even if Isherwood's head appears in his renditions more pear-shaped than it really was. This is, of course, due to the fact that the focus moves most widely in the lower part of the face.

Like Picasso, Hockney begins with a profile view—though facing right. Then he "completes" the nose by means of a wavy line encompassing both its unusually broad tip and the widely separated nostrils. He now pulls the averted parts, the left eye and that ruddy patch of cheek, around the profile line. The eye remains "stuck" at the break point between nose and forehead; the cheek settles down on the flattened bridge of the nose or, in *Christopher with His Glasses On*, between the rims of the glasses. Hockney's formula allows him to include the philtrum, which connects the nose with the pursed lips, roughly as in a face seen from a single viewpoint. One could almost say that these two faces have central axes, if this were not flagrantly contradicted by the dislocated cheeks. The eyeglasses pose a problem, as always in portraiture, since they dim the radiance of the eyes. In *Christopher with His Glasses On* Hockney finds a marvelous way out of this dilemma. He paints short blue rays, which issue from the pupils and conjoin with Isherwood's busy eyebrows. Thus the bespectacled eyes flash sardonic fire. If in this version the writer seems to shake with suppressed chuckles, he appears in the other more subdued, his whole being summed up in a wry smile.

In two lithographs of 1985, *An Image of Gregory* and *An Image of Celia* (figs. 17 and 18), Hockney carries the portrait with a

Fig. 18. *An Image of Celia*, 1985

moving focus one step further, from Cubism into Futurism; for in both cases the sitters are shown in widely divergent poses, so that their arms and legs are multiplied. Yet Hockney gives us to understand that these two works do not really portray people but modes of depiction. In the case of *Gregory* he destroys the illusion by encasing the upper and lower parts of the figure in picture frames of different sizes; in *Celia* he replaces one of her two heads by a small canvas with her features as they appeared on a recent cover of French *Vogue* (fig. 19).[27]

Both Picasso and Hockney are, in one aspect of their works, painters of sunny countries and of the leisurely life around their beaches and swimming pools. We know of both artists that their first visits to the respective countries were accompanied by déjà vu experiences. Picasso said about his first visit to the Côte d'Azur: "I don't want to pretend to clairvoyance, but really I was staggered: everything was there just as it was in a canvas which I had painted in Paris. Then I realized that this landscape was mine."[28] Hockney relates that "California in my mind was a sunny land of movie studios and beautiful semi-naked people." About his first trip to Los Angeles in the winter of 1963–64: "Within a week of arriving there in this strange big city, not knowing a soul, I'd passed the driving test, bought a car, driven to Las Vegas and won some money, got myself a studio, started painting, all in a week. And I thought, it's just how I imagined it would be."[29] During the intervening years he has made his home in the Hollywood Hills and has himself become as much of a hallmark of Southern California as Southern Californian landscape and life-style have become hallmarks of his painting.

Nowhere has he expressed his love for his adopted country with as much vigor as in that grand, epic landscape called, after the road leading to his house, *Mulholland Drive: The Road to the Studio* (1980, fig. 21). This painting contains—apart from a joyous appropriation of the colorism of van Gogh and Matisse—the most ingenious use of Hockney's ideas about Picasso and Chinese landscape painting. Only face-to-face with this enormous, seven-by-twenty-foot canvas can one fully experience its impact. The work was painted from memory in three weeks. But, then,

Hockney had traversed this area countless times on his way to a studio that he kept for some time in Santa Monica. "You drive around the painting," he points out, "or your eye does, and the speed it goes at is about the speed of the car going along the road."[30]

Following the curving road, the eye absorbs a great variety of motifs, each forming a focal point of its own. No attempt has been made at unified perspective; in fact, the vantage point shifts constantly. In the bottom-left corner the eucalyptus grove, swimming pool, and tennis courts are displayed consistently as if viewed from the top of a hill, with fleeting lines receding toward a low vanishing point. Yet above the grove the ground is tilted upward, until beside Mulholland Drive the bottom of the valley coincides with the painting's surface. In some of Picasso's landscapes from his last years, for instance, *Landscape* (1965, fig. 20),[31] a similar disregard of conventional perspective can be observed: the buildings are staggered one on top of another, and a curved lane shoots up vertically until it reaches a circular plaza, a lookout high in the mountains, which is embedded in the picture plane.

Much of the impact of Hockney's painting is due to its intense hues of green and blue, orange and red (it is painted in acrylic), and to its variegated patterns. The eye is immediately arrested by the conical hill in the center foreground, which is made up of a cascade of chopped brush strokes in red and blue, effectively counterpointed by the broad pattern of the blue-green tree. In other areas flamelike agaves inscribe themselves green into an ultramarine ground, or a simplified telegraph tower cuts across a tilled field, whose furrows are incised into the rust-colored soil.

One of the most startling features are the grid patterns that fill the top section of the canvas. I knew they were copied from the Los Angeles city map and referred to the suburbs of Studio City and Burbank in the San Fernando Valley, but I did not under-

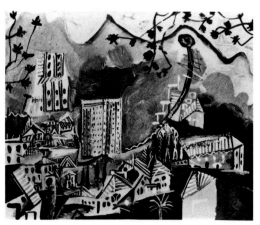

Fig. 19. Cover, French *Vogue*, December 1985–January 1986

Fig. 20. PABLO PICASSO (Spain, 1881–1973), *Landscape*, 1965, oil on canvas, 51⅛ x 63¾ in. (130 x 162 cm)

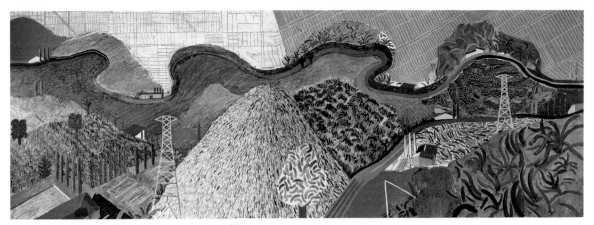

Fig. 21. *Mulholland Drive: The Road to the Studio*, 1980 (pl. 72)

stand their artistic motivation. When I asked Hockney, he only said, "Come on," and within a minute we were driving up and down Mulholland Drive in the twilight. And lo! those suburbs appeared below the hills with their streetlights repeating precisely the grid patterns of the city maps.

Some lines from Rowley's *Principles of Chinese Painting*, quoted by Hockney at the end of his Guggenheim lecture, describe better than any analysis the experience of *Mulholland Drive* and its moving focus:

> By this device one might travel through miles of landscape, might scale the mountain peaks, or descend into the depth of the valleys, might follow streams to their source or move with the waterfall in its plunge. How wonderfully our apprehension of nature has been expanded, combining in one picture the delights of many places seen in their most significant aspects. Such a design must be a memory picture which the artist created after months of living with nature and absorbing the principles of growth until the elements of landscape were "all in his heart." Then, and then only, could he freely dash off hundreds of miles of river landscape in a single scroll in which the design evolved in time like a musical composition.[32]

NOTES

I wish to thank David Hockney for his willingness to answer my queries, and David Ratray for many helpful suggestions.

1. Quoted in Marco Livingstone, *David Hockney* (New York: Holt, Rinehart, and Winston, 1981), 23.
2. Quoted ibid., 41. The paintings, all 1961, are *Figure in a Flat Style, A Grand Procession of Dignitaries in the Semi-Egyptian Style, Swiss Landscape in a Scenic Style* (retitled 1962 *Flight into Italy—Swiss Landscape*), and *Tea Painting in an Illusionistic Style*.
3. Ibid., 164.
4. Ibid., 163.
5. Esther de Vécsey, in *David Hockney: Sources and Experiments*, exh. cat. (Houston: Sewall Art Gallery, Rice University, 1982), 5 and fig. 2, suggests that the compositional model of this print was Picasso's etching no. 12 from the Vollard Suite, *Two Catalan Men Drinking / Two Artists*, 1934.
6. Livingstone, *Hockney*, 166.
7. David Hockney, *The Blue Guitar* (New York: Petersburg Press, 1977).
8. My reading of the poem has been greatly helped by Vendler's analysis in chapter 5 of her book *On Extended Wings: Wallace Stevens' Longer Poems* (Cambridge, Mass.: Harvard University Press, 1969).
9. André Malraux, *Picasso's Mask*, trans. and annot., June Guicharnaud with Jacques Guicharnaud (New York: Holt, Rinehart, and Winston, 1976), 11.
10. Vendler, *On Extended Wings*, 133.
11. Quoted ibid., 137.
12. Quoted in Dore Ashton, *Picasso on Art: A Selection of Views* (New York: Viking, 1972), 9.
13. Quoted ibid., 82.
14. Vendler, *On Extended Wings*, 129. The lines from which Vendler derives this ingenious interpretation run:

Geographers and philosophers	The sea is a form of ridicule.
	The iceberg settings satirize.
Regard. But for the salty cup,	
But for the icicles on the eaves—	The demon that cannot be himself,
	That tours to shift the shifting scene.

15. David Hockney, *David Hockney by David Hockney*, Nikos Stangos, ed., (New York: Abrams, 1977), 288, 293.
16. Livingstone, *Hockney*, 192.
17. The paintings by Picasso are reproduced in Christian Zervos [*Pablo Picasso*, 33 vols. (Paris: Cahiers d'art, 1932–78)] 8: 247; 5: 374; 2: 134; 7: 287.
18. The derivation of this composition from the two Vollard etchings and *Two Nudes on the Beach* has been noted before by de Vécsey in *Hockney: Sources and Experiments*, 7 and figs. 3–5.
19. Zervos, 8: 331.
20. *Picasso: The Last Years 1963–1973*.
21. This is how Robert Hughes summarized a widespread response, though not his own, in "Picasso, The Last Picture Show," *Time*, 19 March 1984: 76.
22. David Hockney, "Important Paintings of the Sixties," unpublished manuscript of lecture, 1. All quotations from Hockney in the following pages are from this source unless otherwise specified.
23. Zervos, 25: 53–87.
24. Zervos, 15: 173.
25. George Rowley, *Principles of Chinese Painting* (Princeton: Princeton University Press, 1959), 61.
26. Anne Hoy, "Hockney's Photocollages," 55–64.
27. *Vogue*, Paris, December 1985–January 1986.
28. Jean Leymaire, *Picasso: The Artist of the Century* (New York: Viking, 1972), 237.
29. *Hockney by Hockney*, 93, 97.
30. Livingstone, *Hockney*, 240.
31. Zervos, 25: 123.
32. Rowley, *Chinese Painting*, 62–63.

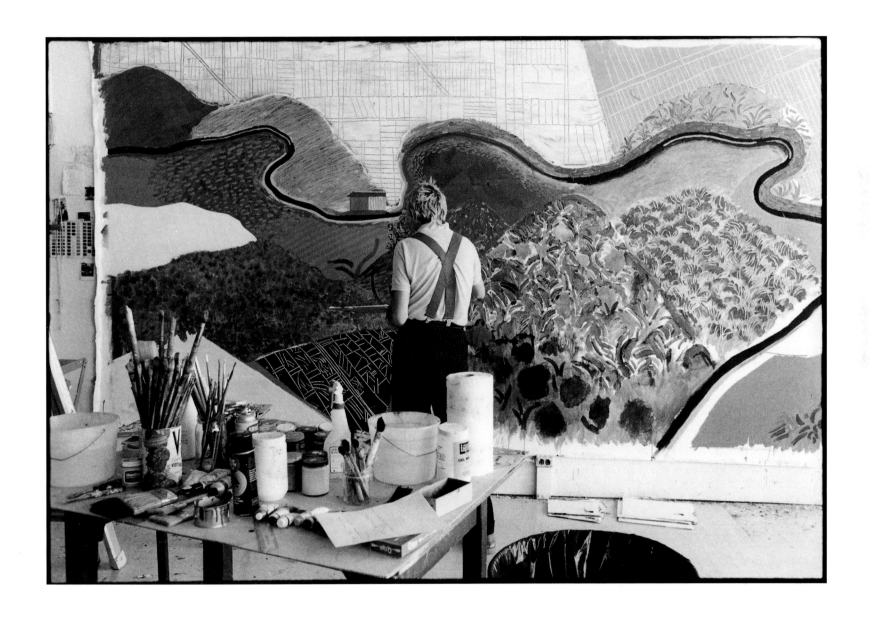

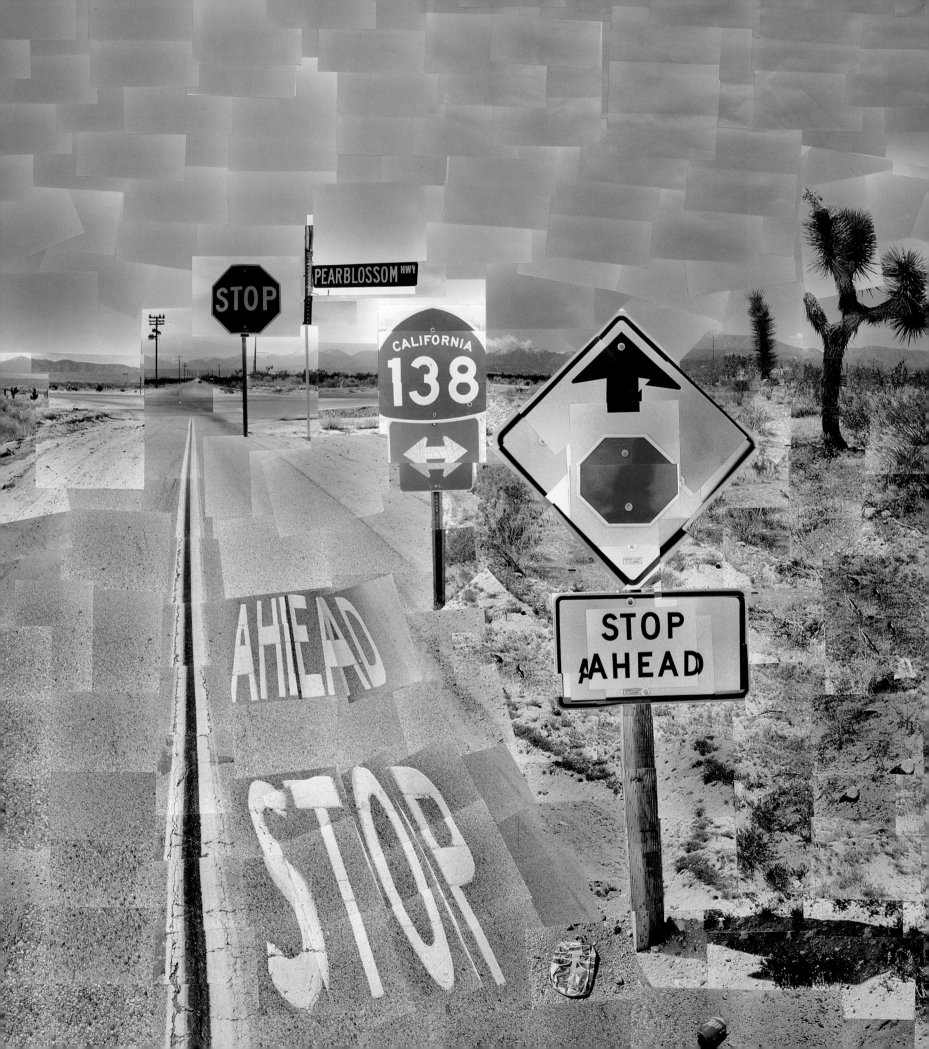

HOCKNEY'S PHOTOCOLLAGES

ANNE HOY

Up to february 1982 David Hockney scorned the camera as nothing more than a recording device. Photographs, even erotic ones, did not hold his attention. "You'd never look at a photo for more than thirty seconds," he said, "unless there were a thousand faces and you were looking for your mother."[1] Though he took "holiday snaps" beginning in 1963 and made photographs as preliminary studies for his paintings from 1968 on, he considered the camera inferior to life drawing as a means of rendering "weight and volume."[2] In his paintings, especially through 1972, he exploited the photograph's intensification of effects of light and the flat, dazzling color of commercial processing but found photography false to perception and to the actual experience of time and space. "Photography is all right," he commented, "if you don't mind looking at the world from the point of view of a paralysed cyclops—for a split second."[3]

But when a visiting curator left some packages of Polaroid film in Hockney's newly decorated house in the Hollywood Hills, he decided to try to represent its three spatial areas. What began on February 26, 1982, with a thirty-print composite (fig. 2) grew into over-life-size, full-length Polaroid portraits of his friends, then into vast photocollages of famous American scenery and complex portrait narratives made from 35mm prints, and climaxed five years later in a panoramic Western landscape composed of more than six hundred prints. Between March and May 1982 Hockney devoted himself to photography with the excitement and absorption that typify his explorations of media new to him. He made more than 140 Polaroid collages. Then, from September 1982 to August 1986, he produced 231 photocollages with Pentax 110 single-lens reflex and 35mm Nikon cameras. He considers *Pearblossom Hwy., 11–18th April 1986* (1986, figs. 1 and 19) the culmination of his photographic experiments. He has made no large-scale photocollages since.

In their sheer number and monumental elaboration Hockney's photocollages are a major body of work within his career. Of a piece with his paintings, drawings, and prints, his camera art is sunny in spirit, personal, even diaristic, in subject matter, and experimental and spontaneous in technique. Here are his characteristic motifs: pools, chairs, windows, travel scenes, double portraits. (His evolution from camera to canvas to photocollage is both circular and progressive. In *Christopher Isherwood Talking to Bob Holman* [1983, fig. 3], for example, Hockney returns to the place and people he painted in 1968 in *Christopher Isherwood and Don Bachardy* [fig. 4], a work based on photographic studies.) In his photocollages, as in his other work, Hockney explores lines and edges; he called his first exhibition of photocollages *Drawing with the Camera.* He also employs photography as a reproductive tool, like etching, lithography, or most recently the office photocopier, but exploits its special features. In taking thousands of photographs, most with popular equipment, and processing his film in Fotomat-type stores, he enjoys the cheap, fast, and easy replication of amateur photography and the cheerful artifice of its hues. His photocollages are accessible in content and means. Indeed Hockney welcomes the recent imitations of 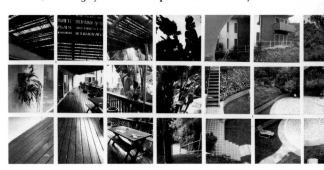 them in American magazine advertisements and French tourist promotions. To him these replicas forecast the "revolution in seeing" he hopes his camera art will foster.

The revolution Hockney seeks is through Modernism. In this

Fig. 1. *Pearblossom Hwy., 11–18th April 1986* (detail), 1986

Fig. 2. *My House Montcalm Avenue Los Angeles Friday February 26th 1982* (detail), 1982, composite Polaroid, 11 x 34 in. (27.9 x 86.4 cm), David Hockney

55

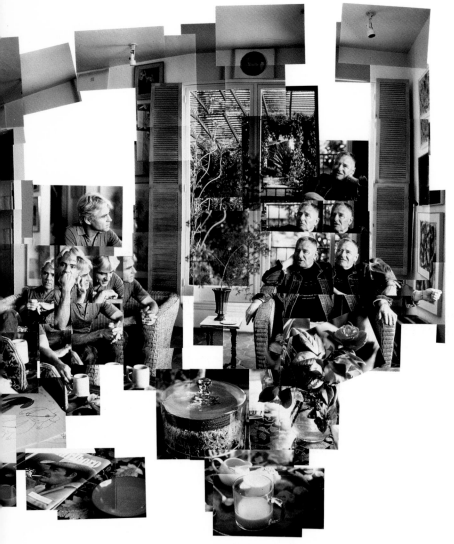

Fig. 3. *Christopher Isherwood Talking to Bob Holman* (detail), 1983 (pl. 88)

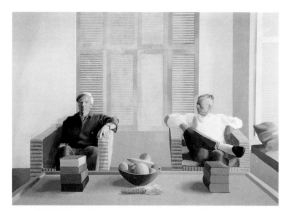

Fig. 4. *Christopher Isherwood and Don Bachardy*, 1968 (in color, p. 36)

regard his photocollages define issues latent in his previous work and give them unique, spectacular resolution. "In a way Modernist art hasn't triumphed yet!" Hockney remarks. "Because we're still stuck with the Renaissance picture—which is the photograph—and we believe it's the most vivid representation of reality."[4] Conventional painting and photography, which ratify one-point perspective, create, not greater realism, but greater distance between spectator and subject, he believes. And with ordinary photographs the viewer lacks the compensation of handwork offered even by perspectival painting, the verisimilitude gained, Hockney says, as "the hand moving through time reflects the eye moving through time (and life moving through time)."[5]

To circumvent these limitations, Hockney turned to Modernist collaging of many photographs. As early as 1970 he had taken photographs sequentially and pasted them down edge to edge as a means of recording more information in architectural studies but without the distortion of a wide-angle lens.[6] He called these works "joiners." Eventually he realized "that if you put six pictures together, you look at them six times. This is more what it's like to look at someone."[7] He notes that the gaze moves perpetually, that visual experience is a composite of shifting views focused by interest and inflected by concept and memory. Sensations of depth and movement are intrinsic to eyesight, he observes, upholding the definition of perception known since Impressionism and seen in Cubism. While a single photograph can encapsulate only a frozen moment—Hockney calls such pictures "one-eyed"[8]—a collage of them suggests the composite experience of observation over time.

Hockney was not the first to make collages of Polaroid SX-70 prints. (In fact, primacy in any of his technical investigations does not concern him.) The Belgian artist Stefan de Jaeger composed still lifes in grids, and the American Joyce Neimanas made thirty imaginative portraits in Polaroid collages between 1980 and 1985. In the 1970s other photographers, such as Lew Thomas, butted several photographs together, as in Hockney's joiners, to create enlarged spaces in interiors and landscapes, while such Conceptualists as Jan Dibbets sequenced color prints in deadpan demonstrations of scientific coordinates like measurements of natural phenomena at regular intervals. While the collages of each of these artists tested or broke the rectangle of the conventional photograph and augmented its depiction of depth, none at-

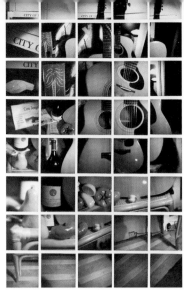

Fig. 5. *Yellow Guitar Still Life, Los Angeles, April 3, 1982*, 1982, composite Polaroid, 28½ x 17½ in. (72.4 x 44.5 cm), David Hockney (in color, p. 34)

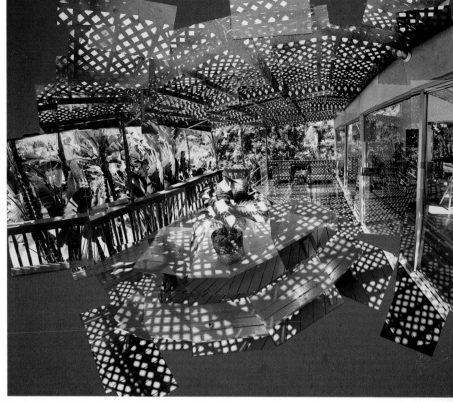

Fig. 6. *Terrace with Shadows, 1985*, 1985, photographic collage, 19 x 28 in. (48.3 x 71.1 cm), David Hockney

tempted to render the flicker and scanning of binocular vision. This goal impels Hockney's exploration of photography and links his camera art with Cubism, as he points out.

His photocollages add "Cubist effects to photography," Hockney says, and the effects range from witty art-historical references to ambitious extensions of Synthetic Cubist drawing, perspective, and collage. He mixes homage and parody here (as in many of his works), demonstrating the freedom he feels to assume styles according to his subject and mood and his delight in layering allusions to high art upon observations of actuality. Picasso, his mentor and "model," appears in various guises in his photocollages.[9] In *The Desk, July 1st, 1984* (1984, fig. 7), Picasso's *Guitar*, a collage made in Céret in 1913, is identifiable in an open book, which cohabits with Cosima Wagner's diaries and, whimsically, a box of large dog biscuits.[10] In *The Paint Trolley* (1984) the cart carries a late volume of the Christian Zervos catalogue raisonné of Picasso's works (Hockney owns the enormous set). And *Terrace with Shadows, 1985* (1985, fig. 6) vibrates with fractured sunlight, an effect informed by Hockney's appreciation of the harlequin diamonds of Picasso's Synthetic Cubism of 1914–18.

More thoroughly referential, some still lifes in Polaroid collages of April 1982 recast Cubist collages in Californian terms. In *Yellow Guitar Still Life, Los Angeles, April 3, 1982* (1982, fig. 5), for example, a guitar on a caned chair seat shares space with a bottle of Mondavi wine, a copy of the *Los Angeles Times*, and artificial fruit while displaying its sound hole from different angles. Hockney's technique—instant photography—and local, topical iconography spoof the solemnity that has now accrued to Cubism as well as underlining the earthy, commonplace subjects and means of Cubist collage, its original celebration of popular culture and private pleasures.

In *Nude 17th June 1984* (1984, fig. 9) Hockney's parody is even

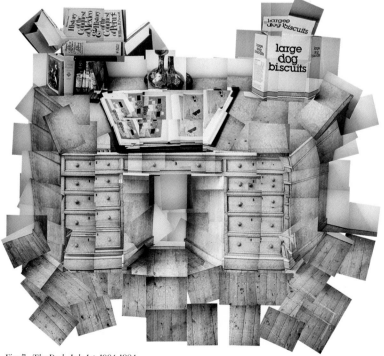

Fig. 7. *The Desk, July 1st, 1984*, 1984

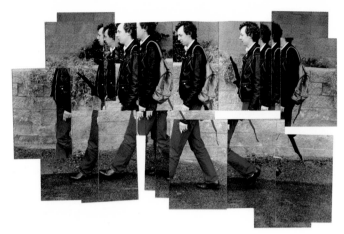

Fig. 8. *Gregory Walking, Venice, California, Feb. 1983*, 1983, photographic collage, 12 x 23 in. (30.5 x 58.4 cm), David Hockney

wider, for he twists mass and museum art together. The subject, unique in his work, originated with a request from a friend, the film director Nicholas Roeg, to photograph his wife, Teresa Russell, in Marilyn Monroe–calendar style for his film *Insignificance*. The pink satin sheets and the actress's pose, obvious wig, and flicking tongue mock pinup conventions. At the same time Hockney's photocollage succeeds at what girlie pictures and great Western paintings of Venus often seek and fail to do: it shows the nude's front and rear simultaneously. It thus adds a footnote to Cubism and to the *Paragone*, the age-old competition between artists for the supremacy of their media. In the Renaissance, sculptors claimed superiority over painters because a single work could depict a beauty's buttocks and breasts. With Cubism, by contrast, Picasso could combine all the erotic zones on a single picture surface. Here Hockney manages the feat with photographs; his model has not moved (except for one foot), but his eyes, mind, and camera have.

"It's our movement that that tells us we're alive," Hockney says. This conviction has sharpened his use of diverse perspective means throughout his career, for they support or counteract the inherent stasis of the picture and thus sharpen our awareness of its illusionism.[11] The conviction also underlies his conception of his photocollages as a whole. In planning an exhibition of them at the International Center of Photography in New York in the fall of 1986, he suggested they be grouped according to their depiction of movement: the subject moving, the artist's moving glance, the artist and subject moving, the artist moving. Though the four categories overlap, of course, and do not emerge in this order in the development of his photography, they help define Hockney's accomplishment with the camera and collage.

The Subject Moving

In the tradition of attempts to represent continuous physical movement in a single picture, Hockney photographed a spinning skater in New York's Central Park in December 1982 and his friend Gregory Evans walking in February 1983 (fig. 8). Tracking familiar movements in one plane like his predecessors in motion photography, Etienne-Jules Marey, Anton Bragaglia, and Dr. Harold Edgerton, Hockney uses collage rather than their stop-

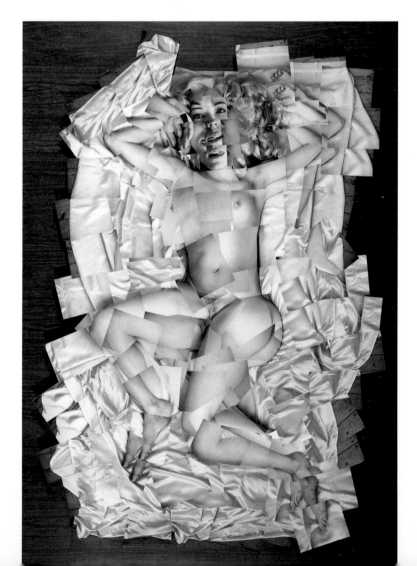

Fig. 9. *Nude 17th June 1984*, 1984, photographic collage, 71¼ x 48¾ in. (181 x 123.8 cm), David Hockney

action multiple exposures to analyze the action. His results with the skater confirmed his awareness that blurs of motion are not phenomena of vision but conventions of photography; his photocollage implicitly criticizes the fuzziness of Marey's Chronophotographs and later scientific studies. The repetition of legs in *Gregory Walking, Venice, California, Feb. 1983* has a mechanistic humor like that of Giacomo Balla's famous Futurist painting, *Dog on a Leash*. But these notations did not sustain Hockney's interest, and such photocollages are few. It was not enough for him to render the nature and duration of a simple physical activity in a static flat medium.

Typically movement interests Hockney as it reveals character or challenges commonplaces of pictorial representation. Both traits of movement are addressed in his photocollage portraiture. As in traditional portraits Hockney's subjects generally sit, in their homes or the artist's studio. But collage obviates the traditional need to distill a characteristic expression and pose into a single image. Collage documents individual fleeting movements of face, hands, and body, then permits a synthesis through choice and juxtaposition of individual prints. The viewer can reconstruct the interaction between subject and artist and in double and group portraits, among the subjects themselves. The square, gridded portrait, for example, of the photographer Bill Brandt and his wife, Noya (1982, fig. 10), reveals their reactions to Hockney's process of Polaroid portraiture.[12] Poses and gestures illuminate their characters; this is a marriage portrait that also records an interaction between artists.

In *The Crossword Puzzle Minneapolis Jan. 1983* (1983, fig. 11) characterization and form are even richer as Hockney portrays the museum director Martin Friedman and his wife, the curator-editor Mildred Friedman, in a collaboration suggesting aspects of their domestic and professional relationship. (That a trivial pursuit can be so revelatory typifies the sharpness and offhand charm of Hockney's observations.) Without the insistent mullions of the Polaroid collages, this composite shows the greater flexibility of collaging with 35mm prints. Hockney maintains the architectonic structure, the sense of vertical and horizontal, characteristic of his Polaroid collages (and of Analytic Cubism), but he overlaps individual prints, multiplying and clustering them according to the degrees of interest of their subjects. Twelve prints portray Mildred Friedman's face, for instance, as she finds a

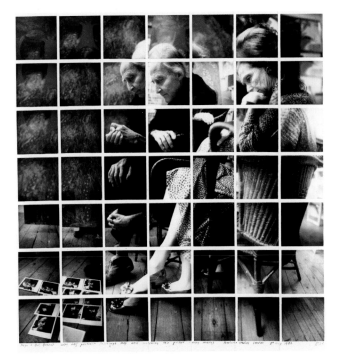

Fig. 10. *Noya + Bill Brandt with Self Portrait (Although They Were Watching This Picture Being Made) Pembroke Studios London 8th May 1982*, 1982

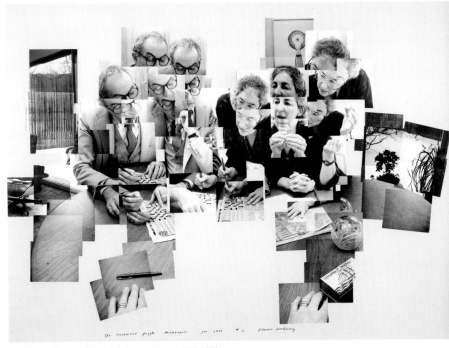

Fig. 11. *The Crossword Puzzle Minneapolis Jan. 1983*, 1983

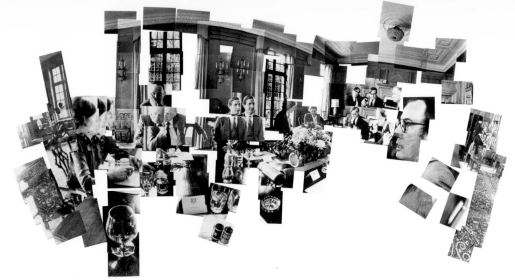

Fig. 12. *Luncheon at the British Embassy Tokyo Feb 16th 1983*, 1983 (pl. 89)

word; the hands of the couple, and Hockney's repeated left hand, form a sign language like the puzzle clues and the photographs themselves within the intellectual configuration of the game and the composite. In showing his hand, Hockney offers a metaphor for the handwork of collage. The whole draws attention to the picture surface and to Hockney's greater technical ease with the 35mm camera. Whereas he made and assembled the Polaroid prints in a single sitting to be sure he had covered all needed details, with a single-lens reflex camera he could click off rolls of film on the spot, then print selected frames and compose them later.

Such a complex composition as *Luncheon at the British Embassy Tokyo Feb 16th 1983* (fig. 12) depends on Hockney's use of 35mm photography. For his Polaroid collages he had to take all details close up (because the Polaroid lens does not do an accurate job at a distance), then assemble them coherently, as if from a single vantage point, as if he had not moved. The detailed prints in both kinds of collages acknowledge that what the questing eye sees is always in focus, but with the more agile lens of SLR cameras Hockney could actually sit still while he scanned and recorded the elements in this large room.

The rolls of film beside Hockney's place card locate him at the ambassador's table and amusingly demystify his process. In other works Hockney depicts his feet, establishing the ground plane, or includes his shadow in the manner of Eugène Atget and Lee Friedlander, two photographers he admires. All this helps to break down the wall in conventional art between the viewer and the view. One's sense of space and place expand in several ways; in *Luncheon at the British Embassy* one joins the privileged, civilized circle in this group portrait and witnesses a comedy of manners as nuanced in social observation as the best of eighteenth-century English conversation pieces.

The Artist's Moving Glance
If *Luncheon at the British Embassy* represents Hockney's glance from one end of the room to the other, his landscapes of Yosemite (*Merced River Yosemite Valley California Sept 1982*, 1982, fig. 13) and the Grand Canyon of September 1982 dramatize the enlargement of spatial definition possible with this panning movement. Their subject is not just celebrated scenery; they are concerned with the depiction of depth and the comparative merits of eyesight and lens optics. In a photocollage such as *The Grand Canyon Looking North, September 1982* (fig. 15) Hockney overcomes the limited field of vision of conventional lenses, their inferiority to binocular vision, which can grasp about 120 degrees without moving and 360 degrees if the head is turned left to right. While the chain-link fence at left marks Hockney's vantage point, the arc of the composition replicates the sweep of his gaze from a stationary position and the curvature of the perimeter of the Grand

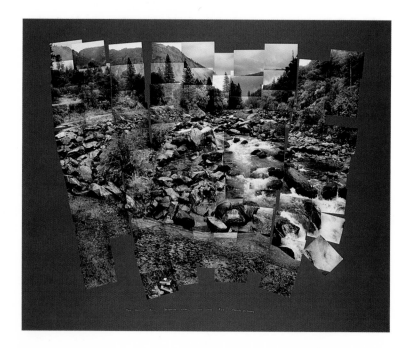

Fig. 13. *Merced River Yosemite Valley California Sept 1982*, 1982, photographic collage, 52 x 61 in. (131.1 x 154.9 cm), David Hockney

Canyon. Eight feet wide, the photocollage fills the field of vision of a viewer standing close enough to discern the separate prints. One is simultaneously aware of the vast depth depicted and the physical form of its depiction, of the diagonals into distance of rock faces and riverbed and the stair-step edges of the bottom of the collage.

With simpler, more familiar forms, Hockney's transformation is more obvious. The *Paint Trolley, Desk,* and *Chair, Jardin de Luxembourg, Paris 10th August 1985* (1985, fig. 14) are almost textbook demonstrations of reverse perspective, like the platform in the foreground of Hockney's *Kerby (after Hogarth) Useful Knowledge* (1975, illustrated p. 20). All three photocollages appeared in the December 1985–January 1986 issue of French *Vogue,* in which the artist was given forty-one pages to design. He took the opportunity to describe and illustrate his perspective theories, which have heightened significance for him since he believes that ways of representing the world reflect philosophic world views and that a change in art—restoring the spectator to a sense of wholeness and activity within pictorial space—can lead to changes in the Zeitgeist. The West used gunpowder and one-point perspective to fire cannons, he points out, whereas the Chinese, who lacked this perspective system, used their gunpowder for fireworks to illuminate the immeasurable night sky.

In the works reproduced in French *Vogue,* the orthogonals of the cubic objects converge on the viewer, not in infinity. "Reverse perspective is about *you*," Hockney says. In seeing both sides of the

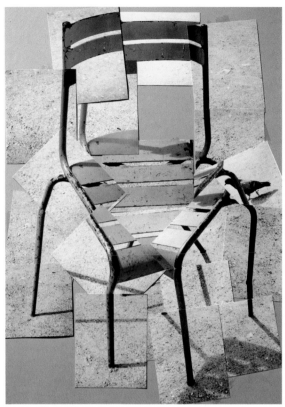

Fig. 14. *Chair, Jardin de Luxembourg, Paris 10th August 1985,* 1985

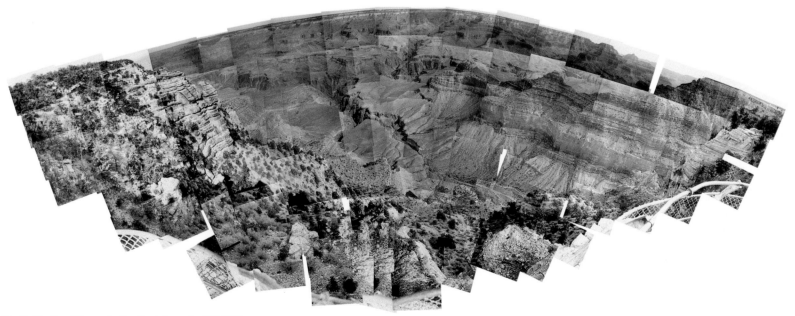

Fig. 15. *The Grand Canyon Looking North, September 1982,* 1982

desk, for example, "you're seeing yourself move—you're seeing your own memory."[13] The references to Picasso in the photocollages underline the fact that their tilted surfaces and apparent projection into the viewer's space link them with Cubism. Hockney stresses the heightened realism possible with these Cubist (and Cézannesque) devices.

The Artist and Subject Moving
On holiday in Hawaii in May 1983 Hockney's friends David Graves and Ann Upton decided to get married, and so Hockney became a wedding photographer. But like no one else. In *The Wedding of David and Ann in Hawaii 20 May 1983* (fig. 17) he attempted to put a saga of movie-romance proportions into a single work. In this wall-size, zigzag triptych the wedding party is ferried to the exotic island ceremony with musicians and minister; they climb to the chapel grotto; Ann and David are married with many views of the kiss and a closeup of the ring. The story is seriocomic and sweet; the action combines aspects of cinema with the variable focus and continuous narrative of Chinese scrolls and medieval painting, in which figures recurring in an extended landscape represent the heroes at successive moments in an unfolding adventure. But apart from *Fredda Bringing Ann and Me a Cup of Tea Los Angeles April 1983* (fig. 16), *The Wedding of David and Ann* and *Photographing Annie Leibovitz While She Photographs Me, Mohave Desert Calif. Feb. 1983* contain the only such analysis of figures in narrative action in Hockney's photocollages. He does not aspire to imitate film or video.

Though Hockney uses cinematic devices in his photocollages —montage, jump cuts, sequences created like pans and dolly shots—he seeks to transcend the restrictions of cinema, which has a relentless movement forward and an almost universal linearity of plot. In these two and all his photocollages, to the contrary, the eye can move from left to right and front to back or vice versa (though one direction is favored) as in oriental landscape paintings or medieval panels. One follows the story and progressive exposure of character and space but at one's own pace.

Yet Hockney is eager to express his own sense of time

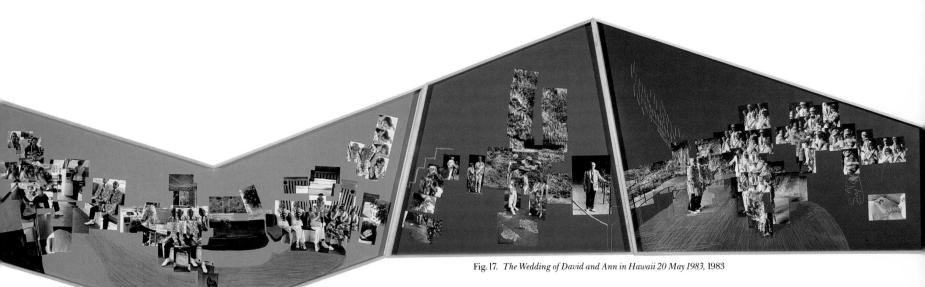

Fig. 17. *The Wedding of David and Ann in Hawaii 20 May 1983*, 1983

through representation of his optical and actual movement. This position is supported by his reading of Henri Bergson and Marcel Proust, one of the significant early twentieth-century novelists influenced by the philosopher. Matter, according to Bergson, is in constant movement, a condition one understands by intuitive grasp of time passing and by subjective experience of one's own physical acts. This is not conventional time, time divisible by clock measurement, but indivisible time or duration. The model of movement captured by cinema, which depends on mechanically analyzed or divided time, offers no guide to the nature of reality. According to the artists who interpreted Bergson, this reality can be conveyed instead by a synthetic view of subjective experience, by the artist's projection of self-awareness onto the external world.[14] Hockney defines the self, the artwork, and the world it represents as sensuous and celebratory. The concreteness and affirmation of this position make it readily understandable and sympathetic. Hockney seeks to convince the viewer of his Bergsonian sense of reality by bringing him into his psychological and physical space; the spectator often stands in his shoes.

The Artist Moving

The most satisfying of Hockney's photocollages depict time in their narrative and encapsulate it in their fabrication. They convey, Hockney hopes, "lived time." Time passing is most easily conveyed by movement through space. With photographs taken

in Japan in February 1983, Hockney first tried to render his physical as well as optical penetration of space.

Walking in the Zen Garden at the Ryoanji Temple Kyoto Feb 21st 1983 (1983) is the eponymous subject of fig. 18. Hockney defines the bottom edge of the garden (and of the collage) with a trail of his "footprints," which resemble Japanese heraldry. His trade-

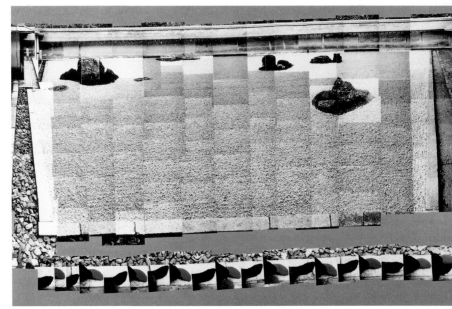

Fig. 18. *Walking in the Zen Garden at the Ryoanji Temple Kyoto Feb 21st 1983*, 1983 (pl. 107)

Fig. 16. *Fredda Bringing Ann and Me a Cup of Tea Los Angeles April 1983* (detail), 1983, photographic collage, 59 x 68 in. (149.9 x 172.7 cm), David Hockney

mark mismatched socks measure off the boundary and mark each standpoint from which he photographed the site. The garden is a rectangle, as if seen from above; the boulders are in profile, seen from ground level. Hockney's blended perspectives show not only what he sees and what he knows but how he knows it: by walking by. Though the picture is rectangular, it is not a view onto Western space but a Modernist object successfully representing an oriental place.

Pearblossom Hwy., 11–18th April 1986 (fig. 19) signifies to Hockney the final development of his photocollages and a combination of photography, painting, and collage.[15] Here he expresses his experience of driving across the California desert through a fusion of the perspective means he had employed before. The picture illustrates Western one-point perspective: the road vanishes into the crossroads and mountain range bisecting the collage. But by showing other perspectives, Hockney insists that this one has no privilege; it is simply the driver's choice, while the passenger may gaze elsewhere: at the litter along the road, for example. Space is wider than possible with any kind of camera (compare the single photograph of this scene that Hockney shows in lectures, illustrated p. 97). Road signs are undistorted shapes that barely diminish in size with distance. Photographed head-on from a ladder, they represent the mental tendency to "correct" distortions of vision; their compression in space represents the ellipsis of perceptions registered at high speed. Hockney shows no car but re-creates the modern (and especially American) sensation of "getting there," of speeding through a flat land.[16] *Pearblossom Hwy.* unites the Cubists' shifting vantage points with the Futurists' subject of high velocity, the continuous narrative construction of Chinese scrolls, the surface enrichments and additive methods of collage, and the documentary detail and swift execution of photography. The work is both Modernist and vividly representational. Hockney uses his kind of photocollage as a Realist, to sharpen the sensations of actuality in his art. He directs attention outward to the world and heightened perception of it. In this his art is most humanist. For beyond the blandishments of his subjects of Mediterranean *luxe, calme, et volupté,* he encourages awareness of sight and delight in its process.

NOTES

1. David Hockney, interview with Lawrence Weschler, 3 September 1984, reel 7, Archives of American Art.

2. Marco Livingstone, *David Hockney* (New York: Holt, Rinehart, and Winston, 1981), 88.

3. Quoted in Lawrence Weschler, *Cameraworks* (New York: Knopf, 1984), 9. In his essay, "True to Life" (pp. 6–41), Weschler details the genesis and development of Hockney's photocollages through May 1983.

4. Quoted in Marco Livingstone, "A Life in Portraits," in *David Hockney: Faces 1966–1984,* exh. cat. (Los Angeles: Laband Art Gallery, Loyola Marymount University, 1987), not paginated.

5. David Hockney, conversation with the author, 27 June 1986, at the artist's house in Los Angeles. Remarks by Hockney that follow without footnotes were made in conversations with the author 27–29 June 1986 at the artist's house, 4 September 1986 on the telephone, and 14 December 1986 again at the artist's house.

6. Livingstone, *David Hockney,* 145.

7. Hockney, interview with Weschler, reel 1.

8. Mark Haworth-Booth, introduction, *Hockney's Photographs,* exh. cat. (London: Arts Council of Great Britain, Hayward Gallery, 1983), 6.

9. See Gert Schiff's commentary in this volume, "A Moving Focus: Hockney's Dialogue with Picasso," 41–52.

10. Owning no dog at the time, Hockney bought the box for its big lettering—"like the Cubists' Bass" beer (Hockney, interview with Weschler, reel 6)—and took it from Los Angeles to London, where he made this photocollage. Despite Hockney's deliberate decorating of the desk, the piece of furniture looks naturally used, as redolent of human presence as van Gogh's chair was of him.

11. He also makes perspective function satirically, enriching the content of his works while drawing attention to their pictorial mechanics. The couple in *The Second Marriage* are enclosed in a box of isometric perspective in keeping with the Egyptian inspiration for the figures. In *Henry Geldzahler and Christopher Scott* (1969) one-point perspective and symmetrical composition give Geldzahler the solemn, iconic stillness of God the Father in a Flemish altarpiece with donor. In *Contre-jour in the French Style—Against the day dans le style français* (1974) the same devices comment on French building and garden design and establish the literal centrality of light to this work.

12. The two were observing their own portrait coming into being but asked Hockney to enter the picture. He obligingly took some self-portraits, laid them at the Brandts' feet, photographed them there, and substituted these prints in the final composite. See Weschler, *Cameraworks,* 15.

13. Hockney, interview with Weschler, reel 7.

14. See Brian Petrie, "Boccioni and Bergson," *Burlington* 116 (March 1974): 141.

15. Hockney executed the prints for the first version of *Pearblossom Hwy.* between April 11 and 18, 1986, taking them on the spot in the morning, having them processed, and then assembling them in the afternoon. In July he decided to make a second, larger version of the collage especially for the International Center of Photography exhibition. This composition shows a wider view of the crossroads on the highway from Los Angeles to Las Vegas, and the sky is more elaborate, painterly, and "holiday blue"—as Hockney terms the commercial color enhancement. The whole measures more than nine feet across and has a typical Hockney misspelling in *Ahead.*

16. *Pearblossom Hwy.* was generated in response to a commission from *Vanity Fair* to illustrate an article by a friend, Gregor von Rezzori, retracing Humbert Humbert's travels across the West in search of Lolita. Hockney intended that illustrations of his photocollages, including a gas pump and identical rooms in the Palmdale Motel, would culminate in *Pearblossom Hwy.,* which would fold out like a road map. The work unfortunately was never used.

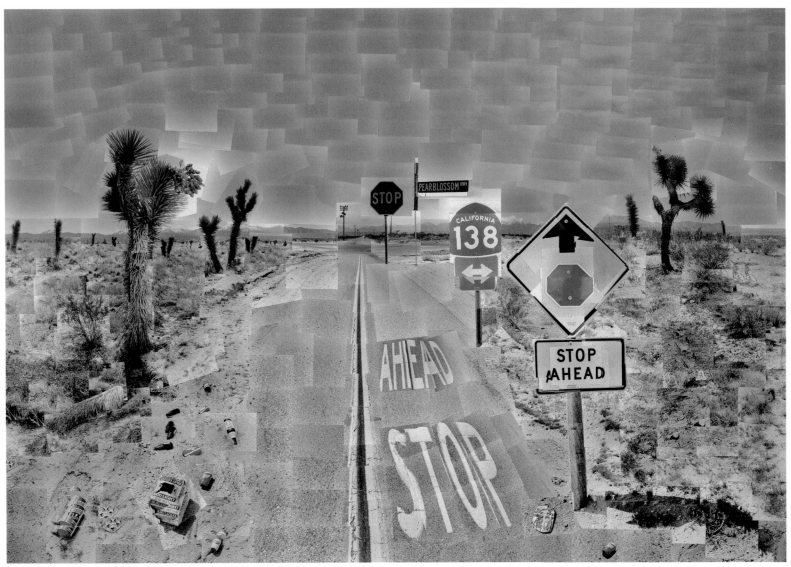

Fig. 19. *Pearblossom Hwy., 11–18th April 1986*, 1986

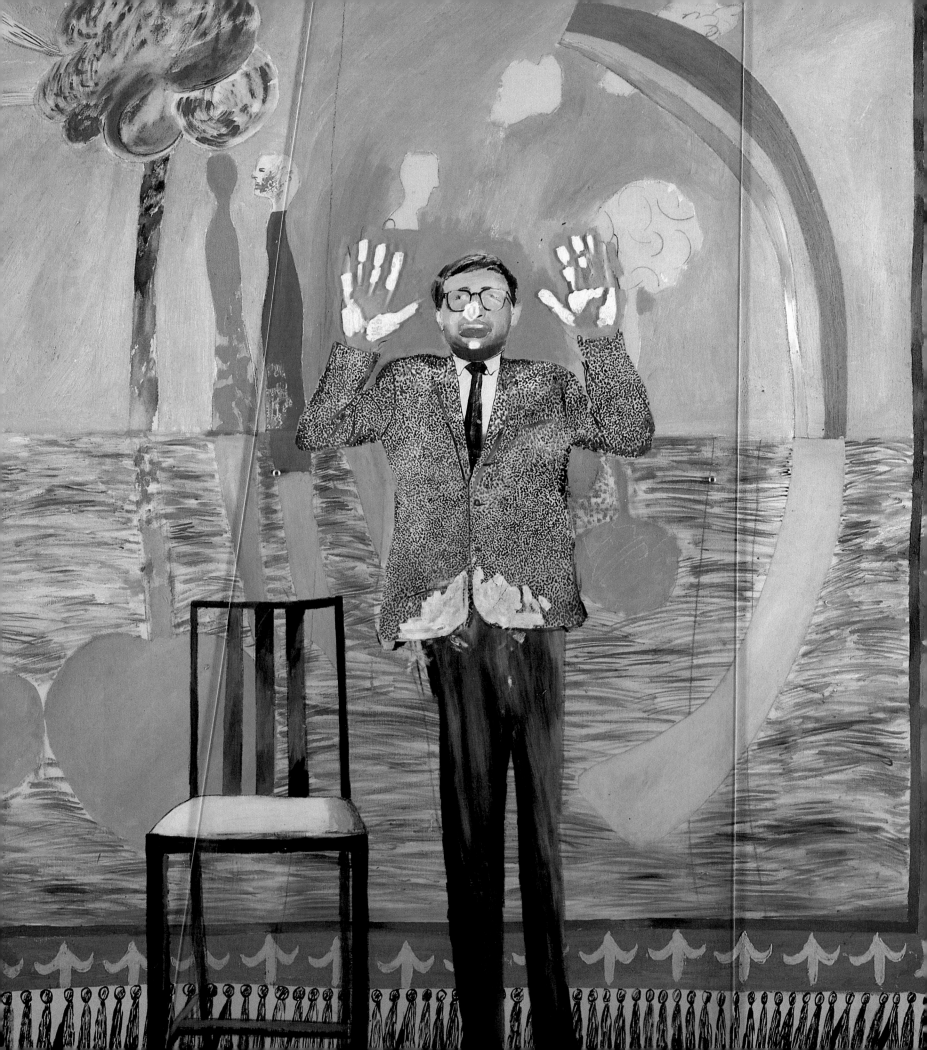

HOCKNEY ON STAGE

KENNETH E. SILVER

WHEN IN 1975 David Hockney created his first opera design—for Igor Stravinsky's *The Rake's Progress,* directed by John Cox at Glyndebourne, England—no one could have predicted, not even the artist himself, the kind of influence that theater would exert on his art in the following years. I think it is no exaggeration to say that Hockney's work for the stage has brought about a revolution in his aesthetic (if one understands the term *revolution* in Vico's sense of both a dynamic change and a return to first principles). Every sphere of his activity, from paintings to photocollages and prints, has been transformed by what he has done and what he had learned in the theater. Indeed it is the very shape of his aesthetic—in both a literal and a figurative sense, as I hope to show—which Hockney has been redrawing since that summer at Glyndebourne.

Not that anyone should have been or was surprised by Hockney's entry into the theater. In point of fact it was not his first time out as a designer of sets and costumes; in 1966 he did both for a production of Alfred Jarry's *Ubu Roi* at the Royal Court Theatre in London. Besides Hockney had studied Shakespeare's plays in school and so was at home with both the form and content of theater. We have only to look, as Martin Friedman has done so thoroughly, at the first decade of Hockney's career as a painter in order to recognize the fascination that theater held for the artist from the start.[1] In works like *Closing Scene, Play within a Play* (fig. 1), and *Seated Woman Drinking Tea, Being Served by a Standing Companion,* all of 1963, we find the stage and/or theater curtain invoked as metaphor for the illusion of three dimensions that artists since the Renaissance have projected onto the two dimensions of the canvas or wall.

Moreover, as he began to sense while struggling to paint the double portrait of George Lawson and Wayne Sleep (1972–75), Hockney had arrived at a kind of impasse in his painting by the

time Cox approached him about *The Rake's Progress.* So meticulously illusionistic had his art become—and we should not forget that this was the moment of Super Realism's popularity—that he sought, as he himself has said, a "release from naturalism."[2] To be sure, the search for egress from an aesthetic cul-de-sac must have functioned as no more than background to the immediate release that the opera commission represented, to wit, a chance to leave the studio and its lonely (and at the moment, frustrating) problems in order to work collectively (especially appealing in the light of Hockney's great love for and knowledge of music). *The Rake's Progress* is an eclectic and unusual combination of elements likely to bring about interesting results: an eighteenth-century English tale—originally told in pictures by Hogarth—set to music by Stravinsky, a twentieth-century Russian.

Hockney's production of *The Rake's Progress* was—and is, for it is still performed by the New York City Opera—a great success. The visual conceit is that of Hogarth's engravings reinterpreted and brought to three-dimensional life by Hockney (fig. 2). As is well known, Hockney depicts the opera by means of colossally rendered cross-hatching, so that everything in the production, including the costumes, is made up of a white ground scored with black, red, blue, or green lines (the colors of eighteenth-century printer's inks). The order and severity of the ubiquitous "etched" network is a brilliant interpretation of Stravinsky's combination of twentieth-century modernism and eighteenth-century classical reference, as the choice to "collapse" this three-dimensional world of parable into a mock-two-dimensional representation is a breathtaking simulacrum

Fig. 1. *Play within a Play* (detail), 1963 (complete image p. 96)

of Stravinsky's—and Hockney's—aesthetic and historical distance from Hogarth's eighteenth-century morality.

Yet if Hockney's design for *The Rake's Progress* is remarkably sensitive both to Hogarth and to Stravinsky, the artist nonetheless managed to give the public an identifiably Hockneyesque production and at the same time to provide himself with what must have been a satisfyingly autobiographical subtext, for not only had Hockney twelve years earlier created A Rake's Progress of his own, a series of etching-and-aquatint prints loosely based on his travels to America, but almost from his very start as an artist Hockney had been a printmaker. There are several lithographs that date from his seventeenth year, including a self-portrait,[3] and a bit later, from the time of his first mature works, after 1961, he regularly made etchings.

Perhaps because of its safe distance from painting (for Hockney is first and foremost a painter), the stage from this initial Glyndebourne experience forward began to function as, at one and the same time, an arena in which to struggle with important aesthetic issues and as a promontory from which both

to look back over his own artistic past and to assess the vast terrain of art history. Thus, if Hockney's *Rake* designs are a meditation upon the medium of the print, his next production at Glyndebourne, in 1978, *The Magic Flute* (with John Cox again as director), is about painting, and specifically about the birth of one-point perspective as it evolved in fourteenth- and fifteenth-century Italy. The visual references are on the one hand to Giotto, Duccio, and Paolo Uccello (the craggy outcropping and fantastic animals, fig. 5) and on the other to an amalgam of *faux*-Egyptian architecture and French garden design (fig. 4). Hockney, who considered the central theme of *The Magic Flute* to be the "progression from chaos to order,"[4] had also sensed, I think, that the development of one-point perspective was the visual correlative of a desire for temporal and spiritual hierarchy, quite literally a manner of organizing the world in the service of centralized power, earthly and divine. Thus, the interiors of Sarastro's palace look alternately like a Theban tomb, the Grand Stairway at the Metropolitan Museum, and an art deco movie auditorium (fig. 3); his gardens are a cross between Giza and Versailles. Interestingly, Hockney's first two operas recapitulate important aspects of the progression of his artistic persona up to that point: from English to cosmopolitan, from the frankly two-dimensional to the illusionistically volumetric.

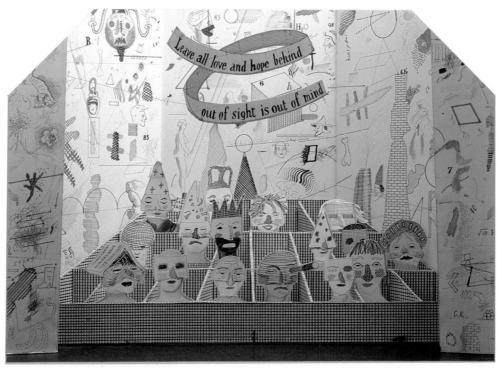

Fig. 2. *Bedlam,* model for *The Rake's Progress,* 1975, 16 x 21 x 12 in. (40.6 x 53.3 x 30.5 cm), Walker Art Center

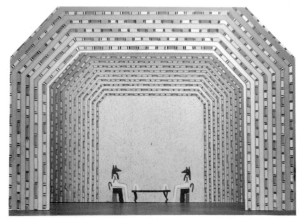

Fig. 3. *A Room in Sarastro's Palace,* model for *The Magic Flute,* 1977, 16 x 21¼ x 12¼ in. (40.6 x 54 x 31.1 cm), Walker Art Center

It was another three years before Hockney designed again for the stage, but that year, 1981, was truly his theatrical *annus mirabilis:* he created two full evenings of opera and dance for the Metropolitan Opera, comprising six works in all. Both programs were heavily involved with heroic figures of the early twentieth-century avant-garde: the first was an evening of three French works collectively entitled *Parade*; the second consisted of three works by Stravinsky: *Le Sacre du printemps, Le Rossignol,* and *Oedipus Rex. Parade* premiered in February, with John Dexter as director and Manuel Rosenthal as conductor. It consisted of Jean Cocteau's short ballet of 1917, *Parade,* set to music by Erik Satie; Francis Poulenc's short comic opera, *Les Mamelles de Tirésias,* of 1947, based on Guillaume Apollinaire's play of 1917; and Maurice Ravel's *L'Enfant et les sortilèges,* also a one-act opera, of 1925, based on Colette's story of 1916. A veritable *Almanach de Gotha* of the Parisian avant-garde of the early years of the century (Picasso, of course, had designed the first *Parade,* choreographed by Leonide Massine and produced by Sergei Diaghilev; George Balanchine had choreographed the original *L'Enfant*), the evening was David Hockney's chance to show us what he had been thinking about French Modernism. Although his treatments of both Stravinsky/Hogarth and Mozart were unquestionably Modern (even Post-Modern in their ironic refraction of older styles and themes), now it was a matter of confronting the masters of the Modern idiom on their own turf and head on.

Again Hockney's reading of art history and of his own history are made to coincide and become mutually enriching: if his production of *The Rake's Progress* is about printmaking (and therefore about line) and *The Magic Flute* about painting (color and volume), then the French triple bill is about collage. Collage is perhaps the most powerful twentieth-century form for the expression of our modern sense of alienation and freedom, of

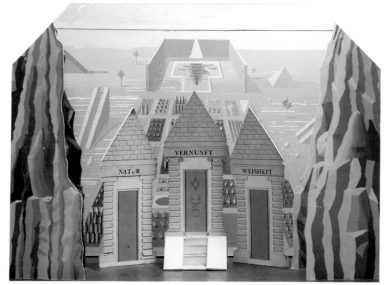

Fig. 4. *Grove with Three Temples,* model for *The Magic Flute,* 1977, 16 x 21¼ x 12 in. (40.6 x 54 x 30.5 cm), Walker Art Center

Fig. 5. PAULO UCCELLO (Italy, 1397–1475), *St. George and the Dragon,* about 1460, oil on canvas, 22¼ x 29¼ in. (113 x 74.3 cm), National Gallery, London

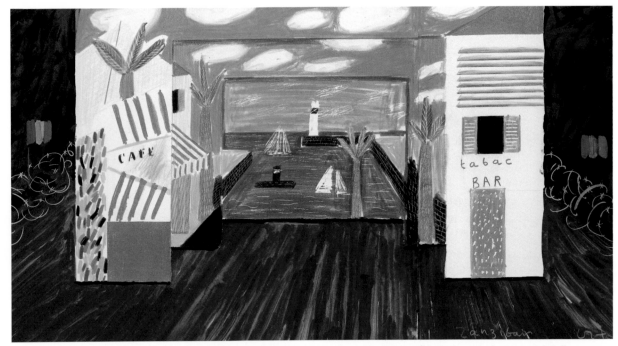

Fig. 6. *Zanzibar*, drawing for *Les Mamelles de Tirésias*, 1980, gouache and crayon on paper, 18⅞ x 35¾ in. (47.9 x 90.8 cm), André Emmerich Gallery

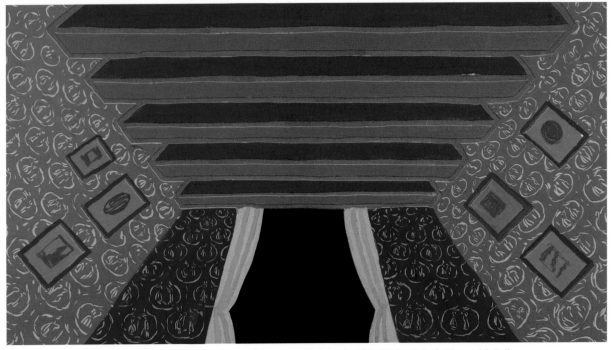

Fig. 7. *The Room*, drawing for *L'Enfant et les sortilèges*, 1980, gouache on paper, 22 ½ x 40 in. (57.2 x 101.6 cm), André Emmerich Gallery

psychic dislocation (to put it negatively) and spiritual mutability (to put it positively), and Hockney makes use of the aesthetic of the "pasted-paper Revolution" as both the form and content of *Parade* and *Les Mamelles de Tirésias. Parade,* which Picasso had conceived as a collage of traditional representation (the famous *Overture Curtain* featured a group of commedia dell'arte characters and circus performers in a tavern on the Bay of Naples) and Cubist imagery (the Cubist "Managers"), was recast by Hockney as a grab bag of fragments. Hockney's version of *Les Mamelles,* whose original sets were designed by the now-forgotten Serge Férat, was in part based upon a Picasso collage of Céret of about 1912,[5] combined with a naively rendered *vieux port* on the Riviera (fig. 6) replete with puffy clouds, scrawls on the water meant to signify waves, and palm trees rendered in signature David Hockney style.

But while Hockney's use of collage as a point of reference for *Parade and Les Mamelles de Tirésias* remains, despite its modernity, a painter's reference—collage was invented and developed first by two painters, Picasso and Georges Braque—something very new had now entered his aesthetic meditations: space. For, to follow our analogy, if Hockney had previously made a printmaker's theater of line and a painter's theater of color and volume, he was now creating a collagist's theater of space, for that is what collage is in formal terms, the literal, physical superimposition of forms, whereby fictive and real space become part of a continuum. This is not to imply that Hockney had previously been unconcerned with space and its metaphorical ramifications; to the contrary, spatial questions had long haunted him. Again, this is especially clear in the paintings of the early 1960s, in which figures are pressed up, noses flattened, against the picture plane or are pushing out against the edges of the canvas like so many Laocoöns, in extremis, unable to extricate themselves from the sometimes limiting life of forms. It is precisely because from the very start Hockney had sensed the two-dimensional world of the picture as both a challenge and a trap that he was so powerfully affected by real space when, by way of the stage, it became available to him as an artistic medium.

How ironic that it should be the medium of make-believe—the theater—that led Hockney out of the realm of fictive space to the threshold of three dimensions. In fact, in the third work of the French triple bill, *L'Enfant et les sortilèges,* one senses, for the

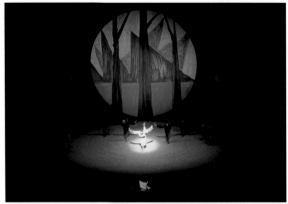

Fig. 8. *Le Sacre du printemps,* Metropolitan Opera, 1981

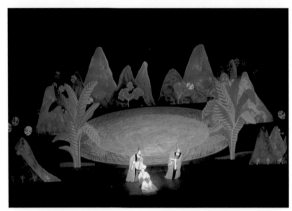

Fig. 9. *Le Rossignol,* Metropolitan Opera, 1981

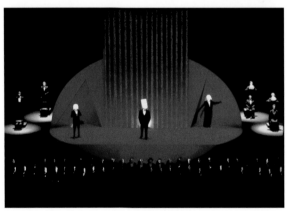

Fig. 10. *Oedipus Rex,* Metropolitan Opera, 1981

first time really, that David Hockney is drunk with space. The living room of the Normandy farmhouse with its beams and low ceiling and its three visible walls splayed out at impossible angles is an intoxicating vision (fig. 7). It pulls the spectator in like a magnet by means of the rushing orthogonals and vibrating blue,

red, and green and at the same times leaves one stranded without directional bearings.

We can now understand why each work of the Hockney three-part Stravinsky evening—*Le Sacre du printemps, Le Rossignol,* and *Oedipus Rex* (figs. 8–10)—has circle motifs in both the general design and the details, and all three works—a ballet, an opera, and an oratorio—were performed upon great circles inscribed on the floor (or on a raised platform, in the case of *Oedipus Rex*). Even the overture curtain, a scrim, depicted a fanciful, giant, round lyre with Stravinsky's name and birthdate inscribed below. For Hockney there was to be no equivocation: the static square, or rectangle, common denominator of both the canvas and the proscenium opening, was being usurped by the circle, that most unstable of forms, symbol here of an elastic, dynamic, conception of space and representation. Instead of a space laterally sliced into receding planes by painted flats, the Stravinsky triple bill presents us with three round "planets," each a distinct, fully realized realm.

It is hardly accidental that within months of the premiere in December of the Stravinsky triple bill, the sixth of his theater productions, while preparing for a retrospective of his photographs at the Centre Pompidou, David Hockney suddenly grew dissatisfied with the conventional photographs he had been taking for so long, as he had previously become dissatisfied with his highly illusionistic painting. In order to go beyond the straitjacketing restrictions of the single photographic image, he began to make photocollages (fig. 11), what he calls "joiners," as a way of constructing a more comprehensive, physically real rendition of the act of seeing.[6] These, of course, were really the direct progeny of, first, the collage aesthetic of the *Parade* triple bill and, second, the spatially circular conception of the Stravinsky evening. The photocollages, in turn, led to the artist's new interest in Cubist art generally and even to quasi-Cubist painted images, like *Self-Portrait on the Terrace* (fig. 13) of 1984, an exquisite visual poem about the outwardly propelled and inwardly residing self, played out on the stage set of Hockney's own terrace and swimming pool, which glows in the night like the opalescent orb of the moon.[7] Indeed, Hockney's house figures in many of his paintings and photocollages of the last few years (fig. 12), the house being perhaps the closest analogue to the theater, a real space in which to fashion an ideal world.[8]

Fig. 11. *Yosemite, May 1982,* 1982, photographic collage, 30¼ x 22¼ in. (76.8 x 56.5 cm), David Hockney

What are we to conclude from the preceding outline and analysis of David Hockney's theater designs? Are we merely talking about formal issues that are of little other than technical interest for David Hockney and perhaps a few specialists? Has Hockney himself become the kind of formalist for whom he once had little but disdain? Is the progression we have been describing—from the essentially pictorial to the spatial—an "internal" affair, or is it in some larger sense exemplary? I think it is the latter, and if one pays sufficiently careful attention to the kinds of things that Hockney has been making and saying recently, the various elements of the artist's Weltanschauung—for I think we are talking about nothing less than a world view—fall into place.

I am going to ask you to imagine David Hockney at the blackboard, by way of a few illustrations that he made for that most unlikely of schoolrooms, the Christmas 1985 issue of Paris *Vogue*.[9] First the artist writes the words *Mort* and *Vie* on the board, and below he draws two faces, much as schoolboy might draw them, one with a frown (tragedy, more or less), the other with a smile (comedy, sort of) (fig. 14). The point here is that the frowning face has a mouth that looks like the downward sloping peaks of the *M* in *Mort*, and the happy face has a mouth like the big, open *V* in *Vie*. Good enough.

But to understand this as anything other than the most simpleminded equation, we must consider another drawing (fig. 15) that Hockney makes on the blackboard. At the top is a schematic rendering of Albertian, one-point perspective, the same one to which Hockney made reference in *The Magic Flute:* a horizon line, a vanishing point, an infinity sign above the van-

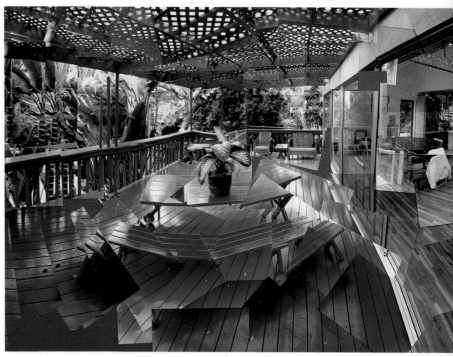

Fig. 12. *Terrace without Shadows 1985,* 1985

Fig. 13. *Self-Portrait on the Terrace,* 1984

Fig. 14. *"Vogue par David Hockney," Vogue,* p. 234.

Fig. 15. *"Vogue par David Hockney," Vogue,* p. 232.

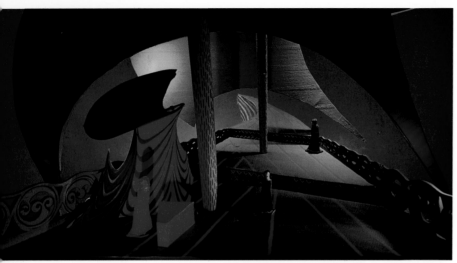

Fig. 16. Model for act 1, *Tristan und Isolde*, 1987, 74 x 78 x 66 in. (188 x 198.1 x 167.6 cm), David Hockney

Fig. 17. Model for act 2, *Tristan und Isolde*, 1987, 74 x 78 x 66 in. (188 x 198.1 x 167.6 cm), David Hockney

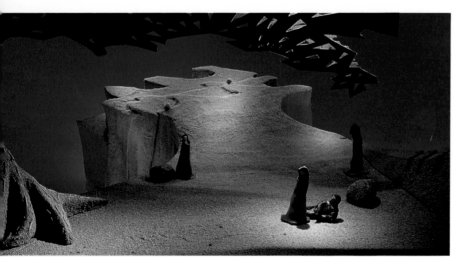

Fig. 18. Model for act 3, *Tristan und Isolde*, 1987, 74 x 78 x 66 in. (188 x 198.1 x 167.6 cm), David Hockney

ishing point, and two receding orthogonals, the proverbial railroad tracks that are parallel close to us and meet at the vanishing point. Hockney writes (and here I translate from the French), "In the theory of perspective the vanishing point is infinity," and then alongside a little dot beneath the image he continues, "and the spectator is an immobile point outside the painting." Below this Hockney makes another schematic drawing: there is only a dot with two lines radiating from it at a 90-degree angle. Here he writes, "If infinity is God, we will never meet, but if perspective is inverted, then infinity is everywhere, infinity is everywhere, infinity is everywhere, infinity is everywhere, and the spectator is now in movement," and in brackets below he asks rhetorically, "Is this better theologically?"

This explains the first drawing: the peak in the word *Mort* (death), which is also the frowning mouth, is the illusory creation of depth in pictures constructed according to Renaissance perspective; the big smiling *V* of *Vie* (life) and of the happy face below is created by the mobile spectator, source of infinity in Hockney's new, neo-Cubist cosmography. It ought not to come as a surprise to discover that David Hockney's progress through theater design has been that of a pilgrim, that the goals have been, at least in part, "theological" all along. Isn't every Rake who charts his progress really a sheep in wolf's clothing? Nor should it surprise us to recognize that the second drawing—that is to say, the two renderings of space, taken together—looks remarkably like a schematic depiction, from above, of a spectator in a theater looking toward the stage. In the darkness of the theater, enveloped by music, drawn toward the brilliant lighting of the stage and its magical effects, and conscious not only of the communal nature of the experience but even of being physically contained within the reassuring vastness, the spectator—all eyes and ears for both the spectacle in front and the spectacle of humanity around—has a glimpse of Hockney's rendezvous with the infinite. Hockney's quest for a more bracing—a more *embracing*—pictorial experience is spiritual at its core.

Is it any wonder, given his visionary aspirations for art, that David Hockney has also found his way to Wagner and the total work of art, the Gesamtkunstwerk? His production of *Tristan und Isolde* for the Los Angeles Music Center Opera (directed by Jonathan Miller and conducted by Zubin Mehta) marshals the combined forces of light, shape, space, scale, and texture in the

service of Wagner's musical drama.[10] Typically, given Hockney's complete immersion in his theater designs, he evokes the appropriate art historical reference here: the ship that carries Isolde from Ireland to Cornwall in act 1 is decorated with Celtic and Hiberno-Saxon patterns as is the foliage of the trees in her garden in act 2. Hockney has also created a setting of enormous scale—the mammoth, billowing sails in act 1; the huge rusticated medieval castle in act 2; the rough, jutting promontory and colossal lime tree in act 3—to convey the enormity of Wagner's musical intentions. Most important Hockney makes use of lighting effects in *Tristan und Isolde* with the evocative power adumbrated in his designs for Ravel's *L'Enfant et les sortilèges*. In the case of *Tristan*, though, Hockney has undoubtedly taken his formal cue directly from Wagner's libretto, where light and dark have iconographic functions: *"Das Licht! Das Licht! O dieses Licht!"* sings Tristan in act 2, cursing the light of malicious *(tückischen)* day and singing the praises of the "twilit splendor of the night." As Isolde approaches and Tristan expires in act 3, the hero in his feverish daze asks, "How's this? Do I hear the light?" *("Wie, hör'ich das Licht?")*. As spectators we both see and hear the light in these settings for Wagner's tragedy: the seductive and lurid lighting of the garden at night in act 2 and the blindingly illuminated and parched earth in act 3 are Hockney's means of bringing Wagner's words and music intensely to life in a way that Wagner, who believed strongly in exploiting all theatrical resources, might himself have envisioned.

But what are we to make of the spatial configuration that dominates all three acts of Hockney's production inasmuch as the deck of the ship in act 1, the garden with its stands of trees in act 2, and the clawlike Breton cliff in act 3 are all variarations of a soaring shape that recedes into space like the renderings of traditional perspective (figs. 16–18) that Hockney now abjures? Has the artist suddenly recanted? Has he turned his back on his own ideas? I think not. Rather, as Hockney has conceived it, all the more poignant will be the foregone conclusion for *Tristan und Isolde,* as the very world that they inhabit—the boat in act 1, the precipice in act 3—assumes the fatal shape of one-point perspective, the sloping peak of "death," the frowning mouth of tragedy. But this is as it should be, after all, because what for Isolde is a *Liebestod* is for the spectator, especially for the Perfect Hockneyite, a song of life.

NOTES

1. Martin Friedman, "Painting into Theater" in *Hockney Paints the Stage,* exh. cat. (Minneapolis: Walker Art Center, 1983). With contributions by John Cox, John Dexter, David Hockney, and Stephen Spender, in addition to Friedman, *Hockney Paints the Stage* is the basic work on the subject of Hockney's theater designs. It is inclusive through the 1981 productions for the Metropolitan Opera. Also interesting is an interview with Hockney concerning his stage designs: Philip Smith, "Sets and Costumes by David Hockney," *Arts* 55 (April 1981): 86–91.

2. The phrase "release from naturalism" appears in *David Hockney by David Hockney,* Nikos Stangos, ed. (New York: Abrams, 1977), 295. Hockney fully discusses his experience painting *Portrait of George Lawson and Wayne Sleep* on pp. 249–50. Friedman and Hockney discuss the painting and related issues ("Hockney had been casting about for alternatives to his compulsive drawing style") in *Hockney Paints the Stage,* 99.

3. *Hockney by Hockney,* ills. 9–11.

4. *Hockney Paints the Stage,* 117.

5. Hockney would have seen the collage (cat. no. 29) in the 1980 exhibition *Picasso from the Musée Picasso,* which he attended at the Walker Art Center. It is worth noting not only a strikingly similar combination of architecture, tiled roof, and trees but even the little *tabac* sign that Picasso includes at the left and Hockney puts over the doorway at the right. For a fuller account of the relationship between Hockney's theater designs and those of the Parisian avant-garde, see Kenneth E. Silver, "Hockney, Center Stage," *Art in America* 73 (November 1985): 144–59.

6. See Mark Haworth-Booth, Introduction in *Hockney's Photographs,* exh. cat. (London: Arts Council of Great Britain, Hayward Gallery, 1983); and Will Ameringer, "David Hockney: Points of View," *Arts* 56 (June 1982): 54–56.

7. See *David Hockney: New Works (Paintings, Gouaches, Drawings, Photocollages),* exh. cat. (New York: André Emmerich Gallery, 1984).

8. In 1982 Hockney said, "Recently we started having the inside of the house painted, using brighter colors. . . . It was partly seeing the De Stijl exhibition at the Walker that inspired me to paint the inside. . . . Then I also remembered that Monet painted the inside of his Giverny house yellow. I remembered going there and suddenly realized that, in a sense, I was doing the same thing. He made his house and garden an environment that he used as subject matter for many years. I can understand the painter doing that" (*Hockney Paints the Stage,* 56). It is worth pointing out that the use of house and/or garden as subject matter is also typical of Matisse's work, especially during the Nice period, in which an enchanted world of self-absorption is the result. These works also had an effect on Hockney's paintings and prints of about 1984–87. See *Henri Matisse: The Early Years in Nice 1916-30,* exh. cat. (Washington, D.C.: National Gallery of Art, 1986).

9. *"Vogue par David Hockney,"* Vogue, Paris, December 1985–January 1986, 219–59. I am referring to p. 234, then p. 232.

10. I thank David Hockney for graciously allowing me to observe him while at work on the *Tristan und Isolde* designs.

A VISIT WITH DAVID AND STANLEY
HOLLYWOOD HILLS 1987

LAWRENCE WESCHLER

FOR A LONG TIME his cameras had been getting smaller and smaller. Polaroid. Nikon. Pentax. A little tiny pocket job, James Bond style. "More and more lifelike," is the way David Hockney had put it to me a few years earlier when he was describing his ongoing explorations and I was preparing the introductory essay for the *Cameraworks* volume, which was going to document some of those investigations. "More true to life. I mean, one's own eye doesn't hang out of one's face, monocular, drooping at the end of some long tube. No, it's nestled in its socket, rolling about, free and responsive. And I feel a camera should be as much like that as possible." Through the medium of his increasingly tiny cameras, he'd been generating increasingly mammoth collages: dozens, hundreds, presently thousands of snapshots shingled one upon another, resolving into extremely intricate and lovely portraits and vistas. An explosion of perspectives—and in the process the utter subversion of the tyrannical hegemony of traditional one-point perspective. "*Wider* perspectives are needed now," Hockney would proclaim as he pulled the cigarette-pack–sized camera out of his pocket and started up once again, snapping away.

So you can perhaps imagine my surprise recently, when Hockney invited me out to his home and studio in the Hollywood Hills above Los Angeles in order to have a look at some of his current work, at finding him hunched over his latest camera: a full-ton monster—a huge blinking box—a Kodak Ektaprint 222 *office copying machine.* Hockney looked up for a moment, beckoned me in, and returned to his labors: snapping, as ever, away.

Hockney's studio is built up over a former tennis court, and actually the copying machines (for there were two, a Canon NP 3525 as well) only occupied one half of the court. The other was taken up with a large, three-dimensional model of his stage designs for an upcoming production of Richard Wagner's *Tristan*

und Isolde. Indeed Hockney's workday that month seemed to consist in a regular volleying, as it were, between Wagner and Xerox. That particular afternoon, however, he seemed mainly interested in talking about his explorations into the artistic possibilities of copying machines.

"A while back," he told me, "I used to enjoy confounding people by declaring that the only thing a photograph might be able to convey with some degree of truthfulness would be a flat surface, as in the reproduction, say, of a painting. When it attempted to depict space, that's when photography seemed to me to get into trouble. The camera, although people think it sees everything in front of it, cannot see the main thing *we* get excited about in front of us, which is space. The camera cannot see it. Only human beings maybe, or anyway only living beings, can see space. That's part of what I was exploring with all those photocollages: how a camera might be transformed to convey space after all, which means how it might be forced to acknowledge time. But it's only just now that I've been returning to my initial insight, which is how good a camera is at conveying a flat surface and the possibilities which that particular sort of effectiveness might afford.

"Because an office copier *is* a camera," Hockney continued, patting his giant beast of a colleague. "When you use it to copy a letter, you're basically getting a photographic reproduction of the letter. It's a camera, and it's also a machine for printing. Over the years, I've made a lot of prints working in several different master printshops. It's an exciting process, but I've always been bothered by the lack of spontaneity: how it takes hours and hours, working

The Tree, November 1986, 1986, eight home made prints, approx. 120 x 120 in. (304 x 304 cm), David Hockney

77

alongside several master craftsmen, to generate an image. How you're continually having to interrupt the process of creation from one moment to the next for technical reasons. But with these copying machines, I can work by myself—indeed you virtually have to work by yourself, there's nothing for anyone else to do—and I can work with great speed and responsiveness. In fact, this is the closest I've ever come in printing to what it's like to paint: I can put something down, evaluate it, alter it, revise it, reexamine it, all in a matter of seconds. Actually I've been trying to come up with a name for what to call these things"—he gestured toward a wall where several of his photocopied creations were hanging on display—"and I've hit on the phrase 'Home Made Prints.' "

To understand how Hockney was generating these Home Made Prints of his, it's useful to keep in mind the model of a self-contained print studio. The prints are wonderfully colorful and various; yet within each edition they are consistent from one "pressing" to the next. But Hockney was not simply producing a finished image, hundreds of color copies of which he was then proceeding to mass produce out of his copying machine. Rather he was working in layers, as in a standard print workshop. Much of his activity over the past several months, he now informed me, had consisted in an exploration of what things look like when they're photocopied, how the machine sees them; and to find out he'd been photocopying everything in sight: leaves, maps, grass, towels, shirts, Plasticine models, painted images, gouaches, washes, ink-thatches. He'd explored how the machine reads these various subjects at various settings and in various colors. He'd even been in touch with some of the technicians at Canon in Japan, having them brew him up some new colors, specifically a yellow for which no previous customer had ever seemed to have any call.

He photocopied everything, and then he cut and collaged. The prints he was eventually creating thus consisted in the culmination of several dozen different operations. By the time he was ready to make an edition of any specific print—say, the charming portrait of his new intimate companion, a dachshund

puppy named Stanley, which he was "editioning" the afternoon I came to visit (fig. 1)—he might have six or ten or fifteen different sheets of paper, layers of the image, which he would now begin successively "combining" inside the photocopier. He'd load the machine's paper feed bin with high-quality Arches paper, the sort used by the finest print studios, and lay his first image on the glass screen, select a color and a setting, run a few copies, recalibrate the settings, and then shoot a hundred sheets, say, through the machine. He'd then take those hundred sheets, evaluate their consistency, reject any copies that failed to pass muster for one reason or another, and then put the remaining sheets back in the feed bin, replacing the first image on the screen with a second and repeating the process. (In this particular instance, the witty, crisp black-ink outline of the first pressing was now being superimposed with a soft, light brown wash—or rather Hockney now replaced the machine's black pigment with brown from one of several canisters he kept alongside the copier; the actual image on the sheet Hockney was photocopying was the palest gray watercolor. Hockney explained that the machine seemed to read the white-gray contrast better than it would a white-brown.) By the end of this particular run, only thirty sheets survived all the operations, and they came to constitute the complete edition of that particular print. Everything else was fed into a nearby paper shredder, which digested the debris into exceptionally high-quality confetti.

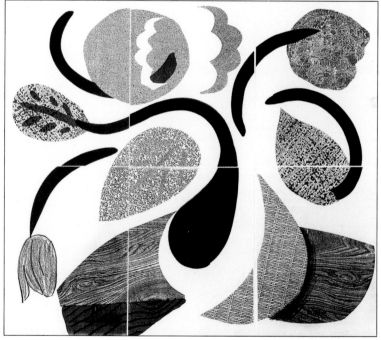

Dancing Flowers, May 1986, 1986, home made print, 22 x 25½ in. (55.9 x 64.8 cm), David Hockney

INSET: *The Red Chair, April 1986*, 1986, home made print, 11 x 8 ½ in. (27.9 x 21.6 cm), David Hockney

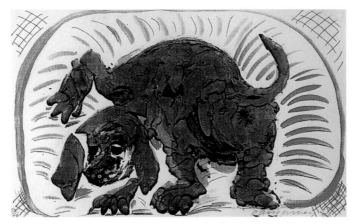

Fig. 1. *Stanley in a Basket, October 1986*, 1986, home made print, 8½ x 14 in. (21.6 x 35.6 cm), David Hockney

It was not only the spontaneity of the process that Hockney seemed to be enjoying in his newly discovered medium. There were certain ancillary benefits he'd come upon along the way as well—for one thing, the blacks. "I've never been able to generate such blacks before," he declared, pointing to the incredibly luscious black tree trunk, set off by a simple, almost luminous green leaf, in one of the prints tacked to the wall. "I think it has something to do with the process by which the pigment is made to adhere to the page. In almost every other printing or painting process the pigment is conveyed to the page through a liquid medium of some sort which then both evaporates into the atmosphere and is absorbed into the page, in either case leaving a sort of visual residue. No matter how black, there's always a trace of reflectivity, a sheen, and you don't get that pure sense of void. With photocopying, however, the powdered pigment is conveyed onto the page by a heat flash rather than a liquid. And there's therefore no subsequent reflective sheen. Just this rich, wonderful black."

Most of these prints seemed to have an uncanny presence and clarity, a startling immediacy. "Somebody the other day was telling me how one of these images just seemed to pop off the page for him," Hockney commented. "But I think that that formulation is subtly wrong. In most other printing processes there are several intervening, intermediary stages in the production, and in a way you can see them in the finished product. The image seems to be hanging back, to be subsumed, as it were, a few millimeters beneath or behind or below the surface of the sheet of paper. But here the process has been more direct—no negatives, no apparatus, just paper to paper—so that if anything, the image can be said to have popped *onto* the surface of the page.

"In general," Hockney continued, "it seems to me that most reproduction in the past has tried to behave as if the page were not there, as if you were looking through the page to the image which was just beyond it, as if the page were like a pane of glass. I'm reminded of those extraordinary George Herbert lines which have fascinated me for years:

A man may look on glass,
On it may stay his eye;
Or if he pleaseth through it pass
And there the Heaven espy.

But what I've been trying to get in some of these recent prints is the beauty of the surface itself, of color on paper, the Heaven that's there. Heaven isn't far away; it's right there on the surfaces before us."

In other words, it was a typical visit to Hockney's studio: the still young, not-*that*-young artist utterly engrossed in and possessed by some new passion, relentlessly pursuing it through all its myriad permutations. Hockney is an awesome worker: the sheer amount of his production—its variety and the density within that variety—is staggering. And all the more so because that sheer intensity of labor runs so contrary to his public persona as a ubiquitous society presence, an endlessly vacationing, lotus-languid bon vivant. Few artists, with the possible exception of Andy Warhol (for whom such exposure was itself, in a sense, the core of his artistic vocation), have so often found their countenances gracing the pages of fashion magazines and artsy journals. David Hockney here and David Hockney there. Indeed in this regard Hockney sometimes reminds me of Kierkegaard or at any rate of the perhaps apocryphal stories about Kierkegaard, who, it was said, used to disguise his own ferocious productivity, particularly during the period in the 1840s, when he was penning a whole series

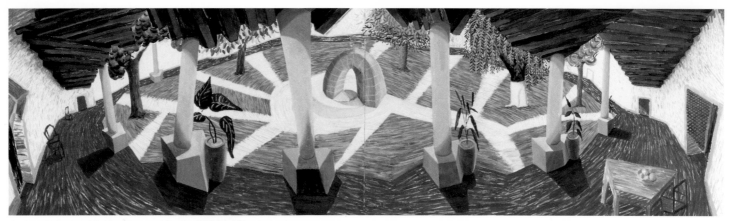

Fig. 2. *A Walk around the Hotel Courtyard Acatlán*, 1985 (pl. 113)

of volumes under countless pseudonyms (each "author" seeming to attack all the others), by continually traipsing about Copenhagen behaving like the most flamboyant and unregenerate of dandies. He'd make a particular point, or so the stories went, of showing up each evening at the opera, making a grand entrance into the concert hall, sitting through the overture, and then ever so quietly, without provoking the slightest notice, exiting the hall and hurrying back to his desk and his countless pseudonymous tasks. (Indeed the exercise was essential to the success of the whole pseudonymous venture; everyone was avidly wondering who all these wildly contentious new authors were, but nobody ever so much as suspected that idle dabbler Søren Kierkegaard.)

I mentioned that story to Hockney now, as I gingerly moved him away from the force field of his photocopying machines and over to a set of easy chairs in the studio's mid-court, and he started to laugh before I could even complete the analogy. "Ah, yes," he said, "I see what you're getting at. I mean, I don't really care what people think, but it is funny. A few months ago, for instance, in New York a friend of mine urged me to come along to the Palladium. I didn't want to, I don't like discos, and I can't stand the music, but in the end I went as a sort of favor to her. And sure enough, there were all these people there photographing other people, and they all photographed me, so that even though I only stayed for about half an hour, the photos were appearing for weeks thereafter. I can see how it could give someone the impression that I'm out partying every night, even though, in fact, I hardly ever go out. But I don't care. In fact, there are certain advantages to people's not taking you too seriously."

Like what?

"Well, think of it the other way. If you're taken very, very seriously, you run the risk of becoming bogged down in another direction which I wouldn't like. One's freer this way. I mean, I take my work seriously, I don't take myself too seriously, but if you spend your whole life doing it, you're obviously taking it seriously in a way. You don't choose to do all that work as a mere dalliance, as nothing at all."

He went on to point out how, for instance, some people, observing his photo albums, imagine he's on vacation all the time. "The thing is," he said, "that's what makes those albums utterly ordinary. Everybody's photo albums document them with their friends and when they go on holiday. People don't spend much time photographing the street they live on. Although, actually, my backyard has been the subject of most of my work. People see me as some sort of hedonist because I always seem to be portraying either my California home or my various travels. But I never traveled out of boredom or the need for new impressions. I've always realized that the bored person will be bored anywhere. The reason I moved from one place to another was to find peace actually, peace to work. It was the nattering that usually got me down. I fled for peace and quiet in each case."

It occurred to me, as Hockney said this, that the reason we think he's always on holiday—in Mexico or Provence or China or Japan or the Southwest and so forth—is because of all the work he brings back from these travels (fig. 2). He portrays others lounging about sleepily (fig. 3)—sometimes in his drawings it seems that all the world's a nap—

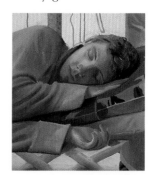

Fig. 3. *Model with Unfinished Self-Portrait* (detail), 1977 (pl. 57)

but he's wide awake and deep at work.

"That's why I settled here in California in 1979, for that matter," he continued. "It suits me here. You can live more privately here than anywhere else and yet still be in a city. In a way I moved here for the isolation."

It's not just the locales portrayed that often give people the wrong impression about Hockney's intentions. "I mean," he continued, "it's like people say, 'Ah yes, you paint swimming pools.' But I must admit, I never thought the swimming pool pictures were at all about mere hedonist pleasure (fig. 4). They were about the surface of the water, the very thin film, the shimmering two-dimensionality. What is it you're seeing? For example, I once emptied out my pool and painted blue lines on the bottom. Well, now, when the water's still, you see just clear through it and the lines are clean and steady. When somebody's been swimming, the lines are set to moving. But where are they moving? If you go underneath the surface, no matter how turbulent the water, the lines are again steady. They are only wriggling *on* the surface, this thinnest film. Well, it's that surface that fascinates me; and that's what those paintings are about really."

The same as with the Xeroxes.

Spend any amount of time with Hockney and you quickly realize that he's an intensely cerebral artist, extraordinarily well read and deeply involved in that reading and extraordinarily thoughtful in those terms about the wider implications of his artistic endeavor. He is endlessly struggling with issues of representation, perception, reality, worldview, the transcendence of constrictions. Curiously, however, most of those implications pass most of the fans of his art right by. What makes Hockney such an iconic presence in contemporary popular culture, it seems to me—all the Hockney posters on living room walls, the Hockney reproductions on the jackets of novels and the covers of records, and so forth—is the sunny benevolence of the subject matter and the unfailingly endearing charm of its rendering. I asked Hockney whether he ever became bothered by the misreading—or anyway, the half-reading—of his work. "I suppose even in the experimental work I have to do it in a charming way," he replied. "That's just my personality. I can't not do it that way, you see. When people say, 'Ah, but, it's much too charming,' I don't really care, because I know something else is going on as well."

I asked him about the roots of that charm. "I think ultimately what it is, is that I'm not a person who despairs. I think that ultimately we do have goodness, really, in us. For instance, with the Ravel opera [*L'Enfant et les sortilèges*, for which he did the stage designs in 1980], I totally responded to that story and the music particularly. And what was it saying? That kindness is our only hope. I think that was in every note of that music. Stunning. And I loved it. I did what I could to make it alive in the theater because basically I believe that. And if I do believe that, that's what I should express. That's where my duty lies. I mean, I'm not naive. I have moments—I don't think happiness is . . . We just get glimpses, tiny moments, that's all. But they're enough. At times I feel incredibly lonely, especially when I'm not working. The impulse can go away, just dry up. But the moment I get to work, the loneliness vanishes. I love it in here, on my own, painting. You know all that stuff about angst in art: I always think van Gogh's pictures are full of happiness. They are. And yet you know he

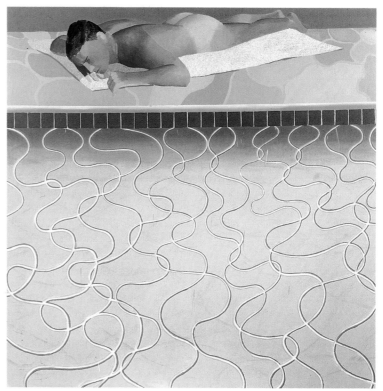

Fig. 4. *Sunbather*, 1966, acrylic on canvas, 72 x 72 in. (183 x 183 cm), Museum Ludwig, Cologne

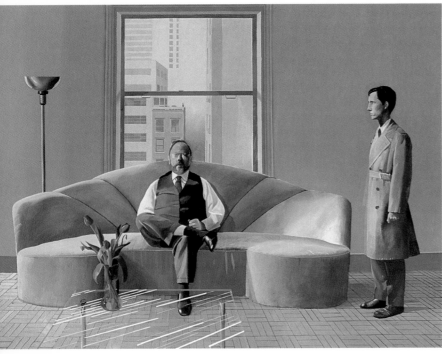

Fig. 5. *Henry Geldzahler and Christopher Scott*, 1969

wasn't happy. Although he must have had moments to be able to paint like that. The idea that he was a miserable wretch and mad is not true. When he was mad, he couldn't paint, actually.

"I guess basically I'm an optimistic person," he continued. "I ultimately think we will move on to a higher awareness, that part of that road is our perceptions of the world as they change, and I see art as having an important role in that change."

A somewhat subtler misperception about Hockney's art is that he is essentially a painter and that all the rest—the theater work, the photocollages, the lithographs, the paper-pulp pools, the Home Made Xerox Prints—are somehow secondary, incidental, or tangential, a series of holding actions or at best experiments leading back to the more serious work of painting. Various commentators have expressed exasperation over Hockney's propensity for such side trips, and they've wondered when he was going to return to the more essential labor. Occasionally Hockney himself has reinforced that sense of priority. "Oh dear," he said to me the day of the New York opening of his second photocollage show in 1983, when we'd taken a walk from the gallery over to the Museum of Modern Art and were suddenly delivered before a Cézanne, a Braque, and a Picasso. "Oh dear, I truly *must* get back to painting." More than three years had now passed, and although he had, in fact, produced a few new paintings—including the major two-panel rendition of *A Visit with Christopher and Don* (1984)—he seemed to be as consumed as ever with his experiments in photography, printing, theater design, magazine layout, and so forth. I asked him whether that hierarchy of expectations mattered in any way to him.

Fig. 6. *Le Parc des sources, Vichy*, 1970

"Less and less," he replied, "if at all. I mean, they're all tending toward the same set of issues—the clear depiction of space in time, the widening of perspective, and so forth—just in different media is all. And they all influence each other. Discoveries in one area move the other along. Just today I made a breakthrough with the design for *Tristan* based on some of the negative-positive contrasts I've been able to generate with the photocopying machines. Both the Xeroxes and the photocollages have been moving more and more to the condition of painting—you can see that especially with that recent *Pearblossom Hwy.* collage [1986], which is the most painterly of any of those I've done. At one point somebody did criticize the photographs for being less like art than the others, and I must admit I couldn't care less in a sense whether they are art or not. I mean, it's not up to me to say, and maybe it's not up to him either. It's certainly interesting where they're leading and where they've led, and you don't stop in the middle of it all because, you know, 'Gee, I'm not sure if this is art anymore.' There's a wonderful quote of Picasso's, which I keep referring to, where he says he never made a painting as a work of art; it was always research and it was always about time. On another occasion somebody was giving him a hard time about something—I forget what the argument was—but Picasso's reply was, 'Ah, then what you're talking about is *mere* painting.' Meaning, of course, that it's always about something else, something bigger. All of this work is undertaken in a spirit of research. I'm not so much interested in the mere objects I'm creating as in where they're taking me, and all the work in all the different media is part of that inquiry and part of that search."

Such probably would not have been the answer he would have given to that question in the early seventies, when painting still clearly occupied the center place in his prodigious production. Ironically though, it was a sort of crisis in the paintings of that period—a sense of dead-endedness that persisted through much of the rest of that decade—which launched him into the other media. The blockage with those paintings provoked questions—at first barely articulated—which provided the contours for much of the research that was to follow.

"Actually it was only a relatively short period," Hockney recalls, "from 1969 to 1972 or so, where I did a number of paintings in a naturalistic style with a very clear one-point perspective. In fact, it was so clear that the vanishing point was bang in the middle of the canvas. In the 1969 portrait of Henry Geldzahler [fig. 5] there's an absolute vanishing point for everything there just slightly above his head. In *Le Parc des sources, Vichy* [1970, fig. 6], it's almost exaggerated, just slightly off center. What I wanted to do, what I was struggling to do, was to make a very clear space, a space you felt clear in. That is what deeply attracts me to Piero [fig. 7], why he interests me so much more than Caravaggio: this clarity in his space that seems so real. Well, I just couldn't achieve that clarity frankly; it was a hopeless struggle, and the painting I eventually gave up on was the double portrait of George Lawson and Wayne Sleep [1972–75], which I never exhibited, though it has been reproduced; it's a very dull picture."

It was reproduced in the 1977 volume *David Hockney by David Hockney,* where interestingly Hockney gives a different account of his reasons for abandoning the picture, as he understood them at the time, citing his growing dissatisfaction with acrylic versus oil

Fig. 7. PIERO DELLA FRANCESCA (Italy, about 1420–92), *The Baptism of Christ,* about 1448–50, tempera and oil on wood, 65¾ x 45⅝ in. (167 x 116 cm), National Gallery, London

DETAIL: *Henry Geldzahler and Christopher Scott*

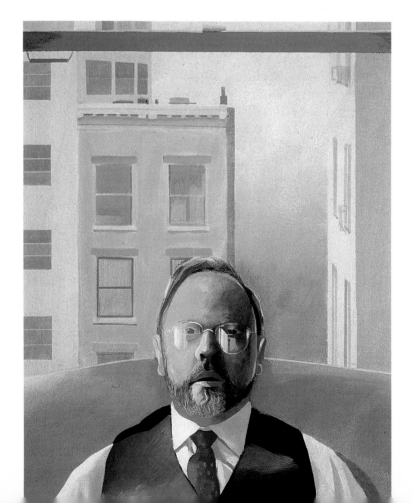

paints and a growing disillusionment with "naturalism" (p. 249). Henry Geldzahler in his introduction to the volume, speculates—no doubt partly basing his speculations on contemporary conversations with Hockney himself—that "In the early 1970s Hockney's technical facility grew to such a degree that it frightened him into pulling back. . . . The double portrait *George Lawson and Wayne Sleep,* abandoned in 1973 and resumed in late 1975, achieved such heights of naturalism and finish that a sentimental and anecdotal quality in the subject matter threatened to undermine the painting's formal strengths" (p. 23).

Ever since his remarkable debut as an artist in the late fifties Hockney's work had been characterized by a youthful zest, a fresh sense of freedom, a playfulness. "If art isn't playful, it's nothing," Hockney interrupted me as I started to make this point in our conversation. "Without play, we wouldn't be anywhere. Play is incredibly important; it's deeply serious as well. It's hardly a criticism of my work to call it playful; on the contrary, it's flattering." I asked him whether there was a sense back there in the early seventies in which the growing technical mastery was no longer allowing the earlier playfulness. He agreed. "Yes, yes, it's true. I couldn't play in that space—the one-point perspective was terribly constricting—and it's only by playing with the space in the years since then that I've been able to make it clearer. Everything since then has been a progression toward a playful space that moves about but is still clear and not woolly."

At the time, back there in 1973, '74, '75, all he realized, in his own words, was that " 'No, no, you cannot go anymore in this direction.' I knew that. I didn't know how to deal with it, so I just slowed down, and I moved into the theater. The first opportunity to do the staging for an opera came up about this point, Stravinsky's *The Rake's Progress* at the Glyndebourne Festival in the summer of 1975. I took this opportunity to work in a different

medium when they asked me, and immediately everything became fresher."

In retrospect Hockney recognizes that one of the ways in which things became fresher was that stage design sprang him into a world of multiple and moving perspectives—sprang him, that is, clear of the constricting ensnarements of traditional one-point perspective. One painting he did during this period as a sort of spinoff from the opera, a product of his extensive researches into Hogarth's original Rake's Progress etchings, was a color rendition (1975, illustrated p. 20) of the black-and-white etching that Hogarth had provided as the frontispiece for an obscure treatise on perspective by one John Kerby. "The original etching was a kind of visual joke, all about common mistakes in perspective," Hockney recalls, "and I found it vastly amusing. The perspective was, of course, all wrong, but what was fascinating was that it still worked as a picture. So I made my painting, although at the time I did it, I did not yet realize what that painting was all about. It took me almost ten years to understand how, for instance, the reverse perspective in the foreground, far from being a mistake, gives the image greater reality."

The mid- and late seventies were the period when Hockney was becoming increasingly involved with Picasso and with Cubism, but that involvement was only gradually and grudgingly revealing its lessons. In the meantime Hockney was continuing to try to make his paintings work.

"I'd moved to Los Angeles and was working on a painting of the view outside my studio on Santa Monica Boulevard," Hockney recalls. "And it wasn't working. It was still stuffy, still asphyxiated by that sense of supposedly 'real' perspective. Eventually I gave it up. At the same time though I'd now moved up here to this house in the Hollywood Hills, and I began a painting depicting the drive down to the studio. (This was before we built this studio up here,

so I was working down there and driving there each morning.) The moment I moved up here into the hills, wiggly lines began appearing in my paintings. The only wiggly lines that I'd had in my L.A. paintings before that were those on water. Buildings, roads, sidewalks were all straight lines, because that's what L.A. looks like in the flatlands: long straight roads, right angles, cubes [fig. 8]. So anyway, I now began to paint this *Mulholland Drive*, too, down there in the studio [fig. 9]. The one which I could see right out the window wasn't working, but this other one which I was painting from memory—the memory of the drive down—was beginning to work. You see, it was all about movement and shifting views—although at the time I didn't yet fully understand the implications of such a moving focus."

In *Mulholland Drive "drive"* is a verb.

"So that *Mulholland Drive* was working," Hockney continued, "whereas *Santa Monica Boulevard* was not. And with *Santa Monica Boulevard,* I now understand, the problem was photography. I think it was necessary for me in a sense to destroy photography— or anyway what I thought photography was—to refute the claims it was making in order to be able to change for myself the whole notion of a painting's being real, of what is real in the world of a painting. It's taken a long time; it took me over five years. I had no idea it would take so long, not that I minded. I mean when people said I was wasting my time, I could care less. What I was learning was amazing to me. I realized more and more what you could do, how you could chop up space, how you could play inside the space, that only by playing could you make it come alive, and that it only became real when it came to life."

• • •

"We've spoken about a lot of this before," Hockney pointed out, referring to our conversations at the time of the *Cameraworks* volume, in the introduction to which the evolution of Hockney's photocollage passion under the growing thrall of Cubism is recounted in some detail. "So we needn't go over it all again. But the principal point, I suppose, is that the major problem with traditional perspective, as it was developed in fifteenth-century European painting and persists to this day in the approach of most standard photography, is that it stops time. For perspective to be fixed, time has stopped and hence space has become frozen, petrified. Perspective takes away the body of the viewer. You have a fixed point, you have no movement; in short, you are not there, really. That is the problem. Photography hankers after the condition of the neutral observer. But there can be no such thing as a neutral observer. For something to be seen, it has to be looked at by somebody, and any true and real depiction should be an account of the experience of that looking. In that sense it must deeply involve an observer whose body somehow has to be brought back in."

As far as Hockney is concerned, the initial Cubist achievement was to make this case with devastating finality at the very moment of photography's apparent triumph. It has taken years for the implications of that achievement to filter through, and indeed most cultural observers, not to speak of the vast majority of average citizens in the world of vision, have still failed to grasp those implications. "Most people, when you say, 'Realism,' still think you're talking about a certain way of seeing from a distance and in good, orthodox perspective," Hockney explains. "When

Fig. 9. *Mulholland Drive: The Road to the Studio,* 1980 (pl. 72)

Fig. 10. Installation view, Museum of Modern Art, New York: PABLO PICASSO (Spain, 1881–1973), *Boy Leading a Horse*, 1906, oil on canvas, 86¾ x 51½ in. (220.3 x 130.6 cm), Museum of Modern Art; *Les Demoiselles d'Avignon*, 1907, oil on canvas, 96 x 92 in. (243.9 x 233.7 cm), Museum of Modern Art

you say, 'Cubism,' they think you're talking about a particular historical style, a kind of painting, say, that was popular for a few years over half a century ago. I think one could mount a certain case against the Museum of Modern Art for helping to perpetuate that fallacy, for diluting the effects of Cubism's visual revolution by encapsulating it, confining it inside the walls of a museum (and even then, only certain walls in certain rooms, devoted to a particular historical moment), as if it need have no effect outside, as if movies or television or photography or politics or life could simply go on without someday having to be Cubified. A while back, I was reading Hilton Kramer's review in the *New Criterion* of

the core installation at the new MOMA, and at one point he described the room containing both Picasso's *Demoiselles d'Avignon* [1907] and his *Boy Leading a Horse* [1906, fig. 10], and almost in passing he referred to the *Boy Leading a Horse* as 'more realistic.' Well, that's, of course, what most people think. (You can imagine if even Hilton Kramer talks like that, what some high school teacher in Kansas is telling his students.) But it isn't actually. That's the point. It isn't. And of course, this obviously means it's still hard to see. No matter how much *Les Demoiselles*, for example, gets praised as 'a great revolution in painting,' the revolution has still not truly arrived yet in the sense that it's still not readable as being the more realistic painting, which it undoubtedly is. Juan Gris said that Cubism wasn't a style, it's a way of life, and I subscribe to that."

Hockney then referred, as he is given to doing often, to a book he'd been reading recently, in this case Pierre Daix's *Le Cubisme de Picasso*. Daix makes a similar point about the need to avoid seeing Cubism in terms of "ephemeral fashions and short-lived schools" and then goes on to relate the power of its revolution "to the fact that physics was simultaneously destroying our three-dimensional space-time perception." During the latter stages of his photocollage activity, Hockney now explained, he had himself been increasingly drawn to the terrain of modern physics.

"I was at a friend's house in Canada," he recalled, "and I was

Pierre Daix

LE CUBISME DE PICASSO

This transformation in painting should be related not to ephemeral fashions and short-lived schools, but to the long duration of changes in cognitive methods and mental attitudes. Perspective has lasted for some five hundred years. Cubism is the chance name given to the first emergence of a different art, or rather to the concertization of differences which suddenly became perceptible. . . .

It is only now, in the last quarter of the twentieth century that we discover that Cubism was not only a revolution in pictorial space, but a revolution in our understanding of pictorial space. This was in all probability linked to the fact that physics was simultaneously destroying our three-dimensional space-time perception. Our discoveries in this field are only just beginning.

Neuchâtel: Ides et Calendes, 1979, 184; translation: *"Vogue par David Hockney," Vogue*, Paris, December 1985–January 1986, 256.

just browsing through some of his books about physics, and in one of them there were just two or three sentences that got me going. Coming back, I picked up several other books, and I found to my amazement that I could read them and follow their arguments. I mean, quantum physics is something way outside my ordinary understanding or involvement, but I quickly found incredible connections with the sorts of things I was concerned about. For instance, in the old Newtonian view of the world, in Newtonian physics, it's as if the world exists outside of us. It's over there, out there, it works mechanically, and it will do so with or without us. In short, we're really not part of nature; it virtually comes to that. Whereas modern physics has increasingly thrown that model into question and shown how it cannot be. Mr. Einstein makes things more human by making measurement at least relative to us, or anyway, to some observer; the supposedly neutral viewpoint is obliterated. There can be no measurement without a measurer. Heisenberg's Uncertainty Principle is, of course, highly technical and specialized. It deals with a paradox in particle physics, showing how if you attempt to measure the velocity of a given particle you won't be able to identify its exact location and vice versa. Previous to this, of course, science believed that given enough technical advancement, it would eventually be able to measure anything, but Heisenberg showed that this was not just a problem of not yet having the right measuring devices but that the problem was inherent in the nature of physical reality itself. The old conception of scientific inquiry had gone on as though we could measure the world as if we weren't in it. Heisenberg showed that the observer, in effect, affects that which he is observing, so that some of those old borders and boundaries begin to blur just as they do in Cubism.

"But perhaps my greatest excitement along these lines," Hockney continued, "came from reading a fairly recent book by a physicist named David Bohm, entitled *Wholeness and the Implicate Order*. Just a second."

Hockney bounded out of his easy chair—out of the studio, down to his house, returning a few minutes later flipping through an obviously well-thumbed copy of the book.

"Here, listen to this." He proceeded to read a long passage from Bohm's introduction (see p. 88).

"The notion that the one who thinks (the Ego) is at least in principle completely separate from and independent of the real-

ity that he thinks about," Bohm writes (and Hockney read), "is, of course, firmly embedded in our . . . tradition. . . . General experience . . . along with a great deal of . . . scientific knowledge . . . suggest . . . that such a division cannot be maintained consistently."

After he'd read several paragraphs further into the text in a state of growing animation, Hockney put down the book, thoroughly invigorated. "You can see why I was so excited," he said. "This insistence on the need to break down borders, to entertain the interconnectedness of things and of ourselves with things: the notion that in science today it is no longer possible to have ideas about reality without taking our own consciousnesses into account. And beyond that, just the language, which Bohm shares with a lot of other physicists. They're always talking about 'overall worldview,' the need for 'new horizons' or 'wider perspectives' or 'a new picture of reality' —all these visual metaphors which a painter of pictures can understand and which have relevance for how he thinks about his own pictures. There's that famous phrase of Gombrich's about the triumph of Renaissance perspective— 'We have conquered reality' —which has always seemed to me such a Pyrrhic victory, again, as if reality were somehow separate from us and the world now hopelessly dull because everything was known and accounted for. These physicists, by contrast, were suggesting a much more dynamic situation, and I realized how deeply what they were saying had to do with how we depict the world, not what we depict but the way we depict it."

I asked Hockney whether he'd shown much interest in science in his school days.

"Not particularly," he replied. "Not really. I was good at mathematics, but I think it was just the playfulness that attracted me. I didn't do too much with it though. I think I took a rather general view of the sciences as somewhat cold and objective. I was going to be an artist, not a scientist, and those were two completely different categories. Finding out that they're not has been very exciting for me. The more I've read of mathematicians and physicists, the more engrossed I've become. They really seem like artists to me. One's struck how it's almost a notion of beauty which seems to be guiding them, how at the frontiers of inquiry, contemporary physics even seems to be approaching and acknowledging eternal mysteries. Science is moving toward art, not art toward science. Of course, in an earlier time one spoke of the arts

David Bohm

WHOLENESS AND THE IMPLICATE ORDER

It is clear that in reflecting on and pondering the nature of movement, both in thought and in the object of thought, one comes inevitably to the question of wholeness and totality. The notion that the one who thinks (the Ego) is at least in principle completely separate from and independent of the reality that he thinks about is of course firmly embedded in our entire tradition. (This notion is clearly almost universally accepted in the West, but in the East there is a general tendency to deny it verbally and philosophically while at the same time such an approach pervades most of life and daily practice as much as it does in the West.) General experience . . . along with a great deal of modern scientific knowledge . . . suggest very strongly that such a division cannot be maintained consistently

Clearly, this brings us to consider our overall world view, *which includes our general notions concerning the nature of reality, along with those concerning the total order of the universe, i.e., cosmology. To meet the challenge before us our notions of cosmology and of the general nature of reality must have room in them to permit a consistent account of consciousness. Vice versa, our notions of consciousness must have room in them to understand what it means for its content to be "reality as a whole."*

The widespread and pervasive distinctions between people (race, nation, family, profession, etc., etc.), which are now preventing mankind from working together for the common good, and indeed, even for survival, have one of the key factors of their origin in a kind of thought that treats things as inherently divided, disconnected, and "broken up" into yet smaller constituent parts. Each part is considered to be essentially independent and self-existent.

When man thinks of himself in this way, he will inevitably tend to defend the needs of his own "Ego" against those of others; or, if he identifies with a group of people of the same kind, he will defend this group in a similar way. He cannot seriously think of mankind as the basic reality, whose claims come first. Even if he does try to consider the needs of mankind he tends to regard humanity as separate from nature, and so on. What I am proposing here is that man's general way of thinking of the totality, i.e., his general world view, is crucial for overall order of the human mind itself. If he thinks of the totality as constituted of independent fragments, then that is how his mind will tend to operate, but if he can include everything coherently and harmoniously in an overall whole that is undivided, unbroken, and without a border (for every border is a division or break) then his mind will tend to move in a similar way, and from this will flow an orderly action within the whole.

London: Routledge & Kegan Paul, 1980, *x–xi.*

and sciences together, in one breath. Nowadays in the paper you get 'Arts and Leisure.' That just shows how far behind the paper is, as usual. But scientists and artists have all kinds of things to say to each other now."

He suddenly laughed. "There's something else I want to show you," he said, getting up and walking over to a long cupboard counter over to the side, rummaging around for a bit, and returning with another book, this time *The Renaissance Rediscovery of Linear Perspective* by Samuel Y. Edgerton, Jr.

"Here. I was just reading this this morning. Listen to this." He read another long passage in which Edgerton started out by suggesting that the invention of linear perspective had been partly responsible for setting the context in which Newtonian physics could both flourish and then, with the invention of progressively more "complex machinery" (also made possible in part by the existence of linear perspective), be superseded by "the new era of Einsteinian outer space." Edgerton concluded by predicting that this new era might one day come to invalidate linear perspective itself: "Surely in some future century," Hockney read, "when artists are among those journeying throughout the universe, they will be encountering and endeavoring to depict experiences impossible to understand, let alone render, by the

Samuel Y. Edgerton, Jr.

THE RENAISSANCE REDISCOVERY OF LINEAR PERSPECTIVE

It should not be overlooked that almost coincidental with the appearance and acceptance of linear perspective came Gutenberg's invention of movable type. Together these two ideas, the one visual, the other literary, provided perhaps the most outstanding scientific achievement of the fifteenth century: the revolution in mass communication. Linear perspective pictures, by virtue of the power of the printing press, came to cover a wider range of subjects and to reach a larger audience than any other representational medium or convention in the entire history of art. It is fair to say that without this conjunction of perspective and printing in the Renaissance, the whole subsequent development of modern science and technology would have been unthinkable

So far as science is concerned can there be any question that the special geniuses of Leonardo da Vinci, Columbus, and Copernicus were given a very special catalysis at this time by the new communications revolution of linear perspective? Indeed, without linear perspective, would Western man have been able to visualize and then construct the complex machinery which has so effectively moved him out of the Newtonian paradigm into the new era of Einsteinian outer space—and outer time? Space capsules built for zero gravity, astronomical equipment for demarcating so-called black holes, atom smashers which prove the existence of anti-matter—these are the end products of the discovered vanishing point.

Or are they? Surely in some future century, when artists are among those journeying throughout the universe, they will be encountering and endeavoring to depict experiences impossible to understand, let alone render, by the application of a suddenly obsolete linear perspective. It, too, will become "naive," as they discover new dimensions of visual perception in the eternal, never ultimate, quest to show truth through the art of making pictures.

New York: Basic Books, 1975, 164–65.

application of a suddenly obsolete linear perspective."

Hockney set the book down. "A lot of good stuff there," he said. "The reason I laughed though is that last paragraph. I mean, I guess I hold with Buckminster Fuller's comment, you know, 'We *are* in outer space.' The idea that outer space is over there and we're not part of it is silly. We're already journeying throughout the universe. It's like how I can never seem to get interested in space movies, because they always seem to me to be about transport and nothing else. Well, transport is not going to take us to the edge of the universe, but an awareness in our heads might. Transport won't be able to do it; it's like relying on buses. But the Einsteinian revolution, like the Cubist, has already done it. Now we just have to open our eyes and see."

Hockney's comments, especially about Heisenberg, reminded me of a point the late anthropologist Jacob Bronowski made in his TV series, *The Ascent of Man*. He pointed out that in one sense Heisenberg during the 1930s had been proving the impossibility of absolute certainty and conversely the need for tolerance of multiple viewpoints (Bronowski even called Heisenberg's the Principle of Tolerance) at the very moment that Hitler was propounding his dogma of absolute certainty.

I mentioned Bronowski's formulation to Hockney, who was silent for a moment and then took it a step further. "It's not just that," he said, "because Heisenberg's and Einstein's physics actually led in two distinct directions. One of them, the more creative aspect, advanced this wider vision, the tolerance for multiple perspectives, which we've been discussing; at the same time though the other, the older, more straightforwardly technical side, was utilizing some of the ideas simply to make bigger and bigger weapons for our old myopic viewpoint of the world.

"Cubism is important for a lot of reasons," he continued, "not the least of which is that it points the way to a greater tolerance and interdependence of perspectives in a world where failure to learn such lessons could have terribly dire consequences."

From twentieth-century physics it was an obvious progression to fourteenth-century Chinese scrolls, obvious to Hockney anyway. "I want to show you something else," he said, returning to the long side counter, rummaging about again, and coming back with another book and a long rectangular box.

"Around the same time I was beginning to get into all the physics books," Hockney recounted, "I happened to be browsing in the bookshop at the Walker Art Center in Minneapolis—let's see, this would have been late 1983 or so—and I came upon a book called *The Principles of Chinese Painting* by George Rowley, very dull cover. I thought, 'Well, most Chinese painting looks the same to me.' But I opened it, noticed the chapter headings, and one of them was called 'Moving Focus.' So I started to read it, bought the book, brought it back to the hotel, and got more and more excited."

What was exciting him about it?

"Well, the attack on perspective. You realized it was an attack on perspective—it was all about the spectator's being in the picture, not outside it—an attack on the window idea, that Renaissance notion of the painting's being as if slotted into a wall, which I'd always felt implied the wall and hence separation from the world. The Chinese landscape artists with their scrolls had found a way to transcend that difficulty. In my own photocollages, some of the ones I'd done on my trip to Japan earlier that year, I'd been pushing the notion of the observer's head swiveling about in a world which was moving in time, but I'd really only just begun to try and deal with how to portray movement of the observer's whole body across space. And that's precisely what these Chinese landscape artists had mastered, according to Rowley. Here, listen."

The passage Hockney proceeded to read me was indeed highly suggestive.

"You can see how relevant that sort of talk was to my concerns at that point. A short while later I happened to be in London, and I went to see some of the scrolls at the British Museum. And then I came back to New York to work on some prints up at Ken Tyler's studio [in Bedford Village, about fifty miles from New York City], and I'd occasionally come into the city and visit the Chinese scrolls department at the Metropolitan. There was a very nice curator there named Mike Hearn, who was assigned to show me some scrolls. That first day I got very excited and was telling him why, and that was getting him excited because normally, he said, he's only showing scrolls to people in the Chinese scroll business, and I was talking about something altogether else. Most of them, the connoisseurs in that field, talk about the exquisite brushwork and the hand. Perfectly good things to talk about—in fact, I saw a direct connection in that regard to the late Picasso, in which all

the activity of painting is made visible, not hidden in layers as in a Dufy, but all very clear and transparent—but it was the way of seeing that fascinated me. Meant the viewer participated. Here, look."

Hockney reached for the rectangular box. "This is a reproduction of a Chinese scroll, which the Japanese have started to make recently. You'll see why they have to make a reproduction, because it's not possible to see this in a book, or for that matter in a museum, where it's all spread out and the effect is destroyed. You have to be able to unroll it in your own hands over time. This would have been a beautiful ivory or ebony box; in reproduction

you get wood. Once you open it, instead of an elaborate silk thing covering it, you get this bit of nylon. And then here is the scroll: something, you realize, is going to unroll. Instead of an electric motor, I will provide the energy, and I can go back and forth. This is a reproduction of a fourteenth-century landscape done in what the Chinese considered all color, which is black and white."

Hockney held the two staffs of the scroll about eighteen inches apart and began unfurling, loosening one side and picking up the slack with the other. "The point is, your body moves. See, you start here looking down on a village from a hilltop. And then, as you alter the edges of the picture, you've moved on in time, and

George Rowley

THE PRINCIPLES OF CHINESE PAINTING

Chinese Painting is an art of time as well as space. This was implied in the arrangement of the group by movement from motif to motif through intervals; in the extended relationship of groups, movement in time became the most memorable characteristic of Chinese design. . . . These early principles were later transformed and enriched until they reached their fulfillment in the supreme creation of Chinese genius—the landscape scroll. A scroll painting must be experienced in time like music or literature. Our attention is carried along laterally from right to left, being restricted at any one moment to a short passage which can be conveniently perused. This situation entirely alters the choice of design principles. . . . In the European tradition, the interest in measurable space destroyed the "continuous method" of temporal sequence used in the Middle Ages and led to the fifteenth-century invention of the fixed space of scientific perspective. When the Chinese were faced with the same problem of spatial depth in the T'ang period, they re-worked the early principles of time and suggested a space through which one might wander and a space which implied more space beyond the picture frame. We restricted space to a single vista as though seen through an open door; they suggested the unlimited space of nature as though they had stepped through that open door and had known the sudden breath-taking experience of space extending in every direction and infinitely into the sky. Again, east and west look at nature through different glasses; one tries to explain and conquer nature through science, and the other wants to keep alive the eternal mystery which can only be suggested. Each seeks truth in its own way, and each has its strengths and weaknesses. The science of perspective achieved the illusion of depth and gave continuity and measurability to the spatial unit; however, perspective put the experience of space into a strait jacket in which it was seen from a single fixed point of view and was limited to a bounded quantity of space. The control of space might give measure to an interior figure scene but it was certainly harmful to landscape painting.

Princeton: Princeton University Press, 1947, 61.

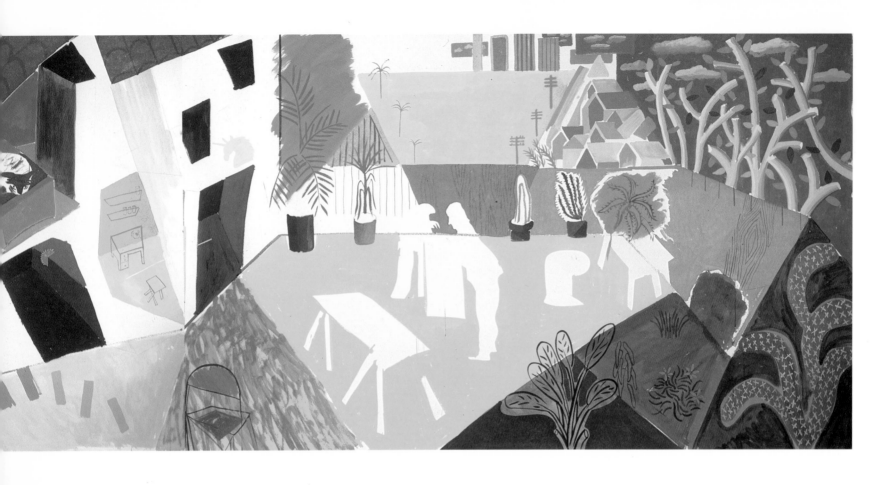
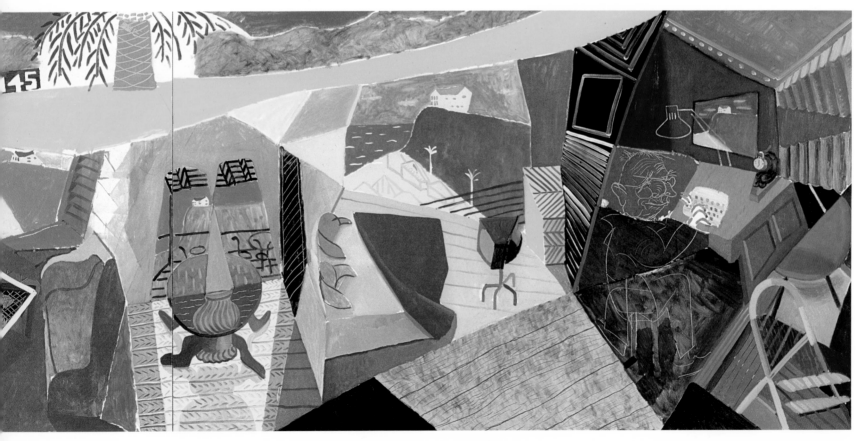

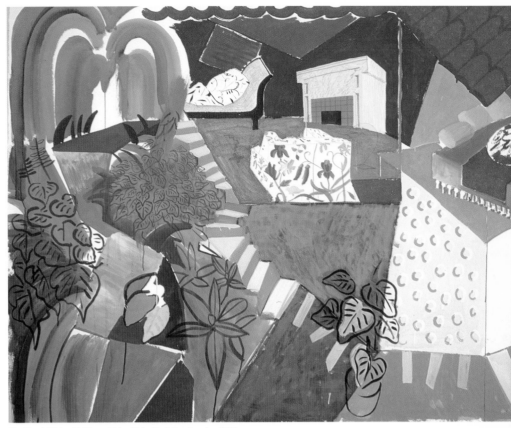

Fig. 11. *A Visit with Mo and Lisa, Echo Park, Los Angeles,* 1984

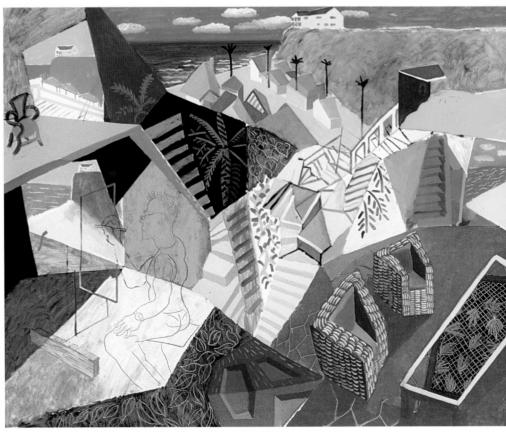

Fig. 12. *A Visit with Christopher and Don, Santa Monica Canyon 1984,* 1984

see, here, now, we've moved down into the valley, skirting the edge of the village, and now here we're looking up toward a mountaintop and, here, moving further—without any break, without panels, rather in a continuous flow of lines—we're now on top of that mountain looking down onto this lake . . . " Hockney continued for a while, narrating the journey.

"There you are," he said, concluding the demonstration, "you've walked *through* a landscape. It's a profoundly different experience from a Western landscape, which is still based on your standing stock still, really.

"Anyway, you can see why I became so fascinated. Mike Hearn showed me thirty or forty of them. The people there at the Met were themselves getting overjoyed, you know, at a practicing contemporary artist taking an interest in their arcane discipline. I ended up giving a little lecture to the staff there, you know, just twenty people or so. I think they believe they're in a backwater in a sense; I mean, obviously loving it but suspecting that everybody else thought it was a backwater, and I think they almost did themselves. And here I was telling them that these scrolls had the greatest possible relevance to the most contemporary of concerns."

One thing that began to form in my mind as Hockney spoke was an analogy to the initial situation of the Cubists. Back in 1907, when Picasso and Braque had wanted to break free of the tyranny of European Renaissance perspective, they'd drawn on non-European African sources. Here Hockney at a similar moment in his career was drawing on non-European Chinese sources.

"Yeah," Hockney concurred, when I tried the notion out on him. "They're actually the same source in a way though. If you think about the beginning of 'modern' painting, with Manet, what you see there is the beginnings of the influence of the East: Japanese prints being seen in Paris around that time and the artists being exposed to another way of seeing. Perspective was driving them crazy in a sense at the Academy and with academic narrative painting. Perspective was making it ridiculous. And here they were exposed to another way of measuring, of seeing, and they got excited: Manet, van Gogh, and so forth. And the Japanese after all derive from the much older Chinese traditions. A generation and a half later the Cubists were similarly drawn to the Africans. So that the beginnings of modern art in Europe are fundamentally anti-European."

I pointed out that ironically this was happening at the very moment of peak European colonization and subjugation of those non-European cultures.

"Wasn't it Ruskin who'd said just a couple generations earlier that there wasn't a piece of art in the whole of Africa outside Egypt?" Hockney responded. "Well, obviously Picasso didn't think so. Everything outside Europe now began to have a major influence on the trajectory of European art. They saw a fresher way, a way of making the observer participate more. *Les Demoiselles d'Avignon,* with that strange evocation of those African masks, draws you into the picture: you as the observer have to start doing things to reconstruct the space. You are getting a more vivid depiction of the *experience* of reality. And yes, for me, those Chinese scrolls at that moment helped me clear to a new way of constructing such experience into my own work."

Hockney came back to Los Angeles and in rapid succession produced a large gouache on paper portraying a visit to the Echo Park home of his friends Mo and Lisa McDermott (1984, fig. 11) and then the major two-panel oil painting of a visit with his friends Christopher Isherwood and Don Bachardy in Santa Monica (1984, fig. 12), both works heavily influenced by the Chinese scrolls and saturated with the temper of Uncertainty.

"In retrospect the gouache was still somewhat crude," Hockney explains, "but with both of these works I was trying to create a painting where the viewer's eye could be made to move in certain ways, stop in certain places, move on, and in so doing, reconstruct the space across time for itself. I was combining lessons from both the Chinese scrolls and my study of Cubism. I mean, unlike the scrolls these were going to be large images meant to be seen all at once, but the thing was, what I was aiming for was that in another sense they wouldn't be able to be seen all at once after all. They were filled with incident, but whenever you focused on any single detail everything else blurred into a sort of complex abstraction of shapes and colors, and the image as a whole was always primarily abstraction. This sense of multiple simultaneous perspectives was something I'd, of course, honed during my work on the photocollages.

"As I say," Hockney continued, "the *Visit with Christopher and Don* was considerably more complex." We were looking up at a large photographic reproduction of the two-paneled canvas (the

original of which was then in storage in New York). Following the usual disclaimers regarding the hopeless inadequacy of any photographic reproduction's conveying the experience of a large work, Hockney proceeded to use the photo as the basis for his description. "You see, it's meant to be read from left to right unlike the Chinese scrolls, although there's a kind of tribute to the scrolls in a sort of prologue, the yellow strip at the top of the canvas, moving from right to left, which represents Adelaide Drive in Santa Monica. When I drive up there, I always know when to stop because of the big palm tree, and then there, at the number 145, there's the little driveway where they park their two cars—or anyway, used to. (Dear Christopher has passed on in the meantime.) From that position you look out over Santa Monica Canyon, which is painted in reverse perspective, so it clearly places you up there looking down. You then come down the steps, and they're painted that way because it's not you looking at the steps from afar, you are actually moving down them as you approach the entryway. You come into the living room, and there are those two wicker chairs, which you might perhaps recognize from the double portrait I did of Christopher and Don back in 1968 or from some of the more recent photocollages. Anyway, from the living room you can look out the window and you see the view of the canyon again, which means you've moved, you have to have to be seeing it. We then make a little detour here to the left into Don's studio, and there's Don drawing. You can go upstairs and downstairs; you see the same view again from two different windows. Then coming back across the living room, moving rightward, you walk down a corridor, past the bedroom. If you notice, the television set, everything, is actually in reverse perspective, meaning you're moving past it, seeing first the front and then the back. And then you walk right to the end, into Christopher's studio and even past him, to the very end, at which point you're looking back on Christopher at his typewriter. You know you're looking back because he's looking out through his window, and it's the same view of the canyon. So there, you've reconstructed the space, and now your eye is free to roam about from room to room, taking in more details.

"It was a very difficult painting to accomplish," Hockney continued. "The problem was how to prevent the eye from stopping, from getting stuck. For instance, that's why both Don and Christopher are rendered transparently. When you look at Christopher, you see him, but when you move along to the bedroom and you're looking at the bed, he dissolves in a sense into patterns of green and blue and red paint. If they'd been rendered solidly, your eye would have tended to fixate on them. Similarly I had to work through several versions before I came to understand that you couldn't have too many verticals or horizontals. (There are too many in the other one, the gouache of Mo and Lisa's; that's one of the problems with it.) In fact, every time a right angle appeared, it seemed to stop the eye's moving. It's all very carefully constructed, even though it might look like chaos at first."

I returned to an earlier question. Didn't this particular oil painting, for example, represent a culmination of sorts, a more significant achievement than some of the same period's works in other media?

"I don't know," Hockney replied. "I don't think so. I mean, you're asking me a question I wouldn't normally think about too much. What you're aware of, I suppose, as the years pass, you might recognize that certain works were key works in that you realized that you really discovered something there.

"For instance, the photocollage of walking in a Zen garden, from 1983. It was the most radical one up to that point, and it's the most radical one in the *Cameraworks* volume. I'd first done an earlier version of sitting in a Zen garden [1983, fig. 14], where the sense of perspective was very strong—the rectangle of the rock garden almost read like a triangle, the perspectival V was so strong. And I started gnawing on this question of how one might present the garden as the rectangle it actually was. I mean, in drawing it would have been easy, and I suppose that with a camera one could have rented a helicopter and shot it from above looking down, but any picture you got that way would have mainly been about being in a helicopter, and I wanted to do something about the rectangular quality of this garden. And then it dawned on me that if I moved along the length of one rim of the garden and snapped a row of shots every few steps, scanning from my feet on upward toward the far rim, I'd eventually be able

Fig. 13. *The Desk, July 1st, 1984*, 1984 (in color, p. 57)

to solve my problem. When I got back to L.A. and had the shots developed and assembled the collage [1983, fig. 15], I grew very excited. My first thought was that I'd made a photograph without perspective. Comparing it with the earlier collage of sitting in a Zen garden, this one of walking seemed to me truer, not the truth, but truer. And I also realized that with this one the viewer was moving through space."

Were there other breakthroughs?

"Well," Hockney continued, "the Zen garden collages came before the Chinese scrolls. A year later, after the scrolls, I did *The Desk* [1984, fig. 13], and that was a very important piece for me because there I was really learning to establish an object in space." He pointed to the poster version of the desk collage tacked to the wall. "As you can see, it's in reverse perspective, which means you're moving about it, seeing it from one side, then the other, coming up close and looking down on it, and this opened up all sorts of possibilities for me. I'd done a space, which was the Zen garden, and now a solid object, this desk, and now the challenge was to find some way of putting them together: the object inside the space. That took time too, but in a way that's what the *Visit with Christopher and Don* painting is about and then later the big *Pearblossom Hwy.* photocollage as well."

Hockney continued looking up at the poster of *The Desk*. "The thing about reverse perspective . . . " he began and then paused. "I mean, my argument has always been that in traditional perspective infinity is a long way away and you can never meet up with it. Whereas if you reverse perspective, infinity is everywhere and you are part of it. There's a vast difference in the two

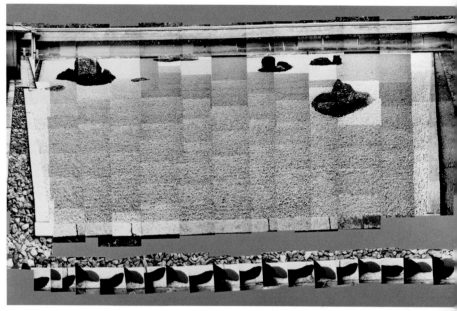

Fig. 15. *Walking in the Zen Garden at the Ryoanji Temple Kyoto Feb 21st 1983*, 1983 (pl. 107)

viewpoints, a totally different way of looking at the world. You haven't just reversed a little game, you've reversed a whole attitude toward life and physical reality.

"Furthermore," he continued, "the traditional Renaissance way is by no means the natural one. You have to be rigorously trained into accepting its conventions; the misperceptions have to be drilled into you. Look at how a child draws a house—you get the front, the sides, the back, the backyard tree, everything all jumbled together—and then the teacher comes and says, 'Wrong, wrong. You can't see all those things at once. Do it this way instead.' But in a sense the child was right in the first place; his version was more alive, and the teacher's is a more impoverished rendition. Or, for instance, a child draws a landscape, and he draws the earth at the bottom of the piece of paper, a brown line, and the sky at the top, a blue line, and a tree in the middle, perched on the brown line of the earth. And the teacher comes along and says, 'No, no. Wrong. You don't need two lines because, well, there's only one line, in the middle, where the sky and the earth meet.' Which is true in a way, but it also fails to acknowledge the piece of paper. What the child has done is taken that piece of paper and said, 'When you look up at the sky, that's the top of the page, and down at the ground is the bottom.' And that is an exact translation of sky and earth made onto a piece of paper. The other way you're looking through the piece of paper, as if it weren't there. But the child knows it is there and is dealing with that surface, at least until the teacher teaches him not to see it."

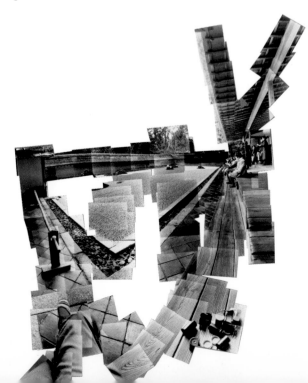

Fig. 14. *Sitting in the Zen Garden at the Ryoanji Temple Kyoto Feb. 19 1983*, 1983 (pl. 106)

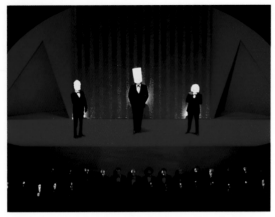

Fig. 16. *Oedipus Rex*, Metropolitan Opera, 1981

As Hockney was speaking, I was again reminded of the childlike quality of much of his early work from his Boy Wonder period in the late fifties and early sixties. I asked him whether he'd been dealing with these sorts of issues even then. "Not in so many words," he replied, "not in these terms. But I have recently been looking back over some of that work, and there are certain striking continuities, things which I've only just now become able to see.

"One of them, for instance, occurred to me a while back when I was reading David Bohm's book, where he talks about how borders must be broken—'for every border is a division or break' —and it occurred to me that probably the most consistent theme in my work is actually that. For instance, there's a little painting from 1962. What happened was that a friend of mine had bought this very elaborate little wooden frame, and I said, 'What are you going to do with that?' He said he was going to put a mirror in it or something, and I said, 'Oh, don't do that. I'll make a painting for it; it seems such a shame, such a beautiful frame.' But what I painted in the frame was a little man, wedged in tight, who's touching all four sides of the picture, and he's shouting, 'Help!' In short, he's really trying to get out of the picture frame.

"Or think of all those early paintings of curtains. People say, 'Oh, they're about the theater.' But you can also read them in another way, for the figures are standing in front of the curtain, which means, again, you're breaking an edge. There's the edge around the four sides, but there's also the implicit edge in front, the glass separating the painting world from the world of the observer. And in some of those early paintings—for instance, *Play within a Play*, from 1963—the figures in the painting are desperately trying to cross over that boundary.

"The theme occurs throughout my work," Hockney went on. "For instance, in the stage designs. In the last piece of theater

work I did before this *Tristan*, the Stravinsky triple bill back in 1981 at the Met, we did *The Rite of Spring* followed by *Le Rossignol* followed by *Oedipus Rex*. And what we did was, *The Rite of Spring* was staged way at the back of the stage; *Le Rossignol* was almost like Italian theater, with the proscenium all around it; and by the time we got to *Oedipus,* to make it like Greek theater, we lit up the proscenium, which had the effect of making that into the set; the whole theater becomes the set [fig. 16], which again is breaking a border, breaking an edge. And you begin to realize what edges do: they're not just showing us things; they're cutting off far more than they're showing us. The edge is the problem. It's the major problem we have to deal with. I mean, it will always be there, but it can be softened with different ways of looking, a more complex image, and that's what we now need to do."

Back in *Play within a Play* (fig. 17) what Hockney had been playing with was the notion of a figure—the painted rendition of a character looking remarkably like himself—trying to step out from the rigidly perspectival world (note the floorboards) of the painting. He can't do it; his face literally gets smudged up against the imaginary glass of the Renaissance window pane. In his latest work, though, it's as if Hockney had reversed the terms of the problem. The world of the painting no longer has to get out to reach the observer, because the observer has gone *in*.

"In *Pearblossom Hwy.*," Hockney now commented, "which is far and away the most complex and the most successful of the photocollages I've done so far—it took me over nine days just to photograph and another two weeks to assemble—the results are quite powerful, I think, in the sense that you're deeply aware of the flat surface but at the same time you start making a space in

Fig. 17. *Play within a Play*, 1963

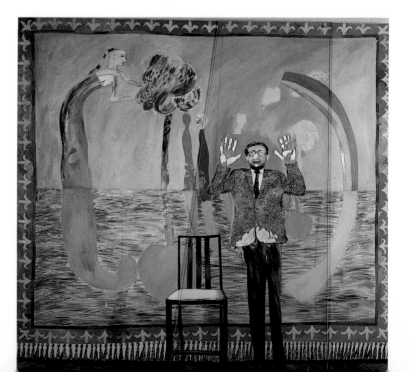

your head. And yet the space is not the illusionistic kind where you feel, 'Oh, I could walk into that,' which is the old type of illusion and sort of a cheat or a contradiction anyway. You're saying, 'Oh, I could walk into that,' only if you tried, you'd kill yourself or you'd hurt yourself anyway; you'd be walking into a brick wall. No, here you don't feel you need to walk into it because you're already in it.

"That's what my most recent work has been about essentially," he continued, "*Pearblossom Hwy.,* the Home Made Prints, the paintings which I've been able to do the last few weeks based on some of the lessons about surface I've gleaned in doing the photocopy prints. Take a look at *Pearblossom,* and then take a look at a standard photographic rendition of the same scene [figs. 18–19], and you realize that you're beginning to deal with a more vivid way of depicting space and rendering the experience of space."

I'd been meaning to ask Hockney something almost since the moment of my arrival (although I had been a bit shy to do so) for there had been a striking change in his physical appearance since the last time I'd seen him several years earlier; he was conspicuously wearing a hearing aid. Actually he was wearing two hearing aids, one in each ear. Now I did ask him about them.

"Well," he replied, "I first realized I was losing my hearing back in 1979. I was giving a seminar in San Francisco, and I kept having to tell the people in the back of the room to repeat their questions; I couldn't hear them. I could see that everybody else could hear them, and I thought, this is strange. I went to have my hearing checked, and they told me I'd already lost 20 percent. They gave me a little hearing aid, but I didn't use it much, didn't think about it much, and eventually even lost the thing. But the hearing loss was having an effect apparently—I was getting more antisocial, in a way, because I just couldn't hear people—and it was getting worse. Sounds were getting both dimmer and more blurred. So in 1984 I went to some specialists, and they all told me the same thing, that it would continue to get gradually worse, there was nothing you could do to arrest it really, but that a more sophisticated hearing aid would help. So I got one, and the moment I put it on, it was like a big muffler had been taken off my head. The guy had said either ear would do since they're both the same. So I went back, and I said, 'I think I'll take two actually.'

He said not too many people put two on; they think it looks too bad, makes you look old. I said, 'I don't really care what it looks like. I'd rather hear.' I mean, I'm not vain in that way. I wanted him to make me a red one and a blue one."

Mismatched. Like his socks.

"I mean," he continued, "you'd have to be daft to think that nobody's going to notice it. But who cares? People come up to me now, and they ask, 'Have you got hearing problems?' and I say, 'Well, I used to have, but I don't now.' It's made a world of difference. Everybody comments on how my body movements have changed: I don't lean over, I can lie back and listen, I don't have to be watching people's faces, lipreading."

The first half of the 1980s, the period when Hockney was struggling with his hearing, also happens to be the time when he was becoming increasingly consumed by his renewed investigations of visual space. I asked him whether he thought there was a relation.

"Well," he said, "of course, hearing is spatial. It is spatial in its essence. It helps you define space—somebody is speaking behind you, there's a noise over to the side—it helps give you your

Fig. 18. *Pearblossom Hwy., 11–18th April 1986,* 1986 (in color, p. 65)

Fig. 19. Pearblossom Highway, Palmdale, California, 1986

bearings in the physical world. Surely as my hearing began to grow muffled, I was having to rely more on my vision. There's the old truism regarding blind people that they use their hearing to help locate themselves and that therefore they probably develop more acute hearing. Well, the reverse must also be true: a loss of hearing ought to lead to more acute vision and in particular visual perception of space. Ordinarily nobody would know, nobody could see the change, unless you were somebody who used vision in some particular way, say, as an artist. So, sure, I think that has been an important influence in the past several years."

Another way of talking about the photocollages and the recent paintings is that they are the product of a man who was suddenly having to look listeningly. And who heard.

At this point in our conversation Stanley came barging in. Well, "barging" is a bit strong. Trotting? Scampering? Slip-and-sliding? There was a lot of yelping involved. He was still a pup, and coordination was not his strong suit. Hockney scooped the baby dachshund into his arms, nuzzled him close to his cheek, and then carried him back over to the photocopying machine to have a look at the just completed portrait.

"This is little Stanley," he explained, "named after the Great Stanley, of course." David cocked his head in the direction of a small oil portrait, hanging on the wall, of Laurel and Hardy. The portrait is the work of David's father, who'd been a great fan. "Everybody's been surprised I got a dog. All my friends are shocked. I don't know why. But one reason I never had animals was that for many years I lived like a gypsy—I was always going off—and you can't, for example, take a dog in and out of England. Even the queen can't. So I didn't even entertain the thought. But recently my friend Ian got a little pup, which I loved–did a portrait. And then a few months later, Ian said, 'He's going to have some little brothers in another litter.' And suddenly I thought, maybe I'll get a dog. So I went over, picked Stanley out— he was only about this big—brought him home. He looked frightened to death. I put a rubber ball in front of him, he just stood there looking at it, and I did a painting of that. At first I thought, 'Oh my God, what have I done? I've made a terrible mistake. I'm going to have to fuss around. I won't be able to go anywhere.' But the problem is, within three days you've fallen in love with this little creature, you realize how, you know, he's relying on me, he

wants to sleep in the bed, he puts his little head on the pillow next to mine. Clearly he either thinks I'm a big dog or he's a little person. I don't know which. But I love him actually."

It was interesting, I pointed out, reflecting on Hockney's comment about his former gypsy life and recalling his earlier allusion to Buckminster Fuller, that at the very moment his work was shooting off into outer space, as it were, he was taking on anchors that were going to tie him down to home.

"That's it," Hockney agreed.

And Stanley was the icon that represented . . .

"That makes me stay here."

He was able to deal with Stanley because he'd achieved that centeredness?

"I've got an excuse to people: Stanley is here. I can't possibly leave Stanley. And actually I've got a lot to do. There are a hundred things I want to be doing. I'm going back into painting; I can feel it coming on strong. I want to stay in one place now. It's mad to always be going off. I'm going to be fifty next year . . . "

Was turning fifty going to be important for him? The retrospective was going to be touring during his fiftieth year.

"Well, I don't see it as a retrospective. I just see it as work done up till now, that's all. Fifty doesn't make any difference to me, although I did laugh at Nick Wilder's comment the other day. He went to somebody's fiftieth birthday, and they said to him, 'Oh, come on, fifty's only middle age,' and he said, 'How many do you know of a hundred?'

"But I'd rather be isolated to do what I want to do now. There's a point when you're young and you need other artists; you feed off other people's ideas as well. But there comes a point when you have to sort stuff out for yourself; you don't need the stimulus anymore. You've had enough actually. I'm aware of that now. I've quite enough stimulus these days from myself. I also enlighten myself. I don't mind if I never go out. I don't mind if I never get invited anywhere. I amuse myself. Especially with Stanley. Because I need to talk to myself out loud, and before I felt a bit of a fool. So naturally Stanley can hear all the lectures now. He listens, and he keeps coming back for more.

"Like I say, one of the main reasons I used to travel was to get away from all the nattering. But I won't have to be worrying about the natterers anymore. Stanley's going to growl at them when they come to the door."

PLATES

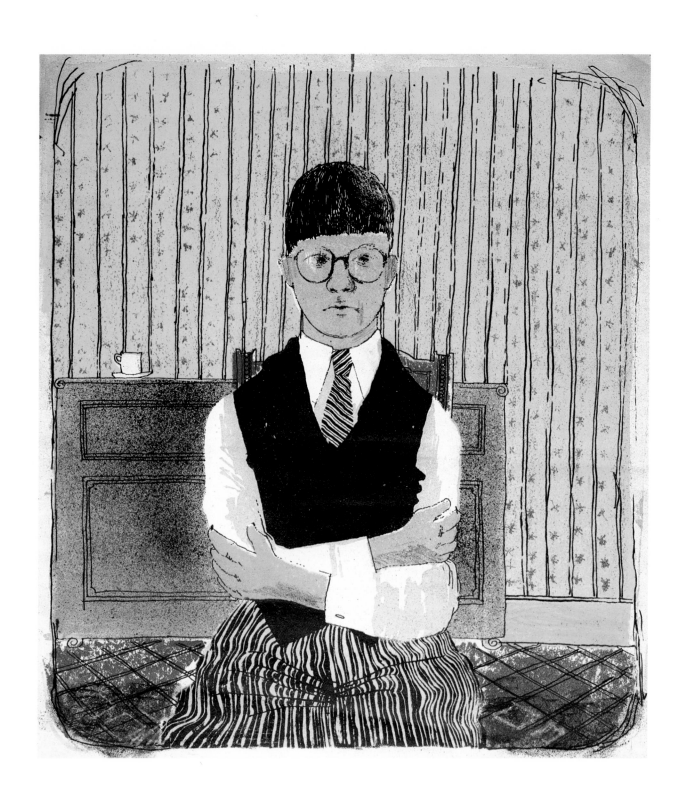

1

Self-Portrait
1954

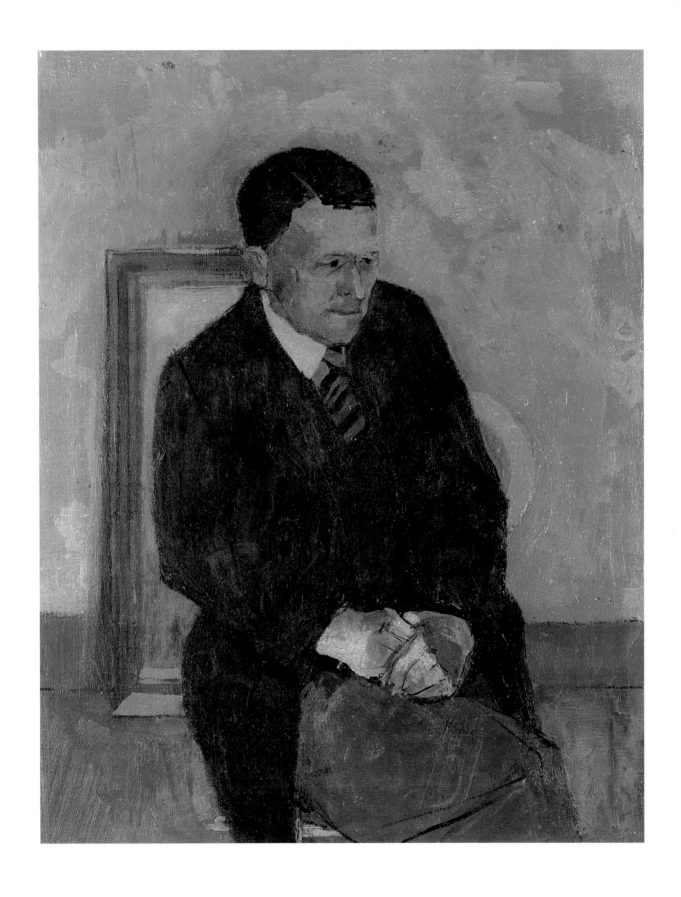

2

Portrait of My Father
1955

3
————

Bolton Junction, Eccleshire
1956

4

Nude
1957

5

Kaisarion
1960

6

The Fourth Love Painting
1961

a *The Arrival*

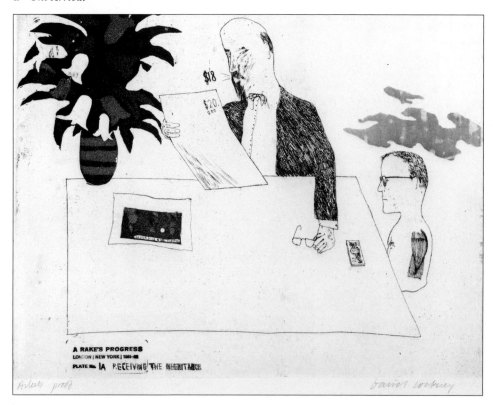

b *Receiving the Inheritance*

7

A Rake's Progress
1961–63

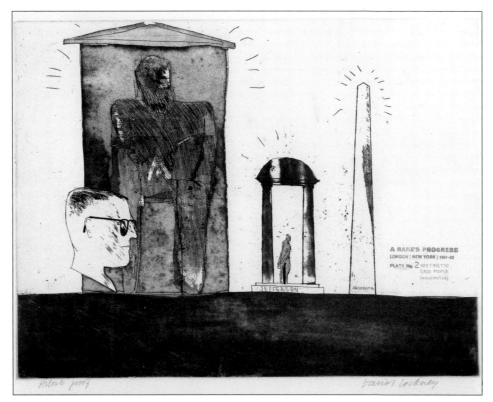

c *Meeting the Good People (Washington)*

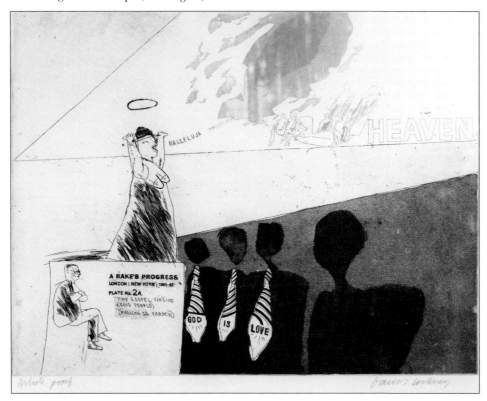

d *The Gospel Singing (Good People) (Madison Square Garden)*

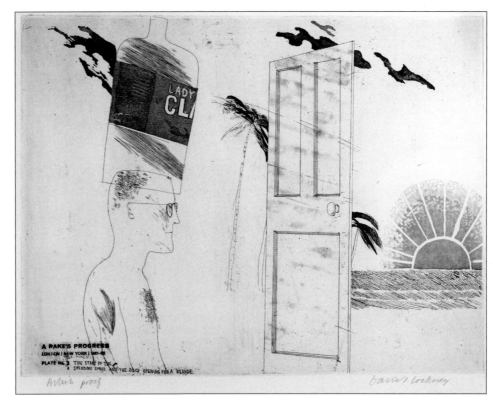

e *The Start of the Spending Spree and the Door Opening for a Blonde*

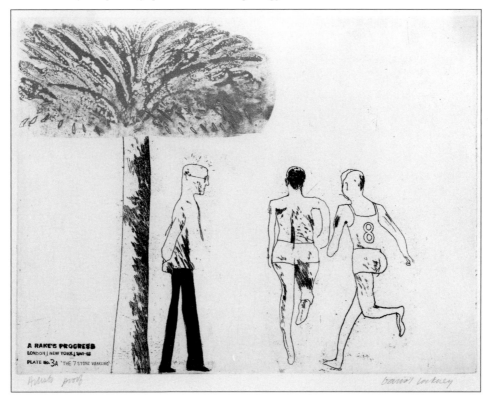

f *The 7-Stone Weakling*

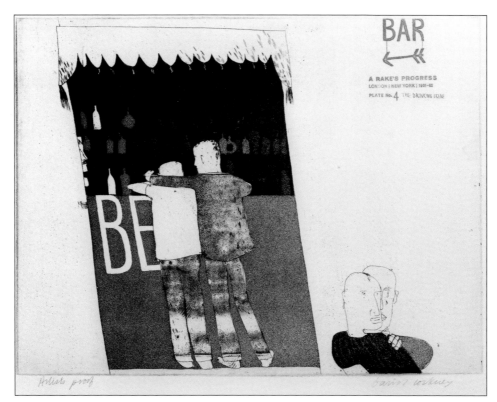

g *The Drinking Scene*

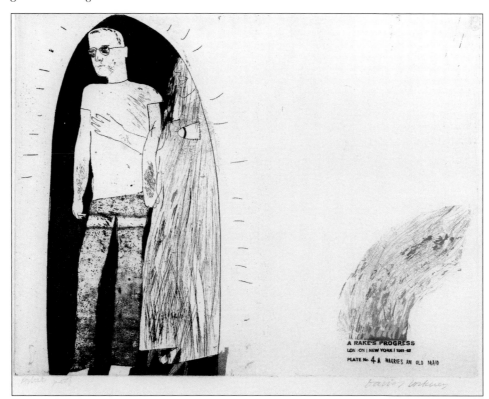

h *Marries an Old Maid*

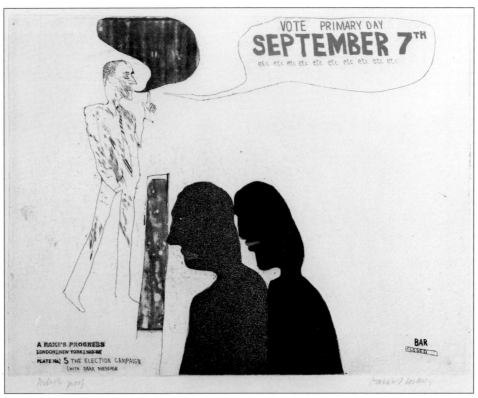

i *The Election Campaign (with Dark Messages)*

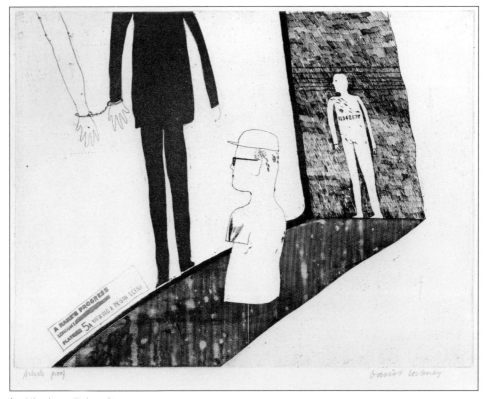

j *Viewing a Prison Scene*

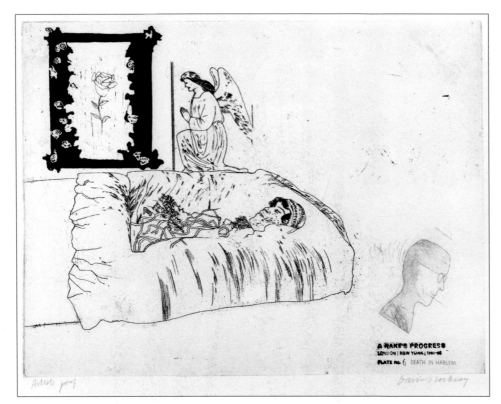

k *Death in Harlem*

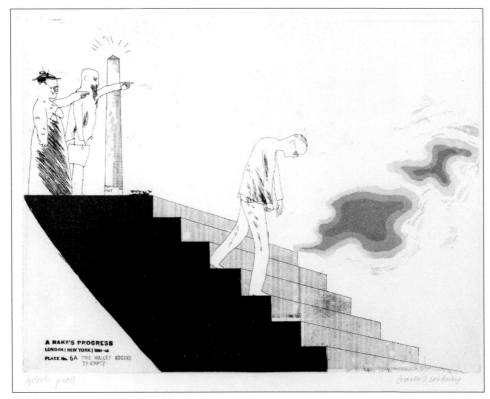

l *The Wallet Begins to Empty*

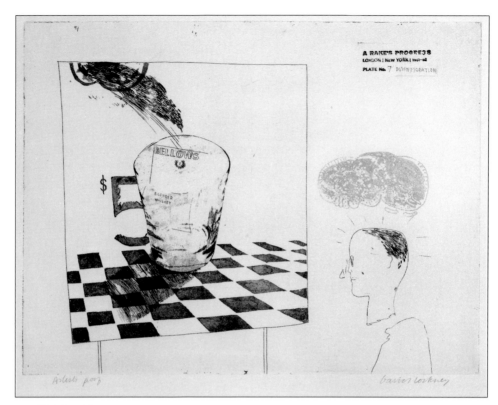

m *Disintegration*

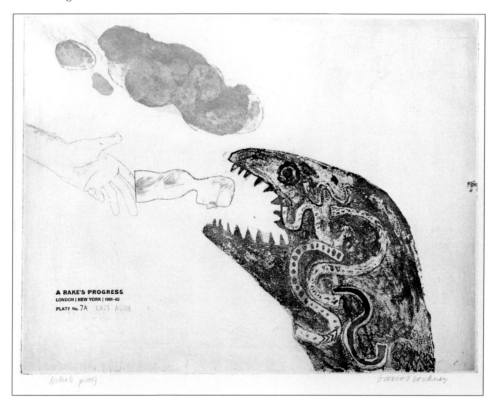

n *Cast Aside*

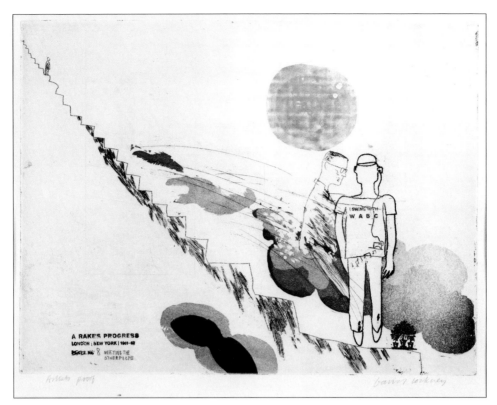

o *Meeting the Other People*

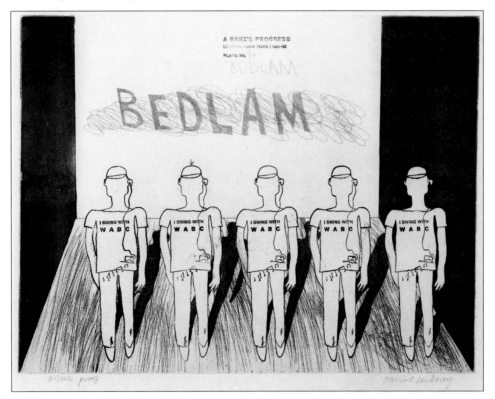

p *Bedlam*

8

Religious Area with Equal Unreligious Area
1961

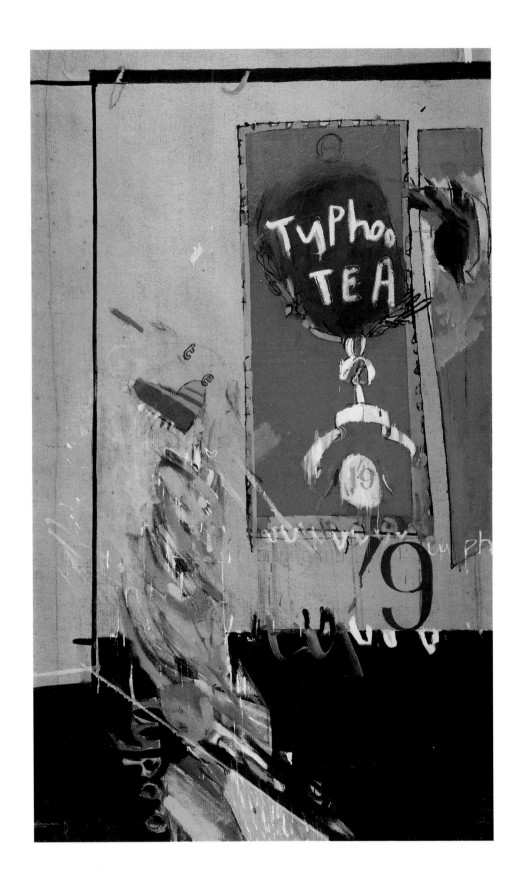

9

The Second Tea Painting
1961

10

———

The Snake
1962

11
———

The Cruel Elephant
1962

12

The First Marriage (A Marriage of Styles 1)
1962

120

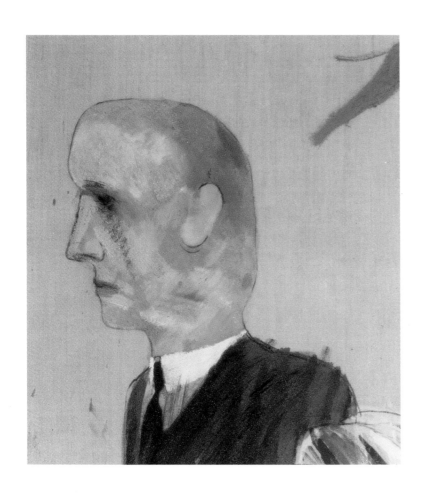

13

A Man Stood in Front of His House with Rain Descending
1962

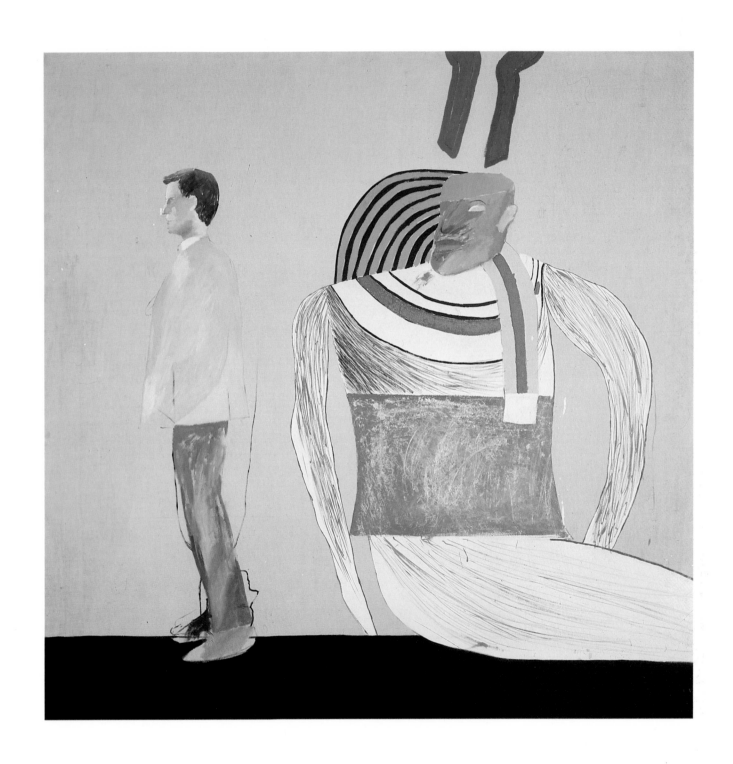

14

Man in a Museum (or You're in the Wrong Movie)1962
1962

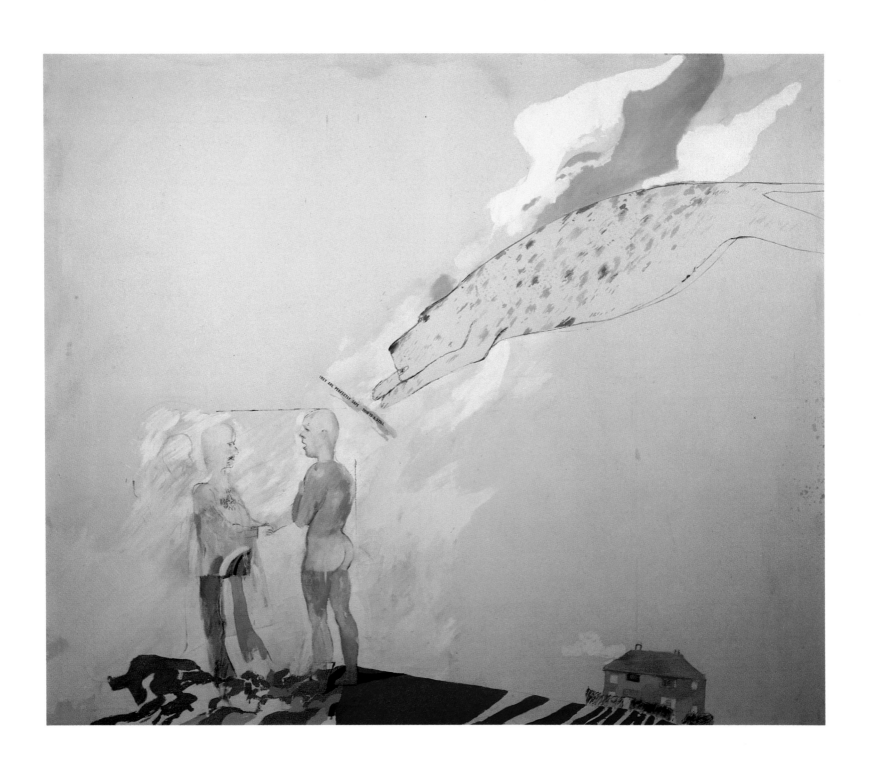

15

Picture Emphasizing Stillness
1962

16

Domestic Scene, Broadchalke, Wilts.
1963

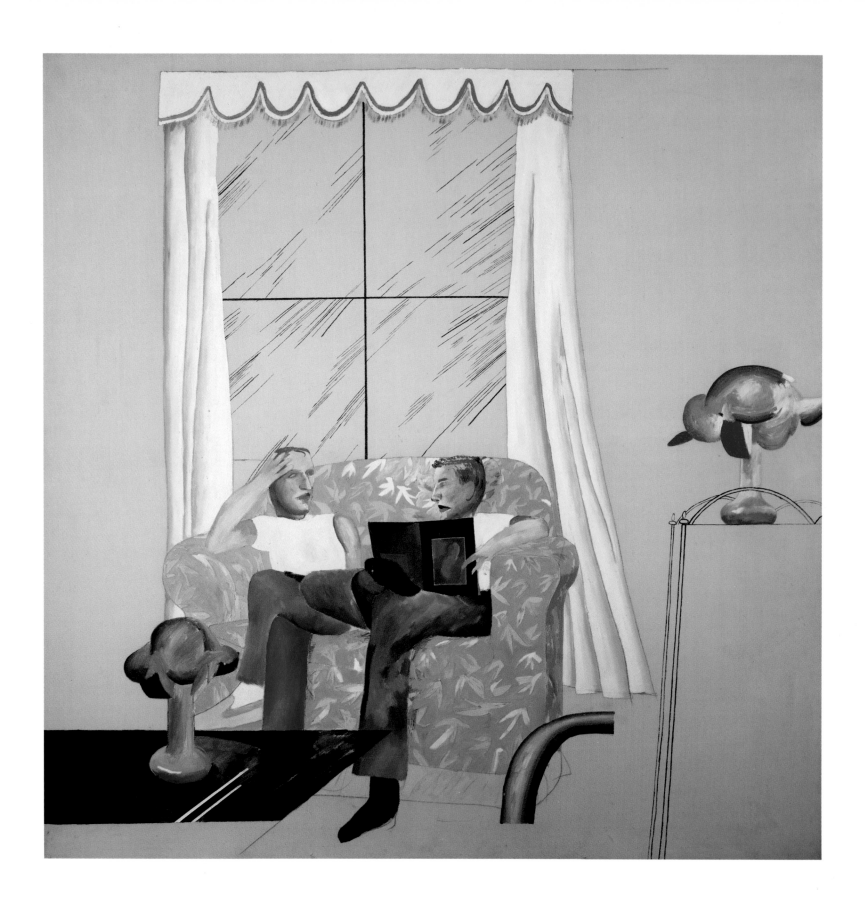

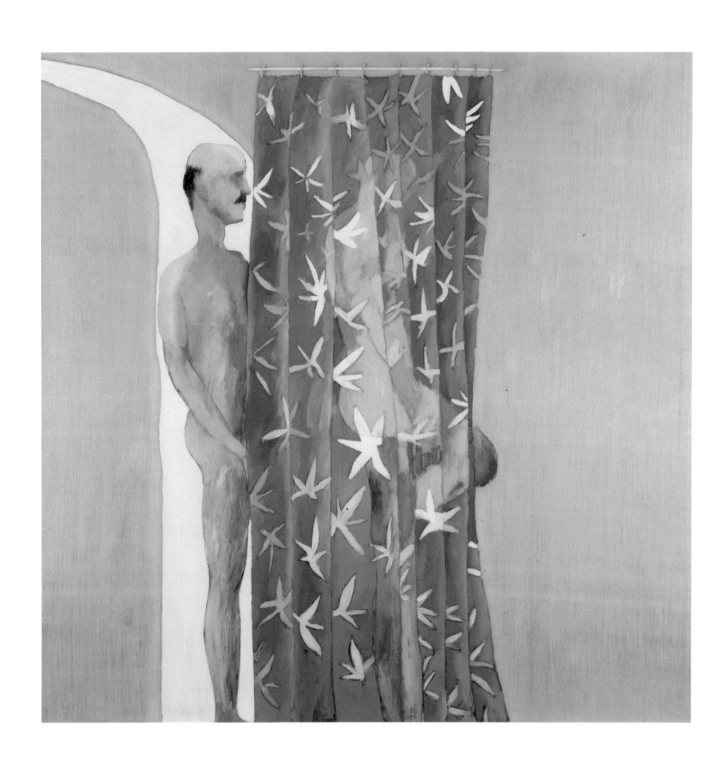

17

Two Men in a Shower
1963

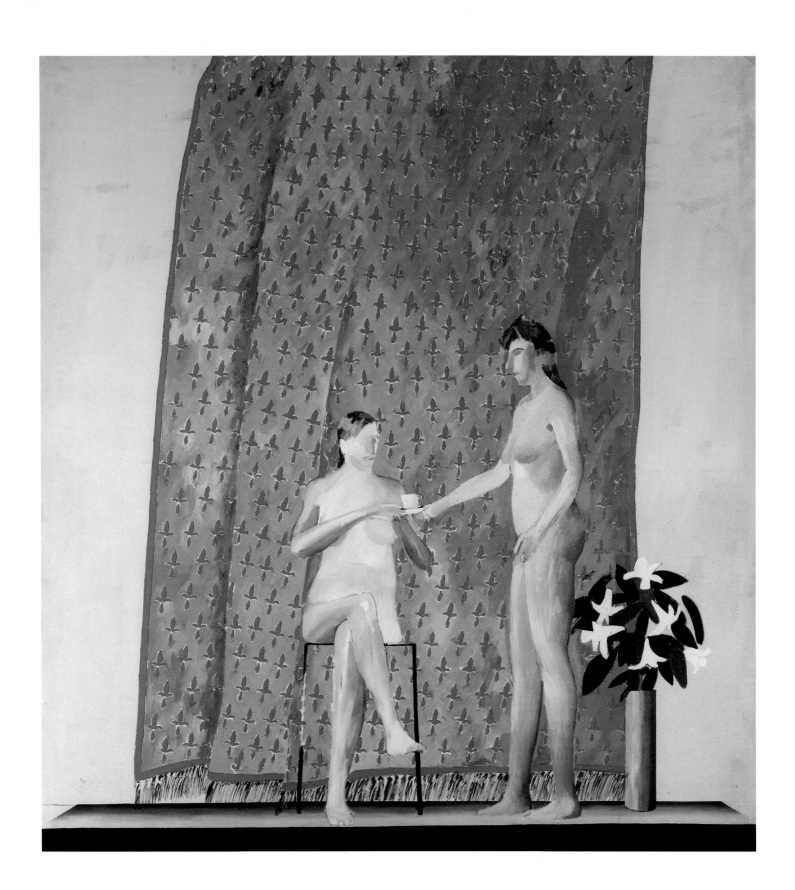

18

Seated Woman Drinking Tea, Being Served by a Standing Companion
1963

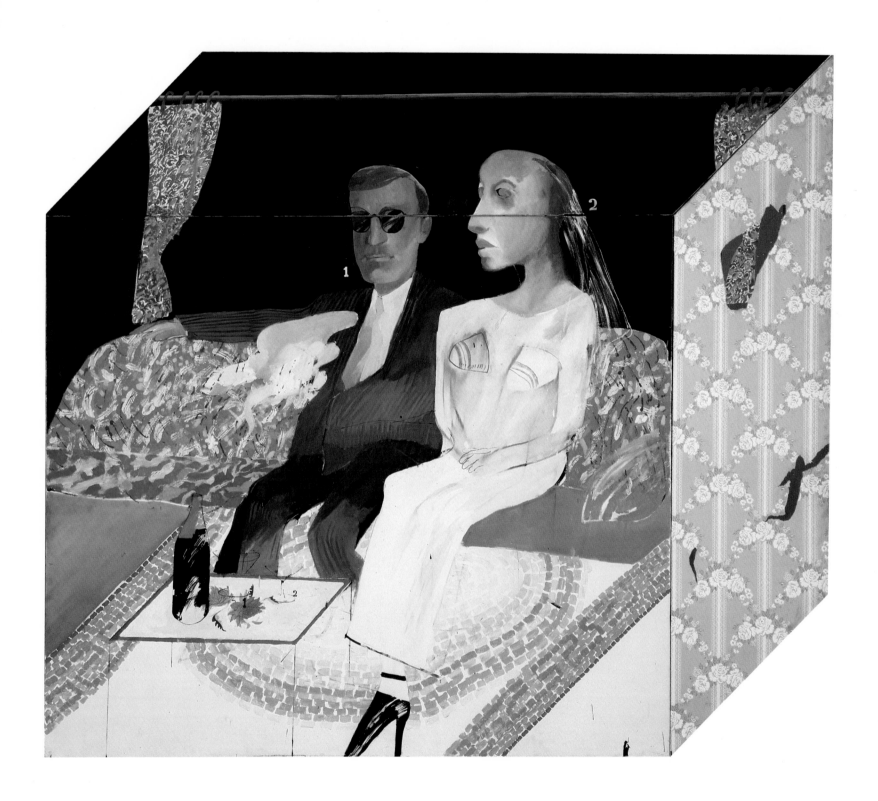

19

The Second Marriage
1963

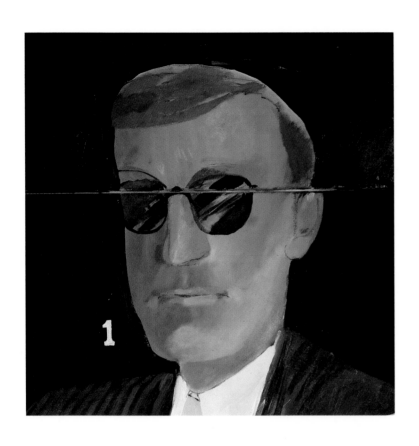

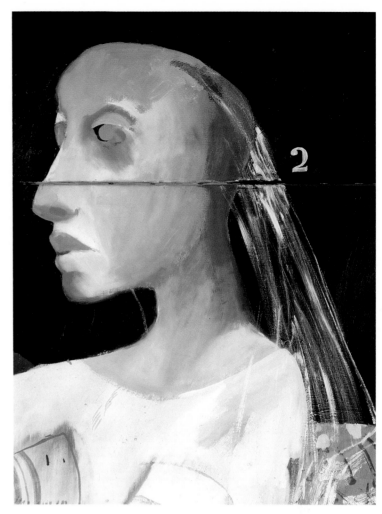

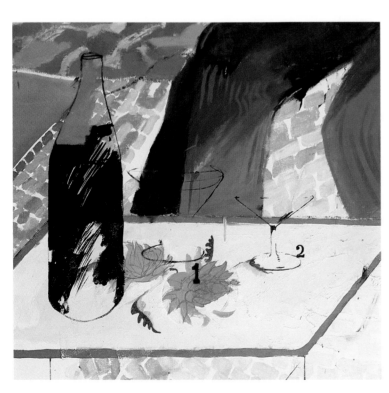

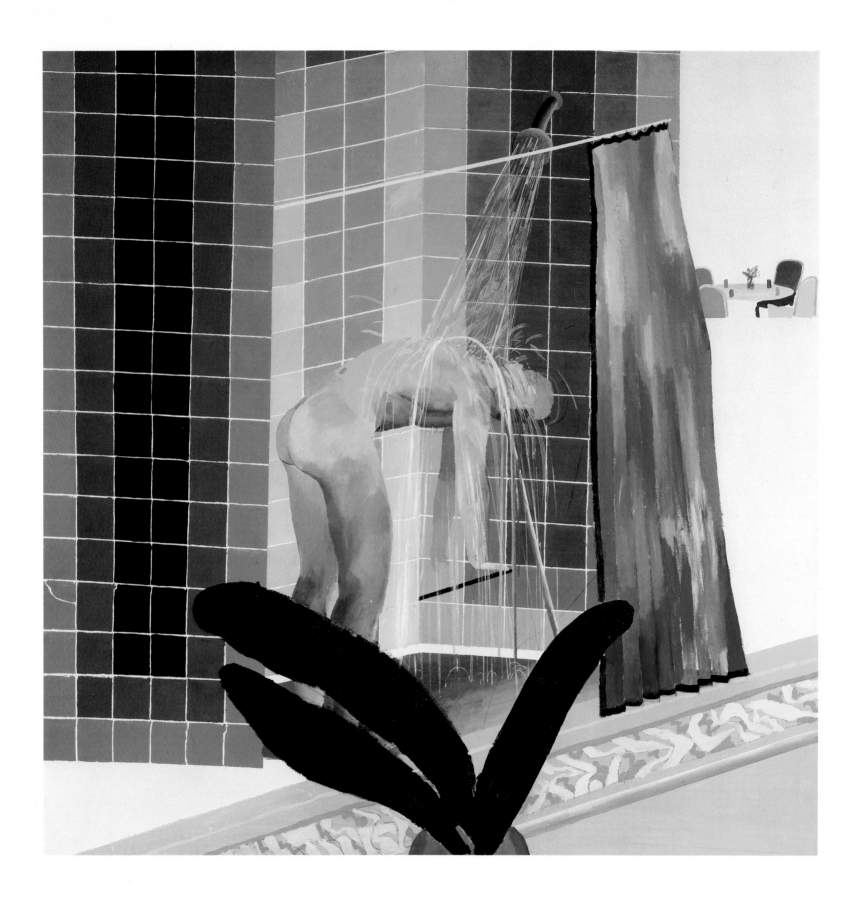

20

Man Taking Shower in Beverly Hills
1964

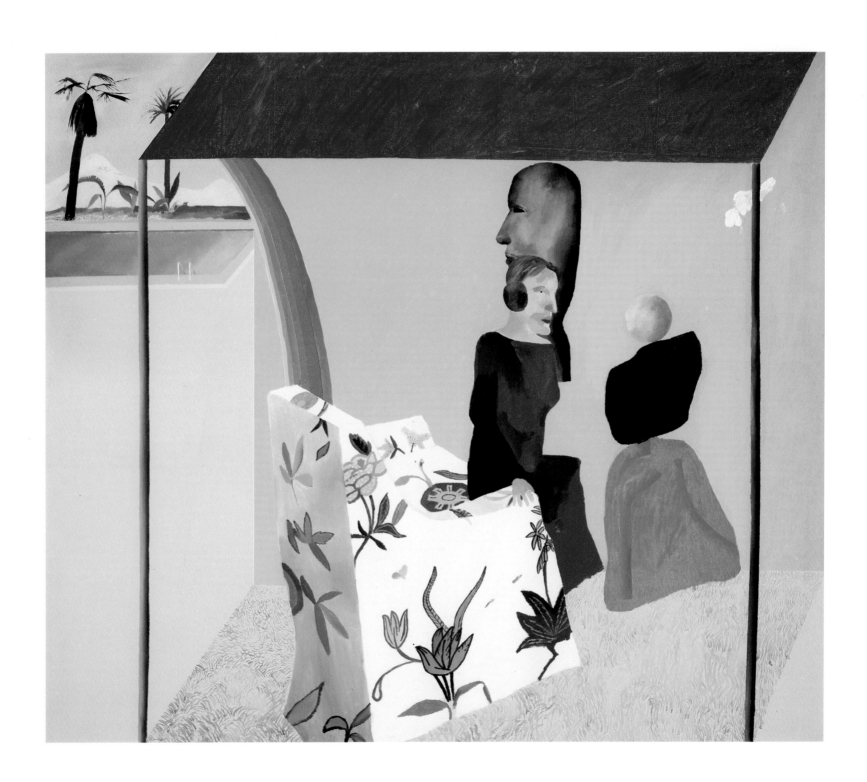

21

California Art Collector
1964

22

Pacific Tree
1964

23

Iowa
1964

24

Ordinary Picture
1964

25
——
Rocky Mountains and Tired Indians
1965

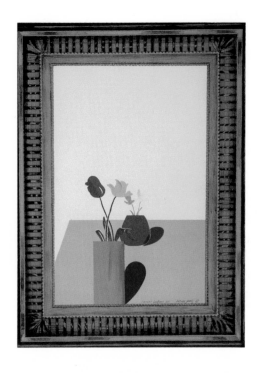

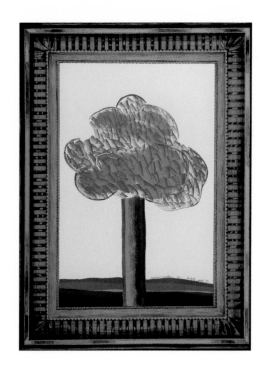

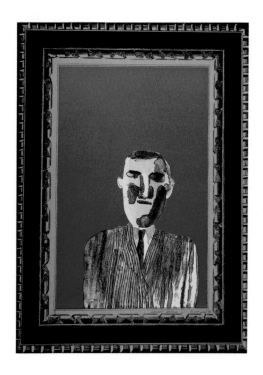

26

A Hollywood Collection
1965

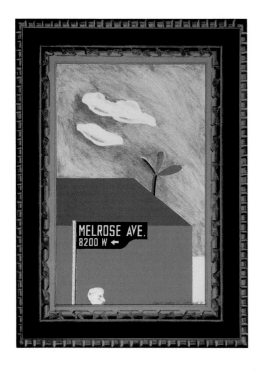

a *Picture of a Still Life That Has an Elaborate Silver Frame*

b *Picture of a Landscape in an Elaborate Gold Frame*

c *Picture of a Portrait in a Silver Frame*

d *Picture of Melrose Avenue in an Ornate Gold Frame*

e *Picture of a Simply Framed Traditional Nude Drawing*

f *Picture of a Pointless Abstraction Framed under Glass*

26A

Picture of a Hollywood Swimming Pool
1964

27

Different Kinds of Water Pouring into a Swimming Pool, Santa Monica
1965

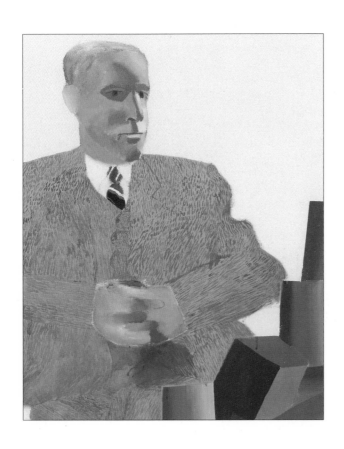

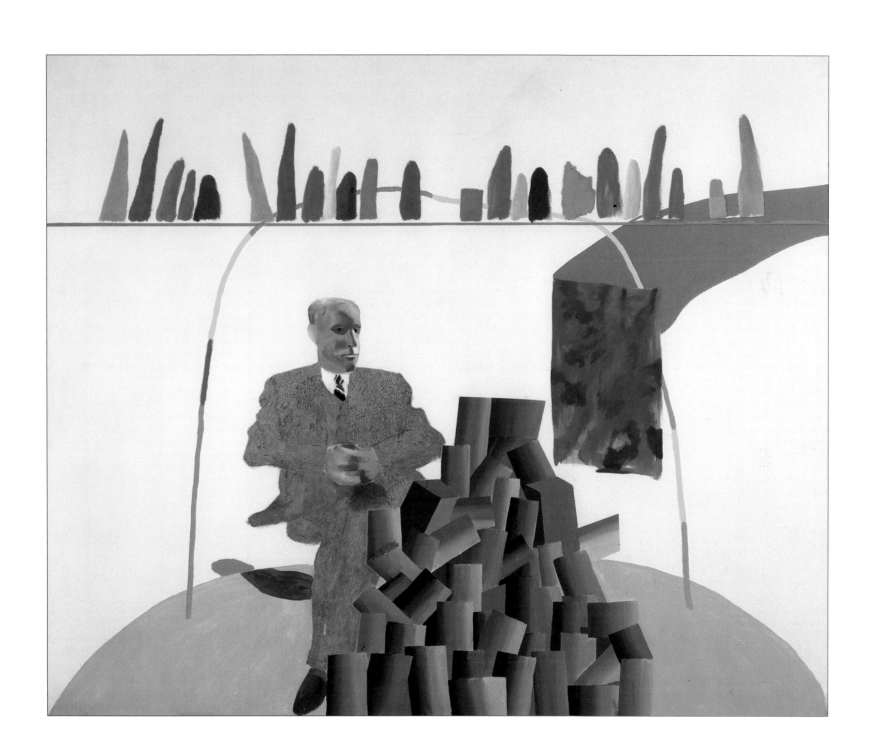

28

Portrait Surrounded by Artistic Devices
1965

29

A Realistic Still Life
1965

30

A Less Realistic Still Life
1965

31
——

Two Boys in a Pool, Hollywood
1965

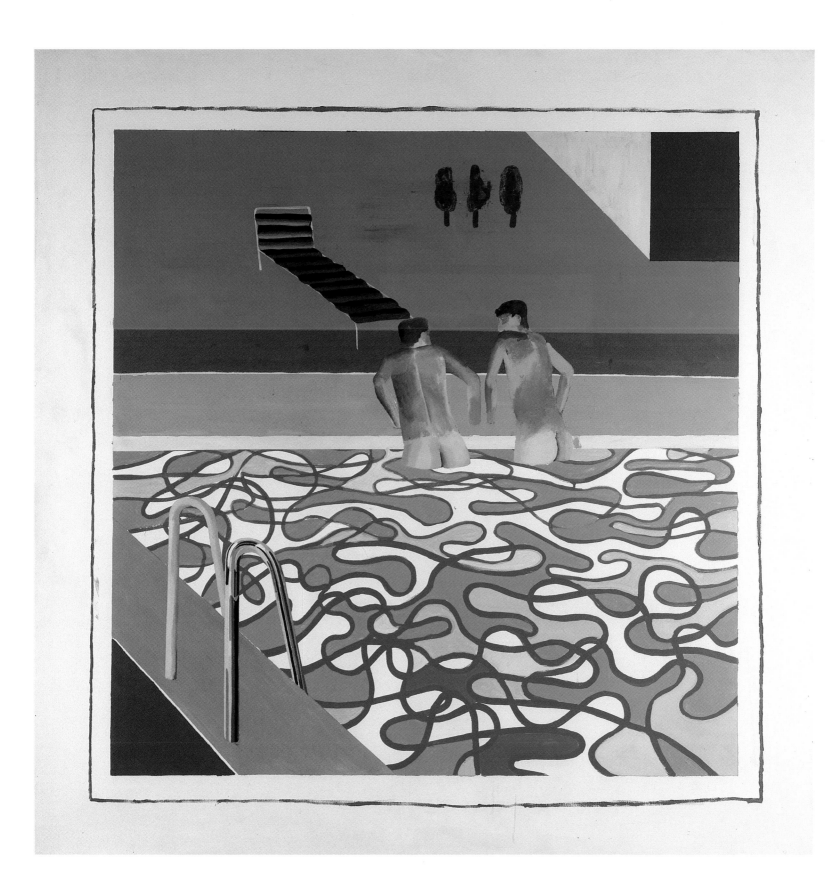

32

Beverly Hills Housewife
1966

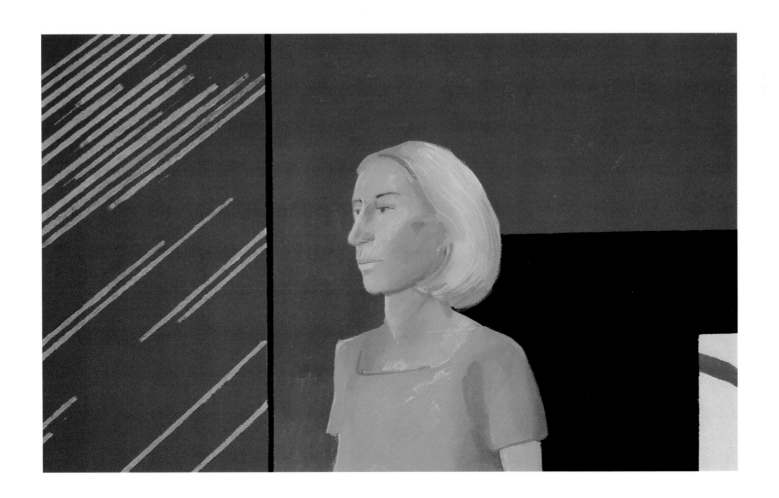

153

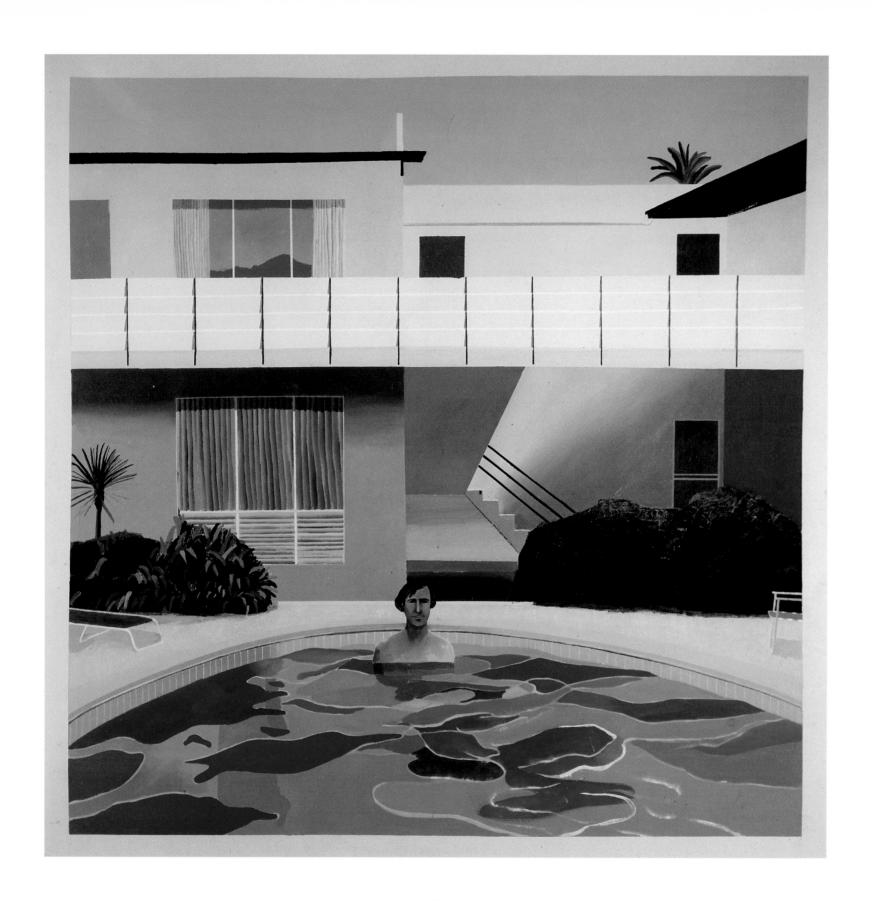

33

Portrait of Nick Wilder
1966

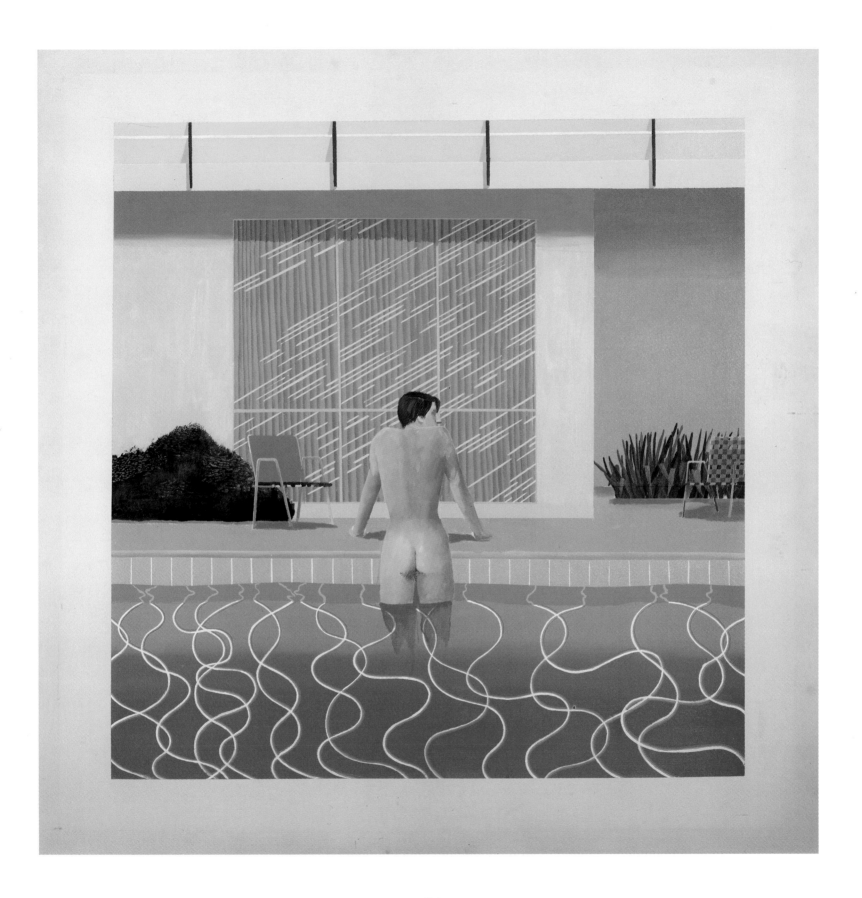

34

Peter Getting out of Nick's Pool
1966

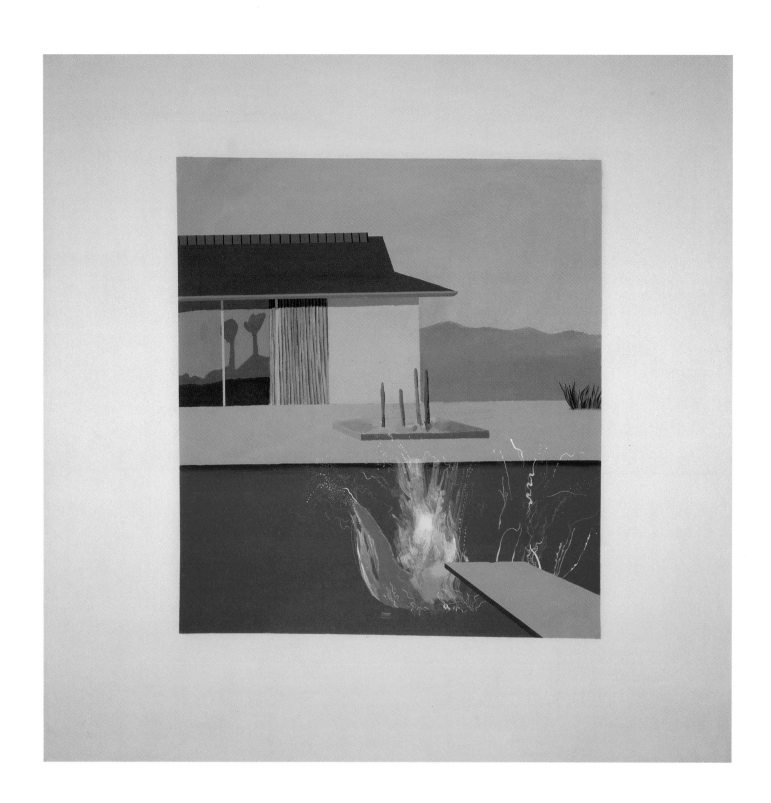

35

The Splash
1966

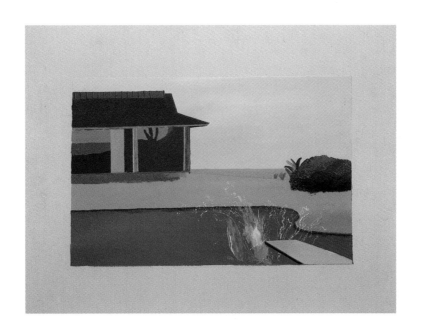

36
———

The Little Splash
1966

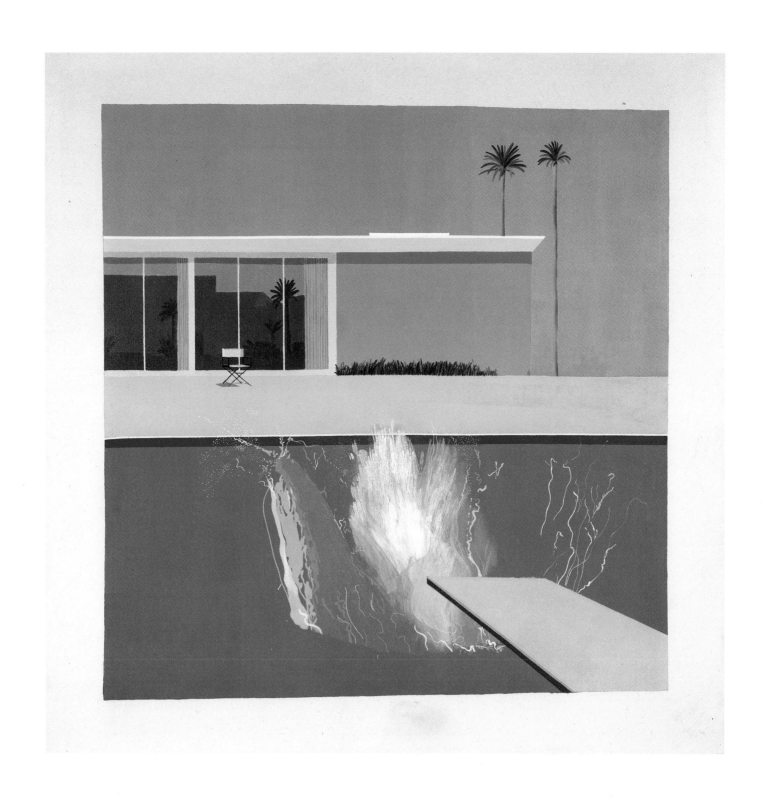

37

A Bigger Splash
1967

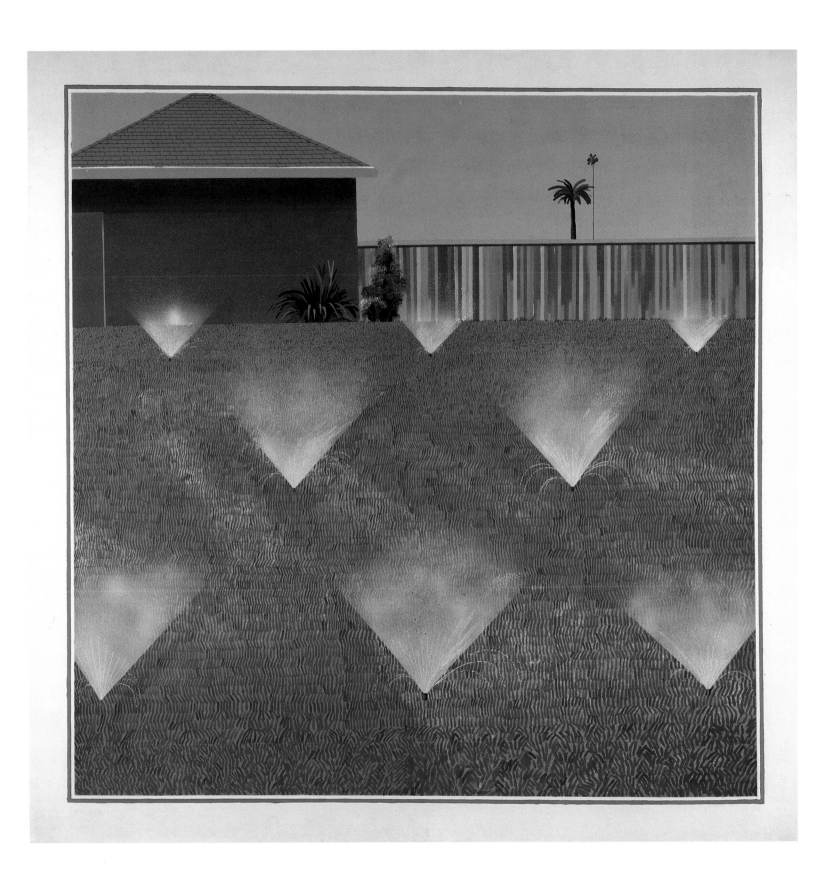

38

A Lawn Being Sprinkled
1967

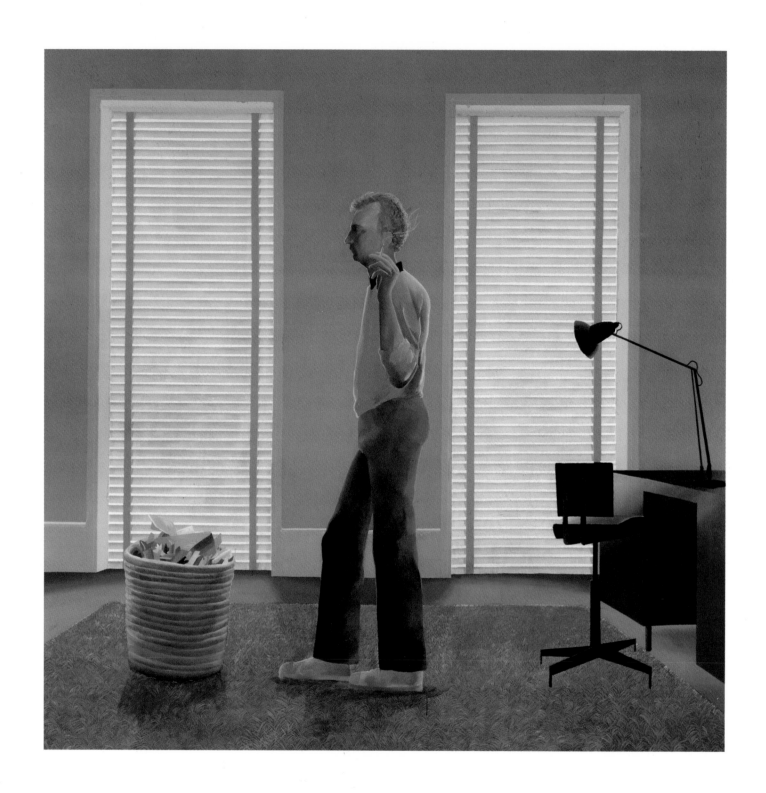

39

The Room, Manchester Street
1967

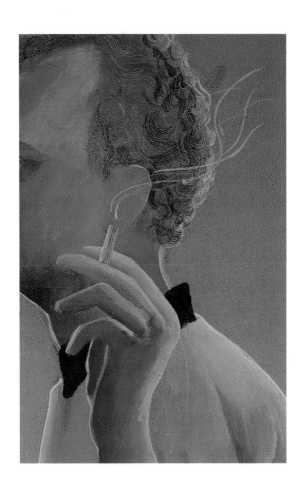

40

Some Neat Cushions
1967

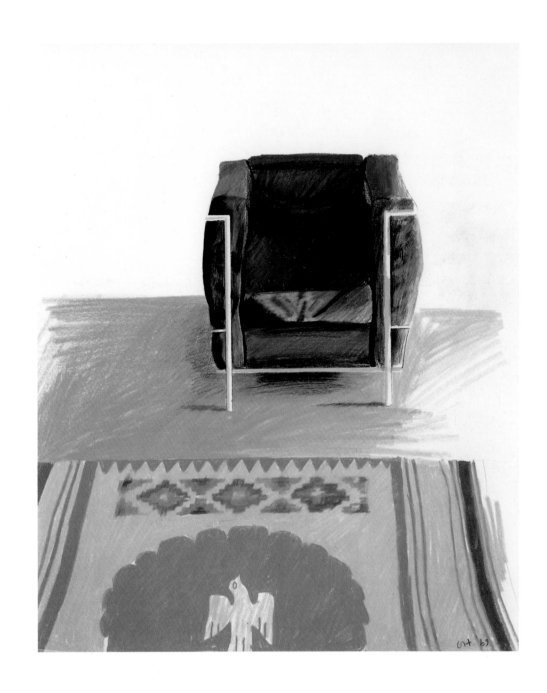

41
—
Corbusier Chair and Rug
1969

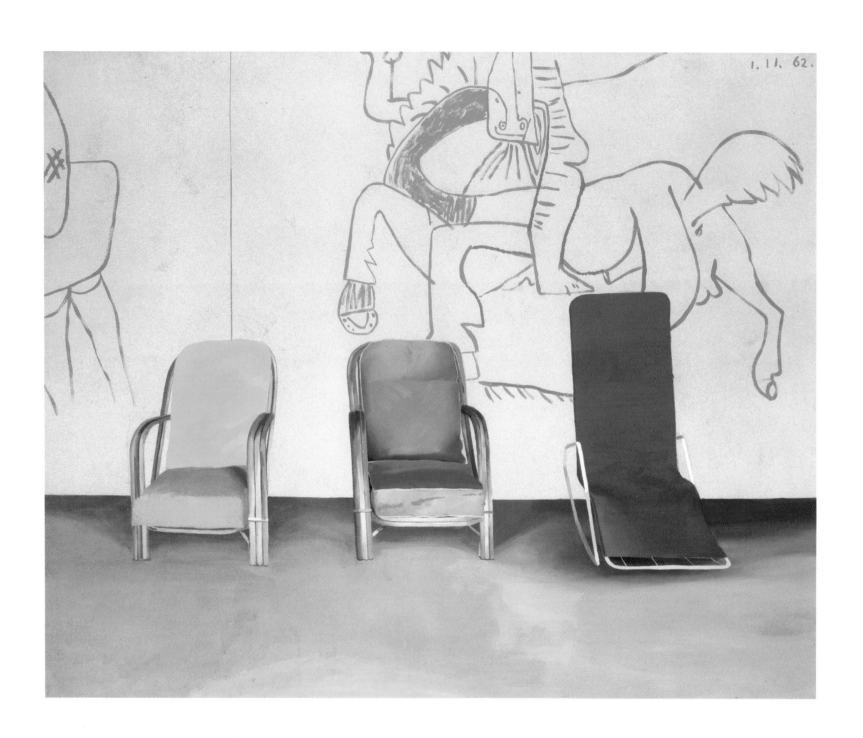

42

Three Chairs with a Section of a Picasso Mural
1970

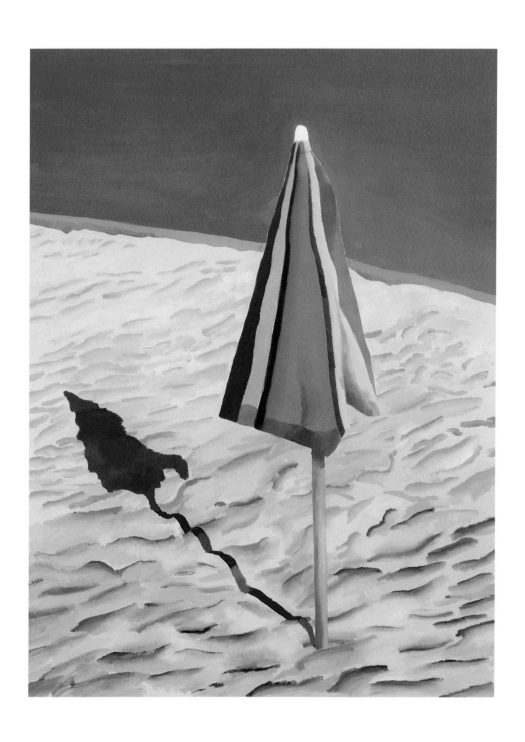

43

Beach Umbrella
1971

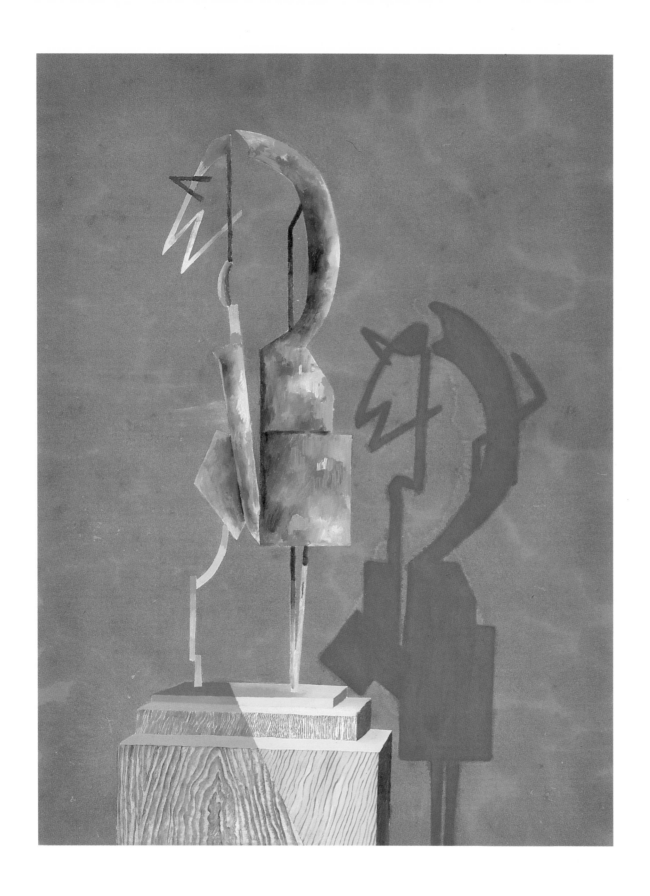

44

Gonzalez and Shadow
1971

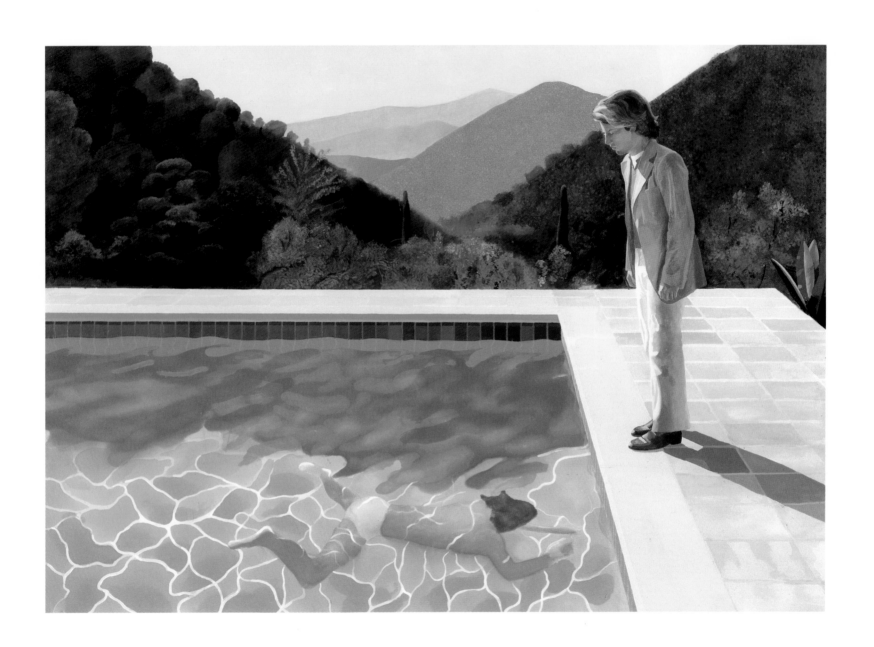

45

Portrait of an Artist (Pool with Two Figures)
1971

46

Rubber Ring Floating in a Swimming Pool
1971

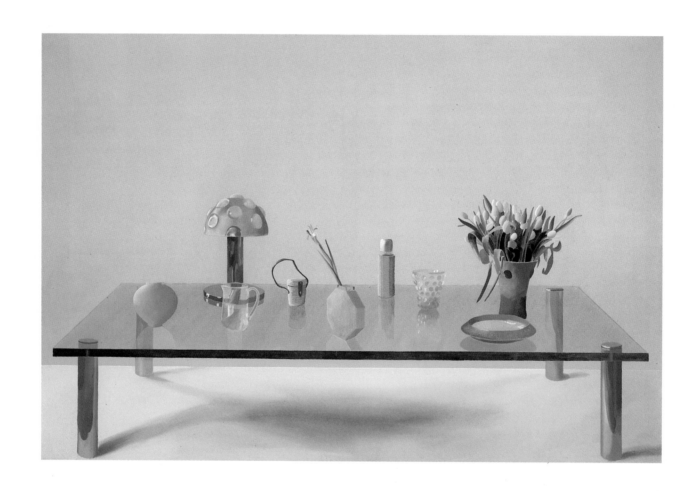

47

Still Life on a Glass Table
1971–72

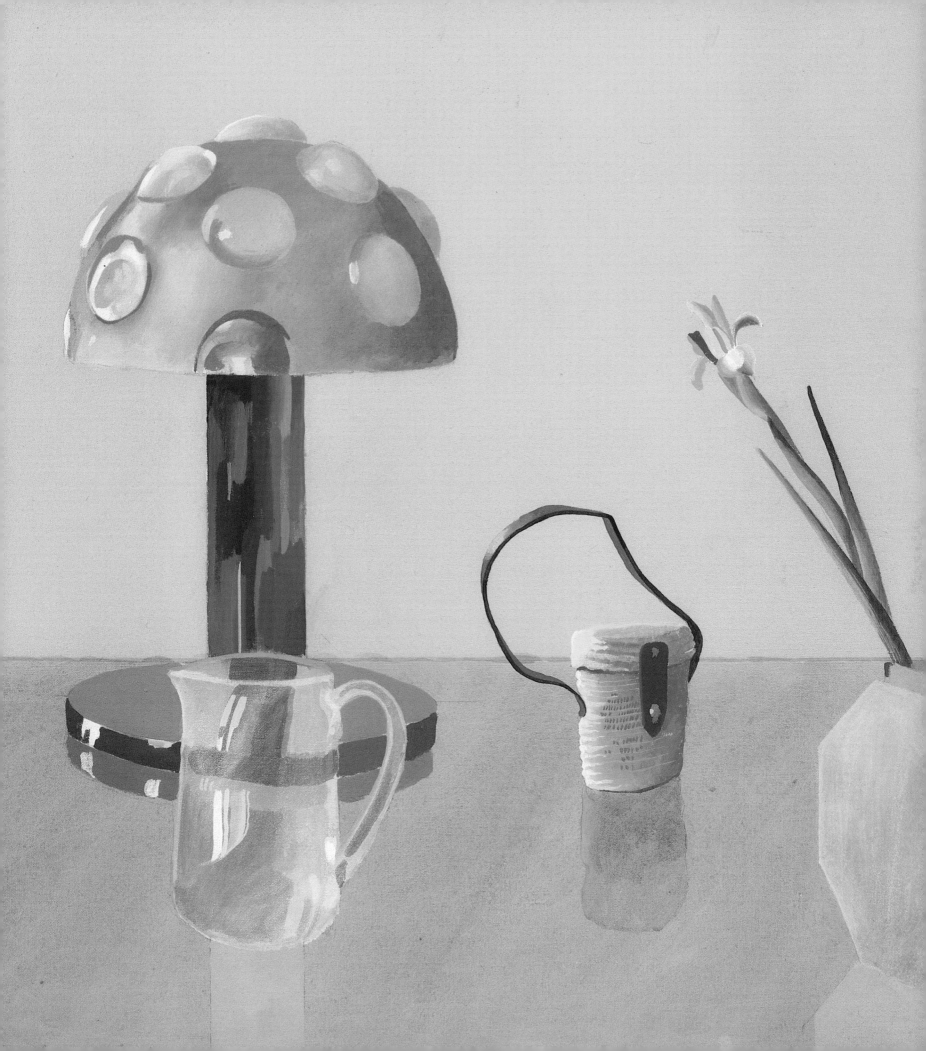

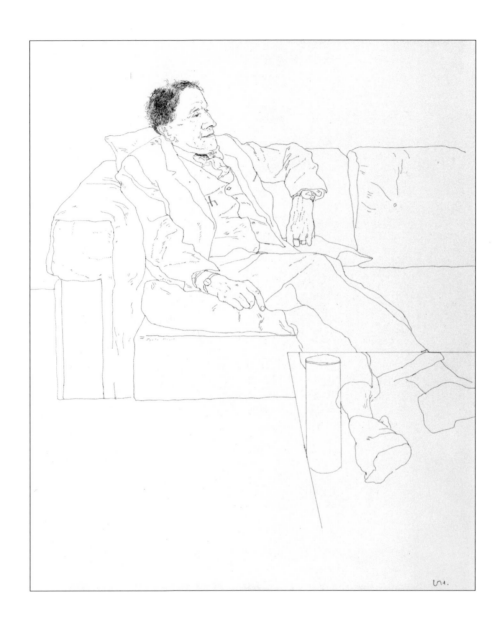

48

The Artist's Father
1972

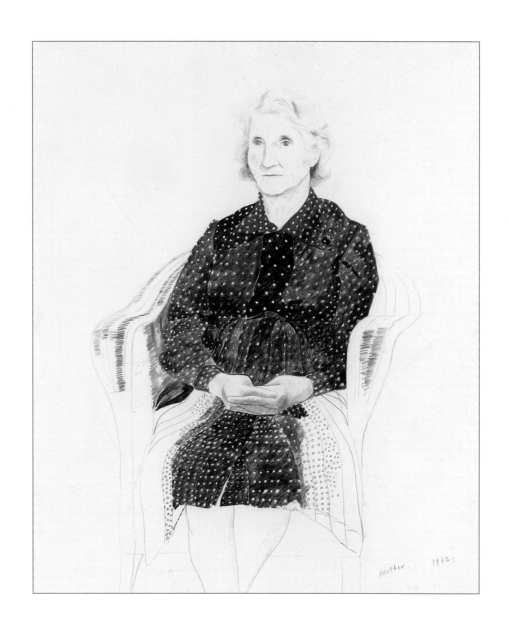

49

The Artist's Mother
1972

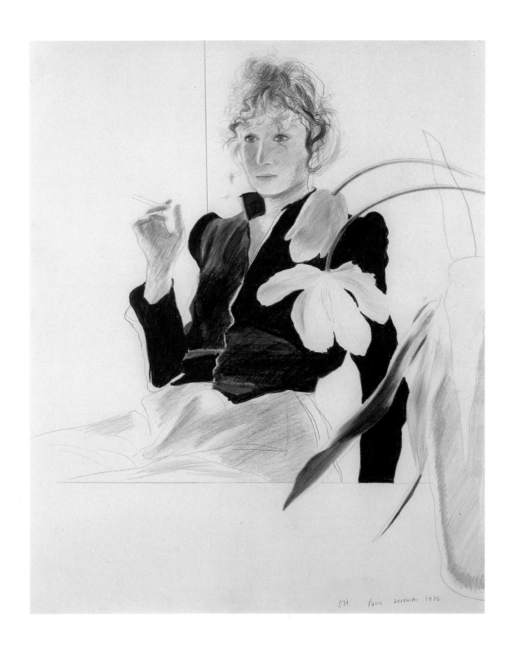

50

Celia in a Black Dress with White Flowers
1972

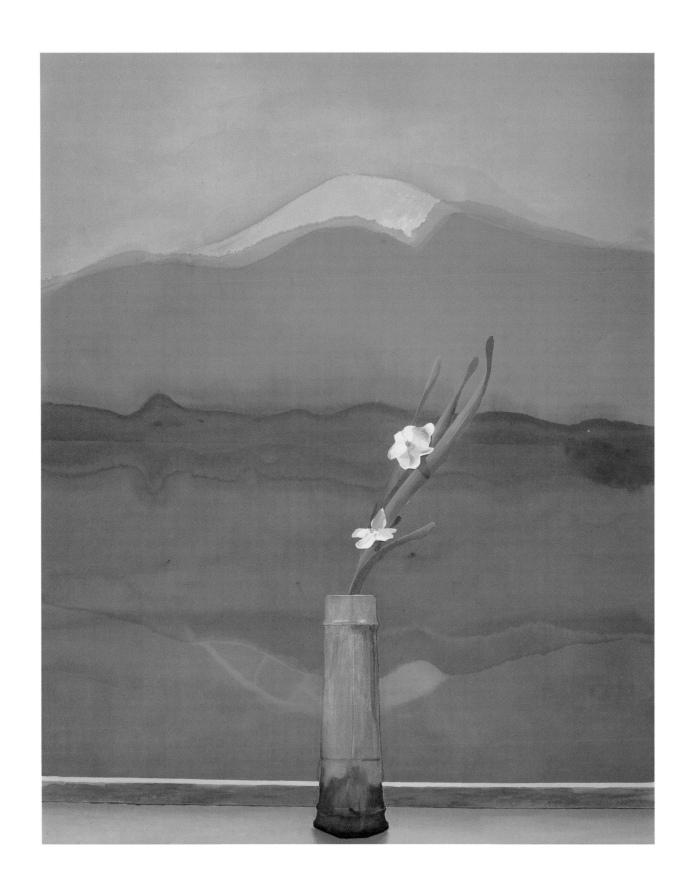

51

Mt. Fuji and Flowers
1972

52

Japanese Rain on Canvas
1972

53

Two Deckchairs, Calvi
1972

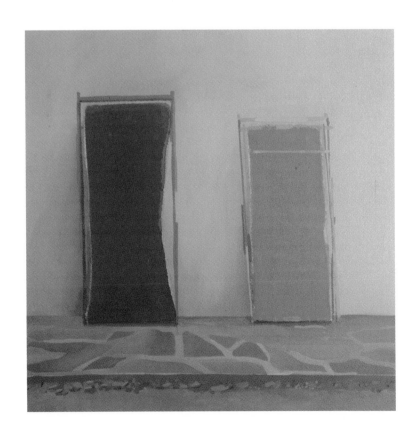

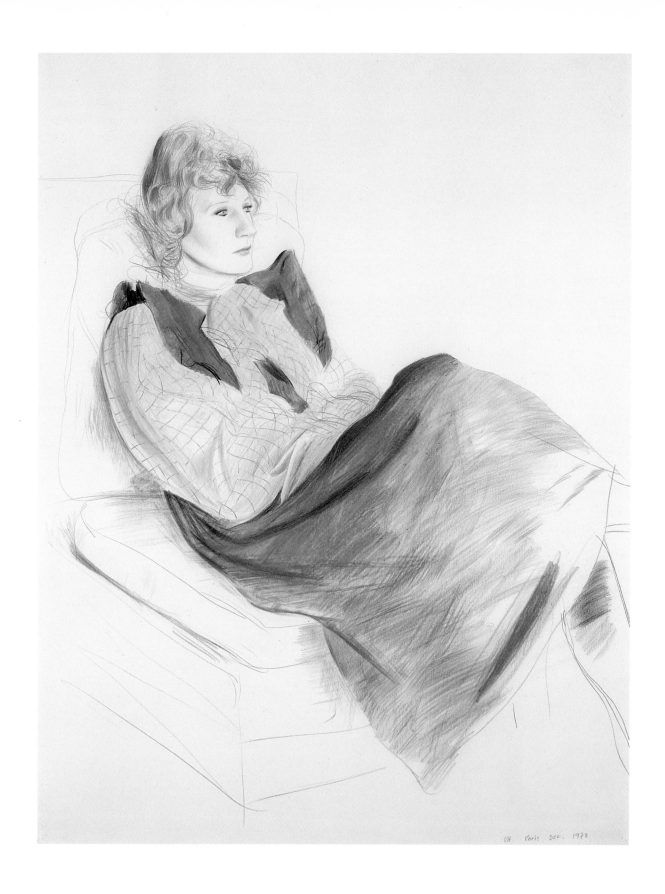

54

Celia Wearing Checked Sleeves
1973

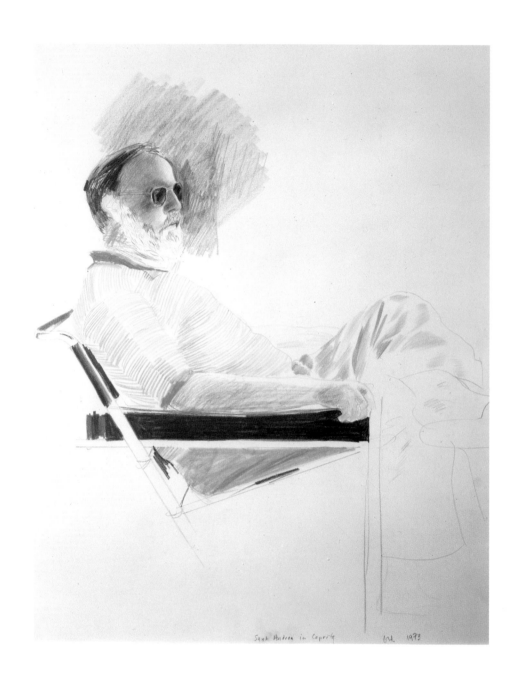

55

Sant' Andrea in Caprile (Henry in Deckchair)
1973

56

Invented Man Revealing Still Life
1975

57

Model with Unfinished Self-Portrait
1977

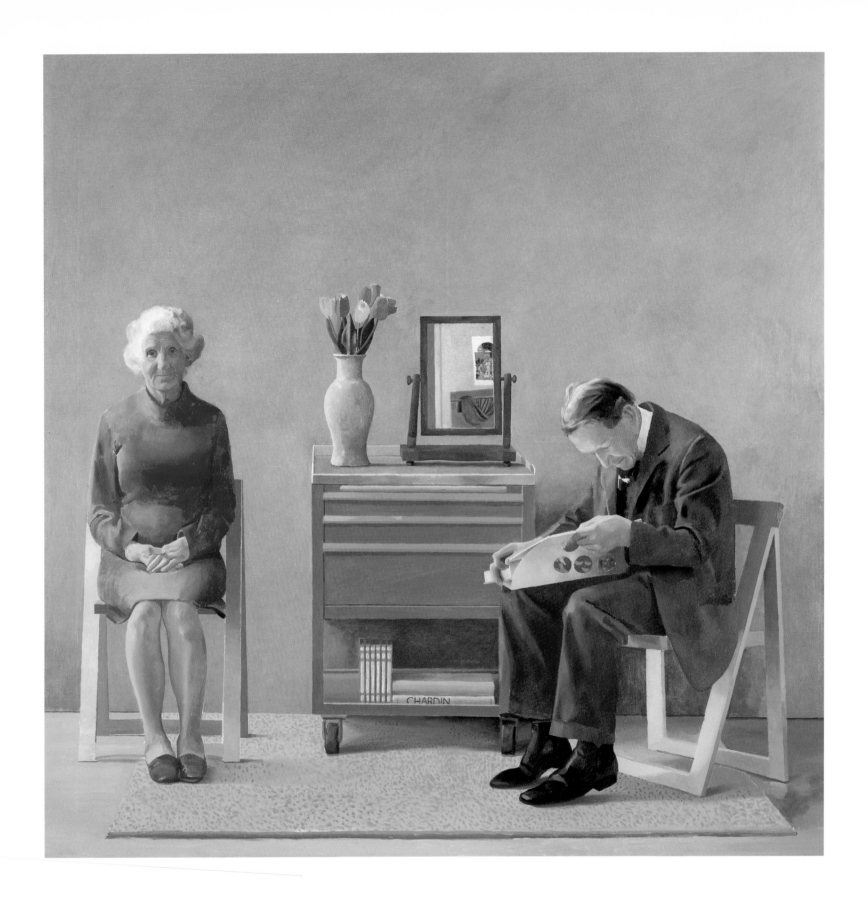

58

My Parents
1977

59

Mother, Bradford, 19 Feb 1978
1978

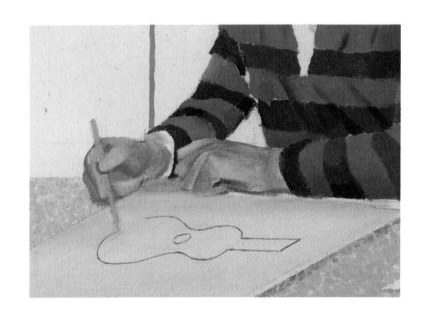

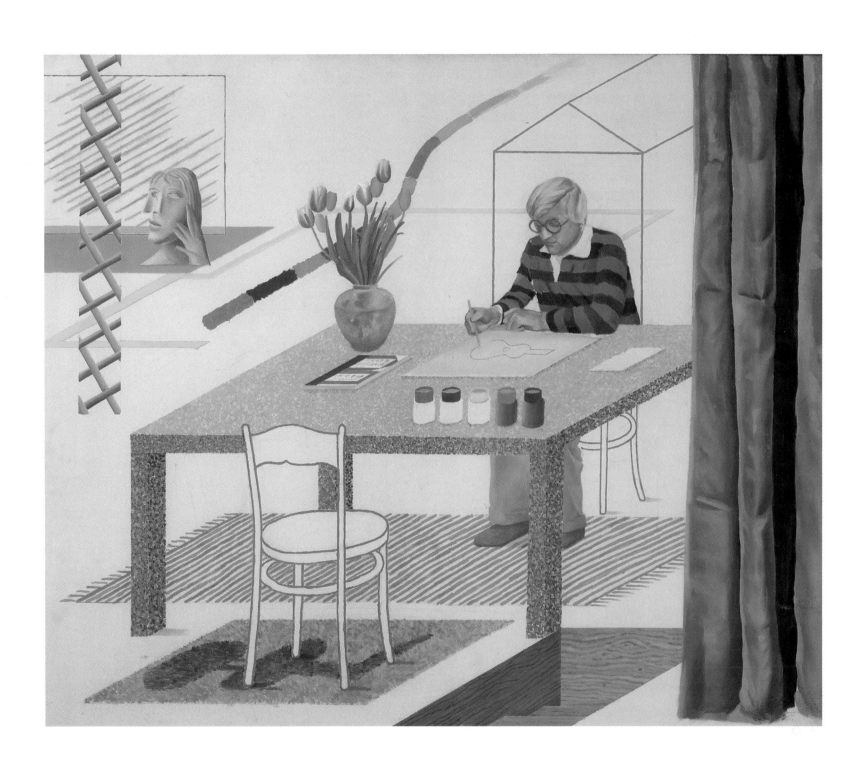

60

Self-Portrait with Blue Guitar
1977

61

Day Pool with Three Blues (Paper Pool #7)
1978

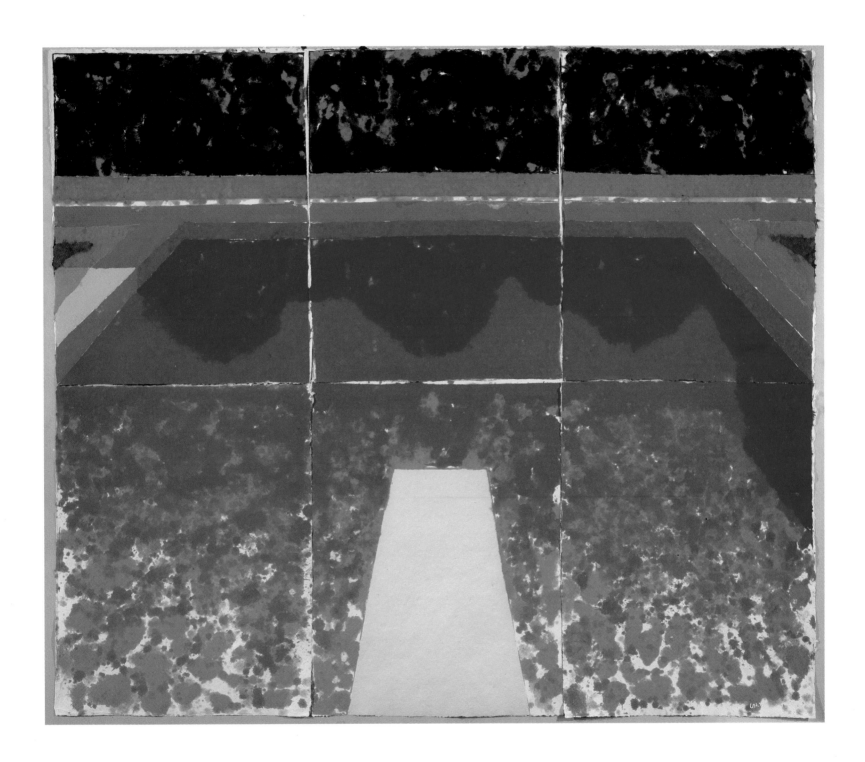

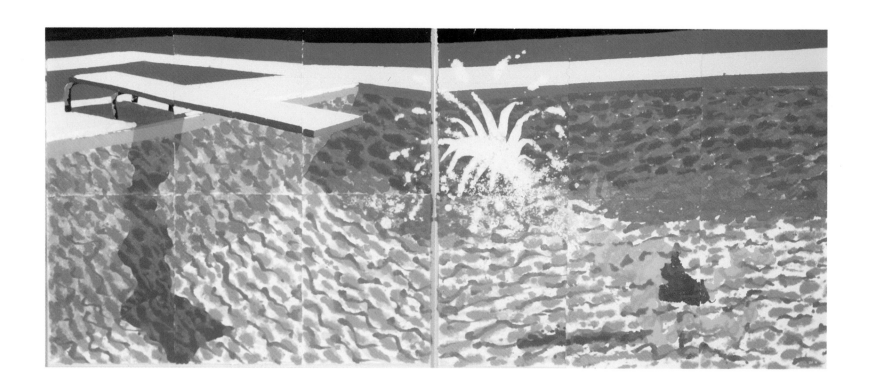

62

A Large Diver (Paper Pool #27)
1978

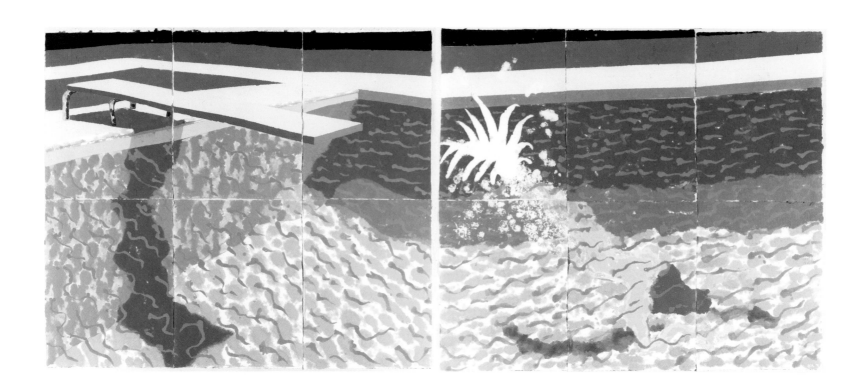

63

Le Plongeur (Paper Pool #18)
1978

64

Celia Amused
1979

65

Celia Elegant
1979

66

Celia Weary
1979

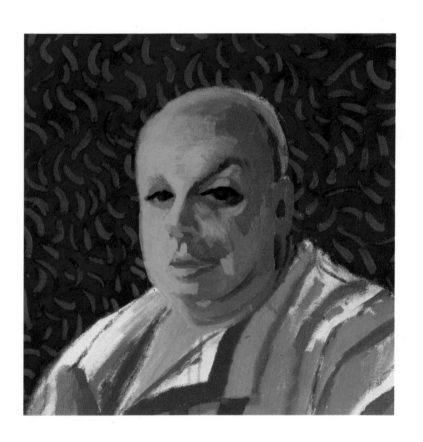

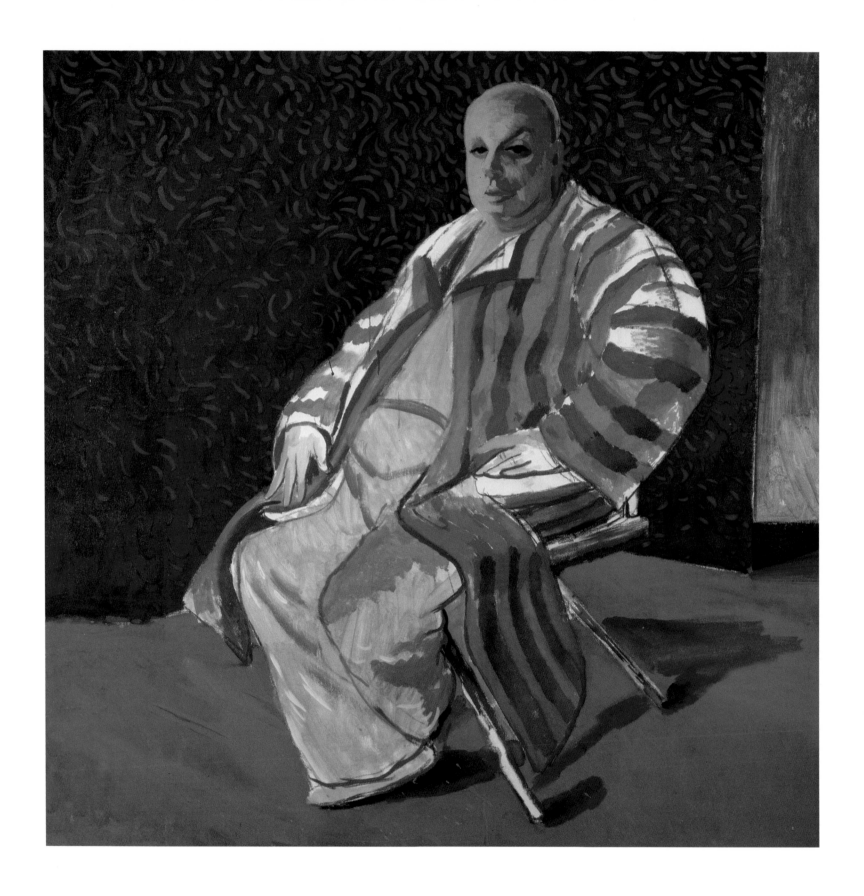

67

Divine
1979

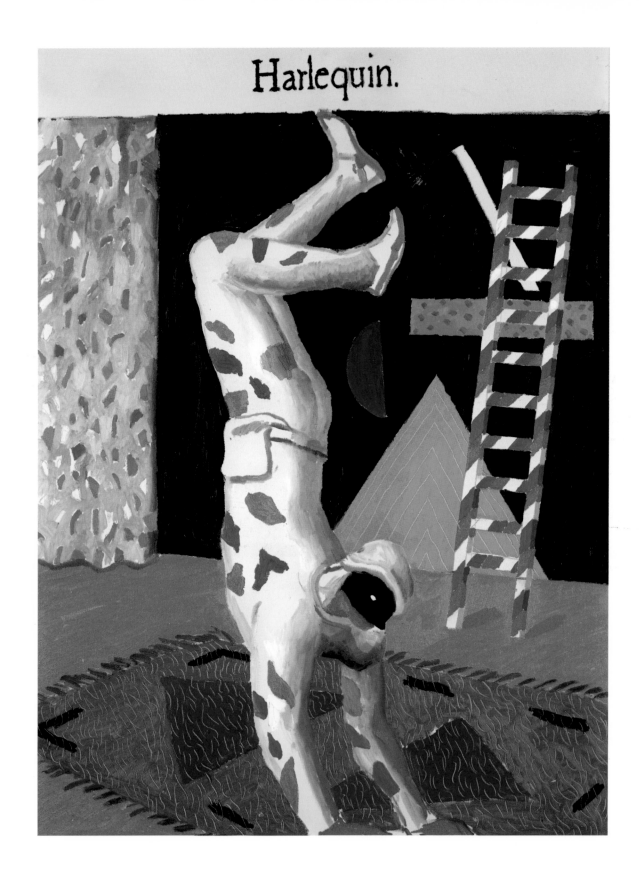

68

Harlequin
1980

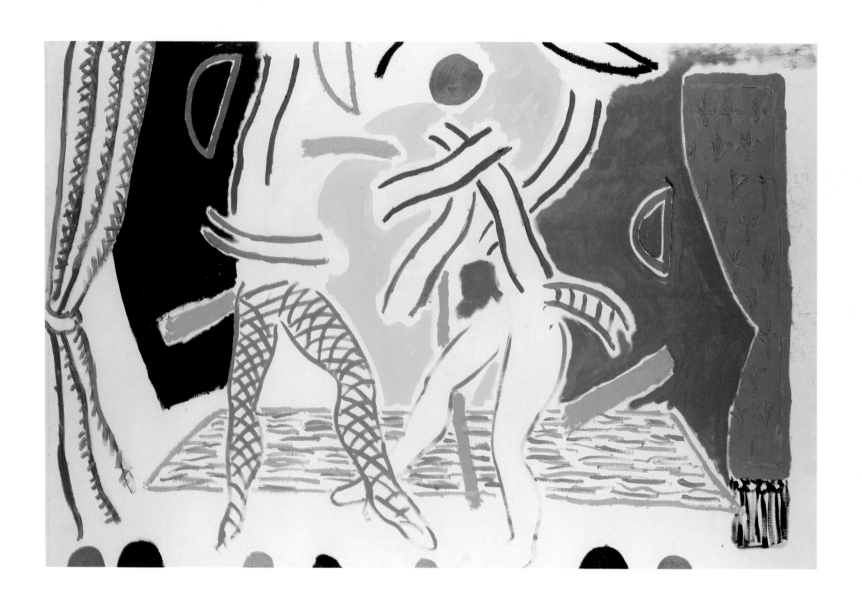

69

Two Dancers
1980

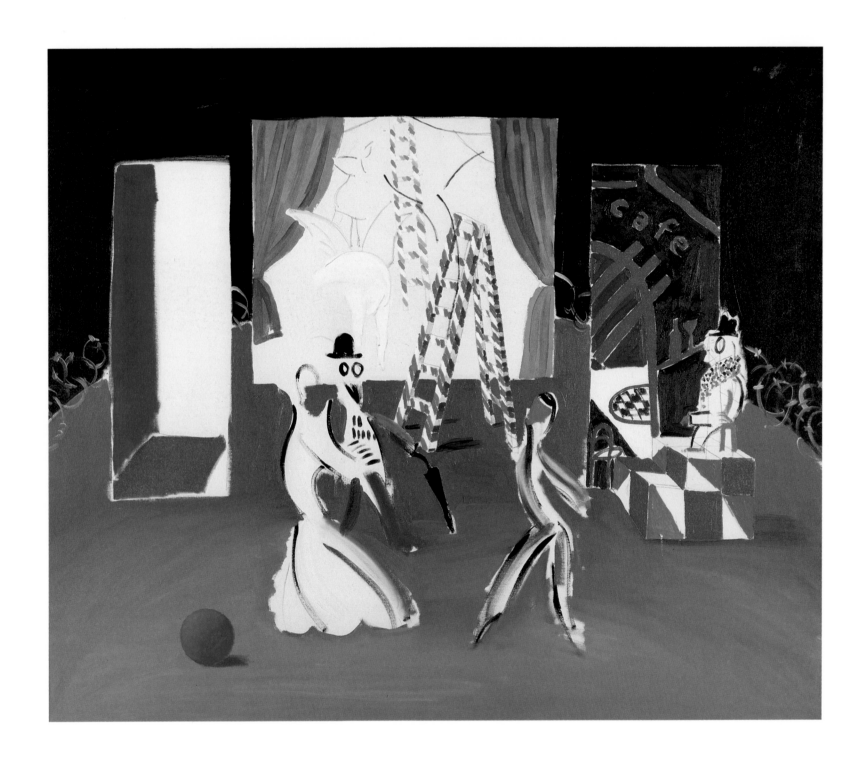

70

Parade with Unfinished Backdrop
1980

71

Ravel's Garden with Night Glow
1980

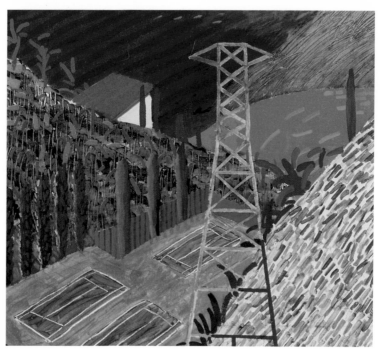

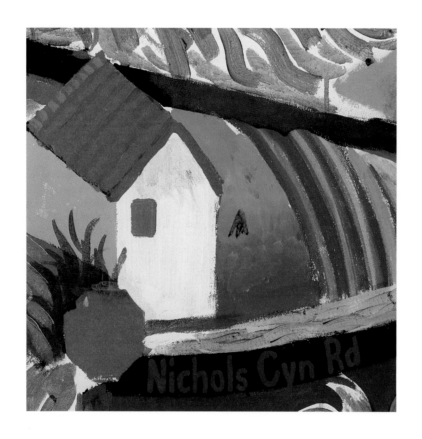

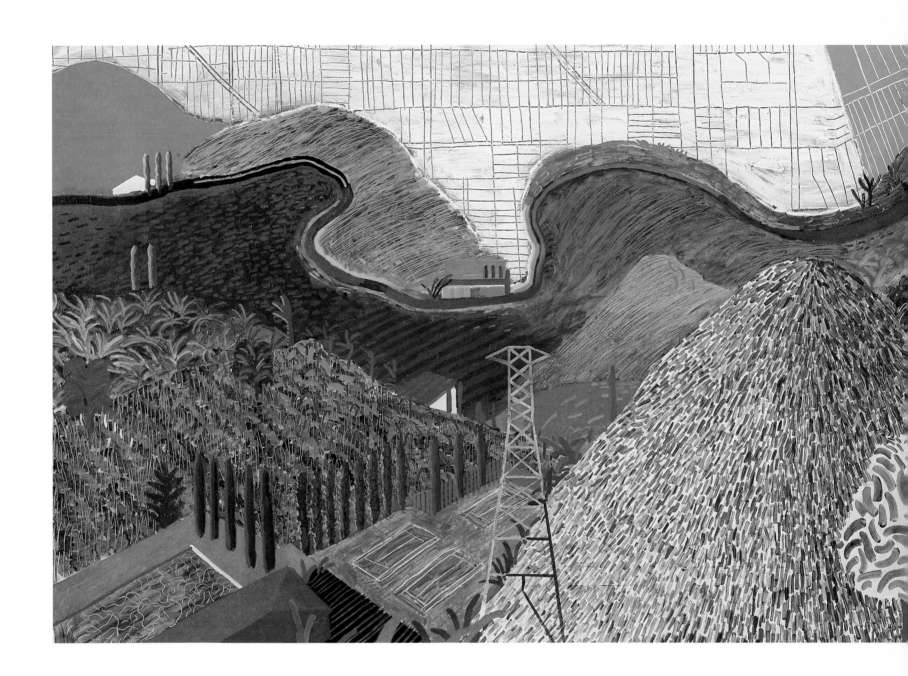

Mulholland Drive: The Road to the Studio
1980

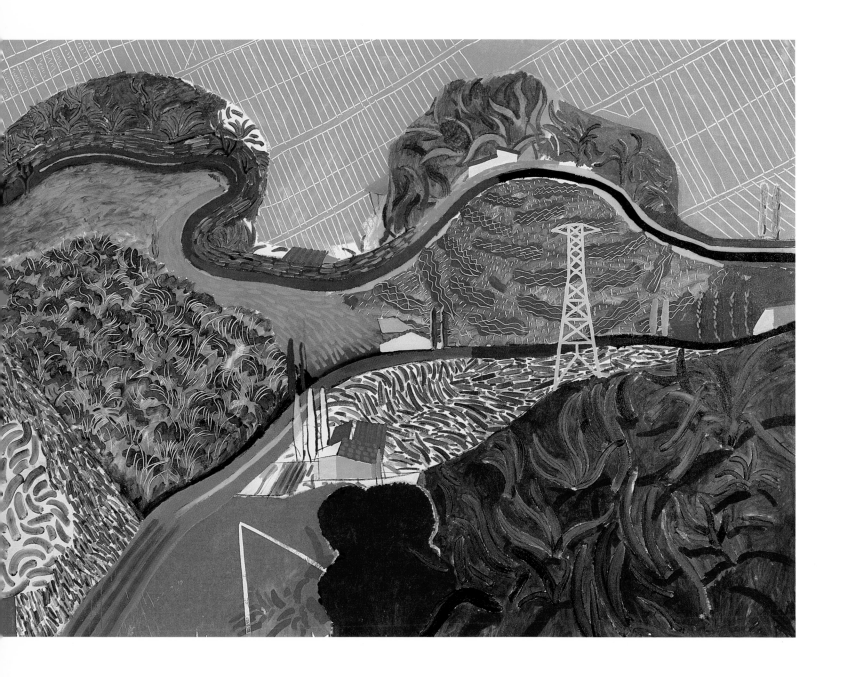

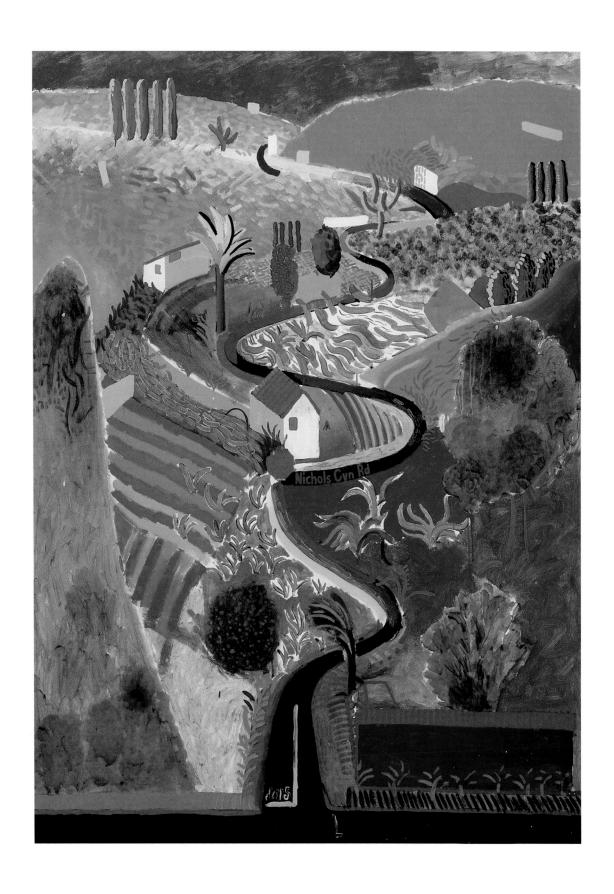

73

Nichols Canyon
1980

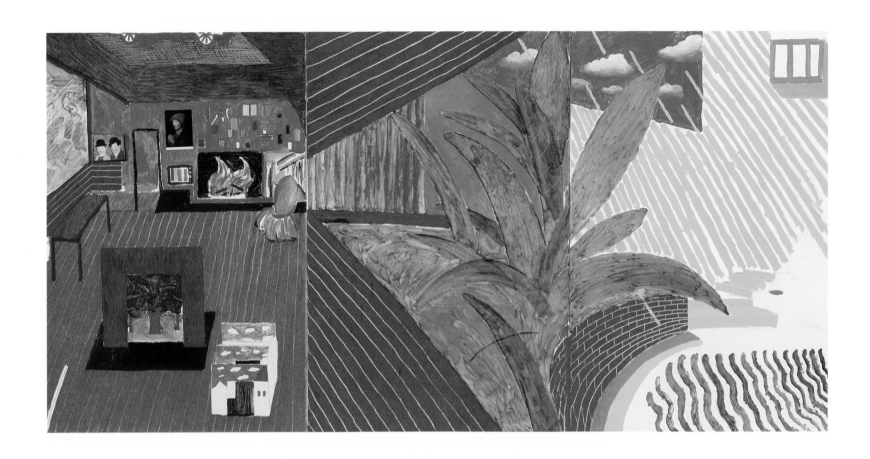

74

Hollywood Hills House
1980

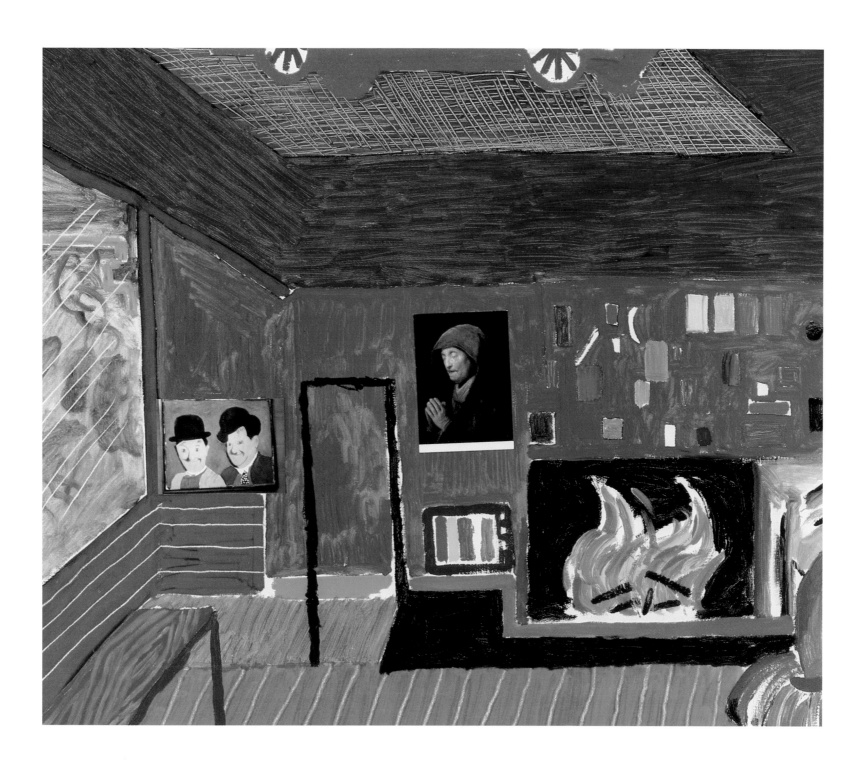

75

The Brooklyn Bridge Nov 28th 1982
1982

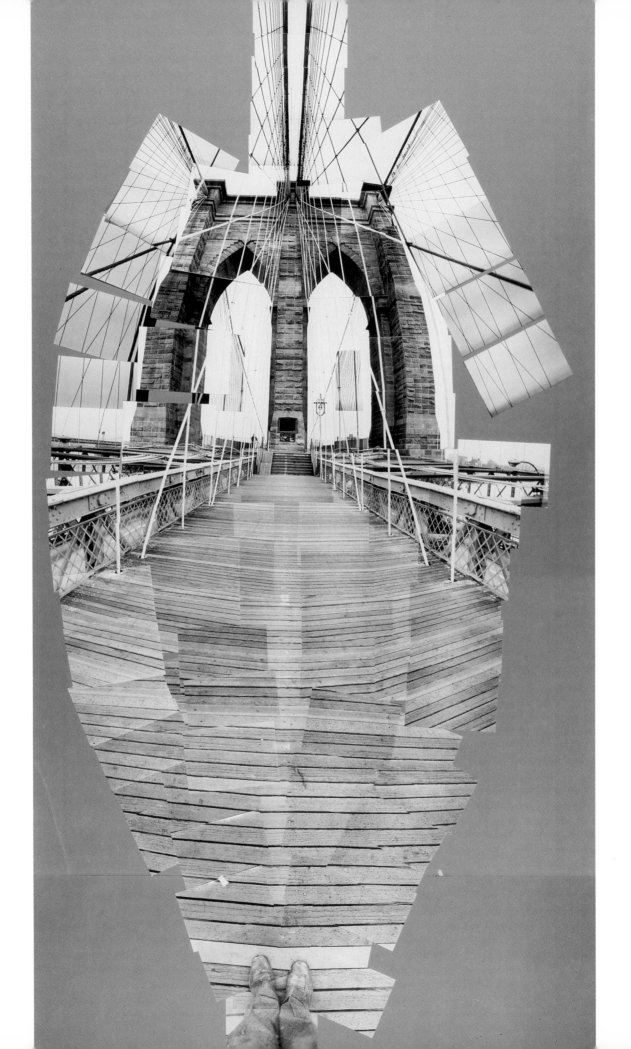

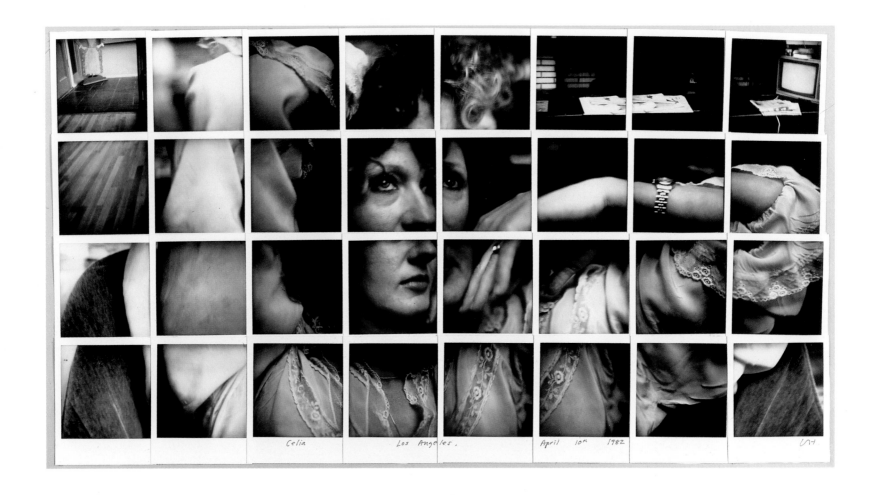

Celia Los Angeles. April 10th 1982

76
—
Celia Los Angeles, April 10th 1982
1982

77
—
Celia Making Tea N. Y. Dec 1982
1982

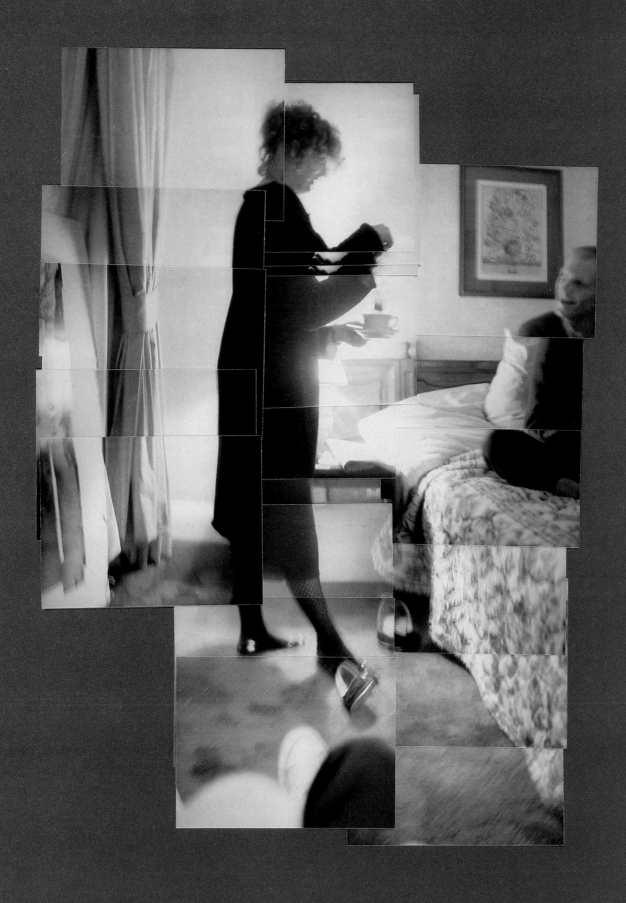

Celia making tea N.Y Dec 1982 #19. David Hockney

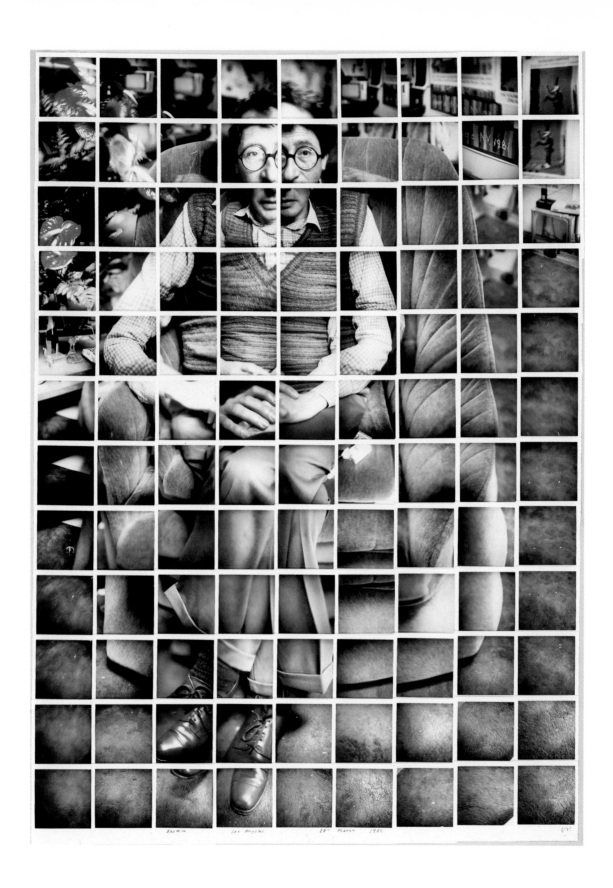

78

Kasmin Los Angeles 28th March 1982
1982

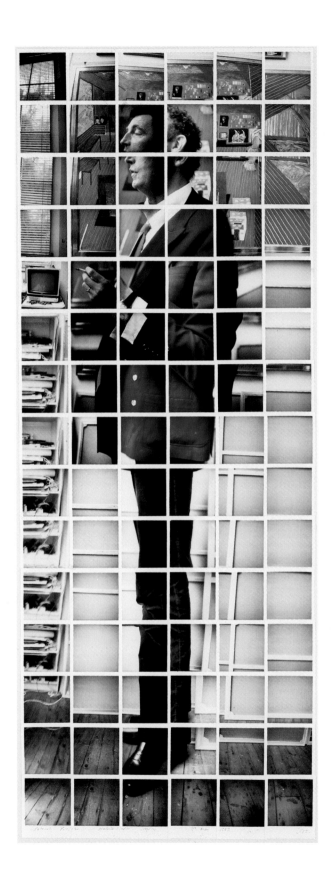

79

Patrick Procktor Pembroke Studios London 7th May 1982
1982

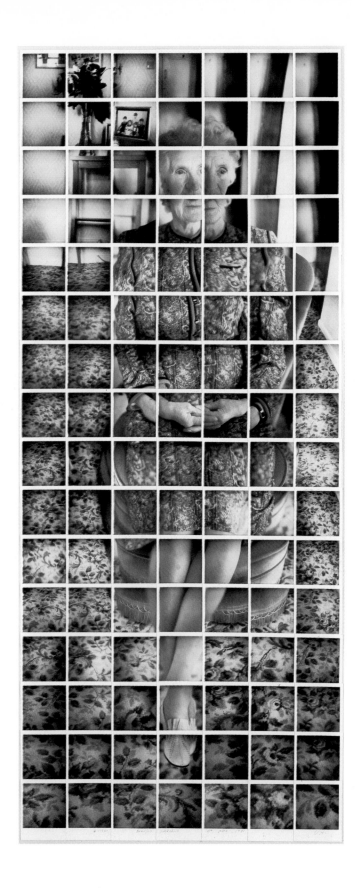

80

Mother Bradford Yorkshire 4th May 1982
1982

81

My Mother, Bolton Abbey, Yorkshire Nov. 82
1982

214

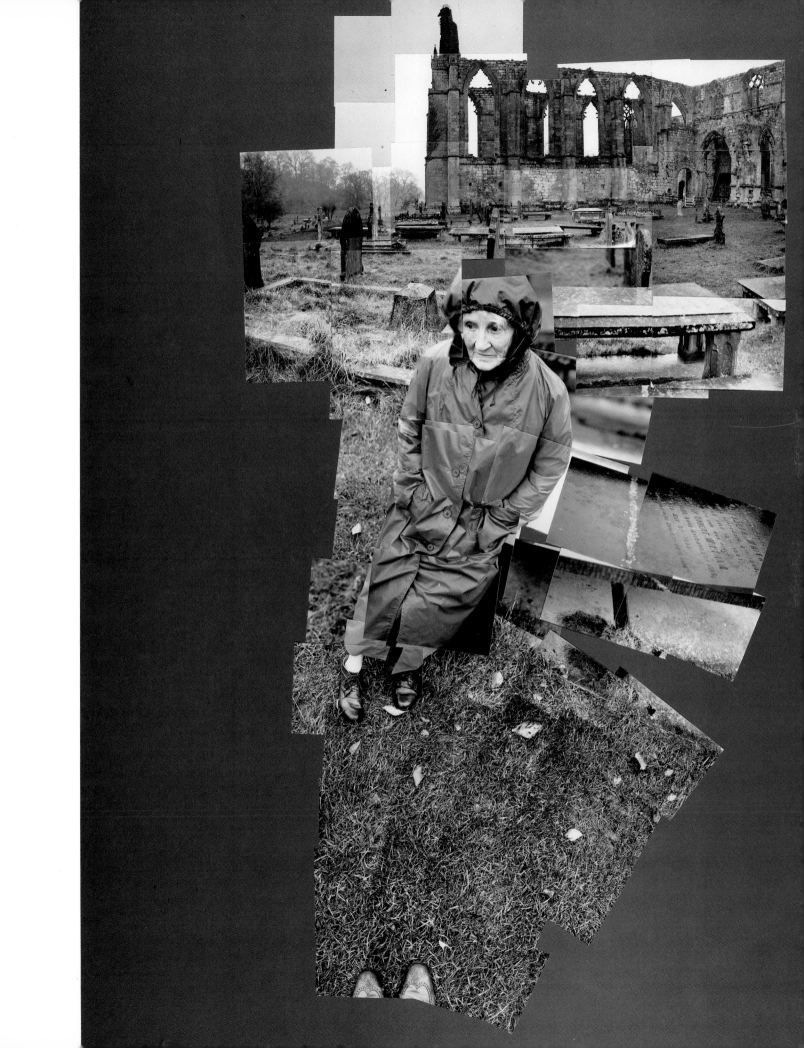

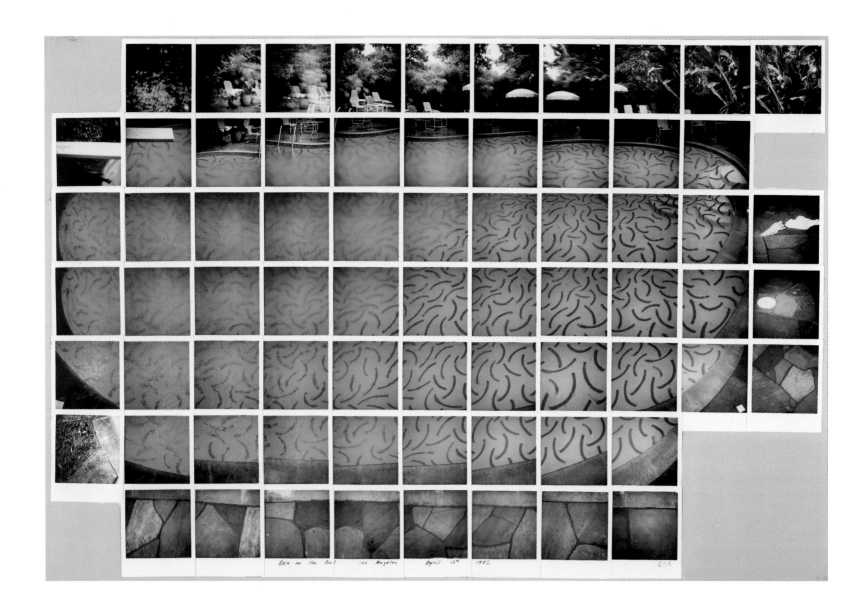

82

Rain on the Pool Los Angeles April 12th 1982
1982

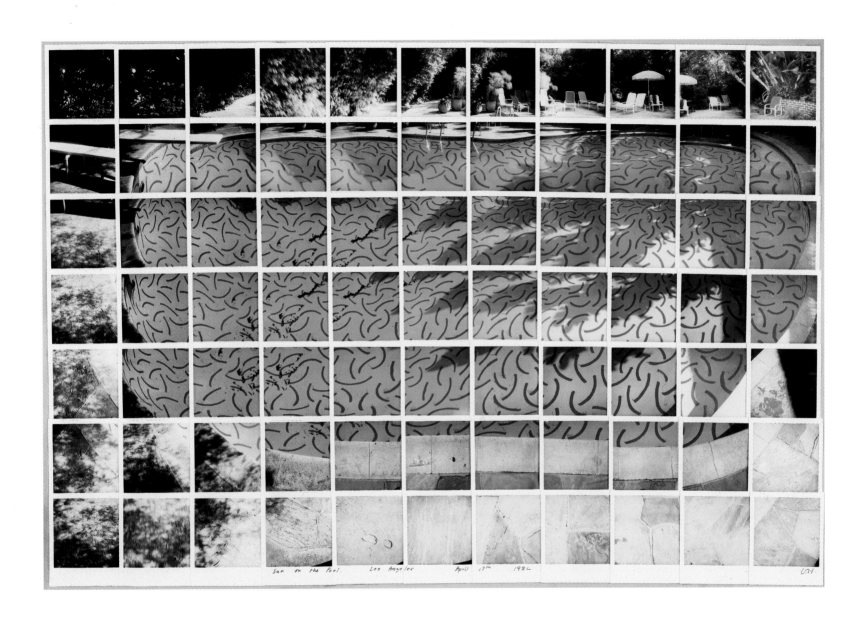

83

Sun on the Pool Los Angeles April 13th 1982
1982

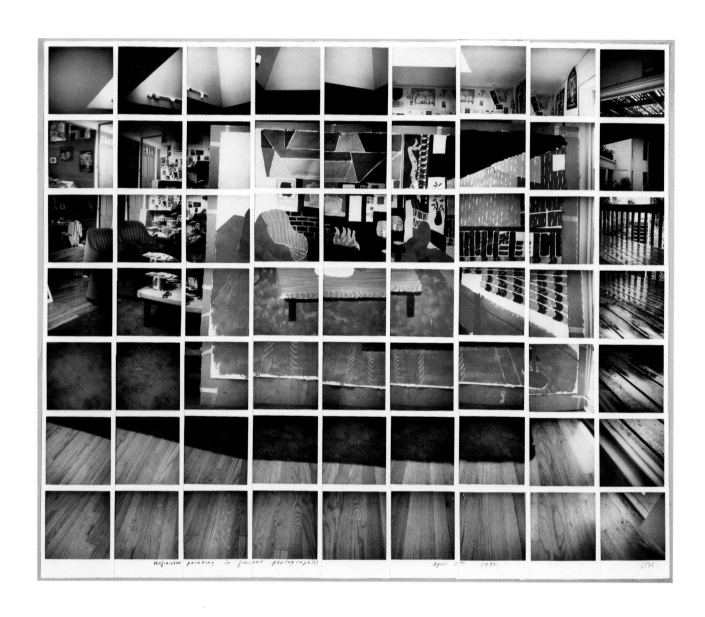

84

Unfinished Painting in Finished Photograph(s) 2nd April 1982
1982

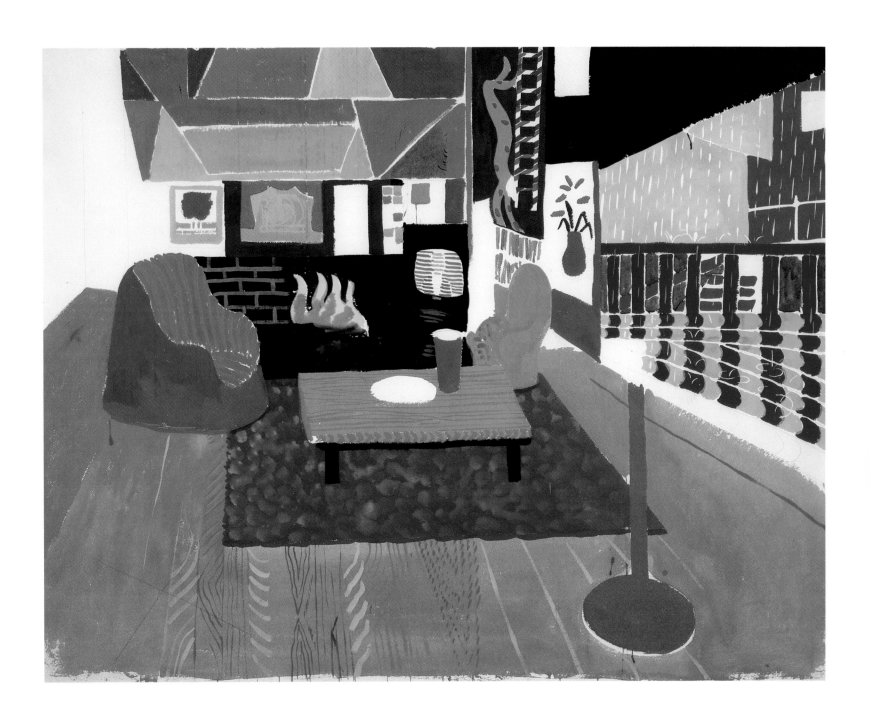

85

Studio. Hollywood Hills House
1982

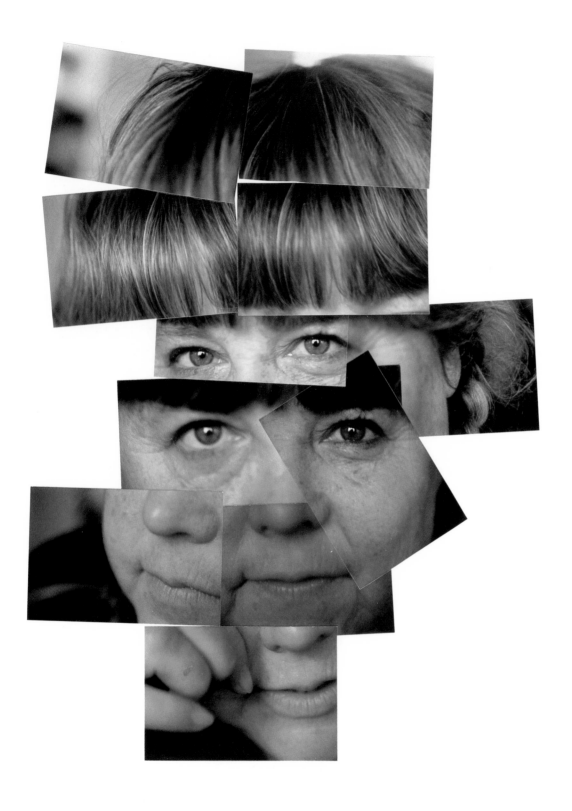

86

Ruth Leserman
1982

87

Billy Wilder Lighting His Cigar Dec. 1982
1982

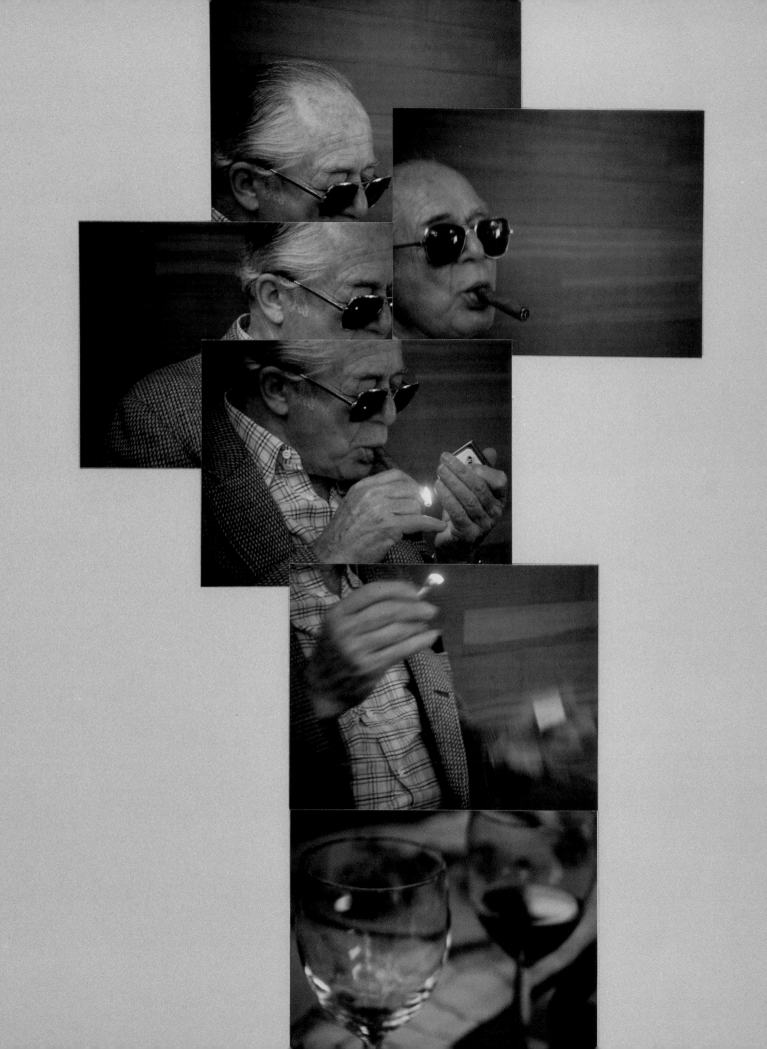

88

Christopher Isherwood Talking to Bob Holman Santa Monica March 14 1983
1983

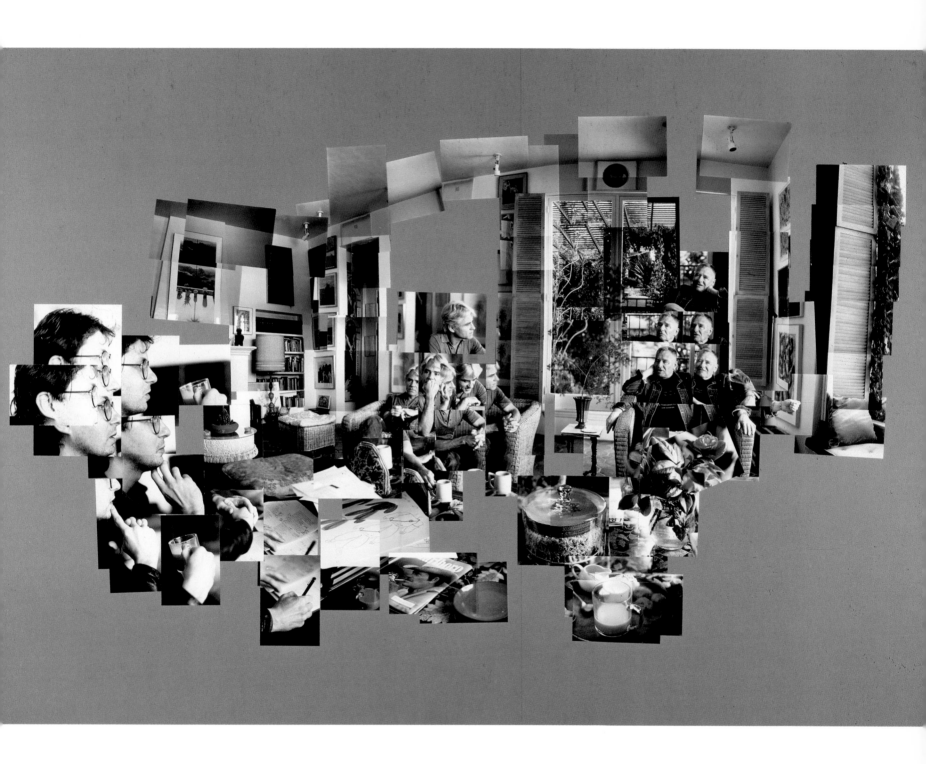

89

Luncheon at the British Embassy Tokyo Feb 16th 1983
1983

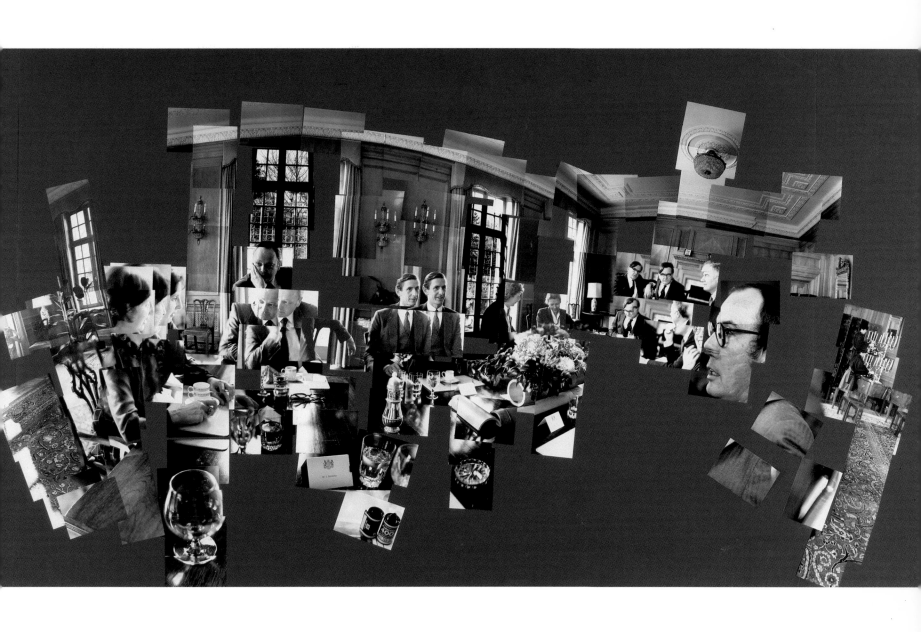

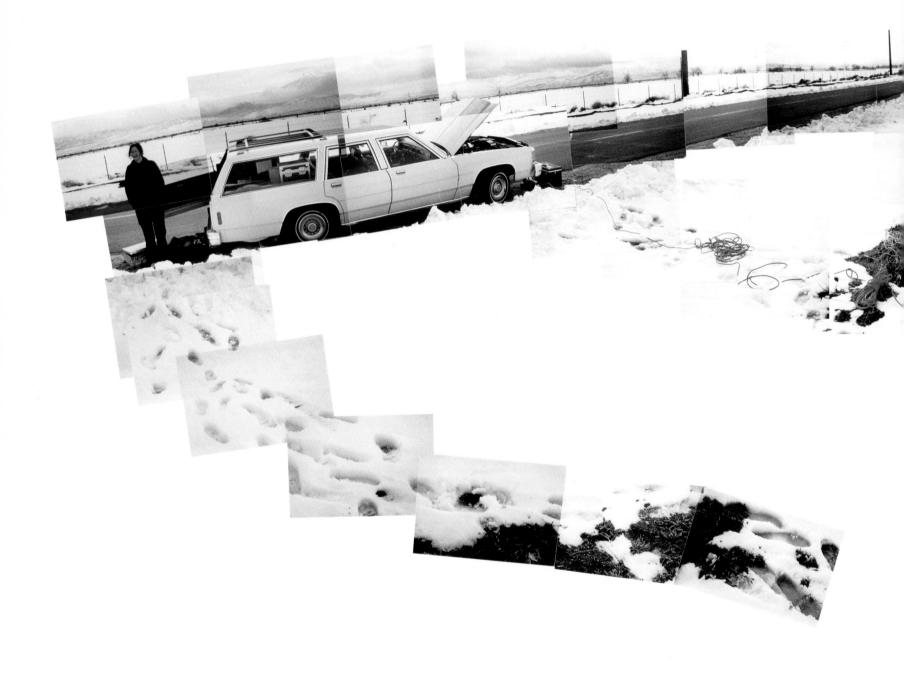

90

Photographing Annie Leibovitz While She Photographs Me,
Mohave Desert Calif. Feb. 1983

1983

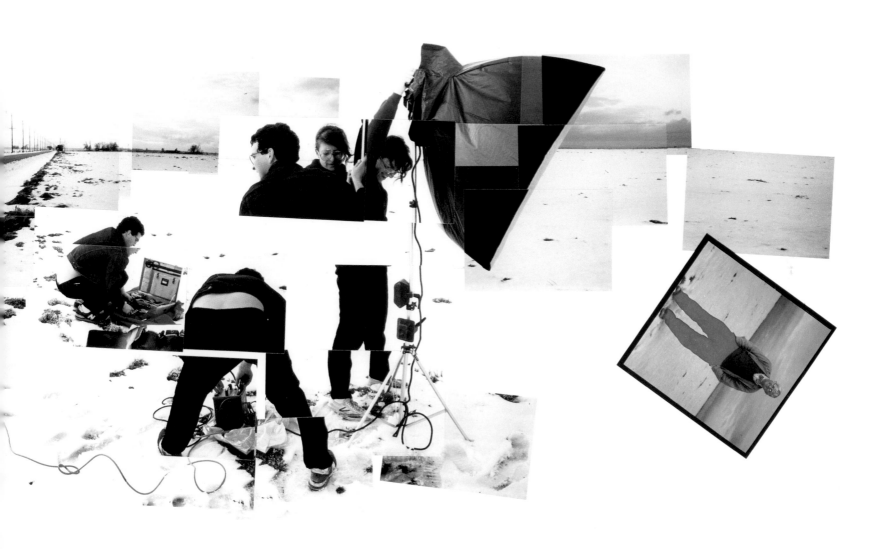

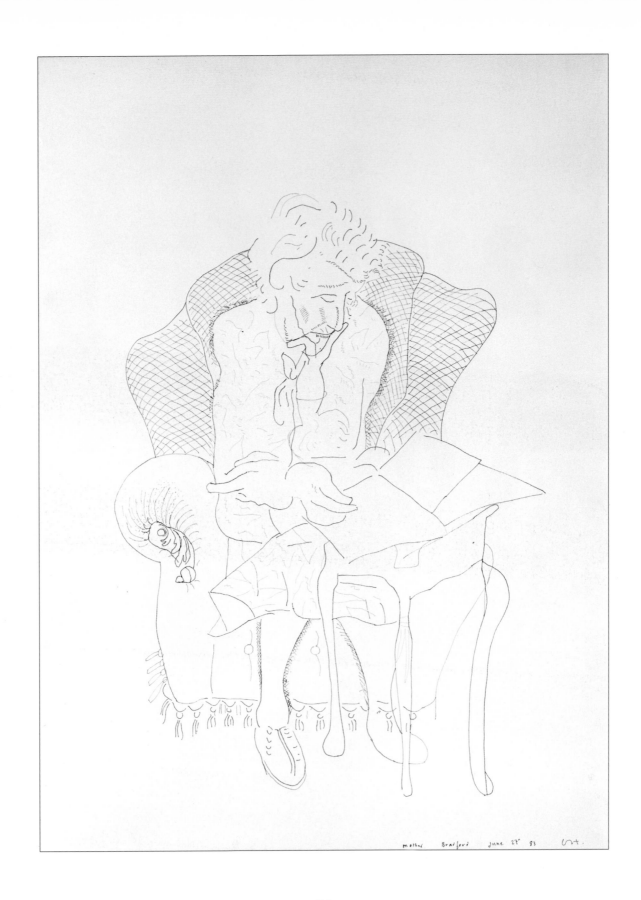

91

Mother, Bradford June 27th 83
1983

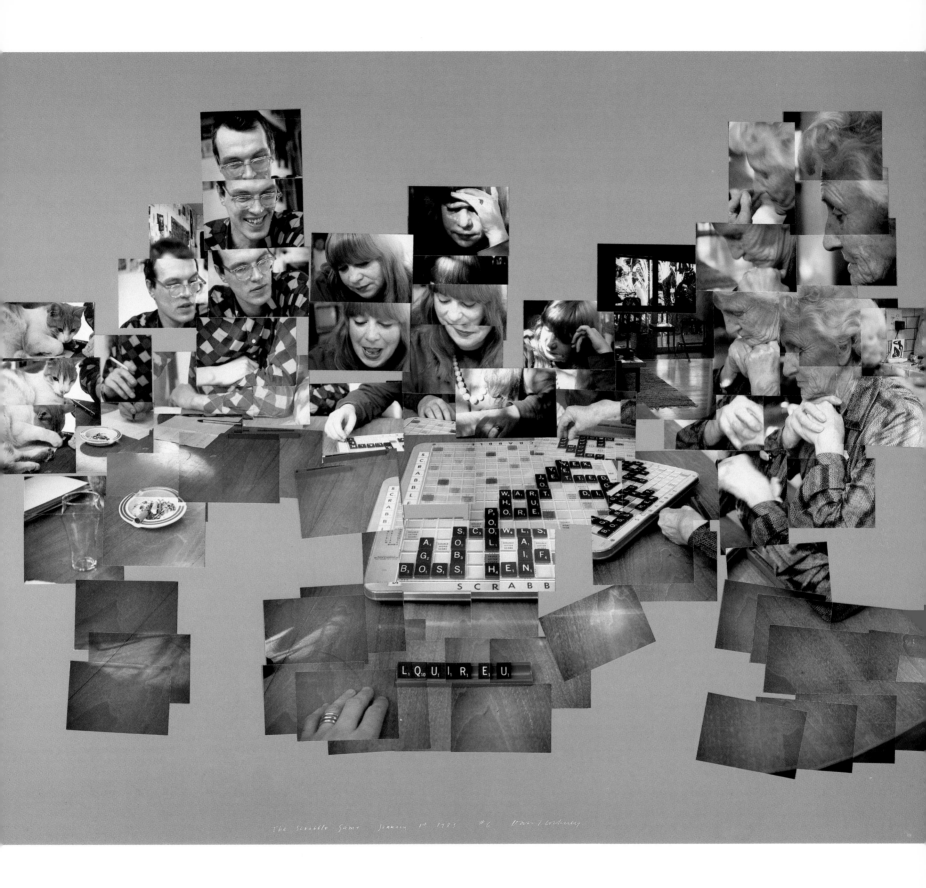

92
—

The Scrabble Game January 1st 1983
1983

93

Design for *Les Mamelles de Tirésias*
1983

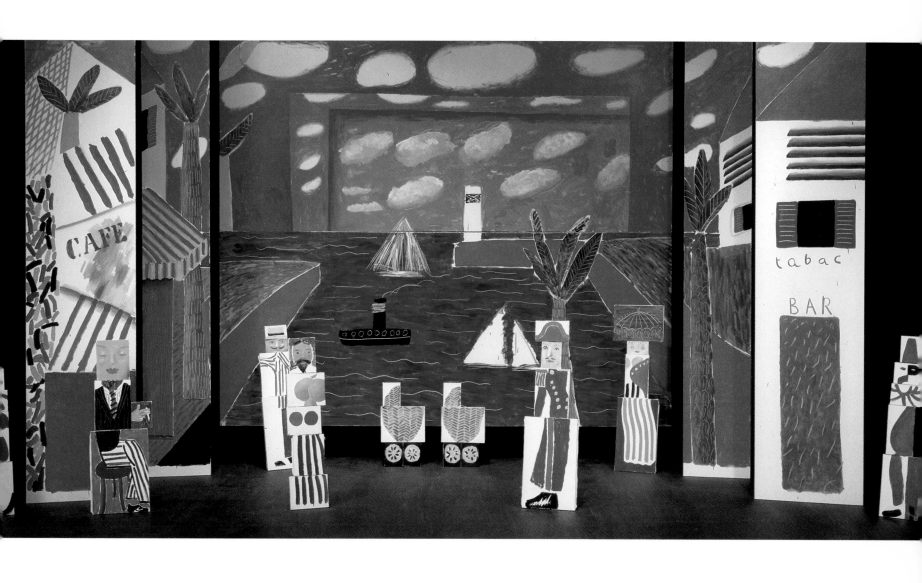

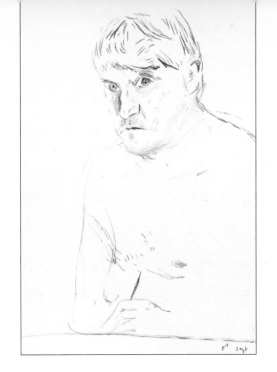

94
———

Self-Portrait 8 Sept. 1983
1983

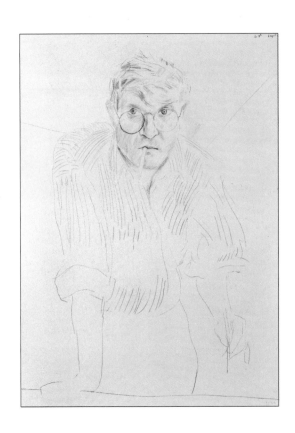

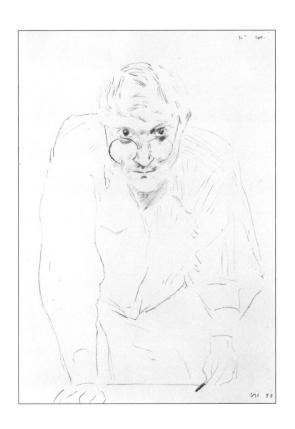

95
———

Self-Portrait 28th Sept. 1983
1983

96
———

Self-Portrait 30th Sept. 1983
1983

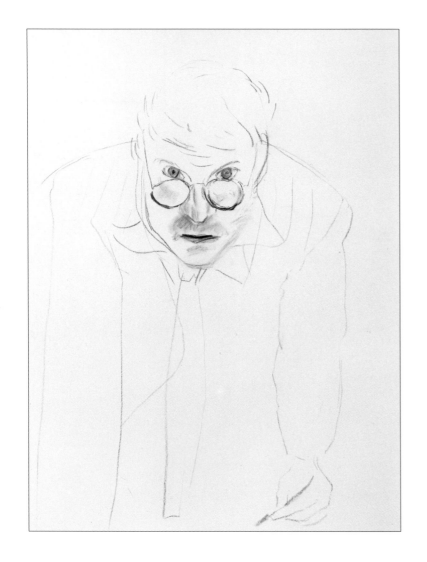

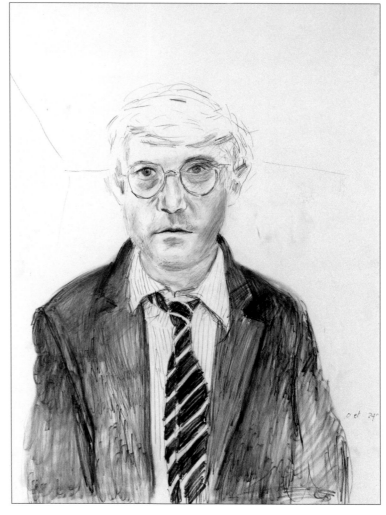

97

Self-Portrait Looking over Glasses

1983

98

Self-Portrait Oct. 24th 1983

1983

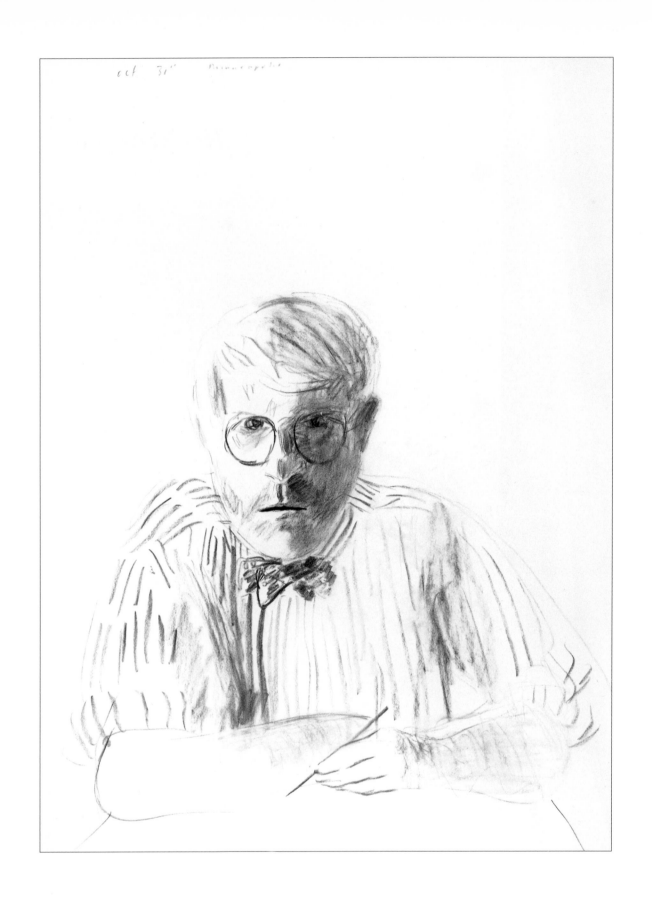

99
—

Self-Portrait Oct. 31st 1983, Minneapolis
1983

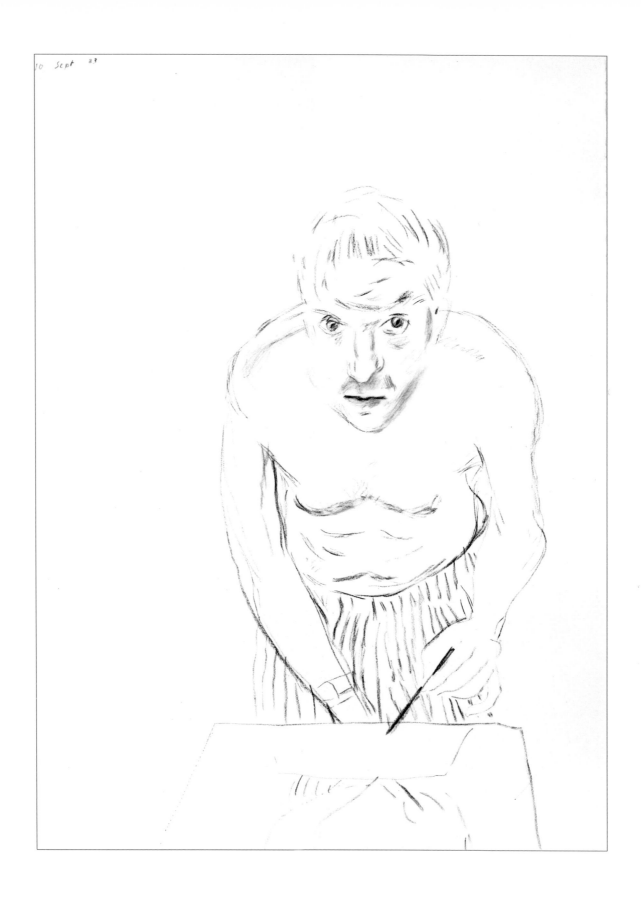

10 Sept 8?

100
—

Self-Portrait Sketch
1983

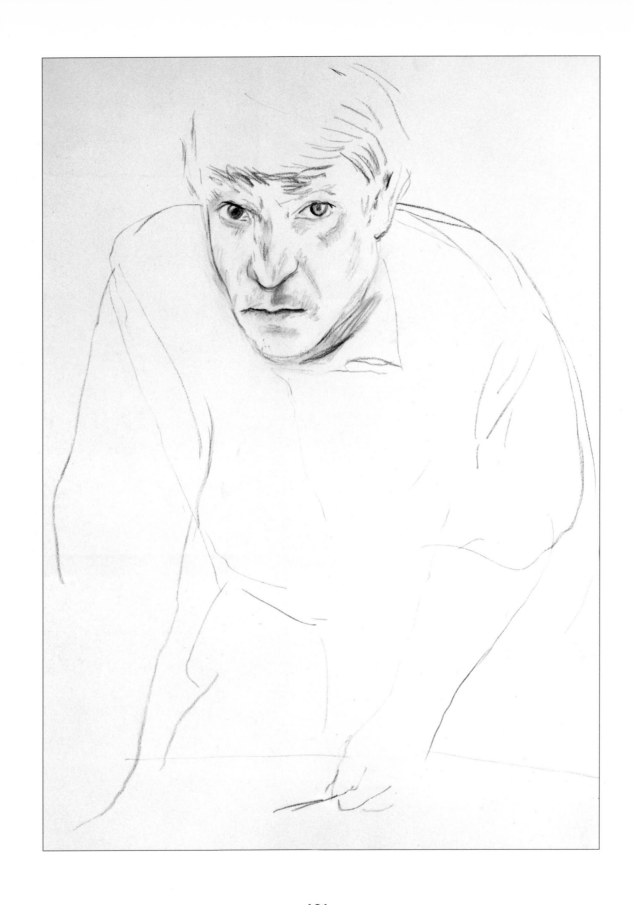

101

Self-Portrait without Glasses
1983

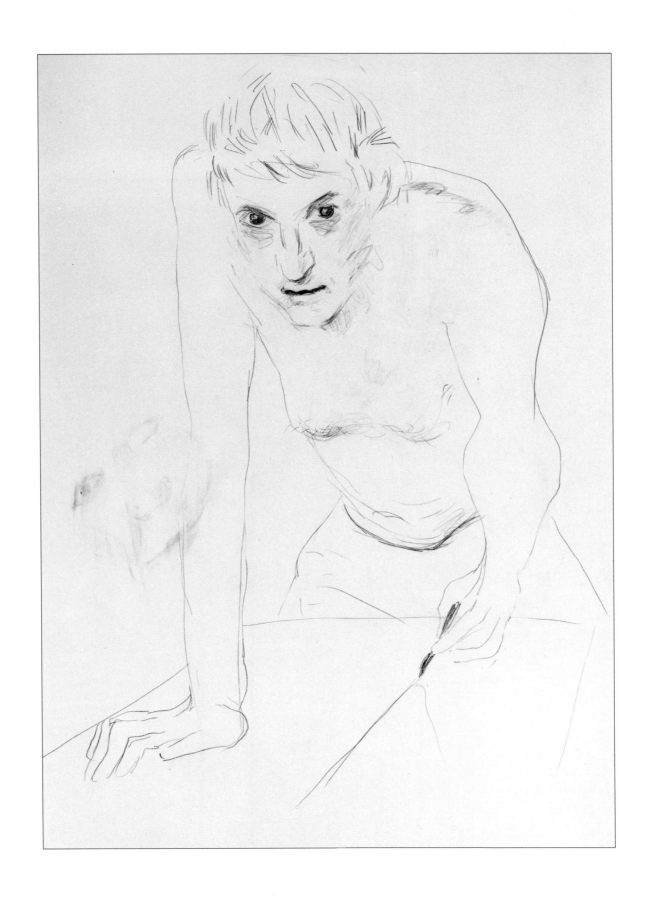

102

Self-Portrait without Shirt
1983

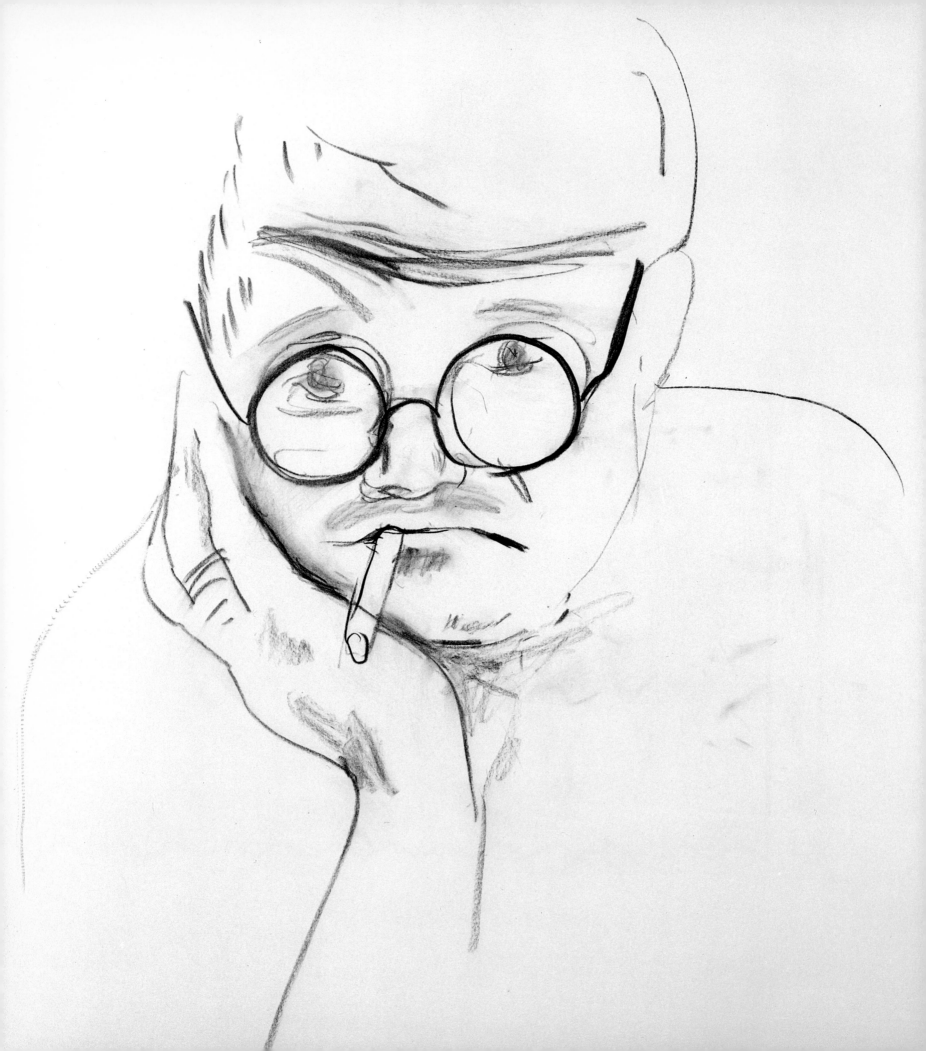

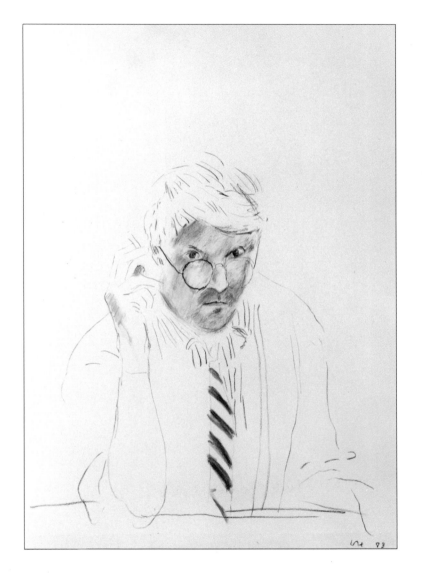

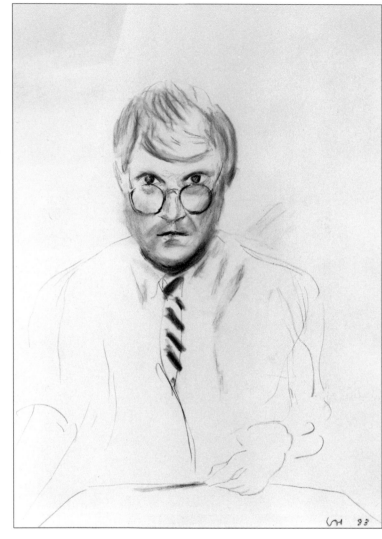

103

Self-Portrait with Cigarette
1983

104

Self-Portrait with Striped Shirt and Tie
1983

105

Self-Portrait with Tie
1983

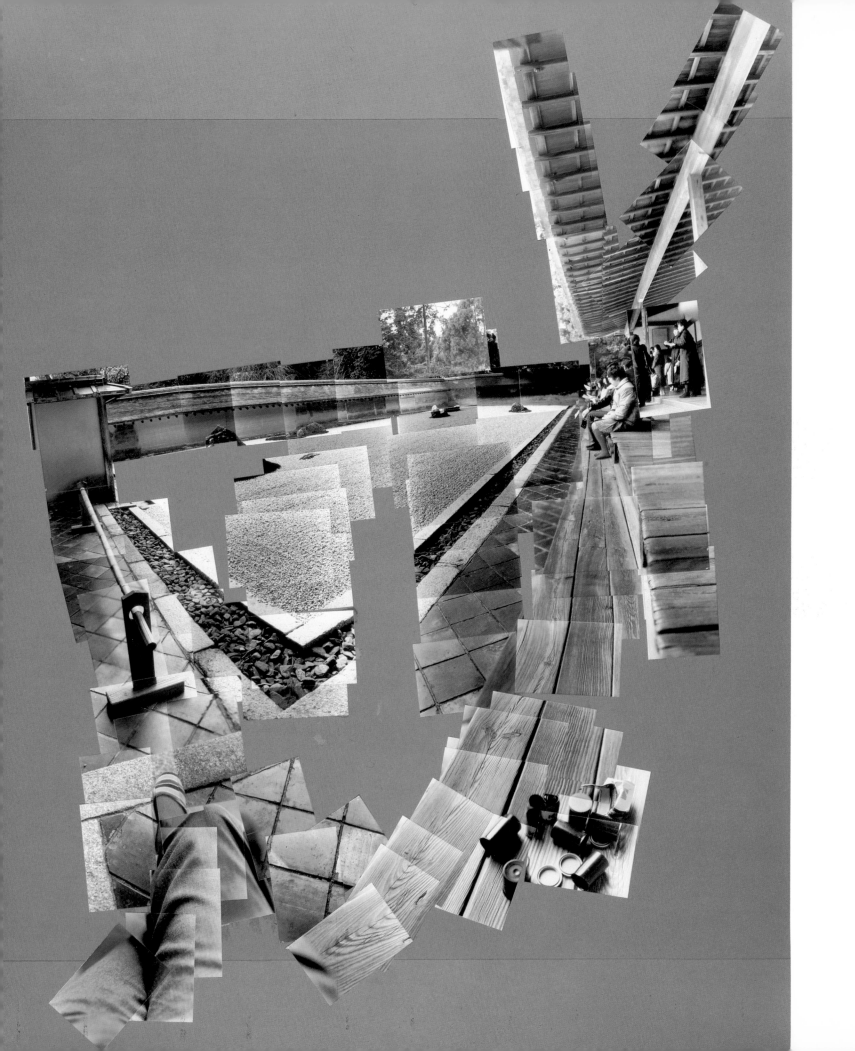

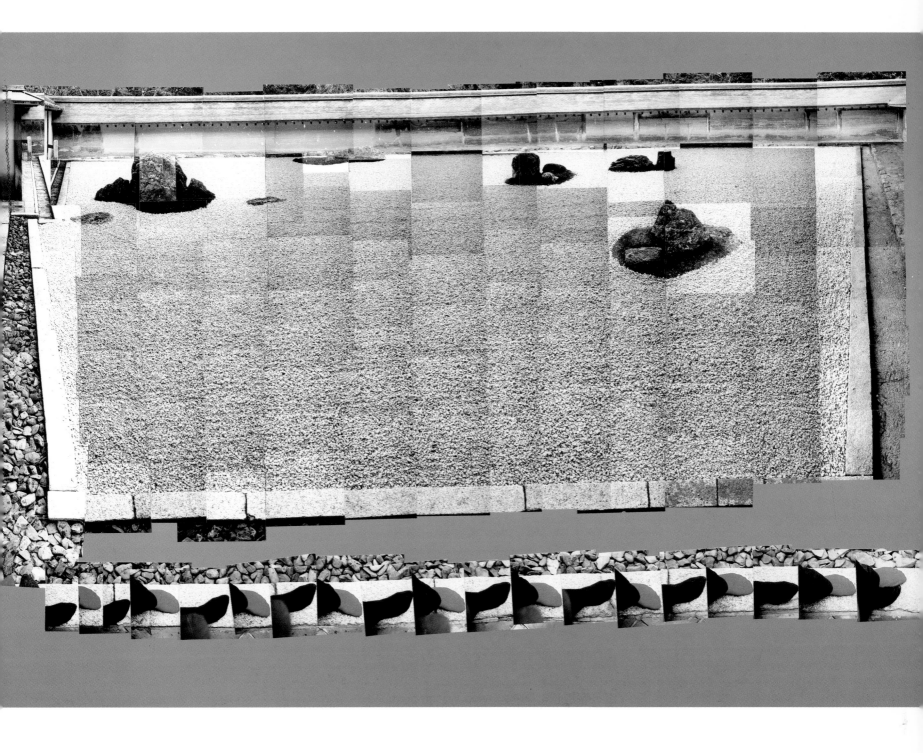

106

Sitting in the Zen Garden at the Ryoanji Temple Kyoto Feb. 19 1983

1983

107

Walking in the Zen Garden at the Ryoanji Temple Kyoto Feb. 21st 1983

1983

108

Celia II
1984

243

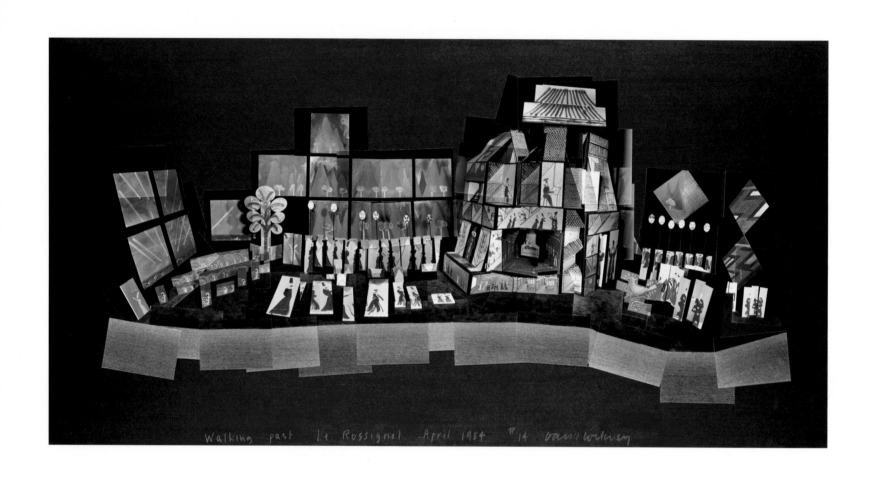

109

Walking Past Le Rossignol April 1984
1984

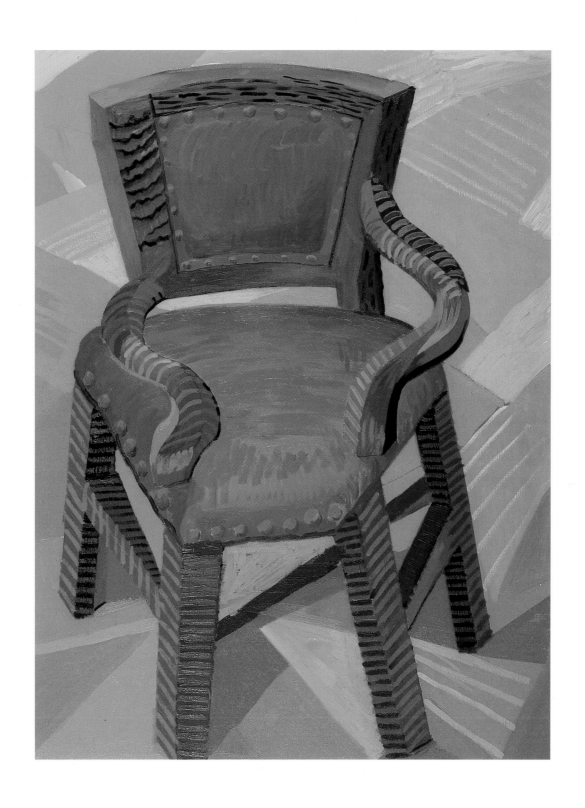

110

The Chair
1985

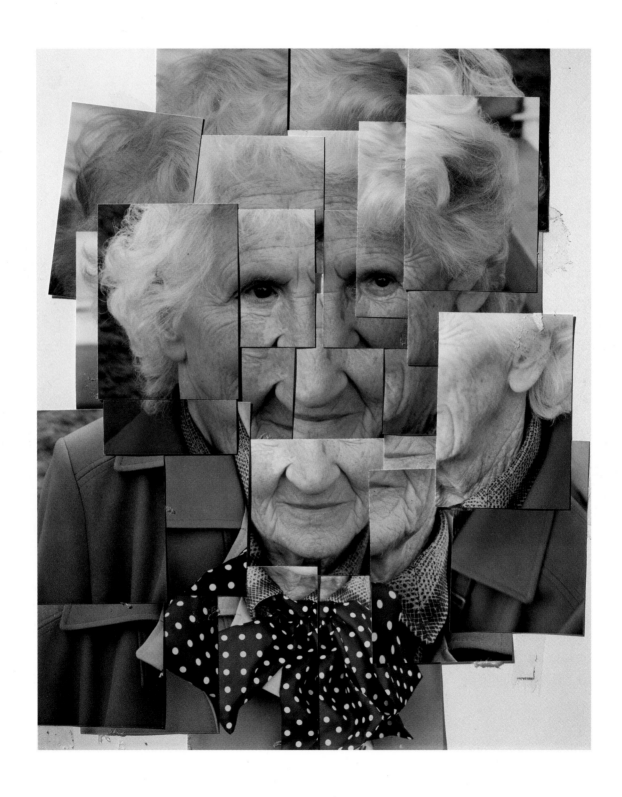

111

Mother 1, Yorkshire Moors, August 1985
1985

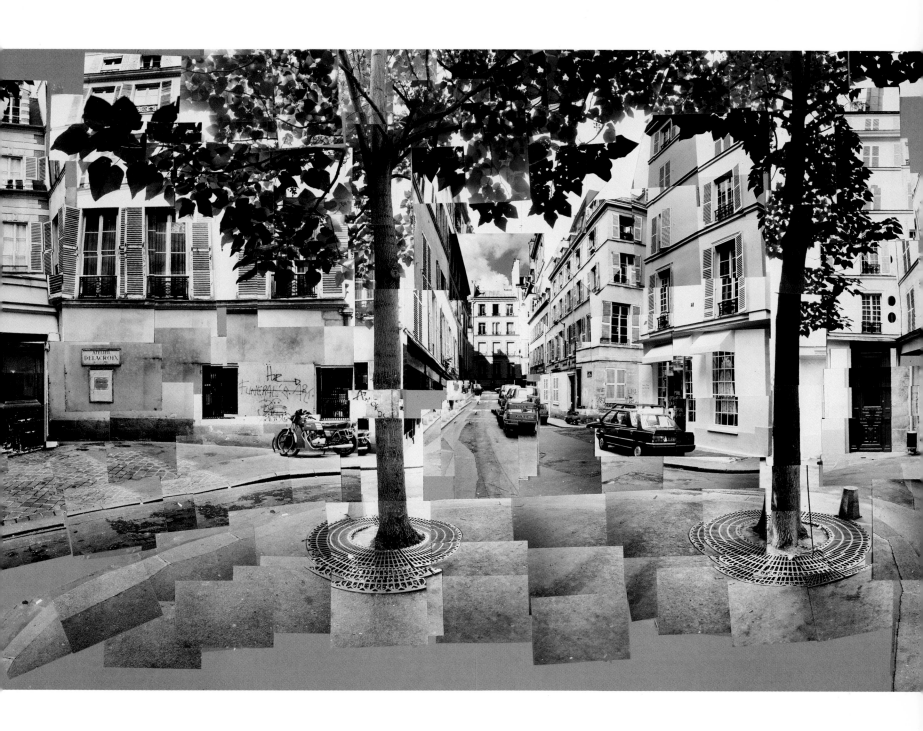

112

Place Furstenburg, Paris, August 7, 8, 9, 1985
1985

247

113

A Walk around the Hotel Courtyard Acatlán
1985

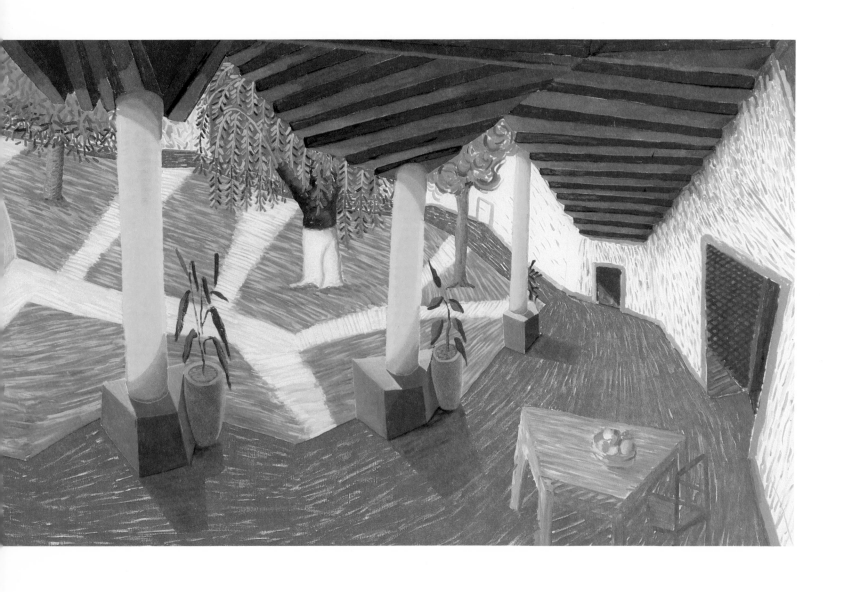

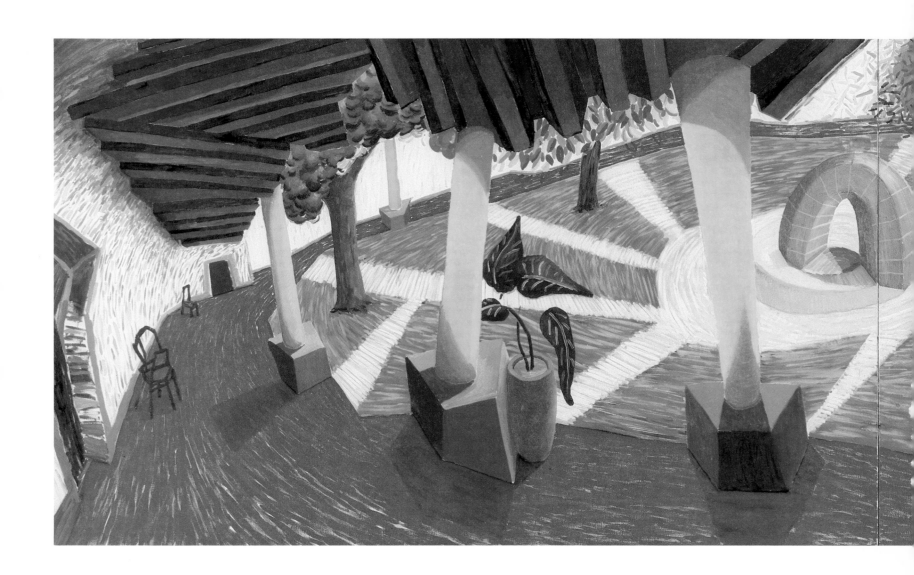

CATALOGUE OF THE EXHIBITION

Self-Portrait
1954
Color lithograph
16 x 12 in. (40 x 30 cm)
Courtesy of the artist

Portrait of My Father
1955
Oil on canvas
20 x 16 in. (50.8 x 40.6 cm)
Courtesy of the artist

Bolton Junction, Eccleshire
1956
Oil on board
48 x 40 in. (121.9 x 101.6 cm)
Bradford Art Galleries and
Museums, West Yorkshire, England

Nude
1957
Oil on canvas
48 x 72 in. (121.9 x 184.1 cm)
Bradford Art Galleries and
Museums, West Yorkshire, England

Kaisarion
1960
Oil on canvas
25 x 12¾ in. (63.5 x 32.4 cm)
Lady D'Avigdor Goldsmid

*The Cha-Cha That Was Danced in the
Early Hours of 24th March*
1961
Oil on canvas
68 x 60½ in. (173 x 158 cm)
Tony Reichardt, FN Queensland,
Australia

Flight into Italy—Swiss Landscape
1961
Oil on canvas
72 x 72 in. (183 x 183 cm)
Kunstmuseum Düsseldorf,
Germany

The Fourth Love Painting
1961
Oil and Letraset on canvas
36 x 28⅛ in. (91 x 71 cm)
Mary Tyler Moore and
Dr. S. Robert Levine

*A Grand Procession of Dignitaries in the
Semi-Egyptian Style*
1961
Oil on canvas
84 x 144 in. (214 x 367 cm)
Edwin Janss, Thousand Oaks,
California

The Most Beautiful Boy in the World
1961
Oil on canvas
70 x 39½ in. (178 x 100 cm)
Werner Boeninger

Myself and My Heroes
1961
Etching
10⅛ x 19¾ in. (26 x 50.1 cm)
Werner Boeninger

A Rake's Progress
1961–63
Etchings
12 x 16 in. (30.5 x 40.6 cm) each
Courtesy of the artist

*Religious Area with Equal Unreligious
Area*
1961
Oil on canvas
20 x 16 in. (50.8 x 40.6 cm)
Collection of Mr. and Mrs. Laurence
B. Mindel

The Second Tea Painting
1961
Oil on canvas
61 x 36 in. (155 x 91 cm)
Private collection

Tea Painting in an Illusionistic Style
1961
Oil on canvas
78 x 30 in. (198 x 76 cm)
Private collection, London

We Two Boys Together Clinging
1961
Oil on board
48 x 60 in. (121.9 x 152.4 cm)
Arts Council of Great Britain

The Cruel Elephant
1962
Oil on canvas
48 x 60 in. (121.9 x 152.4 cm)
Lady D'Avigdor Goldsmid

*The First Marriage (A Marriage
of Styles 1)*
1962
Oil on canvas
72 x 60 in. (183 x 153 cm)
Trustees of the Tate Gallery,
London

*Man in a Museum (or You're in the
Wrong Movie)*
1962
Oil on canvas
60 x 60 in. (152.4 x 152.4 cm)
The British Council

*A Man Stood in Front of His House with
Rain Descending*
1962
Oil on canvas
96 x 60 in. (243.8 x 152.4 cm)
Museum van Hedendaagse Kunst,
Belgium

Picture Emphasizing Stillness
1962
Oil and Letraset on canvas
72 x 62 in. (180 x 153 cm)
Mr. and Mrs. J. J. Sher

The Snake
1962
Oil on canvas
72 x 72 in. (183 x 183 cm)
Private collection, Berlin

Closing Scene
1963
Oil on canvas
48 x 48 in. (122 x 122 cm)
Private collection

Domestic Scene, Broadchalke, Wilts.
1963
Oil on canvas
72 x 72 in. (183 x 183 cm)
Private collection, Berlin

Hand-printed titles vary on some of Hockney's editioned works. The reader may find minor
discrepancies, therefore, between titles in the catalogue of the exhibition and plate captions;
objects reproduced are not in every case the ones exhibited.

The Hypnotist
1963
Oil on canvas
84 x 84 in. (214 x 214 cm)
Private collection

Play within a Play
1963
Oil on canvas and plexiglass
72 x 78 in. (183 x 198 cm)
Joseph Haddad, Beverly Hills,
California

*Seated Woman Drinking Tea, Being
Served by a Standing Companion*
1963
Oil on canvas
78 x 84 in. (198.1 x 213.3 cm)
Andre El-Zenny

The Second Marriage
1963
Oil on canvas
77³/₄ x 90 in. (198 x 229 cm)
National Gallery of Victoria,
Melbourne, Australia, presented by
Contemporary Art Society, London,
1965

Still Life with Figure and Curtain
1963
Oil on canvas
78 x 84 in. (198 x 214 cm)
Private collection

Two Men in a Shower
1963
Oil on canvas
60 x 60 in. (152.4 x 152.4 cm)
Courtesy André Emmerich Gallery
and Leslie Waddington Galleries

Building, Pershing Square, Los Angeles
1964
Acrylic on canvas
58 x 58 in. (147 x 147 cm)
Paul Kantor

California Art Collector
1964
Acrylic on canvas
60 x 72 in. (152 x 183 cm)
Private collection

Iowa
1964
Acrylic on canvas
60 x 60 in. (153 x 153 cm)
Hirshhorn Museum and Sculpture
Garden, Smithsonian Institution,
gift of Joseph H. Hirshhorn, 1966

Man Taking Shower in Beverly Hills
1964
Acrylic on canvas
65¹/₂ x 65¹/₂ in. (167 x 167 cm)
Trustees of the Tate Gallery,
London

Ordinary Picture
1964
Acrylic on canvas
72 x 72 in. (183 x 183 cm)
Hirshhorn Museum and Sculpture
Garden, Smithsonian Institution,
gift of Joseph H. Hirshhorn, 1966

Pacific Tree
1964
Color lithograph
29¹/₂ x 19¹/₂ in. (65 x 49.8 cm)
Private collection

Picture of a Hollywood Swimming Pool
1964
Acrylic on canvas
36 x 48 in. (91 x 122 cm)
Private collection

*Different Kinds of Water Pouring into a
Swimming Pool, Santa Monica*
1965
Acrylic on canvas
72 x 60 in. (183 x 153 cm)
Private collection

A Hollywood Collection
1965
Color lithographs
30 x 22 in. (76.2 x 55.88 cm) each
Los Angeles County Museum of Art,
gift of Mr. and Mrs. David Gensburg
M.68.72.14–19

A Less Realistic Still Life
1965
Acrylic on canvas
48 x 48 in. (122 x 122 cm)
Private collection

Portrait Surrounded by Artistic Devices
1965
Acrylic on canvas
60 x 72 in. (153 x 183 cm)
Arts Council of Great Britain

A Realistic Still Life
1965
Acrylic on canvas
48 x 48 in. (122 x 122 cm)
Waddington Galleries, London

Rocky Mountains and Tired Indians
1965
Acrylic on canvas
67 x 99¹/₂ in. (170 x 253 cm)
Scottish National Gallery of Modern
Art, Edinburgh

Two Boys in a Pool, Hollywood
1965
Acrylic on canvas
60 x 60 in. (152.4 x 152.4 cm)
Private collection, Germany

Beverly Hills Housewife
1966
Acrylic on two canvases
72 x 144 in. (183 x 366 cm)
Private collection, Los Angeles

The Little Splash
1966
Acrylic on canvas
16 x 20 in. (41 x 51 cm)
Mr. Steve Martin

Peter Getting Out of Nick's Pool
1966
Acrylic on canvas
84 x 84 in. (214 x 214 cm)
National Museums and Galleries on
Merseyside (Walker Art Gallery),
England

Portrait of Nick Wilder
1966
Acrylic on canvas
72 x 72 in. (183 x 183 cm)
Fukuoka Sogo Bank, Japan

The Splash
1966
Acrylic on canvas
72 x 72 in. (183 x 183 cm)
Mr. and Mrs. Norman Pattiz

A Bigger Splash
1967
Acrylic on canvas
96 x 96 in. (243.8 x 243.8 cm)
Trustees of the Tate Gallery,
London

A Lawn Being Sprinkled
1967
Acrylic on canvas
60 x 60 in. (153 x 153 cm)
Private collection

The Room, Manchester Street
1967
Acrylic on canvas
96 x 96 in. (244 x 244 cm)
Mr. Steve Martin

Some Neat Cushions
1967
Acrylic on canvas
62 x 62 in. (157.5 x 157.5 cm)
Fujii Gallery, Tokyo

*American Collectors (Fred and Marcia
Weisman)*
1968
Acrylic on canvas
84 x 120 in. (214 x 305 cm)
Art Institute of Chicago, restricted
gift of Mrs. Frederic Pick

*Christopher Isherwood and
Don Bachardy*
1968
Acrylic on canvas
83½ x 119½ in. (212 x 304 cm)
Gilbert de Botton, Switzerland

Corbusier Chair and Rug
1969
Mixed media
17 x 14 in. (43 x 35.3 cm)
David Geffen

Henry Geldzahler and Christopher Scott
1969
Acrylic on canvas
84 x 120 in. (214 x 305 cm)
Abrams Family Collection

Le Parc des sources, Vichy
1970
Acrylic on canvas
84 x 120 in. (214 x 305 cm)
Marquis of Hartington

*Three Chairs with a Section of a Picasso
Mural*
1970
Acrylic on canvas
48 x 60 in. (122 x 152.4 cm)
Collection of Mr. and Mrs. Ahmet
Ertegun

Mr. and Mrs. Clark and Percy
1970–71
Acrylic on canvas
84 x 120 in. (214 x 305 cm)
Trustees of the Tate Gallery,
London

Beach Umbrella
1971
Acrylic on canvas
48 x 35¾ in. (122 x 91 cm)
Collection of Shirley and
Miles Fiterman

Gonzalez and Shadow
1971
Acrylic on canvas
48 x 36 in. (122 x 91.4 cm)
Art Institute of Chicago, bequest of
Solomon B. Smith, 1986

*Portrait of an Artist (Pool with Two
Figures)*
1971
Acrylic on canvas
84 x 120 in. (214 x 275 cm)
David Geffen

*Rubber Ring Floating in a Swimming
Pool*
1971
Acrylic on canvas
35¾ x 48 in. (91 x 122 cm)
Dr. J. H. Beare

Still Life on a Glass Table
1971–72
Acrylic on canvas
72 x 108 in. (183 x 274.4 cm)
Collection of Mr. and Mrs. Ahmet
Ertegun

The Artist's Father
1972
Ink on paper
17 x 14 in. (43.2 x 35.6 cm)
Courtesy of the artist

The Artist's Mother
1972
Crayon on paper
17 x 14 in. (43.2 x 35.6 cm)
Courtesy of the artist

*Celia in a Black Dress with White
Flowers*
1972
Crayon on paper
17 x 14 in. (43.2 x 35.6 cm)
Courtesy of the artist

Japanese Rain on Canvas
1972
Acrylic on canvas
48 x 48 in. (122 x 122 cm)
Private collection

Mt. Fuji and Flowers
1972
Acrylic on canvas
60 x 48 in. (153 x 122 cm)
Metropolitan Museum of Art, Mrs.
Arthur Hays Sulzberger gift, 1972

Two Deckchairs, Calvi
1972
Acrylic on canvas
60 x 48 in. (153 x 122 cm)
Museum Boymans-van Beuningen,
Rotterdam

Celia Wearing Checked Sleeves
1973
Crayon on paper
25½ x 19½ in. (64.8 x 49.5 cm)
Courtesy of the artist

Sant' Andrea in Caprile (Henry in
Deckchair)
1973
Crayon on paper
17 x 14 in. (43.2 x 35.6 cm)
Private collection

The Student: Homage to Picasso
1973
Etching
30 x 22 in. (76.2 x 55.9 cm)
Werner Boeninger

The Artist and Model
1973–74
Etching
32 x 24 in. (81.3 x 61 cm)
Werner Boeninger

Contre-jour in the French Style—
Against the Day dans le style français
1974
Oil on canvas
72 x 72 in. (183 x 183 cm)
Neue Galerie, Sammlung Ludwig,
Aachen

Invented Man Revealing Still Life
1975
Oil on canvas
36 x 28½ in. (91.4 x 72.4 cm)
Nelson-Atkins Museum of Art, Kan-
sas City, Missouri, gift of Mr. and
Mrs. William L. Evan, Jr.

Kerby (after Hogarth) Useful
Knowledge
1975
Oil on canvas
72 x 60 in. (183 x 152.4 cm)
Museum of Modern Art, New
York, gift of the artist and J.
Kasmin and the Advisory
Committee Fund, 1977

Blue Guitar
1976–77
Etchings
7 are 17 x 14 in. (43.2 x 35.6 cm),
13 are 14 x 17 in. (35.6 x 43.2 cm)
Courtesy of the artist

Looking at Pictures on a Screen
1977
Oil on canvas
74 x 74 in. (188 x 188 cm)
On permanent loan to Walker Art
Center, Minneapolis, from the col-
lection of Shirley and Miles
Fiterman

Model with Unfinished Self-Portrait
1977
Oil on canvas
60 x 60 in. (152 x 152 cm)
Werner Boeninger

My Parents
1977
Oil on canvas
72 x 72 in. (183 x 183 cm)
Trustees of the Tate Gallery,
London

Self-Portrait with Blue Guitar
1977
Oil on canvas
60 x 72 in. (152.4 x 182.9 cm)
Museen Moderner Kunst, Vienna
(on loan from Sammlung Ludwig,
Aachen)

Day Pool with Three Blues (Paper Pool
#7)
1978
Colored pressed paper pulp
72 x 85½ in. (182.9 x 217.2 cm)
Tyler Graphics, Ltd.

A Large Diver (Paper Pool #27)
1978
Colored pressed paper pulp
72 x 170 in. (182.0 x 431.0 cm)
San Francisco Museum of Modern
Art, T. B. Walker Foundation Fund
Purchase

Mother, Bradford, 19th February 1978
1978
Ink on paper
14 x 11 in. (35.6 x 27.9 cm)
Courtesy of the artist

Le Plongeur (Paper Pool #18)
1978
Colored pressed paper pulp
72 x 171 in. (182.9 x 434.3 cm)
Bradford Art Galleries and
Museums, West Yorkshire, England

Celia Amused
1979
Lithograph
40 x 29 in. (101.6 x 73.7 cm)
Courtesy of the artist

Celia Elegant
1979
Lithograph
40 x 29 in. (101.6 x 73.7 cm)
Courtesy of the artist

Celia Weary
1979
Lithograph
40 x 29 in. (101.6 x 73.7 cm)
Courtesy of the artist

Divine
1979
Acrylic on canvas
60 x 60 in. (152.4 x 152.4 cm)
The Carnegie Museum of Art, Pitts-
burgh, gift of Richard M. Scaife,
1982

Harlequin
1980
Oil on canvas
48 x 36 in. (121.9 x 91.4 cm)
Courtesy of the artist

Hollywood Hills House
1980
Oil, charcoal, and collage on canvas
60 x 120 in. (152.4 x 304.8 cm)
Walker Art Center, Minneapolis, gift
of David M. and Penny R. Winton

Mulholland Drive: The Road to the
Studio
1980
Acrylic on canvas
86 x 243 in. (218 x 617 cm)
Los Angeles County Museum of Art,
purchased with funds provided by
the F. Patrick Burns bequest

Nichols Canyon
1980
Acrylic on canvas
84 x 60 in. (213.3 x 152.4 cm)
Mr. and Mrs. Richard C. Hedreen

Parade with Unfinished Backdrop
1980
Acrylic on canvas
60 x 72 in. (152.4 x 182.9 cm)
Virginia Museum of Fine Arts, gift
of the Sydney and Frances Lewis
Foundation

Ravel's Garden with Night Glow
1980
Oil on canvas
60 x 72 in. (152.4 x 182.9 cm)
Rita and Morris Pynoos

Two Dancers
1980
Oil on canvas
48 x 72 in. (121.9 x 182.9 cm)
Private collection

*Billy Wilder Lighting His Cigar
Dec. 1982 #19*
1982
Photographic collage
27 x 17½ in. (68.6 x 44.5 cm)
Courtesy of the artist

The Brooklyn Bridge Nov 28th 1982
1982
Photographic collage
42¹⁵/₁₆ x 22¹³/₁₆ in. (109 x 58 cm)
Private collection, courtesy of L.A.
Louver Gallery, Venice, California

Celia Los Angeles April 10th 1982
1982
Composite Polaroid
18 x 39½ in. (45.7 x 100.3 cm)
Courtesy of the artist

*Celia Making Tea. New York
Dec 1982 #19*
1982
Photographic collage
25 x 21 in. (63.5 x 53.3 cm)
Courtesy of the artist

*Grand Canyon Looking North,
September 1982 #13*
1982
Photographic collage
40 x 96 in. (101.6 x 243.8 cm)
Courtesy of the artist

Kasmin Los Angeles 28th March 1982
1982
Composite Polaroid
41¾ x 29¾ in. (106 x 75.6 cm)
Courtesy of the artist

*Mother, Bradford, Yorkshire
4th May 1982*
1982
Composite Polaroid
56 x 33½ in. (142.2 x 85.1 cm)
Courtesy of the artist

*My Mother, Bolton Abbey,
Yorkshire Nov. 82 #4*
1982
Photographic collage
47½ x 27½ in. (120.7 x 69.9 cm)
Courtesy of the artist

*Noya + Bill Brandt with Self-Portrait
(Although They Were Watching This
Picture Being Made) Pembroke Studios
London 8th May 1982*
1982
Composite Polaroid
24½ x 24½ in. (62.2 x 62.2 cm)
Courtesy of the artist

*Patrick Procktor Pembroke Studios
London 7th May 1982*
1982
Composite Polaroid
52½ x 21 in. (133.4 x 53.3 cm)
Courtesy of the artist

*Rain on the Pool, Monday,
April 12th 1982*
1982
Composite Polaroid
25 x 36 in. (63.5 x 91.4 cm)
Courtesy of the artist

Ruth Leserman #1
1982
Photographic collage
30 x 22 in. (76.2 x 55.9 cm)
Courtesy of the artist

Studio. Hollywood Hills House
1982
Gouache on paper
51 x 66 in. (129.5 x 167.6 cm)
Courtesy of the artist

*Sun on the Pool Los Angeles
April 13th 1982*
1982
Composite Polaroid
25 x 36 in. (63.5 x 91.4 cm)
Courtesy of the artist

*Unfinished Painting in Finished
Photograph(s) 2nd April 1982*
1982
Composite Polaroid
25 x 30 in. (63.5 x 76.2)
Courtesy of the artist

*Christopher Isherwood Talking to Bob
Holman Santa Monica March 14 1983
#3*
1983
Photographic collage
43½ x 64½ in. (110.5 x 163.8 cm)
Courtesy of the artist

*The Crossword Puzzle Minneapolis
Jan. 1983 #8*
1983
Photographic collage
33 x 46 in. (83.8 x 116.8 cm)
Courtesy of the artist

Design for *Les Mamelles de Tirésias*
1983
Oil on canvas
132 x 228 x 120 in.
(335.3 x 579.1 x 304.8 cm)
Collection of the Walker Art Center,
Minneapolis, gift of the artist, 1984

*Luncheon at the British Embassy Tokyo
Feb 16th 1983 #12*
1983
Photographic collage
46 x 83 in. (116.8 x 210.8 cm)
Courtesy of the artist

Mother, Bradford June 27th 1983
1983
Ink on paper
30 x 22½ in. (76.2 x 57.2 cm)
Courtesy of the artist

*Photographing Annie Leibovitz While
She Photographs Me, Mohave Desert
Calif. Feb. 1983 #4*
1983
Photographic collage
24½ x 60 in. (62.2 x 152.4 cm)
Courtesy of the artist

*The Scrabble Game,
Jan 1 1983 #10*
1983
Photographic collage
39 x 8 in. (99.1 x 20.3 cm)
Courtesy of the artist

Self-Portrait 8 Sept. 1983
1983
Charcoal on paper
22½ x 18 in. (57.2 x 45.7 cm)
Courtesy of the artist

Self-Portrait 28th September 1983
1983
Charcoal on paper
30 x 22½ in. (76.2 x 57.2 cm)
Courtesy of the artist

Self-Portrait 30th Sept 1983
1983
Charcoal on paper
30 x 22½ in. (76.2 x 57.2 cm)
Courtesy of the artist

Self-Portrait 24th Oct. 1983
1983
Charcoal on paper
30 x 22½ in. (76.2 x 57.2 cm)
Courtesy of the artist

*Self-Portrait 31st Oct. 1983
Minneapolis*
1983
Charcoal on paper
30 x 22½ in. (76.2 x 57.2 cm)
Courtesy of the artist

Self-Portrait Looking over Glasses
1983
Charcoal on paper
30 x 22½ in. (76.2 x 57.2 cm)
Courtesy of the artist

Self-Portrait Sketch
1983
Ink and charcoal on paper
30 x 22½ in. (76.2 x 57.2 cm)
Courtesy of the artist

Self-Portrait with Cigarette
1983
Charcoal on paper
30 x 22½ in. (76.2 x 57.2 cm)
Courtesy of the artist

Self-Portrait without Glasses
1983
Charcoal on paper
30 x 22½ in. (76.2 x 57.2 cm)
Courtesy of the artist

Self-Portrait without Shirt
1983
Charcoal on paper
30 x 22½ in. (76.2 x 57.2 cm)
Courtesy of the artist

Self-Portrait with Striped Shirt and Tie
1983
Charcoal on paper
30 x 22½ in. (76.2 x 57.2 cm)
Courtesy of the artist

Self-Portrait with Tie
1983
Charcoal on paper
30 x 22½ in. (76.2 x 57.2 cm)
Courtesy of the artist

*Sitting in the Zen Garden at the Ryoanji
Temple Kyoto Feb. 19 1983 #4*
1983
Photographic collage
57 x 46 in. (144.8 x 116.8 cm)
Courtesy of the artist

*Walking in the Zen Garden at the
Ryoanji Temple Kyoto Feb 21st 1983 #18*
1983
Photocollage
40 x 62½ in. (101.6 x 158.8 cm)
Courtesy of the artist

*The Wedding of David and Ann in
Hawaii 20 May 1983 #1*
1983
Photographic collage
69½ x 208 in. (176.3 x 528.3 cm)
Courtesy of the artist

Celia II
1984
Oil on canvas
26 x 18 in. (58.4 x 45.7 cm)
Sidney Kahn

Christopher with His Glasses On
1984
Oil on canvas
30½ x 23 in. (77.5 x 58.4 cm)
Dr. Stan Sehler, Milwaukee

Christopher without His Glasses On
1984
Oil on canvas
30½ x 23 in. (77.5 x 58.4 cm)
Courtesy of the artist

The Desk, July 1st, 1984 #17
1984
Photographic collage
48½ x 46½ (123.2 x 118.1 cm)
Courtesy of the artist

An Image of Celia
1984–86
Lithograph
60 x 41 in. (152.4 x 104.1 cm)
Courtesy of the artist

Self-Portrait on the Terrace
1984
Oil on two canvases
84 x 120 in. (213.4 x 304.8 cm)
Rita and Morris Pynoos

*A Visit with Christopher and Don, Santa
Monica Canyon 1984*
1984
Oil on two canvases
72 x 240 in. (182.9 x 609.6 cm)
Courtesy of the artist

*A Visit with Mo and Lisa,
Echo Park, Los Angeles*
1984
Gouache on paper
60 x 201 in. (152.4 x 510.5 cm)
Mr. and Mrs. Harry W. Anderson

*Walking Past Le Rossignol April 1984
#8*
1984
Photographic collage
37 x 73 in. (94 x 185.4 cm)
Courtesy of the artist

The Chair
1985
Oil on canvas
48 x 36 in. (121.9 x 91.4 cm)
Courtesy of the artist

*Chair, Jardin de Luxembourg, Paris 10th
August 1985*
1985
Photographic collage
43½ x 31½ in. (110.5 x 80.0 cm)
Courtesy of the artist

*Mother 1, Yorkshire Moors, August
1985 #1*
1985
Photographic collage
18½ x 13 in. (47 x 33 cm)
Courtesy of the artist

*Place Furstenburg, Paris, August 7, 8, 9,
1985 #1*
1985
Photographic collage
35 x 31½ in. (88.9 x 80 cm)
Courtesy of the artist

Terrace without Shadows 1985
1985
Photographic collage
18 x 24 in. (45.7 x 61 cm)
Courtesy of the artist

*A Walk around the Hotel Courtyard
Acatlán*
1985
Oil on canvas
72 x 240 in. (183 x 610 cm)
Courtesy of the artist

*Pearblossom Hwy., 11–18th April 1986
#2*
1986
Photographic collage
78 x 111 in. (198 x 282 cm)
Courtesy of the artist

CHRONOLOGY

1937

Born July 9 in Bradford, England.

1953–57

Studies at Bradford School of Art.

1957–59

As conscientious objector works in hospitals to fulfill National Service obligation.

Hockney with his mother on the steps of Sacré Cœur, Paris, August 1963

1960

Sees major Picasso exhibition at Tate Gallery, London. Meets John Kasmin, London art dealer, who later (1963) hangs his first solo exhibition, *David Hockney: Pictures with People In* (a selected list of exhibitions and venues is included in the bibliography). Reads complete works of Walt Whitman.

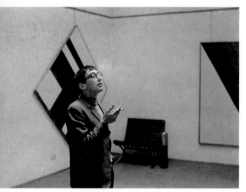

John Kasmin in his gallery, London, May 1965

1959–62

Studies at Royal College of Art, London; classmates include R. B. Kitaj and other founders of Pop art movement in Britain. In London sees works of American Abstract Expressionists, including Willem de Kooning, Jackson Pollock, and Mark Rothko.

1960–61

Executes *Doll Boy* and other Love Paintings.

1961

Guinness Award for Etching, first prize. *John Moores Liverpool Exhibition 1961*, Walker Art Gallery, Liverpool, Junior Section prize. First visit to United States.

1962

Graduated from Royal College of Art; gold medal winner.

1963

Executes first Shower Paintings. Travels to Egypt. Paris Biennale, graphics prize. First visit to Los Angeles. Meets Henry Geldazhler, curator of twentieth-century art at the Metropolitan Museum of Art, New York.

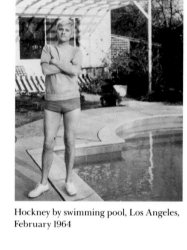

Hockney by swimming pool, Los Angeles, February 1964

1964

Moves to Los Angeles. Makes first Swimming Pool Paintings. Begins making instant (Polaroid) photographs. Begins working with acrylic paints. Meets master printer Ken Tyler, fashion designer Celia Birtwell, and writer Christopher Isherwood. Teaches at the University of Iowa, Iowa City (June–July). 8th International Exhibition of Drawings and Engravings, Lugano, first prize.

1965

7th International Exhibition of Graphic Art, Ljubljana, purchase prize. Teaches at the University of Colorado, Boulder.

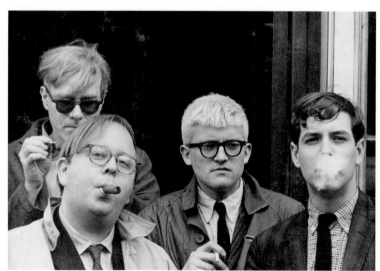

Andy Warhol, Henry Geldazhler, Hockney, and Jeff Goodman, New York, May 1963 (photo by Dennis Hopper)

Celia Birtwell with her son George in Ken Tyler's swimming pool, March 1973

1966

First International Biennale of Graphic Art, Cracow, award. Designs Royal Court Theatre production of Alfred Jarry's *Ubu Roi*.

1966–67

Teaches at University of California, Los Angeles.

1967

John Moores Liverpool Exhibition 6, Walker Art Gallery, Liverpool, first prize. Teaches at University of California, Berkeley.

1968

First large double portraits. Increased use of 35mm photographs as references for paintings. Moves to London.

1970

Traveling retrospective at the Whitechapel Art Gallery, London: *David Hockney: Paintings, Prints and Drawings 1960–1970*. Pastes photographs together in first Joiners.

Hockney and Henry Geldzahler, Corsica, July 1973

Ken Tyler working on a print depicting Celia Birtwell, March 1973

1973–75

Lives in Paris.

1974

Solo exhibition at the Musée des Arts Décoratifs, Paris—*David Hockney: Tableaux et dessins*—including key works from 1961–74.

1975

Designs Glyndebourne Festival Opera production of Igor Stravinsky's *The Rake's Progress*.

1976

Returns to Los Angeles. Begins working extensively with photography.

1976–77

Reads Wallace Stevens's poem "The Man with the Blue Guitar" and executes a suite of twenty etchings on the theme (published 1977).

Stephen Spender, Christopher Isherwood, and Hockney on the Staten Island ferry, New York, February 1974

Park in Vichy, France, June 1973

Hockney and Peter Schlesinger at the Los Angeles County Museum of Art, September 1966

Christopher Isherwood, Maurice Payne, Mo McDermott, and Hockney, in Tony Richardson's empty swimming pool, Hollywood, November/December 1974

1978

Designs Glyndebourne Festival Opera production of Wolfgang Amadeus Mozart's *The Magic Flute.*

1980-81

Designs "triple bill" for Metropolitan Opera: Erik Satie's *Parade,* Francis Poulenc's *Les Mamelles de Tirésias*, and Maurice Ravel's *L'Enfant et les Sortilèges.* Sees *Picasso from the Musée Picasso* at Walker Art Center, Minneapolis; exhibition includes collages.

1981

Designs Metropolitan Opera productions of Stravinsky's *Le Sacre du Printemps, Le Rossignol,* and *Oedipus Rex.* Travels to China with Stephen Spender.

1982

6th Norwegian International Print Biennale, gold medal. First composite Polaroids and photographic collages.

Jerry Sohn swimming in Hockney's pool, Los Angeles, September 1983

Temple at foot of a rocky hill, China, 1981

1983

Friedrich von Schiller Foundation, Shakespeare prize. University of Bradford honorary doctorate in letters. Skowhegan School of Painting and Sculpture, award for graphics. Begins to study Chinese scrolls and reads George Rowley's *Principles of Chinese Painting.*

1984

Kodak photography book award for *Cameraworks.*

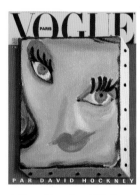

French *Vogue,* December 1985–January 1986 (cover)

1985

International Center of Photography, New York, first annual award, art category. San Francisco Art Institute, honorary degree in fine arts. Otis Art Institute of Parsons School of Design, Los Angeles, honorary doctorate in fine arts. Designs cover and 41 pages for French *Vogue* December 1985–January 1986 issue.

1986

First Home Made Prints created on photocopiers. Completes *Pearblossom Hwy., 11–18th April 1986,* culmination of experiments in collaged photographs.

1986-87

Designs Los Angeles Music Center Opera production of Richard Wagner's *Tristan und Isolde.*

Compiled by Carol S. Eliel

PHOTO SOURCES AND CREDITS

Unless otherwise indicated, all photos are reproduced courtesy of the artist or the lenders. A complete list of works exhibited and lenders appears on pp. 251–57.

Marlborough Fine Art, London: 2.
John Webb: 12, 15, 16c, 26b, 29a, d, 36b, 37a–c, 56b, 103, 106, 119–21, 145–47, 186.
Steven Oliver, Los Angeles County Museum of Art: 14, 16a, 17b, 27c, 34c, 42, 44, 45a, 46a, c, 47, 49b, 51a, 57a, c, 60b, 63a, 66–67, 73a–b, d, 74, 78–79, 80c, 84, 94, 96b, 108–16, 142–43, 152–53, 156–57, 159–61, 169, 172, 174, 180, 184–85, 187, 194–95, 201–2, 219, 221, 228, 232–39, 245.
Art Gallery of New South Wales: 17a.
Steven Sloman: 22, 27a–b, 40–41, 50, 80a, 82a, 83b, 92b, 107, 165–66, 168, 170–71, 191, 242–43, 249.
Mark Farrington: 23, 34b, 35a–b, 55, 59a, 210, 212–14, 216–18.
John Donat: 29b.
Pushkin Museum, Moscow: 34a.
Art Institute of Chicago: 36a, 167. Copyright ©1987. All rights reserved.
Museum of Modern Art, New York: 45b–c, 86.
Musée Picasso, Paris: 45d.
David Kellogg: 46b, 48b, 51b.
Tyler Graphics Ltd.: 50a–b. Printed and published by Tyler Graphics Ltd. Copyright © by David Hockney/Tyler Graphics Ltd., 1986.
Steven Oliver and Peter Brenner, Los Angeles County Museum of Art: 52, 85, 203.
Wayne Shimabukuro: 53.
Richard Schmidt: 54, 57b, 65, 76–77, 97a.
Richard Schmidt or James Franklin: 56a, 58, 59b, 60a, 62, 63b, 72, 73c, 95, 209, 211, 215, 220, 223, 225–27, 229, 240–41, 244, 246–47.
James Franklin: 68a.
Walker Art Center, Minneapolis: 68b, 69a–b.
National Gallery, London: 69c, 83a.
André Emmerich Gallery: 70.
Clay Humphrey: 71, 96a.
Museum Ludwig, Köln: 80b, 81.
Jerry Sohn: 99.
Tate Gallery, London: 104–5, 193.
Art Gallery of Hamilton, Ontario: 125.
Steven Young: 134, 204–5.
Sotheby's: 163.
Twelvetrees Press: 258c. Reproduced courtesy of Twelvetrees Press and Dennis Hopper.

BIBLIOGRAPHY

Compiled by Meg Duff and Beth Houghton
Tate Gallery Library

Despite the wealth of published material by and about David Hockney, this is the first extensive bibliography on the artist to be published. The sheer volume of material, the slight nature of much of it, and the ephemeral character of many of the publications concerned made the undertaking difficult.

In order to keep this bibliography to manageable proportions and yet make it as useful as possible, we have concentrated on the more substantial items and on those most readily available to researchers. The bibliography is also biased toward English-language publications. A more comprehensive bibliography, containing materials excluded from all the categories described below, is available for consultation in the library of the Tate Gallery, London.

The items in the bibliography are divided into five sections: books and portions of books; solo exhibitions; selected group exhibitions; articles in periodicals; and films, videos, and radio and television programs. Books are listed alphabetically by author, with titles under "Hockney" arranged chronologically. Exhibitions and articles in periodicals are in chronological order. In the second and third sections exhibitions are listed whether or not a catalogue was published.

Books and Portions of Books This includes books by and about the artist and a very small selection of the many general books in which he is mentioned.

Solo Exhibitions This list aims to be comprehensive, though there are bound to be omissions. Where a catalogue was published to accompany the exhibition, full bibliographical details are given, if known. For shows that toured extensively—such as *Travels with Pen, Pencil and Ink; Hockney Paints the Stage;* and *Hockney's Photographs*—not all variants of published catalogues have been included, but some indication of the itinerary of the exhibition is given.

Selected Group Exhibitions It would be impracticable to list all the group exhibitions in which Hockney has participated, and this list is necessarily selective. It is most comprehensive for the period of the 1960s, the early part of the artist's career. Details of the number of works by Hockney that were exhibited and of published exhibition catalogues are given where known.

Articles in Periodicals This is an extremely selective listing of general articles and more substantial solo-exhibition reviews appearing in generally accessible publications, although some shorter reviews have been included when they constitute the only review of a particular exhibition. Group-exhibition and book reviews have been excluded for the most part, as have the numerous, and sometimes quite substantial, reviews published in daily newspapers.

Films, Videos, and Radio and Television Programs Again, this is a selective listing, compiled and verified largely by the BBC, Karen Kuhlman, and Mitch Tuchman.

BOOKS AND PORTIONS OF BOOKS

Amaya, Mario. *Pop As Art: A Survey of the New Super Realism.* London: Studio Vista, 1965, pp. 34, 117–20, 123, 131, 141.

Bragg, Melvyn. *David Hockney on Modern Art: An Interview with Melvyn Bragg.* London: Arts Council of Great Britain; ILEA Learning Materials Service, 1982. Transcript of videocassette, 1981.

Cavafy, C. P. *Fourteen Poems by C. P. Cavafy.* Chosen and illustrated with twelve etchings by David Hockney. Translated by Nikos Stangos and Stephen Spender. London: Editions Alecto, 1966. Published in five limited editions.

Fuller, Peter. *Beyond the Crisis in Art.* London: Writers and Readers, 1980, pp. 168–89. Interview.

David Hockney. *A Rake's Progress: A Poem in Five Sections [by] David Posner; A Rake's Progress, London New York 1962 [etchings by] David Hockney.* London: Lion & Unicorn Press, 1967. Etchings first published in a limited edition of fifty by Editions Alecto, 1963.

———. *Six Fairy Tales from the Brothers Grimm: With Original Etchings by David Hockney.* London: Petersburg Press in association with the Kasmin Gallery, 1970. Four limited-edition portfolio sets of 100, plus artist's proofs, with a miniature edition (4¼ in. long, 61 pp.) published simultaneously.

———. *72 Drawings by David Hockney: Chosen by the Artist.* New York: Viking; London: Jonathan Cape, 1971.

———. *David Hockney by David Hockney.* Edited by Nikos Stangos. Introduction by Henry Geldzahler. London: Thames and Hudson, 1976; New York: Harry N. Abrams, 1977.

———. *The Blue Guitar [etchings]: The Man with the Blue Guitar [poem by] Wallace Stevens.* London and New York: Petersburg Press, 1977. Limited-edition portfolio of the etchings also published October 1977.

———. *18 Portraits by David Hockney.* Los Angeles: Gemini G.E.L., 1977.

———. *75 Drawings by David Hockney.* [Preface] by Peter Weiermair. Innsbruck: Allerheiligenpresse, 1977.

———. *Travels with Pen, Pencil and Ink.* Introduction by Edmund Pillsbury. London and New York: Petersburg Press, 1978. Published on the occasion of the traveling exhibition of the same title. *See also* Solo Exhibitions, Yale Center for British Art, 1978–80.

———. *Pictures by David Hockney.* Selected and edited by Nikos Stangos. Introduction by David Hockney. London: Thames and Hudson; New York: Harry N. Abrams, 1979. Swiss edition: *Bilder von David Hockney.* Zurich: Diogenes, 1980. Japanese edition: Tokyo: Orion Press, 1984.

———. *David Hockney Paper Pools.* Edited by Nikos Stangos. London: Thames and Hudson; New York: Harry N. Abrams, 1980.

———. *David Hockney: 23 Lithographs 1978–1980.* New York: Tyler Graphics, 1980. *See also* Solo Exhibitions, Tyler Graphics, June 1980.

———. Foreword to *The Drawing Book,* by Jeffrey Camp. New York: Holt, Rinehart and Winston, 1981. British edition: *Draw: How to Master the Art.* London: Andre Deutsch, 1981, pp. 6–7.

———. *David Hockney Photographs.* London and New York: Petersburg Press, 1982. German edition: *David Hockney Photograph.* Munich: Schirmer/Mosel, 1983. Published on the occasion of the exhibition *David Hockney photographe,* Paris, 1982. *See also* Solo Exhibitions.

———. *On Photography: A Lecture at the Victoria & Albert Museum November 1983.* New York: André Emmerich, 1983. Reprinted Bradford, England: National Museum of Photography, Film and Television, 1985, on the occasion of Hockney's lecture "Wider Perspectives Are Needed Now" there July 1985.

———. "Pinturas importantes de la década de los sesenta." In *Picasso, 1963–1973: su última década.* Mexico City: Museo Rufino Tamayo, 1984, pp. 80–90. Exhibition catalogue. Text is a resume of a lecture on Picasso given at the Solomon R. Guggenheim Museum, New York, 3 April 1984.

———. *Martha's Vineyard and Other Places: My Third Sketchbook from the Summer of 1982, David Hockney.* Text edited by Nikos Stangos. 2 vols. London: Thames and Hudson; New York: Harry N. Abrams, 1985. Includes facsimile of sketchbook.

Kinneir, Joan, ed. *The Artist by Himself: Self-Portrait Drawings from Youth to Old Age.* St. Albans and London: Granada Publishing; New York: St. Martin's, 1980, pp. 35–39. Early letters and a self-portrait.

Lambert, J. W. "To the Rise of the Curtain." In *Glyndebourne Festival Programme Book 1978.* Glyndebourne: Glyndebourne Festival Opera, 1978, pp. 94–100. Cover illustration by Hockney.

Livingstone, Marco. *David Hockney.* World of Art Library. London: Thames and Hudson; New York: Holt, Rinehart and Winston, 1981. Revised edition to be published in 1988.

Petersburg Press 1968–1973. London: Petersburg Press, [1973]. Stock catalogue. Includes prints by Hockney.

Rothenstein, John. "David Hockney, Born 1937." In *Modern English Painters: Volume 3, Hennell to Hockney.* 2d ed. London: Macdonald, 1984, pp. 223–31. Originally published in *Modern English Painters: [Volume 3] Wood to Hockney.* London: Macdonald; New York: St. Martin's, 1974, pp. 221–31.

Shanes, Eric. *Hockney Posters.* London: Pavilion Books, 1987.

Spender, Stephen, and David Hockney. *China Diary.* London: Thames and Hudson; New York: Harry N. Abrams, 1982. Japanese edition published by arrangement with Thames and Hudson.

Spies, Werner. "The Myth of Water and Dream: An Assessment of the Work of David Hockney, Paris, 1974." In *Focus on Art.* New York: Rizzoli, 1982, pp. 197–202. German edition: *Das Auge am Tatort.* Munich: Prestel, 1979. Article reprinted from the *Frankfurter Allgemeine Zeitung.*

Webb, Peter. "Appendix IIIC: David Hockney." In *The Erotic Arts.* London: Secker and Warburg, 1975, pp. 375–78. Interview.

———. *A Portrait of David Hockney.* London: Secker and Warburg; New York: McGraw-Hill, 1988.

Weschler, Lawrence. *Cameraworks: David Hockney.* London: Thames and Hudson; New York: Alfred A. Knopf, 1984.

Whitechapel Gallery, London. *David Hockney: Paintings, Prints and Drawings 1960–1970.* Revised edition. London: Lund Humphries, 1970. For original edition, *see* Solo Exhibitions, Whitechapel Gallery, 1970.

SOLO EXHIBITIONS

1963

Bear Lane Gallery, Oxford. [Drawings.]* January-February. Exhibition held simultaneously with John Latham's *Assemblages.* No catalogue traced.

Editions Alecto, The Print Centre, London. *David Hockney: A Rake's Progress and Other Etchings.* December. [17] pp. Includes a statement by Hockney.

Kasmin Limited, London. *David Hockney: Pictures with People In.* December. Folded card, [4] pp.

1964

Lane Gallery, Bradford. *David Hockney: A Rake's Progress and Other Etchings.* January. 16 works. [10] pp. Includes a statement by Hockney.

Heffer Gallery, Cambridge, England. *Exhibition of Original Contemporary Lithographs, Including the Suite A Rake's Progress by David Hockney.* February. Private-view card.

Prestons Art Gallery, Bolton, England. *David Hockney: A Rake's Progress.* August-September. 16 works. Folded card, [4] pp. Includes a statement by Hockney.

Alan Gallery, New York. *David Hockney.* September–October. 13 works. Folded card, [4] pp.

Associated American Artists Galleries, New York. [A Rake's Progress.] October.

1965

Kasmin Limited, London. *David Hockney: Pictures with Frames and Still Life Pictures.* December. Card, [2] pp.

1966

Palais des Beaux-Arts, Brussels.

Studio Marconi, Milan. [Drawings.]

Galleria dell'Ariete, Milan. *David Hockney.* March. 10 works. [12] pp. Text by Patrick Procktor. Italian text.

Stedelijk Museum, Prentenkabinet, Amsterdam. *David Hockney: Tekeningen en Etsen.* April–May. 51 works. Folded card, [4] pp. Text by Gene Baro.

* The compilers were not able to trace or gain access to printed materials for every exhibition. Words in brackets indicate unverified exhibition titles or descriptions.

Kasmin Limited, London. *David Hockney: Preparatory Drawings of the Sets for the Production of Ubu Roi by Alfred Jarry . . . Twelve Etchings Inspired by the Poems of C. P. Cavafy.* July. Private-view card.

1967

Norwich School of Art, England. [*A Rake's Progress.*] No catalogue traced.

Landau-Alan Gallery, New York. *David Hockney: New Paintings and Drawings.* March–April. 10 works. Folded card, [4] pp.

Mala Galerija, Ljubljana. *David Hockney.* July. 19 works. [20] pp. Introduction by Gene Baro. Parallel Serbo-Croatian/French text.

1968

Museum of Modern Art, New York. No catalogue traced.

Alecto Gallery, London. *David Hockney Exhibition.* January. 37 works. Typescript price list, [1] p.

Kasmin Limited, London. *David Hockney: A Splash, a Lawn, Two Rooms, Two Stains, Some Neat Cushions and a Table . . . Painted.* January. Folded card, [4] pp.

Kasmin Limited, London. *David Hockney: Personal Drawings.* September. Private-view card. No catalogue traced.

Galerie Mikro, Berlin, in collaboration with Petersburg Press, London. *David Hockney: Oeuvrekatalog—Graphik.* October. 29 works. [50] pp. Text by Wibke van Bonin. Parallel German/English text.

1969

André Emmerich Gallery, New York.

Whitworth Art Gallery, Manchester. *Exhibition of Paintings and Prints by David Hockney.* February–March. 31 works. 27 pp. Introduction by Mario Amaya.

Rodman Hall Arts Centre, St. Catherine's, Ontario. *Graphics by David Hockney.* November. 25 works. [28] pp. Text by T. A. Heinrich. Includes statements by Hockney.

Kasmin Limited, London. *David Hockney: Etchings 1969.* December. Private-view card.

1970

Galerie Springer, Berlin.

Lane Gallery, Bradford. *David Hockney.* 42 works. Folded checklist, [10] pp.

Whitechapel Gallery, London. *David Hockney: Paintings, Prints and Drawings 1960–1970.* April–May. 100 pp. Introduction by Mark Glazebrook. Interview with Hockney. *See also* revised edition of this catalogue, published as a book, under "Whitechapel." Traveling to Hanover, Rotterdam, Belgrade.

Kestner-Gesellschaft, Hanover. Traveling from Whitechapel Gallery, London. *David Hockney.* May–June. 43 pp. [70] pp. of plates. Introduction by Wieland Schmied. Includes an interview with Hockney. German text.

Muzej Savremene Umetnosti, Belgrade. Organized by the British Council. Traveling from Whitechapel Gallery, London. *David Hockney: slike, crtezi, grafike 1960–1970.* September–October. 157 works. [42] pp. Introduction by Mark Glazebrook. Parallel Serbo-Croatian/English text.

André Emmerich Gallery, New York. *David Hockney: Six Fairy Tales from the Brothers Grimm and Other New Etchings.* October–December. Folded card, [4] pp.

Kasmin Limited, London. *David Hockney: Recent Drawings.* December. Private-view card.

1971

Frankfurter Kunstkabinett, Frankfurt. *David Hockney: Illustrationen zu sechs Märchen der Brüder Grimm.* January–February. 16 pp. Includes an interview with Hockney.

Kunsthalle Bielefeld. *David Hockney: Zeichnungen, Grafik, Gemälde.* April–May. 79 works, and 12 works by Peter Schlesinger. 41 pp. Text by Günther Gercken.

1972

Circulating loan exhibition organized by the Victoria and Albert Museum, London. *David Hockney: Grimm's Fairy Tales; Suite of Etchings.* 38 works. [8] pp. Includes an interview with Hockney.

Renée Ziegler, Geneva.

Kinsman Morrison Gallery, London. [*David Hockney Prints.*] January.

D.M. Gallery, London. March.

André Emmerich Gallery, New York. *David Hockney: Paintings and Drawings.* May. [12] pp.

Fieldborne Gallery, London. [*Graphics 1954–72.*] November.

Kasmin Limited, London. *David Hockney: New Paintings and Drawings.* December. Private-view card.

1973

Holburne Museum, Bath. [*Prints.*] March.

André Emmerich Gallery, New York. [*Prints.*] June.

Jordan Gallery, London. July.

Galerie Herbert Meyer-Ellinger, Frankfurt. *David Hockney.* August–October. 6 pp.

M. Knoedler & Co., New York. *David Hockney: Print Retrospective.* October–November. 34 works. [23] pp. Text by Barbara Mathes.

1974

Gallery 21, London. *David Hockney.* 25 works. Typescript price list, [1] p.

Kinsman Morrison Gallery, London. [*Lithographs.*] January–February.

D.M. Gallery, London. *David Hockney: Print Retrospective.* March. Duplicated typescript, 3 pp.

Garage Art Ltd., London. *David Hockney: A Loan Exhibition of Recent Drawings.* July. Poster.

Dayton's Gallery 12, Minneapolis. *David Hockney: Drawings.* October–November. [38] pp. Text by John Loring.

Musée des Arts Décoratifs, Paris. Organized jointly with the British Council. *David Hockney: Tableaux et dessins: Paintings and Drawings.* October–December. 105 works. 58 pp. Introduction by Stephen Spender. Includes an interview with Hockney.

Knoedler Contemporary Prints, New York. [David Hockney: A Collector's Christmas.] November–December.

La Medusa Grafica, Rome. [Drawings, Etchings and Lithographs.] December.

Michael Walls, New York. [David Hockney.] December.

1975
Margo Leavin Gallery, Los Angeles.

Dorothy Rosenthal Gallery, Chicago. [Drawings and Prints.] March.

Galerie Claude Bernard, Paris. *David Hockney: Dessins et gravures.* April–May. 44 works. [68] pp. and checklist, [3] pp. Text by Marc Fumaroli.

Elaine Ganz European Gallery, San Francisco. [Drawings.] May–June.

Gallery 21, London. [David Hockney: The Rake's Progress.] July.

Manchester City Art Gallery. *David Hockney: Designs for The Rake's Progress.* October. Duplicated typescript, [5] pp.

Nijmeegs Museum, Nijmegen, The Netherlands. *David Hockney: schilderijen, tekeningen en prenten.* October–November. 135 works. [65] pp. Text by F. J. G. van der Grinten.

1976
Davis and Long, New York.

Nicholas Wilder Gallery, Los Angeles.

Sonja Henie og Niels Onstad Kunstsenter, Høvikodden, Norway. Organized with the assistance of the Arts Council of Great Britain. *David Hockney.* 130 works. [16] pp. Swedish text. Traveling to Göteborg, Sweden.

Sonnabend Gallery, New York. [20 Photographic Pictures.]

Louisiana Museum, Humlebaek, Denmark. *David Hockney.* February–March. 129 works. Catalogue published in *Louisiana Revy* 16 (January–March): cover, 3, 38–39. Danish text.

Jordan Gallery, London. April.

National Gallery of Victoria, Melbourne. *David Hockney Prints Selected from the Collection of the Australian National Gallery, Canberra.* April. 66 works. 32 pp. Includes an interview with Hockney. Traveling within Australia.

Festival Gallery, Bath. *David Hockney.* May–June. 23 works. Duplicated typescript checklist, 2pp.

Laing Art Gallery, Newcastle-upon-Tyne. *David Hockney: Paintings, Drawings and Prints.* June–July. 117 works. 32 pp. Introduction by Stephen Spender.

Sonnabend Gallery, Paris. [Photographs.] October.

Waddington Galleries 1, London. In association with Kasmin. *David Hockney: Drawings and Paintings (1960–65).* November. [12] pp.

Galería Juana Mordó, Madrid. *David Hockney.* December. Folded card, [6] pp. Traveling to Fundação Calouste Gulbenkian, Lisbon.

Robert Self Gallery, London. [Paintings by David Hockney.] December. Introduction by Henry Geldzahler.

1977
Dorothy Rosenthal Gallery, Chicago.

Galerie D'Eendt, Amsterdam.

Galerie Neuendorf, Hamburg. [Paintings and Drawings 1961–1975.]

Gallery One, San Jose State University Art Department, California.

Getler/Pall Gallery, New York.

La Hune, Paris.

Tehran Museum of Contemporary Art. *David Hockney: Travels with Pen, Pencil and Ink.* About 190 pp. Texts in English and Farsi. Includes statements by Hockney.

Staatliche Graphische Sammlung, Munich. *David Hockney: Zeichnungen und Druckgraphik.* February–April. 61 works. [46] pp. Text by Christian Geelhaar. Includes statements by Hockney.

Fundação Calouste Gulbenkian, Lisbon. Organized with the assistance of the British Council. Traveling from Galería Juana Mordó, Madrid. *David Hockney: gravura e desenho.* July–August. 122 works. [88] pp. Introduction by Stephen Spender. Includes statements by Hockney.

Wolverhampton Art Gallery. *David Hockney: Drawings and Prints.* October. 141 works. Folded poster, [4] pp.

André Emmerich Gallery, New York. *David Hockney: New Paintings, Drawings and Graphics.* October–November. [23] pp.

1978
Gallery at 24, Miami.

Nishimura Gallery, Tokyo.

Waddington Galleries, Toronto.

Yale Center for British Art, New Haven. Traveling exhibition organized by the International Exhibitions Foundation, Washington, D.C. *David Hockney: Prints and Drawings* [also known as *Travels with Pen, Pencil and Ink*]. February–March. 150 works. 32 pp. Introduction by Gene Baro. Traveling to Portland, Minneapolis, Wichita, Bloomfield Hills, Kansas City, Washington, D.C., Denver, Toronto, Toledo, San Francisco, and New York. 1978–80. *See also* book *David Hockney: Travels with Pen, Pencil and Ink,* under "Hockney." *See also* exhibition Tate Gallery, London, July–August 1980.

Albertina, Vienna. *David Hockney: Zeichnungen und Druckgraphik 1959–1977.* January–February. 109 works. About 174 pp. Introduction by Peter Weiermair. Traveling to Innsbruck, Graz, and Salzburg.

Sudley Art Gallery, Liverpool. *David Hockney: A Rake's Progress.* April. 16 works. Duplicated typescript, [4] pp. Text by Marco Livingstone.

Century Galleries, Henley-on-Thames. November.

1979
Foster Goldstrom Fine Arts, San Francisco.

Frances Aronson Gallery Ltd., Atlanta.

M. H. de Young Museum, San Francisco.

Museum of Modern Art, New York. [Blue Guitar Etchings.]

André Emmerich Gallery, New York. January.

Midland Group Gallery, Nottingham. Traveling exhibition organized in association with the Scottish Arts Council and Petersburg Press. *David Hockney Prints 1954–77.* January–February. 218 works. [248] pp. Introduction by Andrew Brighton. Traveling to Aberdeen, Edinburgh, Glasgow, Paisley, Southampton, Bradford, Stoke-on-Trent, Liverpool, and Cardiff.

Artists Market, Covent Garden, London. [David Hockney: Paper Pools.] February. No catalogue traced.

Knoedler Gallery, London. [Paper Pools.] February.

Warehouse Gallery, London. *Paper Pools: David Hockney.* February. Folded card, [4] pp.

André Emmerich Gallery, New York. [Paper Pools.] March.

Britten-Pears School for Advanced Musical Studies, Recital Room, Aldeburgh. *Exhibition of Paintings, Drawings and Prints by David Hockney.* June. 39 works. Duplicated typescript price list, 2 pp. For the thirty-second Aldeburgh Festival.

Gimpel-Hannover und André Emmerich Galerien, Zurich. *David Hockney: Bilder und Zeichnungen, Graphik.* September–October. 7 works. Card.

1980
Albert White Gallery, Toronto.

André Emmerich Gallery, New York.

Art and Furniture, Manchester. *Pictures by David Hockney.* Duplicated typescript, [7] pp.

Getler/Pall Gallery, New York.

Knoedler/Kasmin Gallery, London.

Laguna Beach Museum of Art, California.

Petersburg Press, New York.

Tyler Graphics, New York. *David Hockney: Lithographs 1978–1980.* June. Duplicated typescript price list, 2 pp. *See also* book *David Hockney: 23 Lithographs 1978–1980,* under "Hockney."

Tate Gallery, London. *David Hockney: Travels with Pen, Pencil and Ink.* July–August. [20] pp. Includes statements by Hockney. Exhibition previously traveling in the United States. 1978–80.

Jordan Gallery, London. [The Blue Guitar.] August.

Arun Art Centre, Arundel, England. *David Hockney: Modern Graphics.* August–September. 31 works. Duplicated typescript price list, [8] pp.

Graves Art Gallery, Sheffield. *Hockney's Progress: Drawings, Theatre Designs, Paintings and Prints.* September–October. 152 works. Folded card, [10] pp. Introduction by Frank Constantine.

1981
André Emmerich Gallery, New York.

Castelli Graphics, New York.

Galerie Claude Bernard, Paris.

Galerie Herbert Meyer-Ellinger, Frankfurt. [David Hockney: Exhibition of *Parade* Studies.]

Gallery at 24, Miami.

Gallery at 24, Palm Beach.

Les Art International, Johannesburg.

Knoedler Gallery, London. Presented by Kasmin. *Celia and Flowers, 1965–1980 . . . Exhibition of Etchings, Aquatints and Lithographs by David Hockney.* May. 35 works. [4] pp.

Ashmolean Museum, Oxford. *David Hockney: Stage Designs for "The Rake's Progress" and "The Magic Flute."* May–June. [4] pp. Introduction by K. J. Garlick.

Riverside Studios, London, in association with Knoedler Gallery, London. *David Hockney: Paintings and Drawings for "Parade," a French Triple Bill for the Metropolitan Opera, New York.* May–June. 126 works. Duplicated typescript in folder, [19] pp. Includes an interview with Hockney.

1982
L.A. Louver Gallery, Venice, California. No catalogue traced.

New York Public Library.

Nishimura Gallery, Tokyo.

Rex Irwin Gallery, Sydney.

Susan Gersh Gallery, Los Angeles.

Christie's Contemporary Art, New York. *David Hockney.* May–June.

Michael Parkin Fine Art, London, in association with Mark Glazebrook. *Hockney and Poetry.* May–June. 50 works. [12] pp. Introduction by Stephen Spender. Text by Michael Parkin and Mark Glazebrook.

André Emmerich Gallery, New York. *Drawing with a Camera.* June–July.

Knoedler Gallery, London. Presented by Kasmin. *David Hockney: Composite Polaroids.* June–July. 23 works. Private-view card and duplicated typescript checklist, [2] pp.

Musée National d'Art Moderne, Centre Georges Pompidou, Paris. *David Hockney photographe.* July–September. 96 works. Introduction by Alain Sayag. Essay by Hockney. French edition published by Herscher, 1982. For English edition *see* book *David Hockney Photographs,* under "Hockney."

Sewall Art Gallery, Rice University, Houston. *David Hockney: Sources and Experiments.* September–October. 50 works. 11 pp. Introduction by Esther de Vécsey.

Knoedler Gallery, London. Presented by Kasmin. *David Hockney . . . Exhibition of Drawings and Photographs of China.* November–December. Private-view card and duplicated typescript price list, [3] pp.

André Emmerich Gallery, New York. December.

1983
Thomas Babeor Gallery, La Jolla, California. No catalogue traced.

Frankfurter Kunstverein, Frankfurt. *David Hockney.* March–April. 45 works. 86 pp. Text by Peter Weiermair. German text.

André Emmerich Gallery, New York. *David Hockney: New Work with a Camera.* May–June. 40 works. Duplicated typescript price list, 1 p.

L.A. Louver Gallery, Venice, California. [Photocollages.] May–June. No catalogue traced.

Richard Gray Gallery, Chicago. [Photocollages.] May–July. No catalogue traced.

Knoedler/Emmerich Gallery, Zurich. [Photocollages.] June–July. No catalogue traced.

Knoedler/Kasmin Gallery, London. [Photocollages.] July–August. No catalogue traced.

Bjorn Bengtsson, Varberg, Sweden. [Photocollages.] September–October. No catalogue traced.

Nishimura Gallery and Nagase Photo Salon, Tokyo. *David Hockney: New Work with a Camera.* October. 17 works. [44] pp. Mainly Japanese text.

William Beadleston, New York. *David Hockney in America.* November–December. 22 works. [32] pp. Text by Christopher Finch.

Walker Art Center, Minneapolis. *Hockney Paints the Stage.* November–January 1984. 227 pp. Text by Martin Friedman, with contributions by John Cox, John Dexter, David Hockney, and Stephen Spender. Traveling to Mexico City, Toronto, Chicago, Fort Worth, San Francisco, and London. *See also* catalogues for Mexico City exhibition, February–April 1984, and London exhibition, August-September 1985.

Hayward Gallery, London. Organized by the Arts Council of Great Britain. *Hockney's Photographs.* November–February 1984. 100 works. 32 pp. Introduction by Mark Haworth-Booth. Includes statements by Hockney. Traveling to Bradford, Milton Keynes, Cambridge, Bath, and Dublin. Subsequently traveling to Spain, Portugal, France, Japan, New Zealand, and Australia under the auspices of the British Council.

Royal Festival Hall, London. *David Hockney: Posters.* December–January 1984. 65 works. Folded sheet, [4] pp. Introduction by Brian Baggott.

1984
Art and Sport Gallery, [Brussels]. [Prints.] No catalogue traced.

Björn Wetterling Gallery, Stockholm. [Prints and Drawings.] No catalogue traced.

Carpenter/Hochman, Dallas. [Photocollages.] No catalogue traced.

Galerie Esperanze, Montreal. [Prints and Photocollages.] No catalogue traced.

Greenberg Gallery, St. Louis. [Photocollages.]

Jeffrey Fraenkel Gallery, San Francisco. [Photocollages.] No catalogue traced.

Les Art International, Johannesburg. *David Hockney: Two Decades.* 36 pp. Includes statements by Hockney.

Richard Gray Gallery, Chicago. [New Drawings.] No catalogue traced.

Museo Rufino Tamayo, Mexico City. Traveling from Minneapolis. *El Gran Teatro de David Hockney: óleos, acuarelas, maquetas, escenografías.* February–April. 51 pp. Text by Martin Friedman. *See also* catalogue *Hockney Paints the Stage,* November 1983–January 1984.

Knoedler, Zurich. *David Hockney: Ausgewählte Druckgrafik.* April–May. Folded card, [4] pp.

Milwaukee Art Museum, Photography Gallery. *David Hockney: Photo-Composites.* May–September. 9 works. Folded sheet, [6] pp. Text by Verna Posever Curtis. Publication includes catalogue of exhibition *Chuck Close: Handmade Paper Editions,* held simultaneously.

Mira Godard Gallery, Toronto. *Hockney Prints.* June.

Abbot Hall Art Gallery, Kendal, England. *Hockney's Progress.* June–September. 51 works. Duplicated typescript, [7] pp. Text by J. C. S. Barnes.

Associated American Artists Gallery, New York. [Six Fairy Tales from the Brothers Grimm.] September–October.

André Emmerich Gallery, New York. *David Hockney: New Works: Paintings, Gouaches, Drawings, Photocollages.* October–November. [20] pp.

1985
André Emmerich Gallery, New York. [Moving Focus Prints and Paintings.] No catalogue traced.

——— . [Paintings from the 1960s.]

——— . [Photocollages.] No catalogue traced.

Galerie Claude Bernard, Paris. [Moving Focus Prints and Photocollages, Drawings, and Paintings from *Vogue* (Paris).] No catalogue traced.

Greg Kucera Gallery, Seattle. [Prints and Photocollages.] No catalogue traced.

Knoedler Gallery, London. [Moving Focus Prints, Paintings, and Photocollages.] No catalogue traced.

Nishimura Gallery, Tokyo. [Moving Focus Prints.] No catalogue traced.

Richard Gray Gallery, Chicago. [Moving Focus Prints.] No catalogue traced.

Lloyd Shin, Wilmette, Illinois. January.

Fundación Caja de Pensiones, Madrid. Organized by the Arts Council of Great Britain, coordinated by the British Council. Traveling from Hayward Gallery, London. *Hockney Fotógrafo.* February–March. 101 works. 63 pp. Introduction by Mark Haworth-Booth. Includes text by Hockney.

Hayward Gallery, London. Organized by the Arts Council of Great Britain. Traveling from Minneapolis. *Hockney Paints the Stage.* August–September. 262 pp. Text by Martin Friedman, with contributions by John Cox, John Dexter, David Hockney, and Stephen Spender. *See also* catalogue for original exhibition, November 1983–January 1984.

College Art Gallery, New Paltz, New York. [Photocollages.] October. Traveling to State University of New York, Albany, and College of Santa Fe.

Fundação Calouste Gulbenkian, Lisbon. Organized in collaboration with the British Council. Traveling from Hayward Gallery, London, and from Museu Nacional de Soares dos Reis, Pôrto. *David Hockney Fotógrafo.* November. 101 works. [46] pp. Introduction by Mark Haworth-Booth. Includes text by Hockney.

L.A. Louver, Venice, California. *David Hockney: Wider Perspectives Are Needed Now: An Exhibition of Recent Lithographs.* December–January 1986. 16 works. Folded card, [4] pp.

1986

André Emmerich Gallery, Zurich. [Moving Focus Prints and Paintings.] No catalogue traced.

Contemporary Art Center, Honolulu. [*The Rake's Progress;* Theater Sets "Bedlam" and "Auction Scene"; Models and Drawings and Etchings.] No catalogue traced.

Gallery One, Toronto. [Photocollages and Theater Drawings.] No catalogue traced.

Harvard University, Cambridge, Massachusetts. [Moving Focus Prints.] No catalogue traced.

Honolulu Academy of Art. [Photocollages, Paintings, and Drawings.] No catalogue traced.

Matrix/Berkeley, University Art Museum, Berkeley, California. [Paintings and Photocollages.] No catalogue traced.

Traveling exhibition organized by the International Exhibitions Foundation, Washington, D.C. *Photographs by David Hockney.* 80 works. 47 pp. Introduction by Mark Haworth-Booth. Essay by Hockney. Traveling to Boca Raton, Aspen, Davenport, Lawrence, Madison, Santa Barbara, Toledo, Sarasota, Akron, Winnipeg, Notre Dame, Jacksonville, Tulsa, Nashville, Lincoln, Philadelphia, Williamsburg, and Peoria. 1986–89.

Art Center College of Design, Pasadena. [Photocollages, Cibachromes, Polaroids, and Moving Focus Prints.] February-March. No catalogue traced.

Museum of Modern Art, Toyama. Originally organized by the Arts Council of Great Britain. Travel throughout Japan organized by the British Council and the Japan Association of Art Museums. *Hockney's Photographs.* February–March. 101 works. 100 pp. Mainly Japanese text. Traveling from Hayward Gallery, London.

Tynte Gallery, Adelaide, Australia, as part of the Adelaide Festival. *David Hockney Photocollages.* March. 24 pp.

Tate Gallery, London. *David Hockney: Moving Focus Prints from Tyler Graphics Ltd.* March–May. 32 works. [16] pp. Includes folded poster.

Galerie Kajforsblom, Helsinki. [Photocollages and Moving Focus Prints.] August–September. Folded card, [10] pp.

Knoedler Gallery, London. *Still Lives and Interiors: David Hockney.* August–September.

International Center of Photography, New York. *David Hockney's Photocollages: A Wider Perspective.* September–November. Folded sheet, [8] pp. Text by Anne Hoy. Traveling to Museum of Art, Tel Aviv, and Clarence Kennedy Gallery, Cambridge, Massachusetts. 1987.

Auckland City Art Gallery, New Zealand. Traveling originally from Hayward Gallery, London. *Hockney's Photographs.* December–January 1987. Travel throughout New Zealand organized by the British Council.

L.A. Louver Gallery, Venice, California. Simultaneously at André Emmerich, New York; Knoedler Gallery, London; and Nishimura Gallery, Tokyo. *David Hockney: Home Made Prints.* December–January 1987. [28] pp. Text by David Hockney.

1987

Laband Art Gallery, Loyola Marymount University, Los Angeles. *David Hockney: Faces 1966–1984.* January–March. 71 works. Designed by David Hockney. Essay and commentaries by Marco Livingstone.

National Museum of Photography, Film and Television, Bradford. [Home Made Prints.] March. 35 works.

New Mexico State University, Las Cruces. *David Hockney Photocollages and Polaroids.* November–December. 25 works.

SELECTED GROUP EXHIBITIONS

1960

R. B. A. Galleries, London. *London Group 1960.* January-February. 2 works. [10] pp.

——— . *Young Contemporaries 1960.* March–April. 2 works. 15pp. Introduction by Peter Cresswell.

1961

——— . *The Graven Image.* Hockney received the Guinness Award and First Prize for Etching.

——— . *Young Contemporaries 1961 Exhibition Catalogue.* February-March. 4 works. 12pp. Introduction by Lawrence Alloway.

Walker Art Gallery, Liverpool. Traveling exhibition organized by the Arts Council of Great Britain. *New Paintings 58–61.* July–August. 1 work. [16] pp. Introduction by Alan Bowness.

Musée d'Art Moderne de la Ville de Paris. *Deuxième Biennale de Paris: Manifestation biennale et internationale des jeunes artistes.* September–November. 3 works. 150 pp., [102] pp. of plates. Introduction by Raymond Cogniat.

Walker Art Gallery, Liverpool. *The John Moores Liverpool Exhibition 1961.* November–January 1962. 1 work. 22 pp. Introduction by Walter Clark. Hockney received a prize in the Junior Section.

1962

Galerie Vanier, Geneva. *Art phantastique.*

R. B. A. Galleries, London. *The Graven Image.*

Royal College of Art, London. *Diploma Exhibition.* No catalogue traced.

R. B. A. Galleries, London. *Young Contemporaries Exhibition Catalogue 1962.* January. 5 works. 21 pp. Introduction by Andrew Forge.

Congress House, London. *Exhibition of New Art.* June. 3 works. 23 pp. Introduction by Tom Dreiberg. This exhibition was part of the Festival of Labour.

Institute of Contemporary Arts, London. *Four Young Artists: Maurice Agis, John Bowstead, David Hockney, Peter Phillips.* July. 4 works. Folded card, [6] pp. Introduction by Roland Penrose.

Arthur Jeffress Gallery, London. *New Approaches to the Figure.* August–September. 3 works. [12] pp.

Grabowski Gallery, London. *Image in Progress.* August–September. 3 works. [24] pp. Introduction by Jasia Reichardt. Includes a statement by Hockney.

National Museum of Modern Art, Tokyo. *3rd International Biennial Exhibition of Prints in Tokyo 1962.* October–November. 3 works. [106] pp. Introduction by Seisuke Inada and Yūsai Takahashi. Traveling to Osaka.

Stedelijk van Abbemuseum, Eindhoven, The Netherlands. *Kompass II: Contemporary Paintings in London.* October–December.

Royal College of Art, London. *Towards Art? The Contribution of the RCA to the Fine Arts 1952–62.* November–December. 4 works. 29 pp. Introduction by Carel Weight.

1963
International Biennale, Hong Kong.

R. B. A. Galleries, London. *The Graven Image.*

Arthur Tooth and Sons, London. *1962: One Year of British Art, Selected by Edward Lucie-Smith.* January–February. 3 works. [12] pp. Introduction by Edward Lucie-Smith.

Midland Group Gallery, Nottingham. *Pop Art.* May–June. 5 works. [4] pp.

Tate Gallery, London, and Whitechapel Gallery, London. Organized by the Contemporary Art Society, London. *British Painting in the Sixties.* June. 3 works. [38] pp. Introduction by John Sainsbury. Exhibition in two parts held simultaneously at Tate and Whitechapel. Works by Hockney in section 2 at Whitechapel. Selections from exhibition traveling to Manchester, Glasgow, Hull, and Zurich.

Moderna Galerija, Ljubljana. *V. mednarodna grafična razstava 1963: ve exposition internationale de gravure 1963.* June–September. 3 works. About 300 pp. Introduction by Zoran Kržišnik. Parallel Serbo-Croatian/French text. Hockney received special mention.

Kasmin Limited, London. *The 118 Show.* August. Private-view card.

Alan Gallery, New York. *1963–1964.* [Opening Exhibition.] September. Folded card, [4] pp.

Orell Füssli Buchhandlung, Zurich. *Britische Graphische Szene: Aperçu de gravures britanniques: British Graphic Scene.* September. 3 works. [36] pp.

Musée d'Art Moderne de la Ville de Paris. *Troisième Biennale de Paris: Manifestation biennale et internationale des jeunes artistes.* September–November. 7 works. 200 pp., [90] pp. of plates. Introduction by Raymond Cogniat.

Walker Art Gallery, Liverpool. *The John Moores Liverpool Exhibition.* November–January 1964. 1 work. [20] pp. Introduction by Ben Shaw.

1964
Art Institute of Chicago.

Museum voor Schone Kunsten, Ghent. [Human Figure since Picasso.]

Städtische Kunsthalle, Dusseldorf. [British Painters of Today.] Traveling to Munich, Stuttgart, Frankfurt, Berlin, and Bremen.

Villa Ciani, Lugano. *8th International Exhibition of Drawings and Engravings: Bianco e nero.* Hockney received First Prize.

Blackburn Art Gallery, England. Traveling exhibition organized by the Arts Council of Great Britain. *6 Young Painters: Peter Blake, William Crozier, David Hockney, Dorothy Mead, Bridget Riley, Euan Uglow.* January. 5 works. Folded card, [6] pp. Traveling to Newcastle, Kingston-upon-Hull, Eastbourne, Cambridge, and Sheffield.

Institute of Contemporary Arts, London. *Study for an Exhibition of Violence in Contemporary Art.* February–March. 2 works. [12] pp. Introduction by Roland Penrose.

South London Art Gallery. *Prominent British Print Makers.* February–March. 16 works. 15 pp. Introduction by Charlotte Bull.

Whitechapel Art Gallery, London. Awards by the Peter Stuyvesant Foundation. *The New Generation: 1964.* March–May. 4 works. 106 pp. Introduction by David Thompson.

New Metropole Arts Centre, Folkestone. *John Barnes, David Hockney, John Latham, George F. Pollock, Marcello Salvadori.* April. 16 works. [18] pp.

Städtische Kunstgalerie, Bochum, Germany. *Profile III: Englische Kunst der Gegenwart.* April–June. 2 works. [88] pp. Text by Herbert Read and Roland Penrose.

Tate Gallery, London. Organized by the Calouste Gulbenkian Foundation. *Painting and Sculpture of a Decade 54–64.* April–June. 2 works. 276 pp.

Alan Gallery, New York. *Summer 1964.* June–July. Folded card, [4] pp.

Haags Gemeentemuseum, The Hague. *Nieuwe realisten.* June–August. 3 works. Newspaper format, 44 pp. Traveling to Akademie der Künste, Berlin.

Kasmin Limited, London. [Group Exhibition.] July–September. Private-view card.

Arts Council Gallery, Belfast. Organized by the Arts Council of Northern Ireland, Belfast. *The New Image.* September. 4 works. [8] pp. Introduction by Ronald Alley.

[Museum of Contemporary Art], Skopje, Yugoslavia. [Bradford Artists.] September. 1 work. [47] pp. Introduction by Peter Bird. Some English text. Mainly Cyrillic script.

Art Gallery of New South Wales, Sydney, in association with the British Council. *Three Exhibitions for British Fortnight: Young British Painters 1955–1963; English Artist-Potters 1913–1960; English Domestic Silver 1660–1910.* September–October. 1 work. [42] pp. Introduction by Daniel Thomas.

Museum des 20. Jahrhunderts, Vienna. *Pop etc.* September–October. 3 works. 72 pp. German text.

Museum of Modern Art, New York. *Contemporary Painters and Sculptors As Print Makers.* September–October. 11 pp.

Mathildenhöhe, Darmstadt. *1. Internationale der Zeichnung.* September–November. 3 works. 340 pp. Texts by Heinz Winfried Sabais et al.

Galerie Krugier et Cie., Geneva. *Rencontres: Jeune Peinture et sculpture internationales.* Suites no. 8. November. [8] pp. and 6 folded lithographs loose in cover.

Institute of Contemporary Arts, London. *ICA Screen-Print Project.* November. 1 work. Folded card, [4] pp.

National Museum of Wales, Cardiff. *Pick of the Pops.* November–December. 4 works. [8] pp. Introduction by John Ingamells.

Piccadilly Gallery, London. *Recent Acquisitions and Discoveries Christmas 1964.* December–January 1965. 1 work. [12] pp.

Prestons Art Gallery, Bolton. *Prestons Winter Exhibition 1964–65.* December–January 1965. 1 work. Folded card, [4] pp.

1965

Palais des Beaux-Arts, Brussels. *Pop art, nouveau réalisme, etc.*

Riksförbundet för Bildande Konst och SAN, Stockholm. *Op & pop: aktuell engelsk konst.* 2 works. [31] pp. Text by Leif Nylén. Swedish text.

University of Bangor, Wales. *Arts Festival.*

Walker Art Center, Minneapolis. Organized in association with the British Council and Calouste Gulbenkian Foundation. *London: The New Scene.* February–March. 7 works. 72 pp. Texts by Martin Friedman et al. Traveling to Washington, D.C., Boston, Seattle, Vancouver, Toronto, and Ottawa.

Walker Art Gallery, Liverpool. *Industry and the Artist.* February–March. 1 work. [14] pp. Introduction by T. J. Stevens.

Moderna Galerija, Ljubljana. *VI. mednarodna grafična razstava '65: VIe exposition internationale de gravure '65.* June. 3 works. About 330 pp. Introduction by Zoran Kržišnik. Parallel Serbo-Croatian/French text. Hockney received the Purchase Prize.

Bear Lane Gallery, Oxford. *Trends in Contemporary British Painting . . . Selected by Ronald Alley.* June–July. 3 works. [12] pp. Introduction by Ronald Alley.

Alan Gallery, New York. *65–66.* [Opening Exhibition.] September–October. 1 work. Folded card, [4] pp.

Galerie Creuze, Paris. *La Figuration narrative dans l'art contemporain.* October. 4 pp.

Arnolfini Gallery, Bristol. *Impressions on Paper.* October–November. 3 works. Folded card, [6] pp.

1966

Cracow. *First International Biennale of Graphic Art.*

Galerie der Spiegel, Cologne. [English Graphic Art.]

Galleria dell'Ariete, Milan. [Four Englishmen.]

Arnolfini Gallery, Bristol. *British Prints in the Sixties.* May–June. 2 works. Folded card, [4] pp.

Jewish Museum, New York. *The Harry N. Abrams Family Collection.* June–September. 1 work. [24] pp. Introduction by Sam Hunter. Interview with Harry N. Abrams.

Premio Marzotto, Valdagno, Italy. *Mostra di pittura contemporanea comunità europea: Premio Marzotto: La città attuale; immagini e oggetti.* September. 4 works. [100] pp. Text by Michel Conil Lacoste et al. In four languages, including English. Traveling to Baden-Baden, Humlebaek, Amsterdam, London, and Paris.

Piccadilly Gallery, London. *Christmas 1966 Exhibition.* December. 2 works. [16] pp.

1967

IX Bienal de São Paulo. British section organized by the British Council. *Grã-Bretanha 1967: Richard Smith, William Turnbull, Patrick Caulfield, David Hockney, Allen Jones.* 26 works. [25] pp.

Yale University Art Gallery, New Haven. *The Helen W. and Robert M. Benjamin Collection.*

Arts Council Gallery, London. Traveling exhibition organized by the Arts Council of Great Britain. *Drawing Towards Painting 2.* April–May. 15 works. [60] pp. Introduction by Anne Seymour. Traveling to Stoke-on-Trent, Northampton, Oldham, Cardiff, St. Ives, Reading, Liverpool, Bradford, Norwich, Scarborough, and Glasgow.

Moderna Galerija, Ljubljana. *VII. mednarodna grafična razstava 67: VIIe exposition internationale de gravure 67.* June–August. 2 works. 307 pp. Introduction by Zoran Kržišnik. Parallel Serbo-Croatian/French text.

Kunstmarkt 67, Cologne. *Kunstmarkt 67: Verein progressiver deutscher Kunsthändler Köln.* September. Newspaper format, [28] pp.

Palais des Beaux-Arts, Brussels. Organized by the British Council. *Jeunes Peintres anglais: Jonge britse schilders.* October. 5 works. [35] pp. Text by Richard Morphet. Traveling to Berlin and Lausanne.

Vancouver Art Gallery. *Vancouver Print International: Exposition internationale de gravures à Vancouver.* October. 1 work. [48] pp. Introduction by William S. Lieberman.

Galerie Bischofberger, Zurich. *Englische Kunst.* October–December. 7 works. [24] pp. Hockney in part 1, October–November.

Museum of Art, Carnegie Institute, Pittsburgh. *1967 Pittsburgh International Exhibition of Contemporary Painting and Sculpture.* October–January 1968. 1 work. [80] pp. Introduction by Gustave von Groschwitz.

Tate Gallery, London. *Recent British Painting: Peter Stuyvesant Foundation Collection.* November–December. 2 works. 159 pp. Introduction by Alan Bowness.

Walker Art Gallery, Liverpool. *John Moores Liverpool Exhibition 6.* November–January 1968. 1 work. [24] pp. Introduction by John Moores and Harold Hughes. Hockney received First Prize.

1968

Museo Nacional de Bellas Artes, Buenos Aires. Organized by the British Council. *IX Bienal de San Pablo: Gran Bretaña 1967; William Turnbull, Patrick Caulfield, David Hockney, Allen Jones.* 26 works. [12] pp. Text by Alan Bowness.

Midland Group Gallery, Nottingham. *Painting and Sculpture from the Stuyvesant Collection.* February–March. 1 work. Folded card, [4] pp. Introduction by Sylvia Cooper.

Akademie der Künste, Berlin. *Junge Generation Grossbritannien.* April–June. 10 works. 57 pp. Introduction by Alan Bowness.

Bear Lane Gallery, Oxford. *From Kitaj to Blake: Non-Abstract Artists in Britain.* June. 3 works. Duplicated typescript, including price list, 4 pp.

Grabowski Gallery, London. *100th Exhibition.* June–September. 2 works. [20] pp.

Documenta, Kassel, West Germany. *4. documenta: Internationale Ausstellung.* June–October. 8 works. 2 vols.: 328 pp., 160 pp. Introduction by Arnold Bode.

Venice Biennale. *Venezia Biennale 1968: 34. biennale internazionale d'arte.* June–October. 1 work. 2 vols.

Museum of Contemporary Art, Chicago. *Selections from the Collection of Mr. and Mrs. Robert B. Mayer.* July–September. 1 work. [24] pp. Introduction by Jan van der Marck.

Macy's Department Store, New York. Organized by the Institute of Contemporary Arts, London. *Painted in Britain.* September. [20] pp. Introduction by Roland Penrose.

Kunsthalle Darmstadt. *Menschenbilder.* September–November. 2 works. 284 pp. Texts by Arnold Gehlen et al.

Musée des Arts Décoratifs, Paris. *Peintres européens d'aujourd'hui: European Painters Today.* September–November. 2 works. [96] pp. Introduction by François Mathey. Traveling to New York, Washington, D.C., Chicago, Atlanta, and Dayton.

Wiener Secession, Vienna. *Grafik International.* October–November. 5 works. 70 pp. Text by Kristian Sotriffer.

Palazzo Strozzi, Florence. *Contemporary Art Fair: Mostra mercato d'arte contemporanea: English Galleries.* November–December. 4 works. 77 pp. Introduction by Mario Amaya.

1969
Ateneumin Taidemuseo, Helsinki. *Ars 69 Helsinki.* March–April. 1 work. [88] pp. Introduction by Aune Lindström. Finnish/Swedish/English text. Traveling to Tampereen Taidemuseo.

Museum am Ostwall, Dortmund. Organized by the British Council. *Marks on a Canvas: Patrick Caulfield, Bernard Cohen, David Hockney, Paul Huxley, Allen Jones, Mark Lancaster, Jeremy Moon, Bridget Riley, Richard Smith, John Walker.* May–July. 6 works. 108 pp. Introduction by Anne Seymour. Traveling to Hanover and Vienna.

Hayward Gallery, London. Organized by the Arts Council of Great Britain. *Pop Art.* July–September. 2 works. [12] pp. Introduction by John Russell and Suzi Gablik. Also John Russell and Suzi Gablik. *Pop Art Redefined.* London: Thames and Hudson.

Arts Council Gallery, Belfast. Organized by the Arts Council of Northern Ireland. *Artists from the Kasmin Gallery.* August. 6 works. [16] pp.

1970
Camden Arts Centre, London. *Narrative Painting in Britain in the Twentieth Century.* February–March. 1 work. Folded broadsheet, [4] pp. Introduction by Charles Spencer.

Musée d'Art Moderne de la Ville de Paris. *Image/dessin: animation, recherche, confrontation.* January–February. 5 works. [22] pp. Introduction by Suzanne Page.

National Gallery of Art, Washington, D.C. Organized by the Tate Gallery, London, and the British Council. *British Painting and Sculpture 1960–1970.* November–January 1971. 3 works. 124 pp. Introduction by Edward Lucie-Smith.

1971
Arthur Tooth and Sons, London. *Critic's Choice: 1971 Selection by Robert Melville.* March. 4 works. [32] pp. Introduction by Robert Melville.

National Portrait Gallery, London. Organized by the Welsh Arts Council and the Arts Council of Great Britain. *Snap!* March–April. 10 works. Folded leaflet, [8] pp. Text by Roy Strong.

University of Lancaster. Organized in association with the Northern Arts Association. *David Hockney, Alan Davie: Drawings and Paintings.* October. 14 works. Folded broadsheet, [14] pp. Introduction by Helen Kapp. Traveling to Jarrow, Newcastle, Carlisle, Alnwick, and Whitehaven.

1972
Mappin Art Gallery, Sheffield. *Reflections.* April–May. 1 work. [24] pp. Introduction by Frank Constantine.

Ulster Museum, Belfast. *Contemporary Prints.* July–September. 4 works. 47 pp. Introduction by Eric Whittaker.

1973
Whitworth Art Gallery, Manchester, in association with Fanfare for Europe. *British Artists in Europe.* January–February. 1 work. [52] pp. Introduction by Francis W. Hawcroft.

Musée d'Art Moderne de la Ville de Paris. Organized by the British Council. *La Peinture anglaise aujourd'hui.* February–March. 5 works. 59 pp. Introduction by Jacques Lassaigne.

Rhode Island School of Design, Museum of Art, Providence. *Selection III: Contemporary Graphics from the Museum's Collection.* April–May. 2 works. Catalogue printed in *Rhode Island School of Design Bulletin* 59 (April 1973): [3] pp.

Kunsthalle Baden-Baden. *11 englische Zeichner.* May–June. 22 works. [130] pp. Text by Timothy Hilton. Traveling to Kunsthalle Bremen.

Corporation Art Gallery, Harrogate, England. *Yorkshire Art, 1900–1973.* August. 7 works. Duplicated typescript, [15] pp. Text by Helen Kapp.

Palais des Beaux-Arts, Brussels. Organized by the Tate Gallery, London, and the British Council for Europalia 73 Great Britain. *Henry Moore to Gilbert and George: Modern British Art from the Tate Gallery.* September–November. 2 works. 143 pp. Text by Anne Seymour.

1974
Lefevre Gallery, London. *An Exhibition of Contemporary British Painters and Sculptors.* April–May. 1 work. 36 pp.

1975
Traveling exhibition organized by the British Council. *Contemporary British Drawings.* 6 works. [32] pp. Introduction by Norbert Lynton. Traveling to Germany and elsewhere.

Kupferstichkabinett, Berlin. *Druckgraphik der Gegenwart 1960–1975 im Berliner Kupferstichkabinett.* June–August. 23 works. 166 pp. Catalogue by Alexander Dückers.

Los Angeles County Museum of Art. *European Painting in the Seventies: New Work by Sixteen Artists.* September–November. 5 works. 83 pp. in a series of 18 continuously paginated leaflets in slip case. Introduction by Maurice Tuchman. Includes a statement by Hockney. Traveling to St. Louis Art Museum and Elvehjem Art Center, Madison.

1976
Museum of Modern Art, New York. *Drawing Now.* January–March. 1 work. 96 pp. Text by Bernice Rose.

Kunstverein in Hamburg. Organized in association with the British Council. *Pop Art in England: Anfänge einer neuen Figuration 1947–63: Beginnings of a New Figuration 1947–63.* February–March. 13 works. 134 pp. Text by Uwe M. Schneede. Traveling to Munich and York.

Palazzo Reale, Milan. Organized in association with the British Council. *Arte inglese oggi 1960–1976.* February–May. 9 works. 2 vols., 468 pp. Introduction by Guido Ballo and Franco Russoli. Parallel Italian/English text.

Arnolfini Gallery, Bristol. *Michael Craig-Martin: Selected Works 1966–1975; David Hockney: Selected Prints 1965–1974.* April–May. 8 pp.

Museum Boymans-van Beuningen, Rotterdam. *Peter Blake, Richard Hamilton, David Hockney, R. B. Kitaj, Eduardo Paolozzi.* May–July. 25 works. [48] pp. Introduction by Toni del Renzio. Dutch text.

1977

Tate Gallery, London. *Artists at Curwen: A Celebration of the Gift of Artists' Prints from the Curwen Studio.* February–April. 2 works. 167 pp. Text by Pat Gilmour.

Documenta, Kassel. *Documenta 6.* June–October. 12 works. 4 vols. David Hockney included in vols. 2 and 3.

Hayward Gallery, London. Organized by the Arts Council of Great Britain. *1977 Hayward Annual: Current British Art, Selected by Michael Compton, Howard Hodgkin and William Turnbull.* Part 2. July–September. 3 works. 140 pp. Introduction by Michael Compton. Single publication covering both parts of the Hayward Annual (Part 1, May–July).

Künstlerhaus, Bregenz, Austria. *Englische Kunst der Gegenwart.* July–October. 13 works. 306 pp. Introduction by Oscar Sandner. Includes statements by Hockney.

Kestner-Gesellschaft, Hanover. *Künstlerphotographien im XX. Jahrhundert.* August–September. 18 works. 243 pp. Texts by Carl-Albrecht Haenlein et al.

Hugh Lane Municipal Gallery of Modern Art, Dublin, and National Museum of Ireland, Dublin. *ROSC 77: An International Exhibition of Modern Art and Early Animal Art.* August–October. 3 works. 214 pp. Introduction by Michael Scott.

Middlesbrough Art Gallery, England. *The Cleveland Third International Drawing Biennale.* September–October. About 100 pp.

Philadelphia College of Art. *Artists' Sets and Costumes: Recent Collaborations between Painters and Sculptors and Dance, Opera and Theatre.* October–December. 49 pp. Text by Janet Kardon and Don McDonagh. Traveling to Sarah Lawrence College, Bronxville, New York.

1978

L.A. Louver Gallery, Venice, California. *Rare Books and Prints Published by Petersburg Press, 1968–1978.* May.

Internationale Kunstmesse, Basel. *Art 9 '78: International Art Fair Basle: 20th Century Art, Art Books.* June. 588 pp.

National Portrait Gallery, London. *20th Century Portraits.* June–September. 2 works. 80 pp. Text by Robin Gibson.

Chapter, Cardiff. Traveling exhibition organized by the Welsh Art Council. *Flowers: Images by Contemporary Artists.* August–September. 4 works. [40] pp. Text by Laurie McFadden.

1979

Stephen Wirtz Gallery, San Francisco. [Photographs by Helmut Newton and David Hockney.]

Traveling exhibition organized by the British Council. *The Rake's Progress: William Hogarth (1697–1764), David Hockney (1937–).* 6 pp. Text by Edward Lucie-Smith.

Hayward Gallery, London. Traveling exhibition organized by the Arts Council of Great Britain. *Lives: An Exhibition of Artists Whose Work Is Based on Other People's Lives, Selected by Derek Boshier.* March. [76] pp. Introduction by Derek Boshier. Traveling to Cardiff, Chester, Poole, Glasgow, and Liverpool.

Kunsthalle Nürnberg. *Zeichnung Heute: Meister der Zeichnung—Beuys, Hockney, Hofkunst, Quintanilla.* June–October. 57 works. 158 pp. Introduction by Curt Heigl. Catalogue published simultaneously with 2 vols. for the exhibition *1. Internationale Jugendtriennale.* Traveling to Hasselt.

Arnolfini Gallery, Bristol. *Narrative Paintings: Figurative Art of Two Generations, Selected by Timothy Hyman.* September–October. 1 work. [32] pp. Text by Timothy Hyman. Traveling to London, Stoke-on-Trent, and Edinburgh.

Trisolini Gallery, Ohio University, Athens, Ohio. *Seven Artists at Tyler Graphics Ltd.* September–October. 24 pp. Text by Donald Harvey.

L.A. Louver Gallery, Venice, California. *This Knot of Life: Paintings and Drawings by British Artists.* October–December. 32 pp. Introduction by Peter Goulds. Hockney in Part 1 of the exhibition, October–November.

Mappin Art Gallery, Sheffield. Organized by the Arts Council of Great Britain. *The British Art Show: Recent Paintings and Sculpture by 112 Artists, Selected by William Packer.* December–January 1980. 2 works. 136 pp. Introduction by William Packer. Traveling to Newcastle and Bristol.

Scottish National Gallery of Modern Art, Edinburgh. *Four Painters: One Generation—Derek Boshier, Bridget Riley, David Hockney, Patrick Caulfield.* December–February 1980.

1980

Museum of Modern Art, New York. *Printed Art: A View of Two Decades.* February–April. 3 works. 144 pp. Text by Riva Castleman.

Holsworthy Gallery, London. *Prints by David Hockney and Animals in Art by Humphrey Bangham.* July–August. 21 works. Private-view card, [6] pp., and duplicated typescript, including price list, [3] pp.

Mary and Leigh Block Gallery, Northwestern University, Evanston, Illinois. *Collaborations: An Exhibition to Celebrate the Dedication of the Mary and Leigh Block Gallery . . .* September–October. 40 pp. Text by K. K. Foley.

1981

Royal Academy of Arts, London. *A New Spirit in Painting.* January–March. 4 works. 262 pp. Introduction by Christos M. Joachimides, Norman Rosenthal, and Nicholas Serota.

Museen der Stadt Köln. *Westkunst: Zeitgenössische Kunst seit 1939.* May–August. 8 works. 524 pp. Text by Laszlo Glozer.

Nationalgalerie, Berlin. Exhibition from Kupferstichkabinett, Berlin. *Druckgraphik: Wandlungen eines Mediums seit 1945.* June–August. 6 works. 196 pp. Text by Alexander Dückers.

National Gallery, London. *David Hockney: Looking at Pictures in a Book. The Artist's Eye* [exhibition series]. July–August. 1 work plus 4 by other artists chosen by Hockney. 25 pp. and 8 postcards of works by other artists. Text by Hockney.

Los Angeles County Museum of Art. *Art in Los Angeles: Seventeen Artists in the Sixties.* July–October. 3 works. 162 pp. Introduction by Maurice Tuchman.

Richard Gray Gallery, Chicago. *An Exhibition of Fine Contemporary Prints.* December–January 1982.

Stedelijk Museum, Amsterdam. *Instant Fotografie.* December–January 1982. 81 pp. Introduction by Els Barents. Parallel Dutch/English text.

1982

6th Norwegian International Print Biennale, Fredrikstad. Hockney received Gold Medal.

Ashmolean Museum, Oxford. *William Blake to David Hockney.* February–March. 20 pp. Text by R. B. Loder.

Galerie Beyeler, Basel. *Portraits et figures: Faces and Figures: Gesichter und Gestalten.* February–April. 3 works. 88 pp.

Kestner-Gesellschaft, Hanover. *Momentbild: Künstlerphotographie.* March–April. 21 works. 195 pp. Edited by Carl Haenlein.

Stedelijk Museum, Amsterdam. *'60 '80: Attitudes/Concepts/Images.* April–July. 1 work. 248 pp. Introduction by Ad Petersen. Parallel Dutch/English text.

Museum of Art, Carnegie Institute, Pittsburgh. *1982 Carnegie International.* October–January 1983. 3 works. [164] pp. Introduction by Gene Baro. Traveling to Seattle, Perth, Melbourne, and Sydney.

Grey Art Gallery, New York University. *Faces Photographed: Contemporary Camera Images.* November–December. 10 works. [27] pp. Introduction by Ben Lifson.

John Hansard Art Gallery, Southampton. Traveling exhibition organized by the Arts Council of Great Britain. *Painter As Photographer.* November–December. [32] pp. Introduction by Marina Vaizey. Traveling to Wolverhampton, Oxford, Exeter, Nottingham, Camden Arts Centre (London), Windsor, and Bradford.

Sunderland Arts Centre. Organized by the Arts Council of Great Britain. *Paper As Image.* November–February 1983. 2 works. 24 pp. Text by Silvie Turner. Includes statements by Hockney. Traveling to Cambridge, Bangor, Nottingham, Southampton, Brighton, and London.

1983

University Art Museum, Santa Barbara. *Representational Drawing Today: A Heritage Renewed.* March–April. 6 works. 87 pp. Texts by Phyllis Plous and Eileen Guggenheim. Traveling to Oklahoma City, Madison, Colorado Springs.

Victoria and Albert Museum, London. *Personal Choice: A Celebration of Twentieth Century Photographs.* March–May. 1 work. 134 pp. Introduction by Mark Haworth-Booth. Includes text by Hockney.

Museum of Modern Art, New York. *Big Pictures by Contemporary Photographers.* April–June. Checklist, [4] pp.

Oakland Museum, California. *10 California Photographs: In Color.* May–August.

Solomon R. Guggenheim Museum, New York. *Acquisition Priorities: Aspects of Postwar Painting in Europe.* May–September. 1 work. 104 pp.

International Center of Photography, New York. *The Metropolitan Opera Centennial: A Photographic Album.* September–November. 1 work.

National Museum of Modern Art, Tokyo. *Photography in Contemporary Art.* October–December. 3 works. 139 pp. Introduction by Hisae Fujii. Traveling to Kyoto.

Kaiser Wilhelm Museum, Krefeld. *Sammlung Helga und Walther Lauffs im Kaiser Wilhelm Museum Krefeld: amerikanische und europäische Kunst der sechziger und siebziger Jahre.* November–April 1984. 8 works. 242 pp. Introduction by Gerhard Storck.

1984

Palm Springs Desert Museum, California. *Frederick R. Weisman Foundation of Art.* January–February. [8] pp. Traveling to Albuquerque, San Francisco, Salt Lake City, Oakland, Tokyo, and Jerusalem.

Hirshhorn Museum and Sculpture Garden, Washington, D.C. *Drawings 1974–1984.* March–May. 253 pp. Text by Frank Gettings.

National Gallery of Art, Washington, D.C. *The Folding Image: Screens by Western Artists of the Nineteenth and Twentieth Centuries.* March–September. 314 pp. Introduction by Michael Komanecky and Janet W. Adams. Traveling to Yale University Art Gallery, New Haven.

Patricia Heesy Gallery, New York. *Jim Dine and David Hockney: Works on Paper.* May–June.

Institute of Contemporary Arts, Philadelphia. *Face to Face: Recent Portrait Photography. Investigations* [exhibition series] 10. June–July. 4 works. Folded card, [8] pp. Text by Paula Marincola.

Knoedler/Kasmin Gallery, London. *British Painting.* June–July.

Los Angeles County Museum of Art. *Olympian Gestures.* June–October. 1 work. [4] pp.

L.A. Louver, Venice, California. *American/European Painting, Drawing and Sculpture.* July–September.

Tate Gallery, London. *The Hard-Won Image: Traditional Method and Subject in Recent British Art.* July–September. 2 works. 80 pp. Text by Richard Morphet.

Museum of Contemporary Art, Los Angeles. *Automobile and Culture.* July–January 1985. 1 work. 319 pp. Traveling to Detroit Institute of the Arts.

Walker Art Center, Minneapolis. *Prints from Tyler Graphics.* September–March 1985. 31 pp. Introduction by Martin Friedman.

National Gallery of Art, Washington, D.C. *Gemini G.E.L.: Art and Collaboration.* November–February 1985. 9 works. 280 pp. Introduction by Bruce Davis. Text by Ruth E. Fine. Traveling to Seattle Art Museum; Nelson-Atkins Gallery, Kansas City; Terra Museum of Art, Chicago; and Los Angeles County Museum of Art.

1985

Grande Halle de la Villette, Paris. *Nouvelle biennale de Paris, 1985.* March–May. 4 works. 331 pp. Introduction by Georges Boudaille. Includes a statement by Hockney.

Victoria and Albert Museum, London. *From Manet to Hockney: Modern Artists' Illustrated Books.* March–May. 3 works. 379 pp. Introduction by Carol Hogben.

Walker Art Center, Minneapolis. *Paperworks from Tyler Graphics.* April–June. [8] pp. Text by Amy Reigle Newland.

Hirshhorn Museum and Sculpture Garden, Washington, D.C. *Representation Abroad.* June–September. 11 works. 222 pp. Text by Joe Shannon. Includes statements by Hockney.

Aldrich Museum of Contemporary Art, Ridgefield, Connecticut. *A Second Talent: Painters and Sculptors Who Are Also Photographers.* September–December. 54 pp. Text by Robert Metzger.

1986

Queens Museum, New York. *The Real Big Picture.* January–March.

Drawing Society, New York. *Master Drawings from the Drawing Society's Membership.* February–March.

Palais des Beaux-Arts, Brussels. [Music and the Visual Arts in the Twentieth Century.] February–April.

Photographic Resource Center, Boston University. *Photomosaics: The Landscape Reconstructed.* February–April.

Tate Gallery, London. *Forty Years of Modern Art, 1945–1985.* February–April. 3 works. 120 pp. Text by Ronald Alley. List of works issued separately. Duplicated typescript, [10] pp.

BlumHelman Gallery, New York. *Self-Portraits by Clemente, Kelly and Hockney.* March.

Los Angeles Municipal Art Gallery. *Drawing: A Classical Continuum.* March–April.

Schirn Kunsthalle, Frankfurt. *Die Maler und das Theater im 20. Jahrhundert.* March–May. 577 pp. Introduction by Denis Bablet and Erika Billeter.

Richard Gray Gallery, Chicago. *Major New Works.* May.

Art Museum Association of America. Traveling exhibition. *Contemporary Screens.* September–July 1988. 1 work. 48 pp. Text by Virginia Fabbri Butera. Traveling to Cincinnati, Coral Gables, Raleigh, Toledo, and Jacksonville.

1987

Royal Academy of Arts, London. *British Art in the Twentieth Century: The Modern Movement.* January–April. 4 works. 457 pp. Edited by Susan Compton.

International Center of Photography, New York. *Artists by Artists: Portrait Photographs from "Artnews" 1904–1986.* February–April. 1 work.

Holman Hall Art Gallery, Trenton State College, New Jersey. *Word & Image.* April–May. 1 work. [28] pp.

Taipei Fine Arts Museum, Republic of China. *Contemporary Los Angeles.* April–June. 2 works.

Museum of Art, Fort Lauderdale, and Los Angeles County Museum of Art. Traveling exhibition. *Photography and Art: Interactions since 1946.* 1 work. 272 pp. Text by Andy Grundberg and Kathleen McCarthy Gauss. Traveling to New York and Des Moines. June–June 1988.

Museum of Modern Art, New York. *Berlinart 1961–1987.* June–September. 1 work. 284 pp. Traveling to Museum of Modern Art, San Francisco. October–January 1988.

Odakyu Grand Gallery, Tokyo. *Pop Art U.S.A.-U.K.* July–August. 3 works. 174 pp. Parallel English/Japanese text. Text by Lawrence Alloway and Marco Livingstone. Traveling to Osaka, Funabashi, and Yokohama. September–December.

Milwaukee Art Museum. *Contemporary American Stage Design.* September–November.

Hecksher Museum, Huntington, New York. *The Artist's Mother: Portraits and Homages.* November–January 1988. 1 work. Text by Donald Kuspit, John Gedo, and Barbara Coller. Traveling to the National Portrait Gallery, Washington, D.C. April–May 1988.

International Center of Photography, New York. *Legacy of Light.* November–January 1988. 4 works.

Hudson River Museum, Yonkers. *The World Is Round: The Artist and the Expanded Vision.* 4 works. 64 pp. Introduction by Marcia Clark. Traveling to Wilmington, Delaware; Southampton, New York; Nashua, New Hampshire; Albany; and New Paltz. November–March 1989.

ARTICLES IN PERIODICALS

1961

Reichardt, Jasia. *"Les Expositions à l'étranger."* Group exhibition review, John Moores, Liverpool. *Aujourd'hui: Art et Architecture* 34 (December): 60.

1962

Farr, Dennis. "The John Moores Liverpool Exhibition 3." *Burlington Magazine* 104 (January): 30–31.

Smith, Richard. "New Readers Start Here . . . Three Painters in Their Last Year at R.C.A., Derek Boshier, David Hockney, Peter Phillips . . . " *Ark,* no. 32 (Summer): 38–39.

1963

Harrison, Jane. "London at Mid-Season." Includes group exhibition review, *Towards Art?* Royal College of Art. *Arts Magazine* 37 (February): 32–33.

Brett, Guy. "David Hockney: A Note in Progress." *London Magazine* 3 (April): 73–75+.

Whittet, G. S. "David Hockney, His Life and Good Times." *Studio* 166 (December): 252–53.

Richardson, John. "Pop?" Exhibition reviews, Kasmin and Editions Alecto, 1963. *New Statesman* 66 (6 December): 852.

Coutts-Smith, Kenneth. "Hockney." Exhibition reviews, Kasmin and Editions Alecto. *Arts Review* 15 (14–28 December): 10. Reproductions from both exhibitions published in *Arts Review* 15 (28 December 1963–11 January 1964): 3.

1964

Hockney, David. "Paintings with Two Figures." *Cambridge Opinion,* no. 37 (January): 57–58.

Lynton, Norbert. "London Letter." Includes exhibition reviews, Kasmin and Editions Alecto. *Art International* 8 (March): 73–74.

Martin, Ken. "The Quest for Fulfilment." *Observer Magazine* (16 March): 48–49.

Baro, Gene. "The British Scene: Hockney and Kitaj." *Arts Magazine* 38 (May–June): 94–101.

Rivers, Larry and David Hockney. "Beautiful or Interesting." *Art and Literature,* no. 5 (Summer): 94–117. Reprinted in *Pop Art Redefined,* by John Russell and Suzi Gablik. London: Thames and Hudson, 1969.

N[eumann], T[homas]. "David Hockney (Alan and A.A.A.)." In "Reviews and Previews." *Art News* 63 (October): 15.

R[aynor], V[ivien]. "David Hockney." In "In the Galleries." Exhibition review, Alan. *Arts Magazine* 39 (November): 61.

1965
Hodin, J. P. *"David Hockney."* Quadrum, no. 18: 144–45. French text.

1966
Hughes, Robert. "Blake and Hockney." Includes exhibition review, Kasmin, 1965. *London Magazine* 5 (January): 71–73+.

Lucie-Smith, Edward. In "London Commentary." Exhibition review, Kasmin, 1965. *Studio International* 171 (January): 35.

——— . Exhibition preview, Stedelijk Museum, Amsterdam. *Studio International* 171 (April): 159.

Baro, Gene. "David Hockney's Drawings." *Studio International* 171 (May): 184–86.

——— . [Hockney's *Ubu*]. *Art and Artists* 1 (May): 8–13.

Robertson, Bryan. "David Hockney." In "Arts and Amusements." Exhibition review, Kasmin. *Spectator*, no. 7204 (22 July): 121–22.

Overy, Paul. "Alexandria in London." Exhibition review, Kasmin, 1966. *Listener* 76 (4 August): 170.

Russell, John. "Art News from London." Includes exhibition review, Kasmin. *Art News* 65 (September): 22.

1967
Hockney, David. "The Point Is in Actual Fact . . . " *Ark*, no. 41: 44–46.

T., F. "David Hockney." Exhibition review, Landau-Alan. *Arts Magazine* 41 (April): 60.

1968
Burr, James. "Looking in Liverpool and London Shows." Includes exhibition review, Kasmin. *Apollo* 87 (January): 63–64.

Harrison, Charles. "London Commentary: David Hockney at Kasmin . . . " *Studio International* 175 (January): 36–38.

Gordon, Alastair. "Art in the Modern Manner." Includes group exhibition review, *John Moores Liverpool Exhibition 6*, 1967. *Connoisseur* 167 (February): 108–9.

Overy, Paul. "Components of the Scene." Exhibition review, Kasmin. *Listener* 79 (15 February): 222.

Masheck, Joseph. "Colin Self and David Hockney Discuss Their Recent Work with Joseph Masheck." *Studio International* 176 (December): 277–78, 282.

1969
"First Drafts of Grimm: David Hockney." *Ambit*, no. 41: 15–17.

Gordon, Alastair. "Art in the Modern Manner." Includes exhibition review, Whitworth. *Connoisseur* 171 (May): 34.

Shapiro, David. "Hockney Paints a Portrait." *Art News* 68 (May): 28–31, 64–66. Portrait of Henry Geldzahler.

Bowling, Frank. "A Shift in Perspective." Includes exhibition review, Emmerich. *Arts Magazine* 43 (Summer): 24–27.

von Bonin, Wibke. "Germany. Hockney's Graphic Art." Preview of Kestner-Gesellschaft exhibition, 1970. *Arts Magazine* 43 (Summer): 52–53.

1970
"David Hockney, Kestner-Gesellschaft, Hanover." *Magazin Kunst*, no. 39: 1920–21.

Denvir, Bernard. "London." Includes exhibition review, Kasmin, 1969. *Art International* 14 (February): 71–72.

Vaizey, Marina. "David Hockney Etchings, December 1969, Kasmin." *Connoisseur* 173 (March): 195.

Gosling, Nigel. "David Hockney: No Dumb Blond." *Observer Magazine* (22 March): 36–39.

Gilmour, Pat. "David Hockney." Exhibition review, Whitechapel. *Arts Review* 22 (28 March): cover, 183.

Seymour, Anne. "The Golden Boy." *Sunday Times Magazine* (London) (29 March): 22–25, 27.

Battye, John Christopher. "John Christopher Battye Interviews David Hockney." *Art and Artists* 5 (April): 50–53. Interview.

Lucie-Smith, Edward. "At Last the Real David Hockney Steps Forward." *Nova* (April): 40, 45.

Melville, Robert. "Golden Boy." Exhibition review, Whitechapel. *New Statesman* 79 (10 April): 527.

Grinke, Paul. "Love and Friendship. (Arts)." Exhibition review, Whitechapel. *Spectator* 224 (11 April): 488–89.

Salvesen, Christopher. "David Hockney's California." Exhibition review, Whitechapel. *Listener* 83 (23 April): 565.

Denvir, Bernard. "London." Includes exhibition review, Whitechapel. *Art International* 14 (May): 59, 72.

Dunlop, Ian. Exhibition review, Whitechapel. In "London Commentary." *Studio International* 179 (May): 229–30.

Burn, Guy. "David Hockney, Paintings, Drawings and Prints, 1960–70, April–May 1970, Whitechapel Art Gallery." *Connoisseur* 174 (July): 209.

von Bonin, W. *"Formale Probleme in David Hockneys Graphik."* Kunst und das Schöne Heim 82 (July): 425–32, 456. English summary, p. 456.

Coates, Anna. "Photographs by David Hockney." *Album*, no. 7 (August): 44–48.

Fuller, Peter. "Hockney." Exhibition review, Kasmin, 1970. *Arts Review* 22 (5 December): 792.

1971
R[osenstein], H[arris]. "David Hockney (Emmerich [1970])." *Artnews* 69 (January): 19.

"David Hockney Photographer." *Creative Camera* 80 (February): 56–63. Interview.

Denvir, Bernard. "London Letter." Includes exhibition review, Kasmin. *Art International* 15 (February): 42.

Feaver, William. "Safe with Objects." Includes exhibition review, Kasmin. *London Magazine* 10 (March): 85–86+.

Naipaul, V. S. "Escape from the Puritan Ethic." *Daily Telegraph Magazine* (10 December): cover, 38–44.

1972

Varley, William. "Medium Cool: The Drawings of David Hockney." Review of *72 Drawings by David Hockney. Stand* 13, no. 4: cover, 48–54.

Bernstein, Richard. "David Hockney. 'Call Me a Slop Artist if You Like.' " *Interview* no. 23 (July): 34–35, 44–45.

Matthias, Rosemary. "David Hockney's Painting at André Emmerich Uptown." *Arts Magazine* 47 (September): 58.

Gilmour, Pat. "David Hockney, Fieldborne Gallery." *Arts Review* 24 (18 November): 720.

1973

Wolfram, Eddie. "London." Includes preparation for 1972 exhibition at Kasmin. *Art and Artists* 7 (January): 44–45.

Fuller, Peter. "David Hockney, December 1972 (Closing Show), Kasmin Gallery." *Connoisseur* 182 (February): 151.

Feaver, William. "London Letter . . . " Includes exhibition review, Kasmin, 1972. *Art International* 17 (March): 58–59.

Hardie, Shelagh. "South-West." Includes exhibition review, Holburne Museum, Bath. *Arts Review* 25 (10 March): 147.

Wade, Valerie. "The Annual David Hockney Interview: Teatime in Hollywood." *Interview*, no. 34 (July): 19–20, 41–42.

Burn, Guy. "David Hockney, Jordan Gallery." *Arts Review* 25 (14 July): 484.

Wennersten, Robert. "Hockney in L.A." *London Magazine* 13 (August–September): 30–49+. Interview.

"David Hockney (Emmerich)." *Artnews* 72 (September): 86.

Bell, Jane. "David Hockney Print Retrospective at Knoedler." *Arts Magazine* 48 (December): 75.

1974

Furman, Laura. "David Hockney (Knoedler)." *Artnews* 73 (January): 50, 52.

Shepherd, Michael. "David Hockney Prints." Exhibition review, Kinsman Morrison. *Arts Review* 26 (25 January): 28.

Gilmour, Pat. "David Hockney, D.M. Gallery." *Arts Review* 26 (March): 114.

"David Hockney: Solid Gold." *Image* 2 (May): 22–29.

Fuller, Peter. "David Hockney at Garage . . . " *Arts Review* 26 (26 July): 467.

"*Entretien avec David Hockney.*" *Clés pour les Arts*, no. 46 (October): cover, 19–20. Interview.

Sterckx, Pierre. "*David Hockney: Images avec les deux yeux.*" Exhibition review, Musée des Arts Décoratifs. *Chroniques de l'Art Vivant*, no. 52 (October): 26–28.

Loring, John. "David Hockney Drawings." Exhibition review, Dayton's Gallery 12. *Arts Magazine* 49 (November): 66–67.

Oliver, G. Exhibition review, Musée des Arts Décoratifs, 1974. *Connaissance des Arts*, no. 273 (November): 144.

Miles, Ray. "Hockney in Paris." Exhibition review, Musée des Arts Décoratifs. *Arts Review* 26 (1 November): 651.

B[ouyeure], C[laude]. "David Hockney." In "Opus Actualités." *Opus International*, no. 53 (November–December): 120–21.

Nagger, C. "David Hockney." *Zoom* 27 (November–December): 58–65.

1975

Denvir, Bernard. "David Hockney: An Episode in Social Aesthetics." *Art Spectrum* 1 (January): 26–29, 41–43.

Metken, Günter. "*David Hockney, Musée des Arts Décoratifs, Paris, 1974.*" *Kunstwerk* 28 (January): 47. German text.

Peppiatt, Michael. "Heartfield, Hockney, Kokoschka and Fiedler." Includes exhibition review, Musée des Arts Décoratifs, 1974. *Artnews* 74 (January): 99.

Ellenzweig, Allen. "David Hockney . . . Knoedler Contemporary Prints." *Arts Magazine* 49 (February): 13.

Goddard, Donald. "David Hockney. Knoedler." *Artnews* 74 (February): 97–98.

Lubell, Ellen. "David Hockney . . . Michael Walls." *Arts Magazine* 49 (February): 11.

Heilpern, John. "In the Picture with Hockney." *Observer Magazine* (2 February): cover, 12–17.

Baro, Gene. "David Hockney at Knoedler and Michael Walls." *Art in America* 63 (March): 93–94.

Coleman, John. "Chic to Chic." Review of the film *A Bigger Splash. New Statesman* 89 (14 March): 351.

French, Philip. "A Bigger Splash." Film review. *Sight and Sound* 44 (Spring): 120–21.

Gough-Yates, Kevin. "A Bigger Splash." *Studio International* 189 (March–April): 143–45. Interview with the filmmakers.

"Hockney Florilegium." Anthology of exhibition reviews, Musée des Arts Décoratifs, 1974. *Studio International* 189 (March–April): 145–46.

Roberts, Keith. "The Artist Speaks?" Review of the film *A Bigger Splash. Burlington Magazine* 117 (May): 301.

"David Hockney in Paris: A Conversation with Melvyn Bragg." *Listener* 93 (22 May): cover, 672–73. Interview.

Micha, René. "*Hockney.*" Exhibition review, Galerie Claude Bernard. *Art International* 19 (June): 82–83. French text.

Restany, Pierre. "*David Hockney: Une poésie qui va de soi.*" *XXe Siècle* no. 44, new series (June): 118–22. English summaries pp. [188–89]. Includes an interview with Hockney.

Fox-Pitt, Sarah. "*David Hockney und 'The Rake's Progress.*'" *Du*, no. 413 (July): 71–81.

Fuller, Peter. "A Bigger Splash." *Connoisseur* 189 (July): 252.

Campbell, Ormond. "David Hockney: *The Rake's Progress.*" *Arts Review* 27 (25 July): 422.

1976

Holstein, Bent. *"En myte pa 38."* *Louisiana Revy* 16 (January–March): 26–28.

von Graevenitz, Antje. *"Nijmegs Museum Commanderie van St. Jan . . . 'David Hockney, Bilder, Zeichnungen, Druckgraphik' . . . 1975."* *Pantheon* 34 (January–March): 71–72.

Simmons, Rosemary. "David Hockney, Jordan Gallery." *Arts Review* 28 (2 April): 163.

Frackman, Noel. "David Hockney . . . Davis and Long." *Arts Magazine* 51 (September): 15.

Andre, Michael. "David Hockney (Davis and Long.)" *Artnews* 75 (October): 115–16.

Hill, Robert. "David Hockney, F. E. McWilliam, Waddington Galleries." *Arts Review* 28 (12 November): 608.

McEwen, John. "Everybody on Hockney on Hockney." Review of reviews of *David Hockney by David Hockney. Art Monthly*, no. 3 (December–January 1977): 7–8.

1977

Crichton, Fenella. "London Letter." Includes exhibition review, Robert Self, 1976. *Art International* 21 (January): 38.

Micha, René. *"Paris."* Includes exhibition review, Sonnabend, Paris, 1976. *Art International* 21 (January): 43. French text.

"R. B. Kitaj and David Hockney in Conversation." *New Review* 3 (January–February): cover, 75–77. See *Arts Review* 29 April 1977 for critique of this article.

Rubinfien, Leo. "David Hockney, Sonnabend Gallery [New York, 1976]." *Artforum* 15 (February): 69.

Ratcliff, Carter. "The Photographs of David Hockney." *Arts Magazine* 51 (April): 96–97.

Ackerman, D. and M. "Dear Kitaj and David: The Quality of the Creation Is More Important Than the Content." *Arts Review* 29 (29 April): 285–87. Critique of "conversation" in *New Review* 3 (January–February).

Fantoni, Barry. "Gold Fingers, (Sacred Cows)." *Sunday Times Magazine* (London) (1 May): 79.

Henry, Gerrit. "David Hockney (Getler/Pall)." In "New York Reviews." *Artnews* 76 (September): 147.

Fuller, Peter. "An Interview with David Hockney: Part 1." *Art Monthly*, no. 12 (November): 4–6, 8–9. Part 2 appears in no. 13 (December–January 1978): 5–8, 10.

Gosling, Nigel. "Things Exactly As They Are." *Horizon* 20 (November): 46–51.

Conrad, Barnaby, III. "Mr. Geldzahler Looks at Mr. Hockney." Exhibition review, Emmerich. *Art/World* 2 (12 November–9 December): 1, 14.

Deitcher, David. "David Hockney: The Recent Work." *Arts Magazine* 52 (December): 129–33.

1978

"The State of British Art: A Debate. Session 2, Who Needs Training?" *Studio International* 194 (no. 2): 91–92 +. Hockney was a panel member at a conference at the ICA, London, 10–12 February.

Ffrench-frazier, Nina. "David Hockney (Emmerich, Uptown)." In "New York Reviews." *Artnews* 77 (January): 150.

Frackman, Noel. "David Hockney . . . André Emmerich." In "Arts Reviews." *Arts Magazine* 52 (January): 20.

Micha, René. *"David Hockney."* Exhibition review, La Hune, Paris, 1977. *Art International* 22 (January): 70. French text.

Rubinfien, Leo. "David Hockney, André Emmerich Gallery." In "Reviews/New York." *Artforum* 16 (February): 71–72.

Bongartz, Roy. "David Hockney: Reaching the Top with Apparently No Great Effort." *Artnews* 77 (March): cover, 44–47.

Amory, Mark. "Hockney Magic." *Sunday Times Magazine* (London) (28 May): 62–66, 69. *The Magic Flute* at Glyndebourne.

Conrad, Peter. "Grand Designs." *New Statesman* (16 June): 823. *The Magic Flute* at Glyndebourne.

Geelhaar, Christian. "Looking at Pictures with David Hockney." *Pantheon* 36 (July–September): 230–39. Interview.

Fox-Pitt, Sarah. "David Hockney und die *'Zauberflöte.'"* *Du*, no. 451 (September): 4, 6–7, 10. Interview.

Phillpotts, Beatrice. "David Hockney, Century Galleries, Henley-on-Thames." *Arts Review* 30 (24 November): 649.

1979

Crichton, Ronald. "David Hockney as Stage Designer." *Apollo* 109 (January): 50–55.

Evans, Bob. "David Hockney, Midland Group Gallery, Nottingham." *Arts Review* 31 (19 January): 23.

Nisselson, Jane E. "David Hockney, André Emmerich Gallery . . . Through Jan. 27." *Art/World* 3 (18 January–15 February): 8.

De Vecchis, M. *"L'enfant prodige della pittura inglese ha dipinti il grande oviente massonico di Mozart."* *Bolaffiarte* 10 (February–March): 54–56. *The Magic Flute* at Glyndebourne.

Rubinfien, Leo. "David Hockney, André Emmerich Gallery." In "Reviews/New York." *Artforum* 17 (March): 65–66.

Ross, Miriam. "No Joy at the Tate, by David Hockney." *Observer*, London (4 March): 33. Interview.

"Hockney's War on Tate." *Art/World* 3 (16 March–16 April): 1, 4, 7, 12.

Cooper, Emmanuel. "David Hockney." Exhibition reviews, Artists Market and Midland Group. *Art & Artists* 13 (April): 50.

Whelan, Richard. "David Hockney (Emmerich, Downtown)." *Artnews* 78 (April): 144.

Cohen, Colin, et al. "Paper Pools: David Hockney Combines Painting with Papermaking." *Crafts*, no. 38 (May): 42–46.

Bailey, Anthony. "Profiles: Special Effects." *New Yorker* (30 July): 35–36, 41–42, 44, 49–58, 60–69. Illustrated with three drawings by Hockney.

Butterfield, Jan. "David Hockney: Blue Hedonistic Pools." *Print Collector's Newsletter* 10 (July–August): 74–76. Interview.

1980
Albright, Thomas. "Elusive Realism/San Francisco." Includes exhibition review of *Travels with Pen, Pencil and Ink* in San Francisco, 1979. *Artnews* 79 (February): 182–83.

Tatransky, Valentin. "David Hockney . . . Grey Art Gallery." In "Arts Reviews." *Arts Magazine* 54 (June): 26–27.

Kuhn, Joy. "David Hockney: Making Realism Poetic." *Antique Dealer and Collectors Guide* (July): 68–69.

Olbricht, Klaus-Hartmut. *"David Hockney: Ein subtiler Graphiker."* *Kunst und das Schöne Heim* 92 (July): 437–44, 470. English summary, p. 470.

Morris, Lynda. "Hockney's Journeys." Exhibition review, Tate, 1980. *Listener* 104 (10 July): 62–63.

Spalding, Frances. "David Hockney: *Travels with Pen, Pencil and Ink.*" Exhibition review, Tate, 1980. *Arts Review* 32 (18 July): 305.

McEwen, John. "Hockney: At a Crossroads." In "Arts." Exhibition review, Tate. *Spectator* 245 (2 August): 22.

Blakeston, Oswell. "The Blue Guitar, Jordans." *Arts Review* 32 (29 August): 378.

Amaya, Mario. "A Conversation with David Hockney." *Architectural Digest* 37 (September): 188, 192, 196–97. Interview.

Bumpus, Judith. "David Hockney: The Magpie Instinct." *Art & Artists* 15 (September): 8–11.

Ratcliff, Carter. "David Hockney at Emmerich and the Grey Art Gallery." *Art in America* 68 (September): 125.

Geldzahler, Henry. "David Hockney: An Intimate View." *Print Review*, no. 12: 36–50. Text of a lecture delivered at New York University, 15 April 1980, in conjunction with the exhibition *Travels with Pen, Pencil and Ink.*

1981
Loney, Glenn. "David Hockney on 'Parade': Redesigning Modern Opera." *Performing Arts Journal*, no. 15: 65–74.

Geldzahler, Henry. "Hockney Abroad: A Slide Show." *Art in America* 69 (February): 126–41. Text of a lecture delivered at New York University, 15 April 1980, in conjunction with the exhibition *Travels with Pen, Pencil and Ink.*

Steinbrink, Mark. "Hockney's Act at the Met." *New York* 14 (23 February): 36–37. Triple bill at the Metropolitan Opera.

Rich, Alan. "Pure Titillation." *New York* 14 (23 March): 50. Triple bill at the Metropolitan Opera.

McEwen, John. "David Hockney Sets the Stage." *Portfolio* 3 (March/April): 68–70. Triple bill at the Metropolitan Opera.

Smith, Philip. "Sets and Costumes by David Hockney." *Arts Magazine* 55 (April): 86–91. Triple bill at the Metropolitan Opera. Interview.

Russell, John. "A Great Night at the Opera: The Spirit of 1917." *New York Review of Books* 28 (30 April): 40–43. Triple bill at the Metropolitan Opera.

Robertson, Bryan. "Hockney on Stage." *Radio Times* (25 April–1 May): 72–74. "Hockney at Work," BBC 2.

"Time and Likeness: Hockney at Work, BBC 2." *Listener* 105 (30 April): 571.

O'Connor, Patrick. "Hockney on Parade." *Harpers & Queen* (U.K. edition) (May): 158–61. Triple bill at the Metropolitan Opera.

"Hockney's Metropolitan Line." *Observer Magazine* (3 May): cover, 22–25. Triple bill at the Metropolitan Opera.

Harrod, Tanya. "David Hockney, Riverside Studios." *Arts Review* 33 (22 May): 215, 219–20.

"L'Opera de David Hockney." Exhibition review, Galerie Claude Bernard. *Connaissance des Arts*, no. 352 (June): 32. Triple bill at the Metropolitan Opera.

Overy, Paul. "Postcard Magic." Exhibition review, National Gallery, London. *Listener* 106 (6 August): 126.

Horton, James. "The Artist's Eye: David Hockney." Exhibition review, National Gallery, London. *Artist* 96 (September): 25–27.

Steinbrink, Mark. "David Hockney Reinvents Himself." *Saturday Review* (December): 30–31, 33, 35.

1982
Knight, Christopher. "David Hockney's Photographs." *Aperture*, no. 89: 32–47.

Kolodin, Irving. "Stravinsky à la Hockney." *Saturday Review* (February): 46.

Lynn, Elwyn. "Letter from Australia." Includes exhibition review, Rex Irwin, 1982. *Art International* 25 (March–April): 122–23.

de Gaigneron, Axelle. *"Portrait d'aujourd'hui."* *Connaissance des Arts*, no. 362 (April): 88–95.

Lavell, Stephen. "Hockney and Poetry, Michael Parkin." *Arts Review* 34 (21 May): 260–61.

Ameringer, Will. "David Hockney: Points of View." *Arts Magazine* 56 (June): 54–56.

Taylor, John R. "David Hockney: The Artist's Life." *Art & Artists* (August): 28–29.

"David Hockney: Autre art, autre biographie." Exhibition review, Pompidou. *Connaissance des Arts*, no. 368 (October): 50.

Westfall, Stephen. "David Hockney . . . Christie's Contemporary." In "Arts Reviews." *Arts Magazine* 57 (October): 18.

Halperin, Danny. "Unfreezing the Eye." *Telegraph Sunday Magazine* (17 October): cover, 14–20. On the occasion of publication of *David Hockney Photographs.*

Becker, Robert. "New York: David Hockney, André Emmerich Gallery." *Flash Art*, no. 109 (November): 67–68.

Morgan, Stuart. "London . . . David Hockney, Knoedler." *Artforum* 21 (November): 82–83.

Ratcliff, Carter. "David Hockney: Polaroid Composites." *Polaroid Close-up* 13 (November): cover, 3–7.

"Always Sunny." *Listener* (11 November): 16. Interview, "Openings," Radio London.

Butera, Virginia Fabbri. "David Hockney . . . André Emmerich." In "Arts Reviews." *Arts Magazine* 57 (December): 43.

1983

Esterow, Milton. "David Hockney's 'Different Ways of Looking.' " *Artnews* 82 (January): 52–59. Interview.

Tully, Judd. "Paper Chase." *Portfolio* 5 (May): 78–85. Includes statement by Hockney on making paper pool works.

Messer, William. "David Hockney Photographic Collages at the Richard Gray Gallery, Chicago." *British Journal of Photography* 130 (16 September): 971–72.

Gardner, Colin. "David Hockney at L.A. Louver, Los Angeles." *Images & Issues* 4 (September–October): 56–57.

Friedman, Jon R. "Everyday and Historic: The Photographs of David Hockney." *Arts Magazine* 58 (October): 76–77.

Hagen, Charles. "David Hockney, André Emmerich Gallery." *Artforum* 22 (October): 71–72.

Spalding, Jill. *"David Hockney: Entretien." Beaux Arts,* no. 7 (November): 26–31. Interview.

Arwas, Victor. "Transcendental Photography: A Review of David Hockney's Photographs at the Hayward Gallery." *AD: Architectural Design* 53 (November–December): 108–13.

Froiland, Paul. "A New Stage." Exhibition preview, *Hockney Paints the Stage,* Walker Art Center. *Horizon* 26 (November–December): cover, 40–45.

Haworth-Booth, Mark. "A Bigger Flash: Hockney's Experiment with the Camera." Exhibition preview, Hayward, 1983–84. *Sunday Times Magazine* (London) (6 November): 100–101.

Brittain, David. "Hockney's Photographs." Exhibition review, Hayward, 1983–84. *Amateur Photographer* 168 (26 November): 112–13.

Bienek, Horst. *"Erfolg ohne Allüre." Art: das Kunstmagazin* (December): 20–36, 38. (Cover is a portrait of Hockney by Andy Warhol).

Morgan, Stuart. "David Hockney at the Hayward [1983-84]." *Artscribe,* no. 44 (December): 58–59.

Peppiatt, Michael. *"David Hockney." Connaissance des Arts,* no. 382 (December): 72–83.

Hughes, Robert. "All the Colors of the Stage." Exhibition review, *Hockney Paints the Stage,* Walker Art Center. *Time* (5 December): 88–89.

Joyce, Paul. "David Hockney on Photography." *British Journal of Photography* 130 (16 December): 1326, 1328–29, 1331–33. Interview.

Lee, Leonard. "Hockney at the Hayward [1983–84]." *Art Monthly,* no. 72 (December–January 1984): 13–14.

1984

Vaizey, Marina. "The Changing Perspectives of David Hockney." *Connoisseur* 214 (January): 106–11.

Walker, Ian. "Doubting Hockney." In "News and Views." *Creative Camera,* no. 230 (February): 1250–51.

Fox-Pitt, Sarah. "David Hockney: *Hockney Paints the Stage,* Walker Art Center [1983]." *Artforum* 22 (April): 86–87.

Powell, Rob. "Bradford Boy Makes Good." *British Journal of Photography* 131 (6 April): 364.

Weschler, Lawrence. "The Art World: True to Life." *New Yorker* (9 July): 60–71.

Martin, Richard. "The Echoes in Echo Park: Styles and History in David Hockney's New Art." *Arts Magazine* 59 (October): 74–77.

Harris, Dale. "Hockney's Stage." *Performing Arts Magazine* (November): 24–36.

Martin, Richard. "David Hockney." Exhibition review, Associated American Artists. *Arts Magazine* 59 (December): 4.

1985

Martin, Richard. "'In an Old Book': Literature in the Art of David Hockney." *Arts Magazine* 59 (January): 110–13. Text of paper initially presented at the ARLIS/NA and CAA Conference Session on "The Artist and the Book."

O'Brien, Glenn. "David Hockney, André Emmerich Gallery [1984]." *Artforum* 23 (January): 82–83.

Hockney, David. *"120 photos pour une image." Photo,* no. 210 (March): 46–51.

Woods, Alan. "Hockney's Photographs." *Critical Quarterly* 27 (Summer): cover, 7–22.

Sayag, Alain. *"Hockney." Clichés* 18 (July): cover, 62–65. French text.

Fuller, Peter. "All the World's a Stage." Exhibition review, *Hockney Paints the Stage,* Hayward. *New Society* (26 July): 127–29.

Khan, Naseem. "In His Images." *New Statesman* 110 (26 July): 40. On Hockney making a photocollage at the National Museum of Photography, Film, and Television, Bradford.

Mullins, Edwin. "Scenes of Excellence." Exhibition review, *Hockney Paints the Stage,* Hayward. *Telegraph Sunday Magazine* (28 July): 18–23.

Gutterman, Scott. "David Hockney Paints the Stage." *Art and Design* 1 (August): cover, 12–17.

Kelleher, Anne. "A Way of Seeing More." *Harpers & Queen* (U.K. edition) (August): 96–97. Interview.

Fingleton, David. "Hockney Paints the Stage." Exhibition review, Hayward. *Arts Review* 37 (16–30 August): 415.

Cork, Richard. "Design Stage." Exhibition review, *Hockney Paints the Stage,* Hayward. *Listener* 114 (22 August): 36.

Knowles, Adrian. "Hockney Makes a Joiner." *Amateur Photographer* 172 (31 August): 96–99, 109. At the National Museum of Photography, Film, and Television, Bradford.

Taylor, John Russell. "Hockney at the Hayward." *Plays and Players,* no. 384 (September): 5–7.

Wykes-Joyce, Max. *"Hockney Paints the Stage,* Hayward Gallery. (Exhibition Reviews)." *Art & Artists,* no. 228 (September): 33–34.

Martin, Richard. "Demonstrations of Versatility: David Hockney in the Early 1960's." *Arts Magazine* 60 (October): 92–93.

Silver, Kenneth E. "Hockney, Center Stage." *Art in America* 73 (November): 144–59.

Saint-Jean, Pierre. "David Hockney: An Interview." *Gazette des Beaux-Arts* 106 (December): 227–34. Interview. English text.

Hockney, David. *"Vogue par David Hockney."* Vogue, Paris, no. 662 (December–January 1986): cover, 219–59. Special issue with a section designed by Hockney.

1986

Bing. "David Hockney, Not Just Another Poolside Chat." *In Style* [1986]: 32–35, 70. Interview.

Burn, Guy. "Prints: David Hockney." Exhibition review, Tate. *Arts Review* 38 (11 April): 186.

"Hockney at Art Center." Exhibition review, Art Center College of Design, Pasadena, California, 1986. *At Art Center* 5 (June): cover, 2.

"Highlights: A Print Symposium in Hockney Country." *Print Collector's Newsletter* 17 (September-October): 126–30. Includes text of and discussion following Hockney's lecture given at the Contemporary Print Symposium at the Los Angeles County Museum of Art, 17 May 1986.

Hoy, Anne. "David Hockney's Photo-Mosaics." *Artnews* 85 (October): 91–96.

Larson, Kay. "Art: The Oracle of the Obvious." *New York* (6 October): 76–77.

Hughes, Robert. "Time Recomposed of Shards." Exhibition review, International Center of Photography. *Time* (13 October): 94+.

Brown, Betty A. "David Hockney: The Artist As Seer." *Visions: The Los Angeles Art Quarterly* (1 November): 4–7, 28–29. Interview.

Becker, Robert. "David Hockney." *Interview* 16 (December): 160–63. Interview.

Leech, Peter. "Photography as Sculpture: Hockney's Photographs at the Dunedin Public Art Gallery." *Art New Zealand*, no. 41 (Summer 1986–87): 34–35.

1987

Livingstone, Marco. "David Hockney's Faces." *Los Angeles Times Magazine* (18 January): 18–22.

"We Print Your Hockney Original" and "A David Hockney Original: A Bounce for Bradford." *Telegraph & Argus Special* (Bradford) (24 February): 13 and 14–15. Including full-color original print.

"Stat's the Way to Do It." Exhibition review, Museum of Film, Photography, and Television, Bradford. *Amateur Photographer* 175 (28 February): 78–79.

Liebmann, Lisa. "Los Angeles David Hockney L.A. Louver." *Artforum* 25 (March): 138.

Lieberman, Laura. "Between Memory and Vision: David Hockney's Photographic Collages." *Southern Accents* 10 (July–August): 52, 54, 56, 58, 62.

FILMS, VIDEOS, AND RADIO AND TELEVISION PROGRAMS

1969

BBC, London. Television program. "Canvas: The Frescoes, Domenichino." Hockney talks about the frescoes of Domenichino at the National Gallery. 8 May.

——— . "Review." Television program. Hockney proposes new uses for television. 20 December.

1971

——— . Television program. "24 Hours—Titian: The Fight to Keep the Painting *Death of Acteon* in Britain." Includes interview with Hockney. 22 June.

1972

——— . Television program. "Full House." Includes comments by Hockney on the Caspar David Friedrich exhibition at the Tate Gallery. 14 October.

1974

A Bigger Splash. Film. Directed by Jack Hazan. Documentary film of Hockney at work on *Portrait of an Artist (Pool with Two Figures)*.

1975

BBC, London. Television program. "Omnibus: David Hockney in Paris." Interview with Hockney conducted by Melvyn Bragg. 18 May.

——— . Television program. "Arena: Theater." On traveling exhibition of Hockney's sets for *The Rake's Progress*. 1 October.

1976

——— . Television program. "The Book Programme." Interview conducted by Robert Robinson about *David Hockney by David Hockney*. 21 October.

1978

——— . Television program. "The Lively Arts—Seeing through Drawing." Hockney, Jim Dine, Ralph Steadman, and Philip Rawson discuss drawing. 11 March.

1980

——— . Television program. "One Hundred Great Paintings." Hockney discusses Vincent van Gogh's *Café Terrace at Night*. 26 June.

1981

Arts Council of Great Britain and ILEA Learning Materials Service, London. Video. "David Hockney on Modern Art: An Interview with Melvyn Bragg."

BBC, London. Television program. "The Levin Interview—David Hockney." Interview with Hockney conducted by Bernard Levin. 13 June.

1982

Musée National d'Art Moderne, Centre Georges Pompidou, Paris. Video on the exhibition *David Hockney photographe*.

Pablo Picasso: The Legacy of a Genius. Film. Directed by Michael Blackwood. Includes comments by Hockney.

1983

BBC, London. Television program. "Hockney at Work." Hockney designs sets, paints, draws, and takes photographs in Los Angeles and London. 26 April.

London Weekend Television, London. Video. "Portrait of an Artist, Volume 12: David Hockney." Hockney makes photocollages in his home.

National Public Radio, Washington, D.C. Radio program. "All Things Considered." Hockney interviewed by Susan Stamberg about the exhibition *Hockney Paints the Stage*. 28 November.

Walker Art Center. Video. "David Hockney Designs Ravel's Garden." Included as part of the exhibition *Hockney Paints the Stage*.

1984
CBS, Minneapolis. Television program. "CBS Sunday Morning." Interview with Hockney conducted by Charles Kuralt about the exhibition *Hockney Paints the Stage* at the Walker Art Center, Minneapolis. 15 January.

BBC, London. Television program. "Glyndebourne: A Celebration of Fifty Years." Includes comments by Hockney. 30 June.

Archives of American Art, Smithsonian Institution, San Marino, California. Video. "Interview with David Hockney." Interview conducted by Lawrence Weschler. Recorded 3 September.

WFMT, Chicago. Radio program. "Art and Artists." Interview with Hockney conducted by Harry Bouras about the exhibition *Hockney Paints the Stage*. 7 September.

WBBM, Chicago. Television program. "Daybreak." Interview with Hockney conducted by Judy Moen about the exhibition *Hockney Paints the Stage*. 10 September.

WBEZ, Chicago. Radio program. "Midday with Sondra Gair." Interview with Hockney conducted by Sondra Gair about the exhibition *Hockney Paints the Stage*. 10 September.

BBC, London. Radio program. "Kaleidoscope." Interview with Hockney conducted by Colin Ford about *Cameraworks*. 27 September.

CBS, New York. Radio program. "CBS Morning News." Interview with Hockney about the exhibition *David Hockney: New Works: Paintings, Gouaches, Drawings, Photocollages* at André Emmerich Gallery, New York. 17 October.

National Public Radio, Washington, D.C. Radio program. "All Things Considered." Hockney interviewed by Susan Stamberg about *Cameraworks*. 23 October.

————. Radio program. "Morning Edition." Hockney interviewed by Andy Lyman about Cubism and *Cameraworks*. 1 November.

WFMT, Chicago. Radio program. "Studs Terkel's Almanac." Interview with Hockney conducted by Terkel. 3 December.

1985
BBC, London. Television program. "Newsnight." Includes preview of the Hayward Gallery installation of *Hockney Paints the Stage*. 25 July.

————. Television program. "Saturday Review." Interview with Hockney conducted by Stephen Spender about the book *Martha's Vineyard and Other Places: My Third Sketchbook from the Summer of 1982, David Hockney*. 26 October.

Griffin Productions, Ltd., London. Video. "Painting with Light: David Hockney." Hockney demonstrates his use of the Quantel Paintbox. Recorded November.

1986
National Public Radio, Washington, D.C. Radio program. "All Things Considered." Hockney interviewed by Noah Adams on the death of Christopher Isherwood. 1 January.

1987
KUSC, Los Angeles. Radio program. "Live from Trumps." Interview with Hockney conducted by Peter Hemmings about the set designs for *Tristan und Isolde*. 28 February.

CBS. Television program. "CBS Sunday Morning." Hockney shown making a photocollage in context of the exhibition *David Hockney's Photocollages: A Wider Perspective*, International Center for Photography, New York. Includes interview with Hockney conducted by Alan Harper. Fall.

INDEX

INDEX OF WORKS

Boldface indicates illustration.

LENDERS TO THE EXHIBITION

Abrams Family Collection
Mr. and Mrs. Harry W. Anderson
André Emmerich Gallery
Art Institute of Chicago
Arts Council of Great Britain
Dr. J. H. Beare
Werner Boeninger
Bradford Art Galleries and Museums, West Yorkshire, England
British Council
Carnegie Museum of Art, Pittsburgh
Lady D'Avigdor Goldsmid
Gilbert de Botton, Switzerland
Andre El-Zenny
Collection of Mr. and Mrs. Ahmet Ertegun
Collection of Shirley and Miles Fiterman
Fujii Gallery, Tokyo, Japan
David Geffen
Joseph Haddad, Beverly Hills, California
Mr. and Mrs. Richard C. Hedreen
Hirshhorn Museum and Sculpture Garden, Washington D.C.,
 Smithsonian Institution
David Hockney
Edwin Janss, Thousand Oaks, California
Sidney Kahn
Paul Kantor
Kunstmuseum Düsseldorf, Germany
Los Angeles County Museum of Art
Marquis of Hartington
Mr. Steve Martin
Metropolitan Museum of Art
Collection of Mr. and Mrs. Laurence B. Mindel

Mary Tyler Moore and Dr. S. Robert Levine
Museum Boymans-van Beuningen, Rotterdam
Museen Moderner Kunst, Vienna (on loan from Sammlung
 Ludwig, Aachen)
Museum of Modern Art, New York
Museum van Hedendaagse Kunst, Belgium
National Gallery of Victoria, Melbourne, Australia
National Museums and Galleries on Merseyside (Walker Art
 Gallery), England
Nelson-Atkins Museum of Art, Kansas City, Missouri
Neue Galerie, Sammlung Ludwig, Aachen
Mr. and Mrs. Norman Pattiz
Private collection, Berlin
Private collection, courtesy L.A. Louver Gallery,
 Venice, California
Private collection, Germany
Private collection, London
Private collection, Los Angeles
Rita and Morris Pynoos
Tony Reichardt, FN Queensland, Australia
San Francisco Museum of Modern Art
Scottish National Gallery of Modern Art, Edinburgh
Dr. Stan Sehler, Milwaukee
Mr. and Mrs. J. J. Sher
Trustees of the Tate Gallery
Tyler Graphics, Ltd.
Virginia Museum of Fine Arts
Waddington Galleries, London
Walker Art Center, Minneapolis
Several anonymous lenders

D A V I D H O C K N E Y

A R E T R O S P E C T I V E

·

was set in ITC New Baskerville, a revised and updated yet faithful interpretation of the original design by John Baskerville. By 1758 Baskerville had produced eight fonts of type after having worked more than six years on their design. He found his delicate typefaces literally unprintable on the presses of his day and was forced to develop appropriate printing technology concurrently with his type design. The type named for him was designed specifically for setting books and is considered the quintessential transition between Old Style designs and Moderns.

The title and display face used throughout this book is Copperplate Gothic, designed in 1904 by Frederic W. Goudy on commission from the American Type Founders Company.

The text was composed on a Mergenthaler V.I.P. phototypesetter by Andresen Typographics, Tucson. The title was set by Andresen Typographics, Los Angeles, and Aldus Type Studio, Ltd., Los Angeles. The printing was done by Nissha Printing Co., Ltd., Kyoto, Japan, and Gardner Lithographics, Los Angeles; the binding, by Nissha. The text paper is Espel 157 gsm. The book was printed in a first edition of 59,000 copies.

This book was edited by Phyllis Freeman, senior editor, Harry N. Abrams, Inc., and coordinated by Mitch Tuchman, managing editor, Los Angeles County Museum of Art. The design is by Sandy Bell, graphic designer, Los Angeles County Museum of Art, with production assistance by Eileen Delson and Amy McFarland.

COMMERCIAL

PRINTING

IS AN

ARTIST'S

(direct) MEDIUM.

layers can be removed.

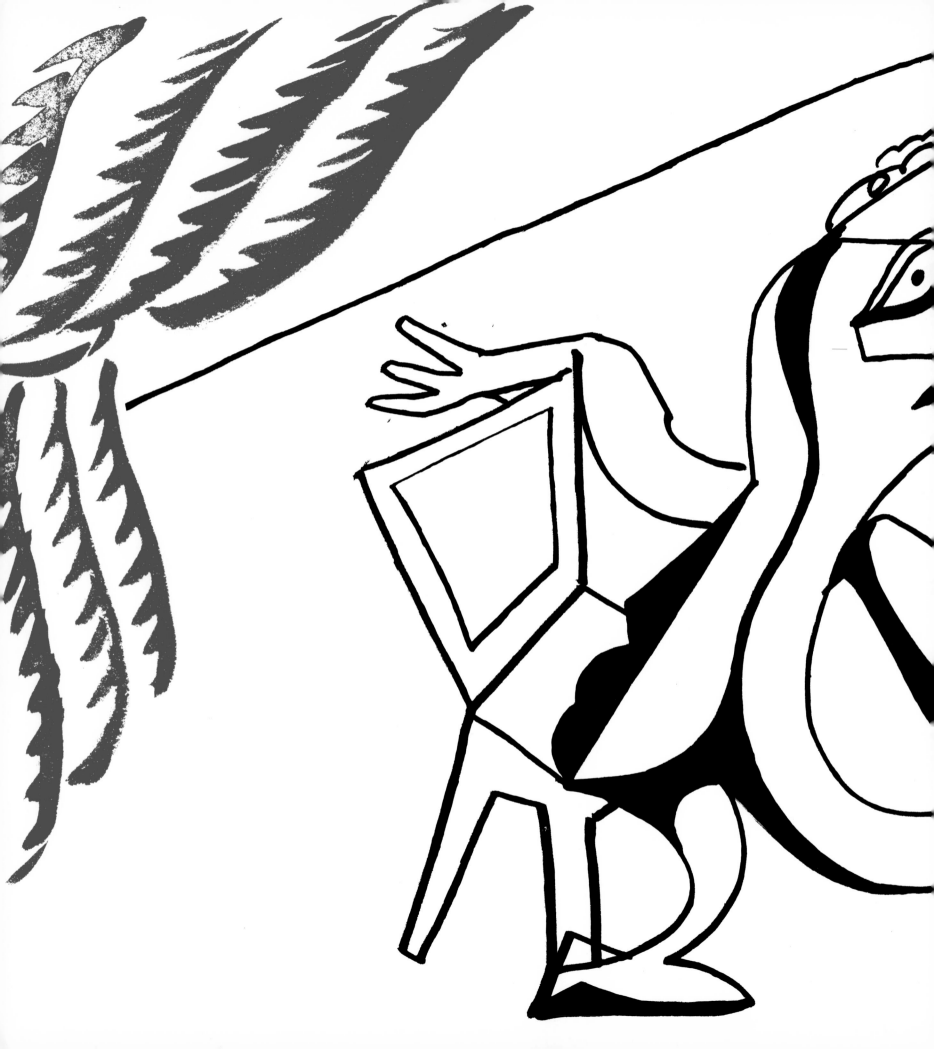

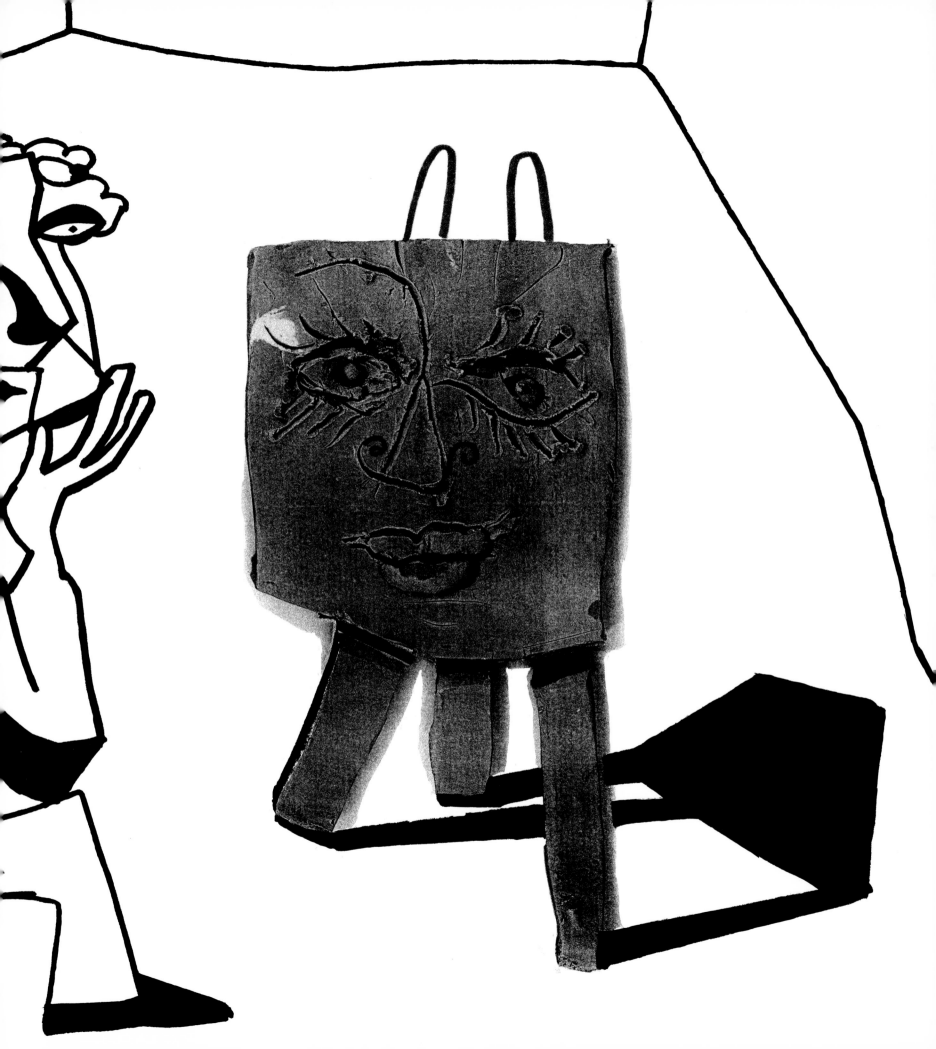

but so

SuR

is il

depth

FACE

usion

The pictures on the previous 23 pages were conceived of using the medium of printing ink on paper. I constructed them by drawing the four colours separately. Each colour was drawn in black-and-white on separate sheets of paper with the thought of the coloured ink in my head. The picture only exists when all four separations are put together. This happens here on this surface. They are therefore not reproductions in the ordinary sense but the original work. (ie. this is the only form they exist in.

They were proofed first on an office copying machine, without which it would not have been possible to construct them. New technologies have started revolutions that need not frighten us They can be humanized by artists. The office copier has opened up commercial printing as a direct artist's medium.

David Hockney.

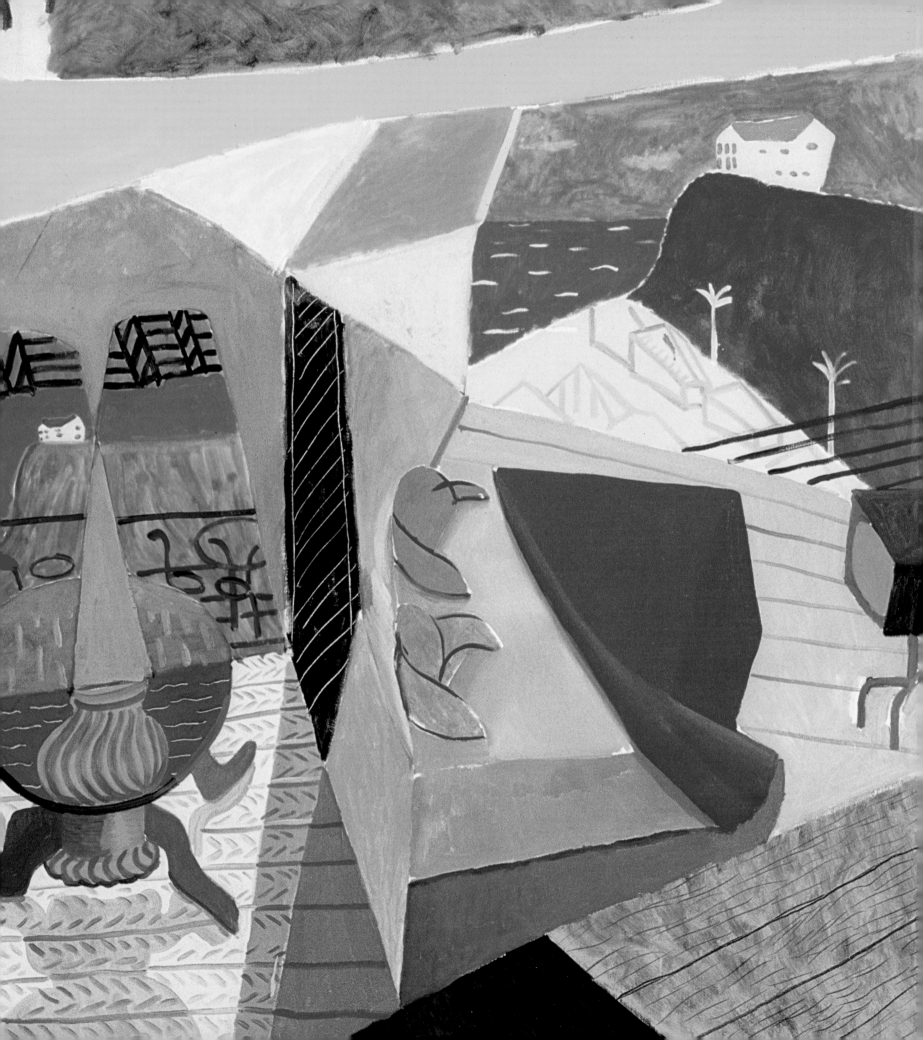